SILVER HOLLOWWARE
for Dining Elegance

Coin & Sterling

Richard Osterberg

Schiffer Publishing Ltd

77 Lower Valley Road, Atglen, PA 19310

This book is dedicated to
my dear friend Marie Whiteside.
For over twenty-five years
we have searched for antiques
and collectibles together.
May we be granted yet another
twenty-five years,
for the search is not yet over!

Copyright © 1996 by Richard Osterberg

Printed in China.
ISBN: 0-88740-955-5

We are interested in hearing from authors
with book ideas on related topics.

Library of Congress Cataloging-in-Publication Data

Osterberg, Richard F., 1938-
 Silver hollowware for dining elegance: coin &
sterling/Richard Osterberg.
 p. cm
 ISBN 0-88740-955-5 (hard)
 1. Silverware--United States--History--19th century-
-Catalogs. 2. Silverware--United States--History--20th
century--Catalogs. I. Title.
NK7112.085 1996
739.2'3713'09034075--dc20 95-49661
 CIP

Published by Schiffer Publishing Ltd.
77 Lower Valley Road
Atglen, PA 19310
Please write for a free catalog.
This book may be purchased from the publisher.
Please include $2.95 postage.
Try your bookstore first.

Table of Contents

Acknowledgements

This book started with a short talk to the Fig Garden Women's Club of Fresno, California. They asked if I would make a presentation about silver hollowware, similar to a talk I had given about flatware. Though at first I hesitated, I decided to try it. Once the presentation's outline was made and the available hollowware items were listed, a hollowware book became a possibility too. I searched my back issues of *Silver Magazine* and noted the many ads featuring beautiful hollowware. I wrote letters to a long list of dealers, museums, and individuals. Soon I had a lengthy phone message from Constantine Kollitus. He sent a package with photographs of many of the items I had seen in *Silver Magazine* over the past fifteen years. Soon others began to arrive. Sherry Langrock of Silver Crest Antiques offered her photographs. Next was Michael Weller. A visit to him at his shop brought a collection of the photographs he had available and wonderful talks about silver. Then Phyllis Tucker of Houston called and sent slides and negatives of her silver. Worked in between all of this were photographs from Bill and Connie McNally at *Silver Magazine,* Maxine Klaput, Gebelein's, Vroman's, Butterfield and Butterfield, the Campbell Soup Museum, Mrs. Martha Swan, Arthur Hippensteel, and my friends Shon and Pat Miller, Marie Whiteside, Bill and Ann Lyles, and Lucille Zoller. To all of these people I owe a special thanks. To my wife Gail—thanks for all your help with the manuscript and for giving so freely of your time and energy; I love you.

Dick Osterberg
P. O. Box 14055
Pinedale, CA 93650-4055

Chapter 1
Styles in Coin & Sterling Hollowware

American silverware can be divided into two main categories. The first is flatware, which consists of the place and serving pieces: knives, forks, and spoons. The second category is hollowware: silver that has been shaped into dishes.

Before 1868, coin silver was the standard for measuring the alloys of silver and other metals used in flatware and hollowware. The amount of actual silver in coin silver varied from silversmith to silversmith, so the designation does not indicate any consistent silver content.

The British, on the other hand, used the excellent British sterling standard, indicating that the alloy was 925/1000 silver. The excellent quality of this standard pressured American producers to adopt the sterling standard around the close of the American Civil War. American silver produced after 1868 usually bears the mark of "sterling," or a "925/1000" mark. Some of the early American pieces done in sterling grade were first labeled as "English Sterling," even though they were made in the United States. This made consumers think that the amount of silver was constant and consistent (even though it often was not). Another reason the American silversmiths adopted the sterling grade was so that they could compete in the English market.

American silver companies hired silver artists to design a myriad of designs. Some of these were original, while others were adapted from European designs. These design elements do not necessarily follow the same periods or styles as those found in the other decorative arts. Thus, the designs of silver hollowware often does not correspond to the furniture of the same period. Charles H. Carpenter, in his text *Gorham Silver,* states that "style names change with time. Few of those used today correspond with those used in the nineteenth century" (page 3).

American silver hollowware is available in a wide variety of styles. Some periods are very similar, but the interpretation of style by a number of manufac-turers resulted in diverse pieces, each with its own particular charm.

A silversmith working in the countryside, miles from any major city, might not be aware of the latest styles for a long time. Nor would his customers, unless they traveled to and from the large cities. This explains why it is possible to find silver that was made in designs that were no longer current at the time of manufacture.

The customers, too, had a great deal of influence on the evolution and longevity of styles. Customers sometimes remembered special designs they had seen while traveling away from home, and on their return described the pieces to their local silversmiths in hopes of having them recreated. This is another way that new styles made their way to different regions.

Customers' tastes and methods of purchase could also extend an old pattern's popularity for years after it had passed its heyday of popularity. A customer who needed time to save money for a particular piece in a favorite pattern may not have been able to afford the purchase until the style was already old-fashioned! Another reason silver pieces can be found with date marks indicated later years than the design style would suggest is that customers often had "matches" made for their heirloom sets if a piece was lost or destroyed, or if they had inherited only part of a set.

Silver styles come and go, but the companies that have been able to remain in business for many years have learned to draw upon public opinion, changing fashion, and (if they are lucky enough to have them) their own archives for inspiration. They are never at a loss for styles that will appeal to the public. After examining many pieces of silver I have chosen to review the following styles: Empire, Gothic Revival, Rococo, Neoclassicism, Art Nouveau, Colonial Revival, Arts and Crafts, and Art Modernism. This is a very simplistic outline, for under each heading there may be several periods that need to be examined. I

will use a series of water pitchers to illustrate my interpretation of each style. Examining water pitchers is a simple way to compare the various periods, since the pitchers are readily available and are complete as individual items.

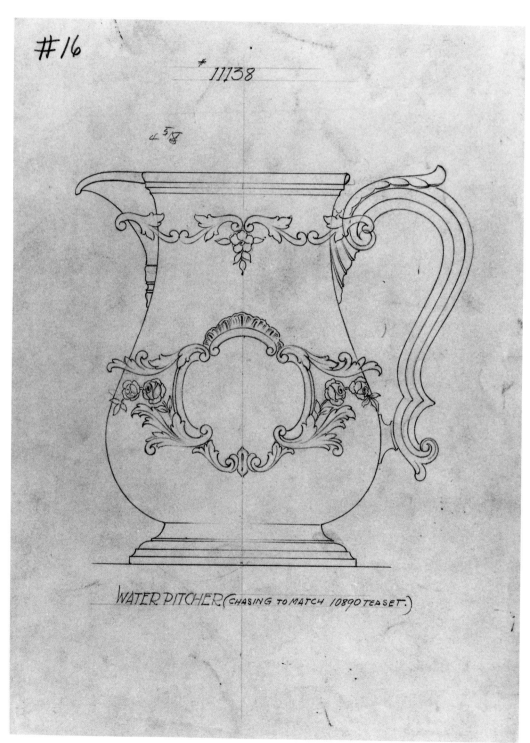

Original line drawing from Shreve and Company for the pitcher #11138, which is chased to match their #10890 tea set. *Courtesy of Argentum Antiques, San Francisco, California. Photograph by Tom Wachs.*

Empire Style

This silver design style, made early in the 1800s, is based on a style of furniture called Empire, introduced during Napoleon's reign. Empire style is the French interpretation of classical design. An Empire piece may be shaped like an urn or an inverted pear, with or without applied bands, and many pieces are bulbous. Each silversmith interpreted the style in his own way. Many pieces are monogrammed with the original owner's monogram and/or crest. American excitement over the emperor Napoleon highlighted the popularity of the style. Edwin Tunis, a well-known artist, illustrator, and muralist, writes in his text *Colonial Craftsman* that he considers even the American Hitchcock chair to be a variant of Empire design, though many have thought it to be a uniquely American piece.

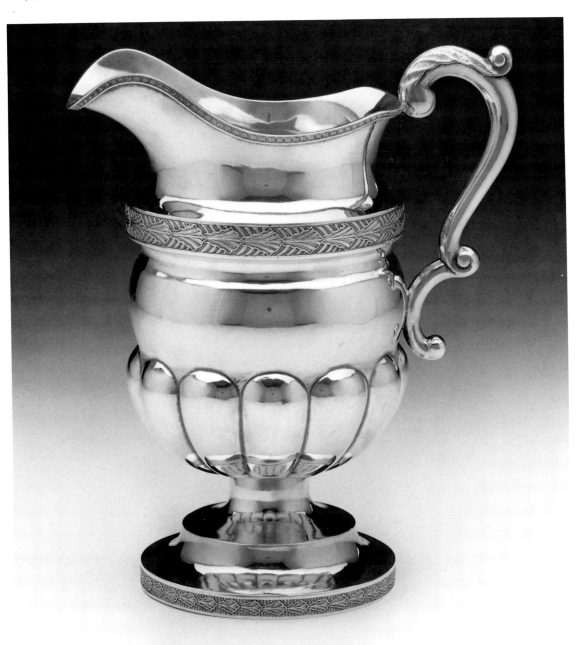

Figure 1.1 — Empire style
A water pitcher illustrating the Empire style. This pitcher was made in Boston by Farnham and Ward sometime between 1810 and 1816. The pitcher is 9 1/2 inches high. *Courtesy of Michael Weller, Argentum Antiques.*

7

Gothic Revival

The Gothic Revival period for silver began earlier and finished later than the same style in architecture, of which architect Alexander Jackson Davis was the undisputed leader. Architecture in this style began in the 1840s and ended with the American Civil War, but Gothic Revival silver continued to be produced even afterwards. Gorham, for example, produced silver items in Gothic Revival style for churches until the close of the nineteenth century. In fact, most of the silver made in this style was made for religious use, which explains why Gothic Revival flatware or home-use hollowware is so scarce.

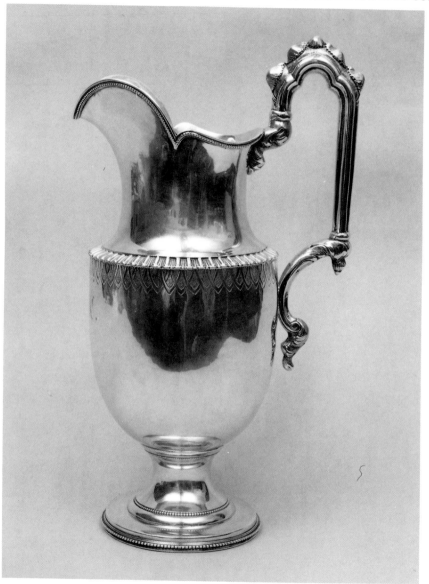

Figure 1.2 — Gothic Revival style
A pitcher by William Gale and Son, circa 1865, typifying the Gothic Revival style. It measures 13 3/4 inches high. This unusual example of the style has straight sides; only the handle carries out the design element, featuring the Gothic arches for which the style was named. Most examples of Gothic Revival silver display the arches on the sides of the vessel.
 This piece is engraved with the crest of the Pell family from Rhode Island. The piece was given to Rev. Dr. Samuel E. Cooke and his wife by the vestry of St. Bartholomew's Church at 44 Madison Avenue in New York on the occasion of their twenty-fifth anniversary. Dr. Cook was the rector from 1850 to 1887 at the church. Dr. Cook's wife descended from the Pell family. *Courtesy of Constantine Kollitus*

Rococo

The Rococo period began in the 1840s and continued until the 1860s. The style makes use of C- and S-scrolls, naturalistic flowers, fruits, and leaves. This was also the time of repoussé work. The word repoussé means "to push out," and the silversmith did just that: he pushed out the design. Then he added fine lines called "chasing" to make truly beautiful designs. Silver historian Charles Carpenter explains that Rococo enjoyed a resurgence in the 1880s and 1890s. This is reflected especially in the flatware designs of the period, such as *Rococo* by Dominick and Haff. Hollowware was much less common, but is still significant.

Many firms manufactured items in the Rococo style. The Maryland silversmiths, however, beginning with Warner and Kirk, are responsible for making this style appealing in the Southern states. Even today, the fancy look of Rococo patterns are more salable in the South; look for Kirk and Sons' current design *Repoussé*. The variations produced by Kirk, Warner, and later the Baltimore Silver Company (which eventually became Stieff) elevated Rococo design to new heights.

Tiffany and the McKay Silver

In 1878, Tiffany's exhibit at the World's Fair in Paris included the tremendously fabulous set of sterling flatware and hollowware made to order for the McKay family, who were one of the group of individuals profiting from the Comstock Silver Mines in Virginia City, Nevada. Mrs. McKay, upon seeing the silver mine, reportedly asked her husband if they could have a silver set made from their own silver. At first it was to be pure silver, but Tiffany's convinced the McKay's that sterling grade was necessary in order for the silver to be usable. The McKay service and the Japanese exhibitions in Paris in 1878, coupled with the tremendous ability of Moore put Tiffany's at the forefront in silver at this time (See Figure 2.34 for an illustration of the punch cup from the McKay service). This is not to say that Gorham was lagging far behind, for they too were cutting new trails in the design and sales based on work from their designer named Wilkinson.

Figure 1.3 — Rococo style
(see photo on color page 17)
A Rococo water pitcher sold by a nineteenth-century jewelry firm, E. P. Roberts & Sons of Hartford, Connecticut. This firm, according to Dorothy Rainwater, began in 1825, and was out of business by 1890.

This style incorporates many individual design trends, all based on interpretations of the classical designs of the Greeks, Romans, and other ancient civilizations. The Neoclassical period began somewhat slowly in the 1840s, and continued until the end of the century. Egyptian revival and Grecian revival are only two of these movements within the neoclassical period.

The Egyptian Revival, spanning from 1865 to 1885, corresponds to the opening of the Suez Canal, a monumental engineering achievement. Silver companies, always looking for new ideas, produced a number of beautiful silver pieces with Egyptian motifs, to which the public responded enthusiastically. The success of this style encouraged silver manufacturers to create other silver items relating to contemporary world events.

A second movement within Neoclassicism was Grecian Revival, which began in 1862 and ended by 1875, only to reappear from 1880 to 1910. The first part of this movement was known as the Classic Cameo period, with medallion designs resembling traditional carved cameos. The second part of this movement was known for its more impressionistic treatment of medallion motifs. D. Albert Soeffing, an expert on silver matters, denoted these two periods as Medallion I and Medallion II. A number of companies made hollowware in these styles, and many of their finest creations survive today in private collections and in museums.

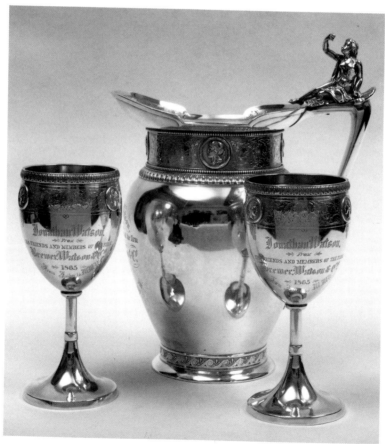

Figure 1.4 — Neoclassical Cameo style
A presentation set, consisting of a pitcher and goblets manufactured by Gorham. The pitcher and goblets have cameo heads, and the top of the handle on the pitcher shows a reclining figure in classical form. The engraving personalizes each piece, making this set even more desirable. *Courtesy of Constantine Kollitus*

Japanese

In the 1870s, the American public was "ripe" for the resurgence of new ideas and especially new art designs. The Japanese movement provided such an event. In 1854, Admiral Perry had opened the "curtain" that surrounded the mysterious island of Japan, which finally began trading with the West. As Japanese influence grew, all the larger silver companies designed a number of fantastic pieces of hollowware and some flatware that today stand as supreme examples of this tremendous period.

The period of American hollowware imitating Japanese style began in 1870 and ended approximately in 1885. Often, these hollowware pieces have a beaten, hand-hammered look (which helps hide surface scratches), and interesting leaves, vines, insects, or flowers "applied" onto the surface of the metal. Some pieces have bands in oriental patterns, which were probably rolled in various widths to compliment the form.

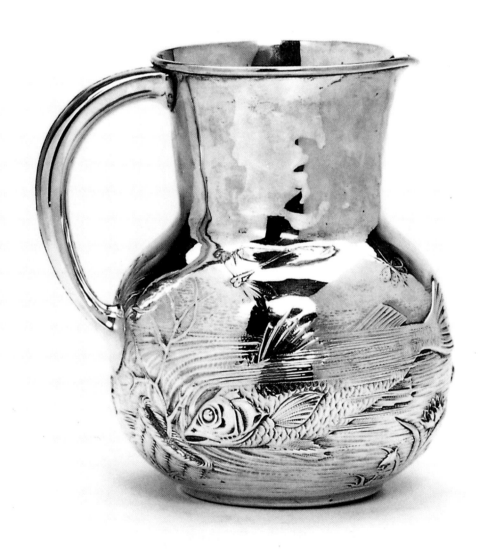

Figure 1.5a — Japanese style
A Gorham pitcher from 1883, embodying the Japanese movement in design. The bulbous base, cylindrical neck, and C-form hollow handle, coupled with the beautiful oriental surface design, make this piece exemplary. It is 7 1/2 inches high and has the Gorham number 1802 on the underside of the base. *Courtesy of Butterfield and Butterfield*

Tiffany was undoubtedly the American leader in Japanese-style silver. Much of the credit for Tiffany's unique Japanese designs goes to designer Edwin C. Moore, who saw many examples of Japanese art at the 1867 Exposition in London. The company later purchased a large number of Japanese artifacts from Christopher Dresser, an Englishman with a penchant for Japanese art items. Probably the best of this collection was used by Tiffany designers for inspiration, and the rest was sold at auction.

Edward C. Moore is responsible for the flatware design known as *Japanese,* which originally was called *Audobon.* This pattern is as interesting today as it was back in 1871 when it was introduced. While the pattern was eventually removed from the active sterling flatware list, Tiffany reissued the pattern in 1956, attesting to its continued popularity.

Tiffany's experimentation allowed them to produce not only beautiful silver, but silver that had copper and gold woven into the designs. This technique, used exclusively with Japanese-style wares, was called "mixed metals." English manufacturers did not enter the lucrative "mixed metals" market; the strict rules regulating the English sterling grade forbade them from adding other metals. This allowed American manufacturers to develop their own niche in the silver market.

Gorham and Whiting were also leaders in bringing Japanese style into the American home. Both produced beautiful pieces in the Japanese style. Gorham's work with the Japanese movement was facilitated by a former Tiffany employee named Frederick A. Jordan, who shared with Gorham many of the metalworking secrets that had been developed by Tiffany.

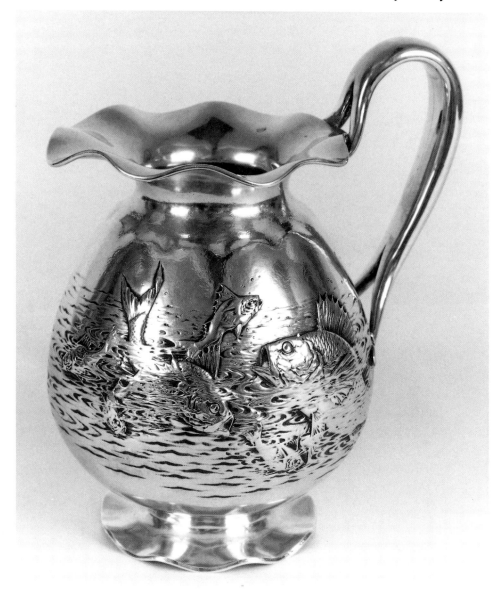

Figure 1.5b — Japanese style
The pitcher, by the Durgin Company of Concord, New Hampshire, is typical of the Japanese form. The beautifully crafted fish and rippling water on the sides of the piece are perfect examples of the style. The base and the top of the pitcher also reflect the gentle waves of the water. The artistic elements work together to carry out the oriental theme. Hollowware from Durgin is not often found; this particular example is especially rare. *Courtesy of Constantine Kollitus*

Art Nouveau

At the end of the nineteenth century, a new style emerged that was known as Art Nouveau. The new style called for flowing lines. In some designs human anatomy was disguised with long flowing hair, cloth, ribbons, or flowers. One of the first Art Nouveau silver designs was the flatware pattern *New Art* from the Durgin Company, a "non line" pattern. "Non line" means that not all the usual place and serving pieces were made, but only a selected few; if these peices sold well, a more complete line of flatware, and maybe even hollowware, was added. There were many other designs and manufacturers of Art Nouveau style silver, but by 1910 the style was obsolete.

Gorham's approach to the Art Nouveau period took a new twist. Under William C. Codman, a master designer from England, Gorham developed the *martelé*, or hand-hammered, style, which only Gorham used. Carpenter believes that Gorham manufactured almost five thousand pieces of hollowware during the time their martelé was in style, between approximately 1899 to 1910. Many of the designs are supposed to have been made by Codman, who made quick sketches and then handed them to the silversmiths assigned to martelé work. Some of the pieces bear Codman's initials or signature, suggesting more he may have taken further interest and followed that silver article throughout the developmental stages until completion. If you examine martelé articles closely, you can see several styles, suggesting that many different designers took part in their development.

Just before the end of the martelé period, Gorham began to add a greater amount of pure silver to their sterling. This made the alloy softer, and it became easier for the silversmiths to work their designs into the metal. Because of this, some martelé is 950 fine — that is, a 950/1000 silver alloy.

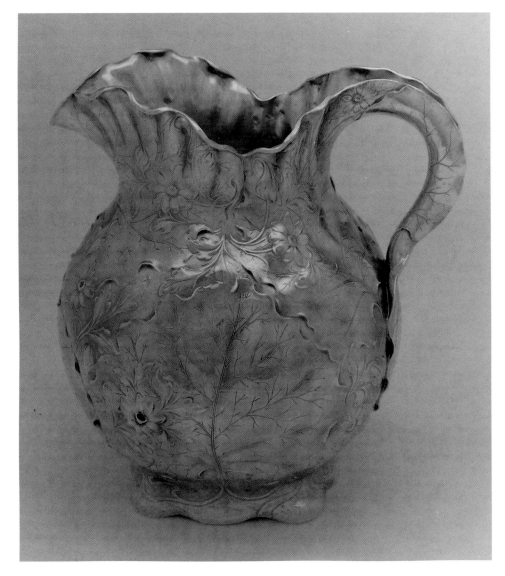

Figure 1.6 — Art Nouveau style
This martelé pitcher shows Art Nouveau modelling. It rests on a square base, from which a round, bulbous form expands. It is capped with a rippled form that merges into the edge of the pitcher and forms the spout. The handle pulls the two sides of the silver pitcher together for half its length before the two sides merge. Leaf veins and daisies are strategically placed on the surface of the pitcher, complimenting the entire design. *Courtesy of Phyllis Tucker Antiques*

Colonial Revival

As is the case with many styles, flatware in the Colonial Revival style was made quite a while before coordinating hollowware appeared. According to some experts, the Colonial Revival style for hollowware began around 1910, although flatware in the style had been seen at the 1876 celebration of America's centennial. Flatware designs based on this style were made by every silver manufacturer, and appeared with regularity after 1876. Examples of these were Gorham's *Old English Tipt* (1870), and Tiffany's *Queen Ann,* (c. 1870), followed by *English King* (1885), and *Colonial* (1895). Durgin in 1910 introduced *Fairfax*, which Gorham continues to produce.

Hollowware pieces were often significant financial investments — sometimes once-in-a-lifetime purchases — and were generally kept on display for all to see. Because of this, many customers thought it best to buy hollowware pieces in tried-and-true styles, among which was Colonial Revival. Colonial Revival has been popular for over one hundred years. Of particular note in this style is a Gorham hollowware pattern called *Plymouth*. A trip to an antique show almost always turns up something in that pattern, and indeed it is still being manufactured today.

Colonial Revival style was not limited to silverware; look at furniture by Adams and Sheraton, and at many types of china. Generally, the style features a squareness of form not found often in other styles. In silver, the pattern can be engraved, and at times has even been repousséd, yet the fundamental style remains. Many items in Colonial Revival have a pedestal base, which is different from the original colonial items upon which the revival was based.

Arts and Crafts Movement

The Arts and Crafts movement traces its roots back to the designs of William Morris (an English artisan who worked in the early 1880s), and continued through the 1920s. Simple lines with occasional hand-hammering are characteristic of Arts and Crafts silverwork. In the United States these items are best represented by a number of smaller manufactures. Among these are Friedell, Blanchard, Stone, Gebelein, the Old Newberry Crafters, and the Kalo Workshops.

The intention of Arts and Crafts silversmiths was to strengthen public respect for handmade items. To do this, they intentionally let signs of the craftsman's work show in the finished product — sometimes hammer-marks are visible, or finely-crafted rivets. Because of this, Arts and Crafts hollowware has a much different look from other styles of silver, which were usually much more polished and ornate. The Arts and Crafts movement is thought to be a reaction to the growth of industry. Industrial production had often diminished the individual's pride in his workmanship; independent craftsmen had become anonymous workers, producing countless items all alike, with little room for personal creativity. The Arts and Crafts movement sought to put the craftsman back in charge.

Figure 1.7 — Colonial Revival
(see photo on color page 17)
A pitcher by Gorham in the *Etruscan* pattern. In an old brochure describing the pattern, Gorham says that the hollowware "embodies the very spirit of Greek art in all its purity and graciousness, but also one of its most characteristic patterns—that which we now call the Greek Fret." The pattern is truly influenced by the Adams brothers' furniture designs and the Neoclassical style. The pitcher has the distinctive fret design worked along the square base and also on the band around the upper central portion of the pitcher. *Courtesy of Phyllis Tucker Antiques*

Figure 1.8 — Arts and Crafts style
A pitcher from Shreve and Company exemplifying Arts and Crafts silver work. The hand-beaten handle and the applied edge lend a feel of craftsmanship that captures the spirit of this period. The lines on this sturdy pitcher are clean and simple. *Courtesy of Michael Weller, Argentum Antiques*

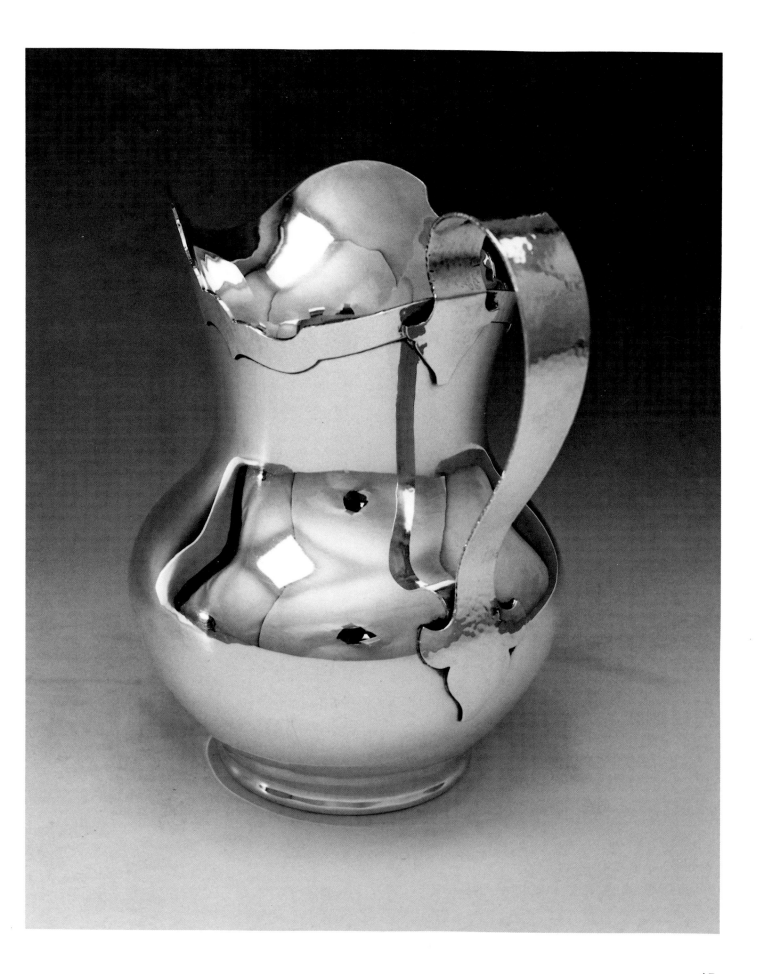

Art Modernism

Modernism began in the 1920s and continues through the present day. Two of the main styles in this period were Art Deco and Futuristic design. In vogue during the '20s and '30s, Art Deco silver hollowware featured straight lines and compact spouts. A second style was Futuristic, typified by Georg Jensen's work in Denmark. Reed and Barton's *Diamond* flatware and hollowware are examples of this movement. Straight angular lines with simplified designs are characteristic of the movement.

Tiffany introduced a futuristic pattern in 1937. It did not sell well, and went out of production. It is now back in production; perhaps the public is now ready to adopt the style. Few examples can be found in the secondary market—through antique dealers, etcetera.

The following chapters focus on specific silver hollowware items, all for use in the dining room. By no means is this a totally definitive text, showing every hollowware piece ever made in silver. I have included only those pieces which were available to me while I was writing the book.

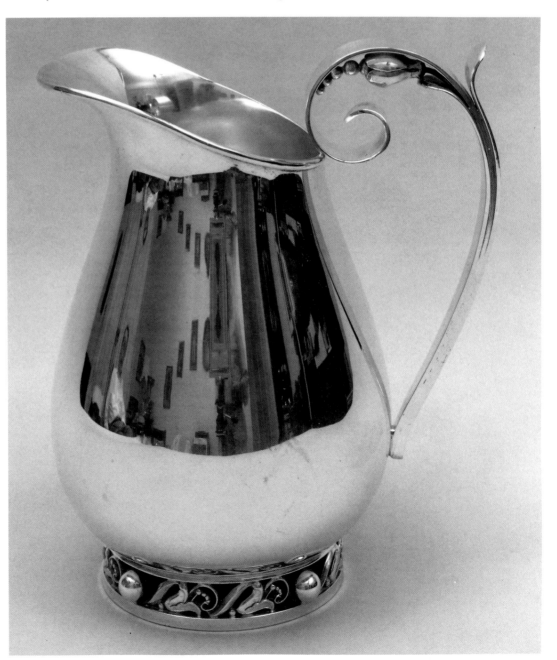

Figure 1.9 — Art Modernism
A pyriform vessel created by Alphonse La Paglia, who worked near his home in a shop built by International Silver Company in 1952. His work can best be compared to that of Danish artisan Georg Jensen or of Gorham silversmith Eric Magnusson. Modern yet classical lines appear on La Paglia work. The base of this pitcher is ornamented with a row of stylized lilies and leaves; tucked under the graceful handle is a seed pod with seeds bursting open and spilling out. La Paglia's untimely death in 1953, just a year after he began working with the International Silver Company, was a definite loss to the silver-buying public. *Courtesy of Constantine Kollitus*

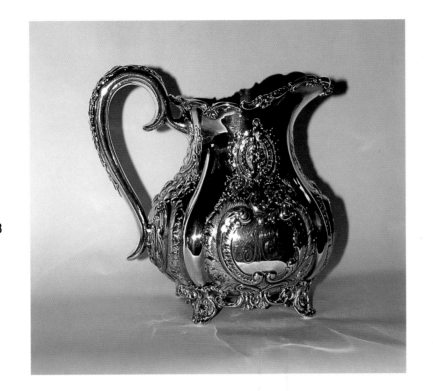

1.3

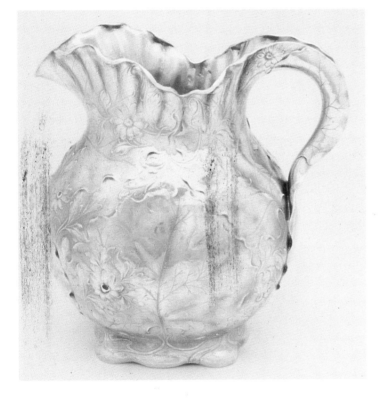

1.6

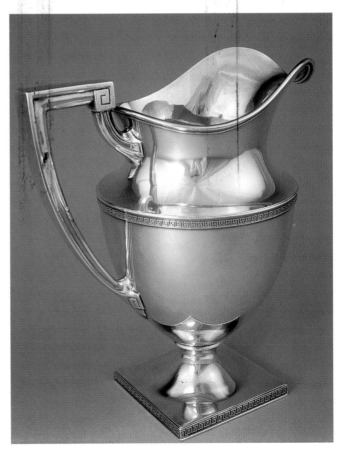

1.7

17

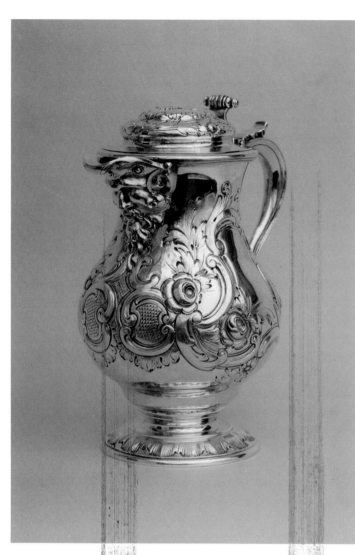

2.2a

2.2c

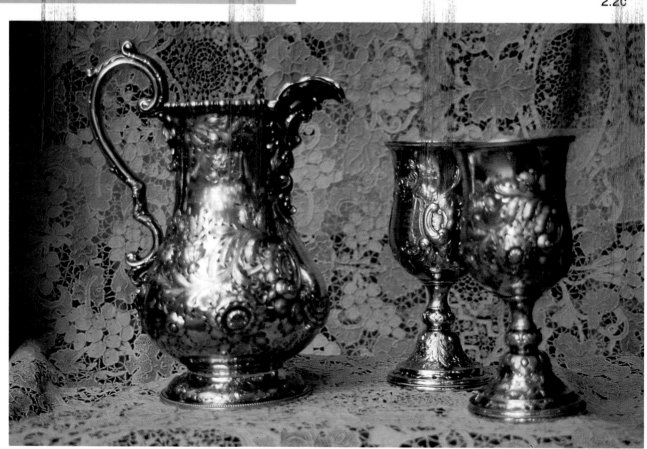

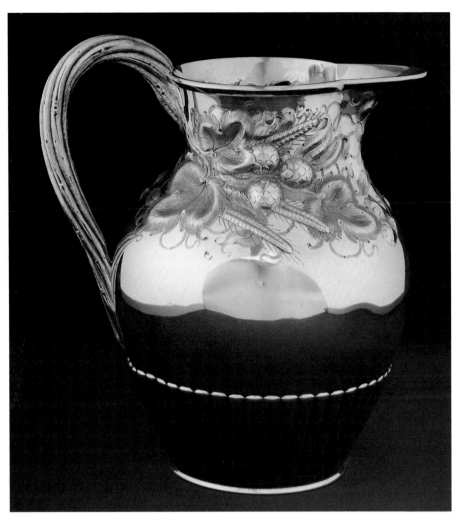

2.3

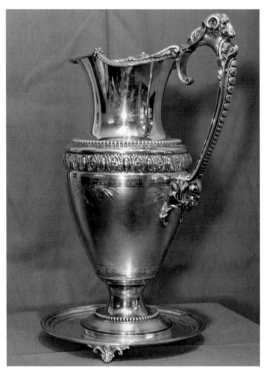

2.7

2.11a

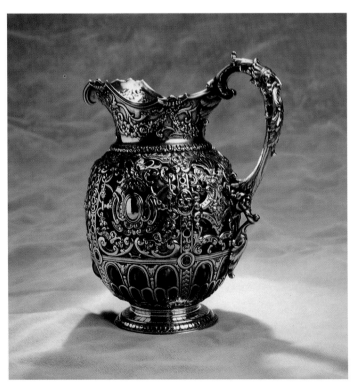

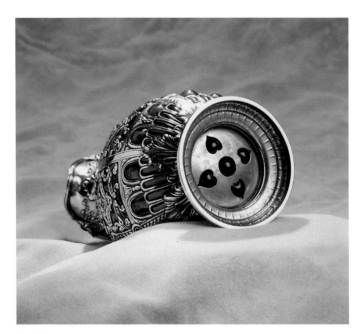

2.11b

19

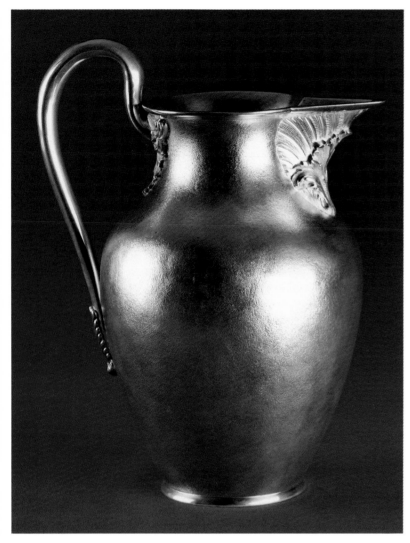

2.13

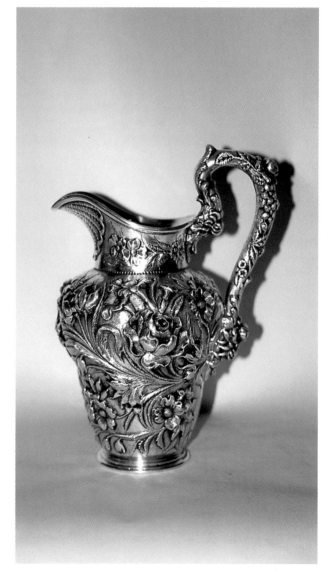

2.16

20

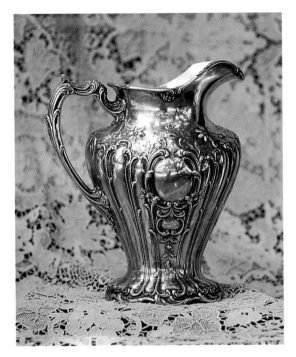

2.18a

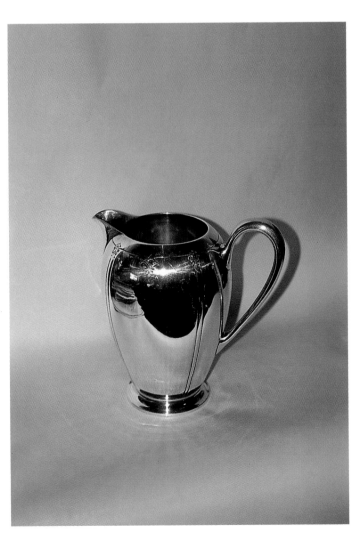

2.21

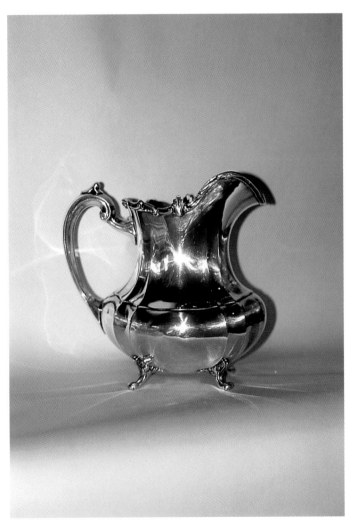

2.22

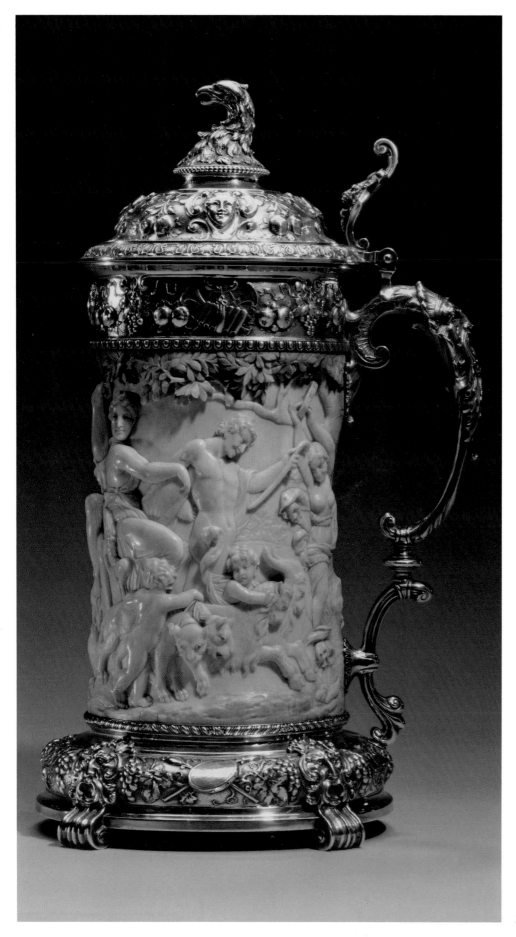

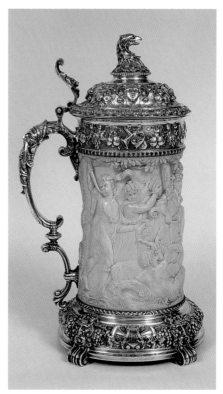

2.25c

2.25b

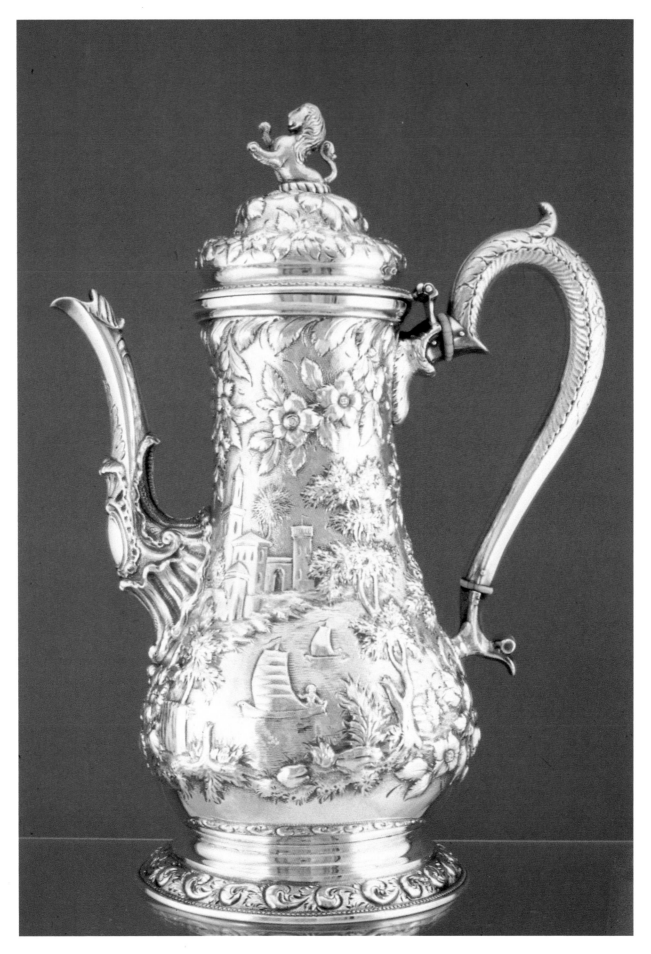

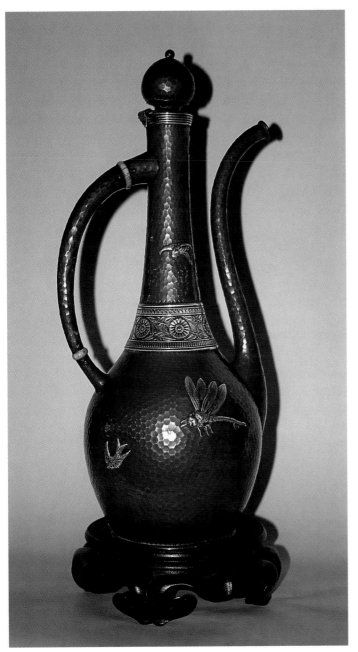

3.14a

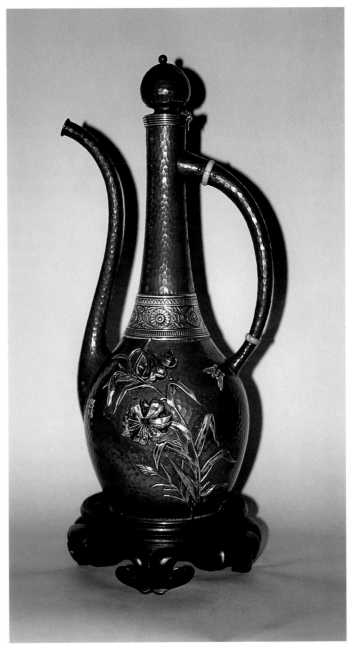

3.14b

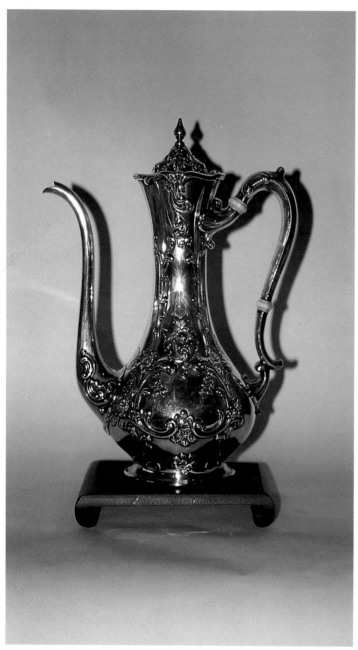

3.19

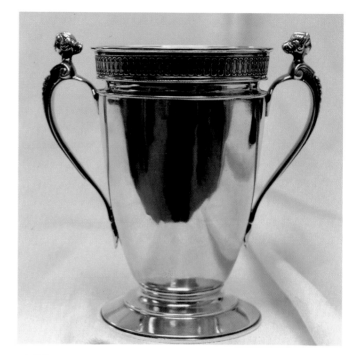

3.26

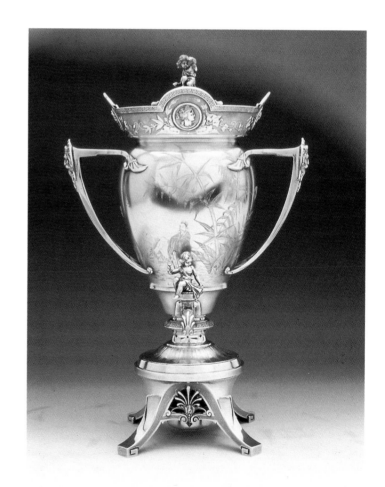

3.29

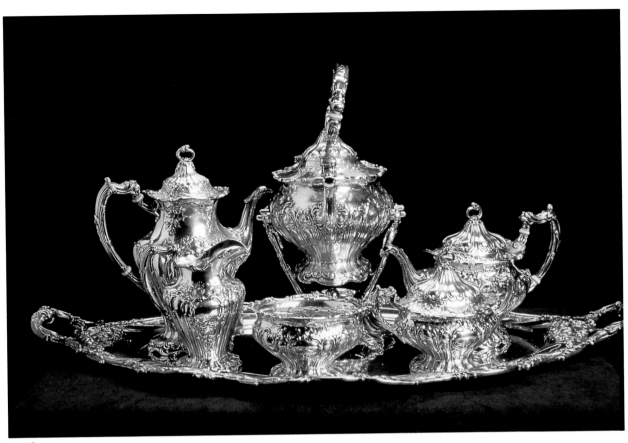

4.16

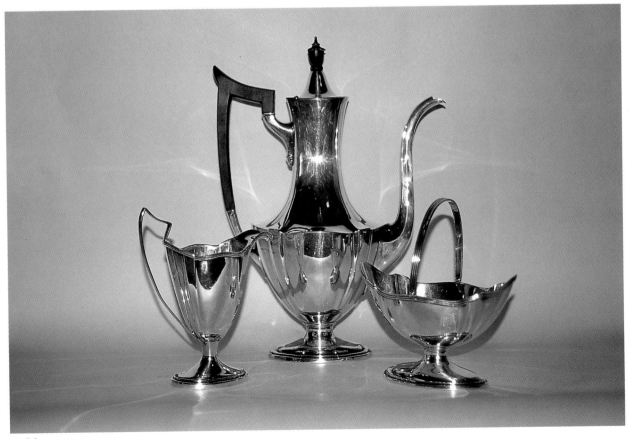

4.20

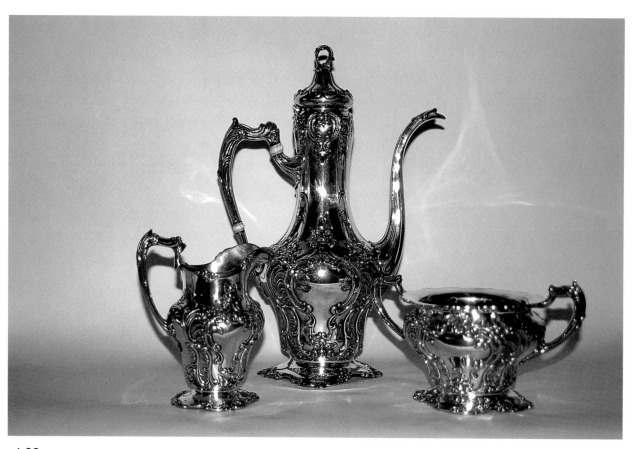

4.22

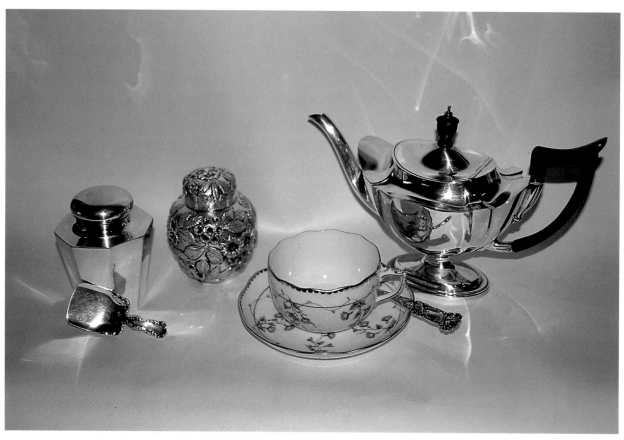

5.11

28

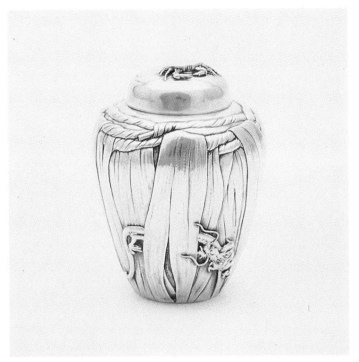

5.14

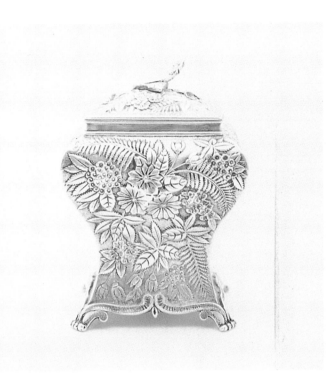

5.15

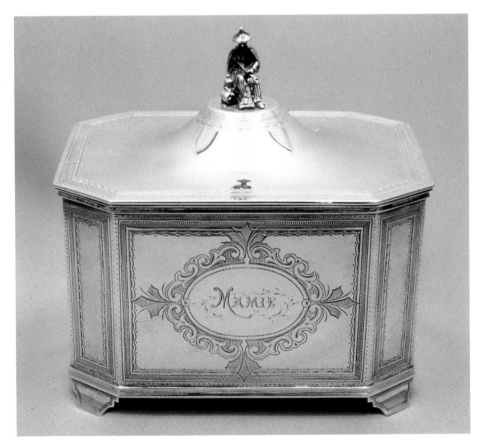

5.16

29

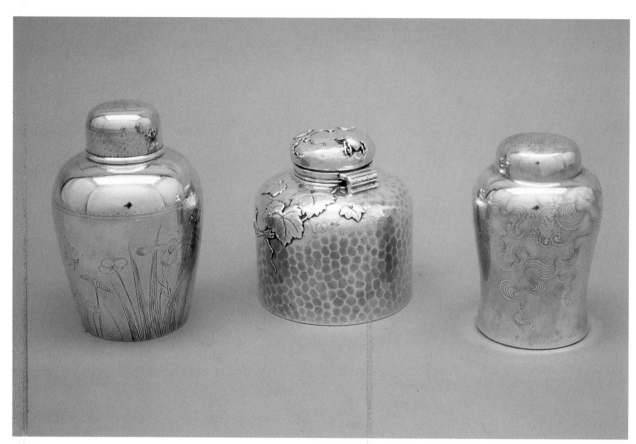

5.17

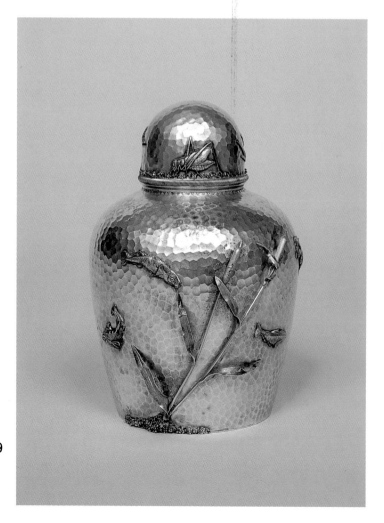

5.19

6.12

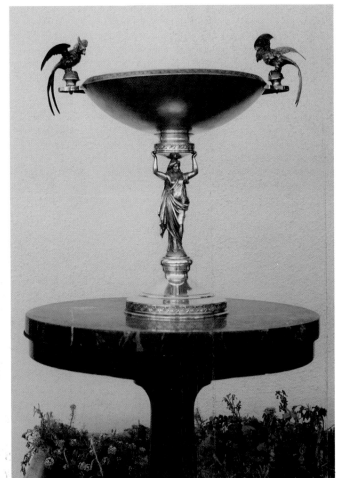

7.9

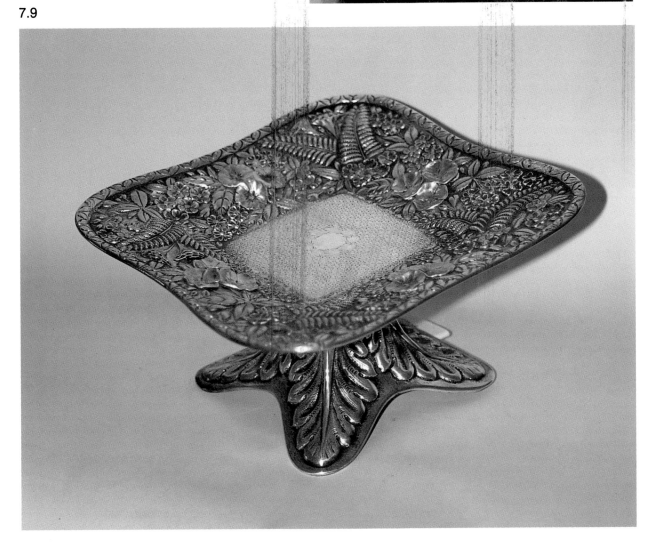

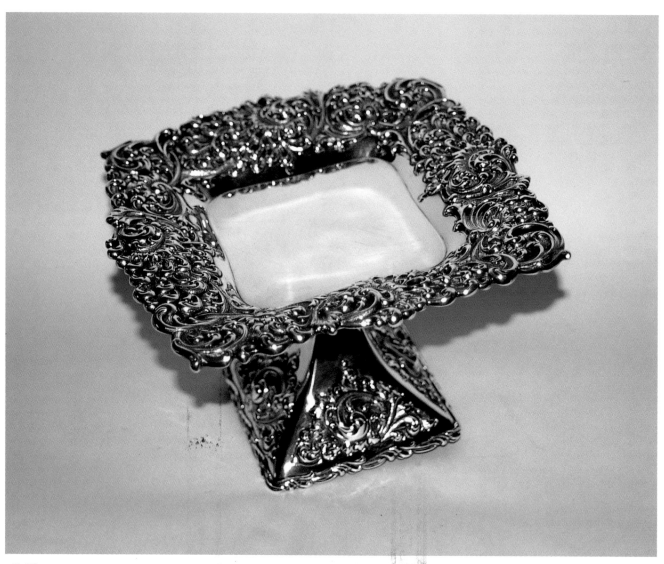

7.12

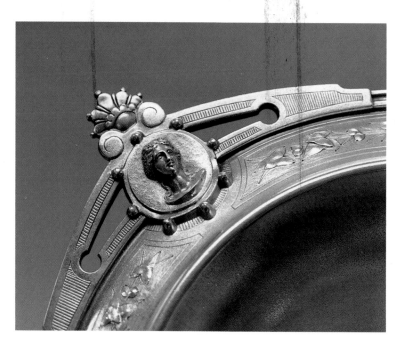

7.19b

32

Chapter 2
Pitchers, Ewers, Goblets, & Beakers

Phyllis Tucker, a well-known Houston silver dealer, says that ". . . water pitchers made an important statement in the Victorian home—that is to say they gave a hint of graciousness." In the days before soft drinks and iced tea were available, good fresh spring water was a true necessity, and had to be accessible to guests and to members of the household.

A pitchers is a vessel with a handle and a spout. Some are footed, while others have a pedestal base. The design of any particular pitcher often typifies the design period after which it was modelled, as the examples in Chapter 1 show. Basically there are two sizes of pitchers—large, for beverages, and small, as part of a tea set. Exceptions are hot milk pitchers (as shown in Figure 2.35), which are somewhere between the two.

Another form associated with pitchers is the "ewer." This item is usually identified as being shaped somewhat differently than a pitcher, but it has all the same attributes: a bulbous body, a handle, and an area for pouring. Most of the items identified as ewers are very tall, somewhat vase-shaped, with a flared lip for pouring. Michael Weller of Argentum Antiques in San Francisco feels the ewer originated in medieval times, and was originally paired with a bowl—a set which eventually degenerated to the bedroom pitcher and bowl. Then ewers became known as "sideboard silver," meant mainly for display.

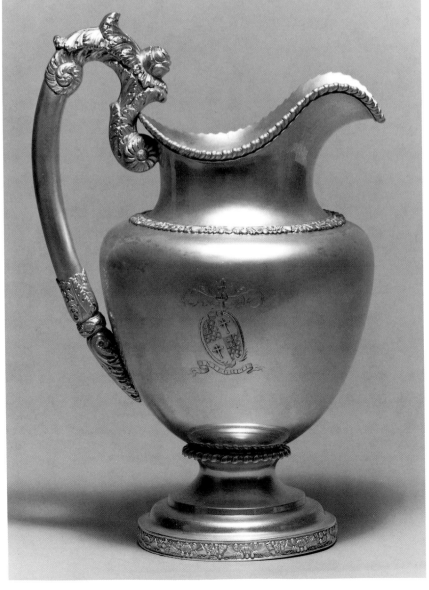

Figure 2.1a
A water pitcher by Forbes, circa 1825. This piece stands a massive 11 1/2 inches high. The bold handle presents designs with leaves and vines. The rim and the top of the body have a gadroon border that gives strength to this pitcher, and the base has a rolled design. A coat of arms is engraved on the side. *Courtesy of Constantine Kollitus*

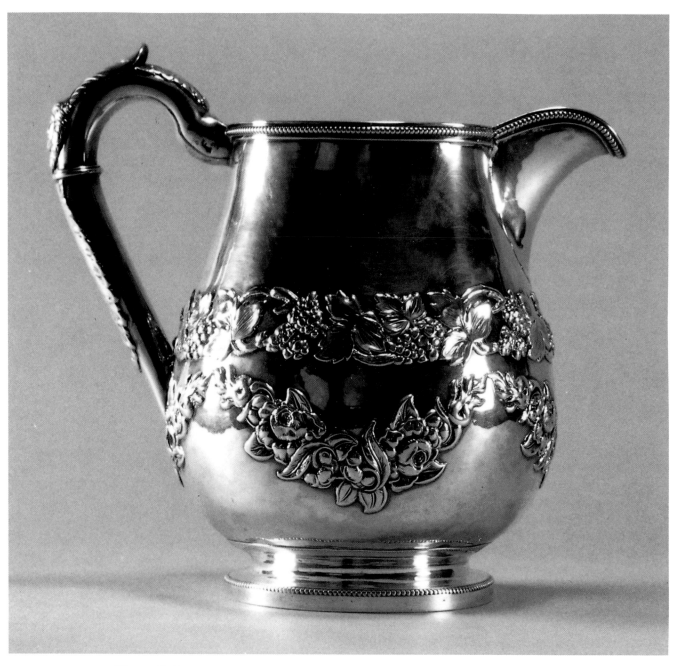

Figure 2.1b
An early water pitcher by Samuel Kirk. The applied decoration features swags of grapes, leaves, and flowers. There is a female head on the handle. Delicate beading circles the rim, the spout, and the top of the base. This particular piece bears the Baltimore assay mark for the year 1824, and stands 8 1/4 inches high. *Courtesy of Michael A. Merrill, Inc.*

Figure 2.2a *(see photo on color page 18)*
A covered water pitcher made in 1841 by John Chandler Moore, exemplary of Rococo work. This particular piece shows some of the genius behind Moore with its pouring lip modeled after a head, and the delicate bail for opening the lid. On scrolls on the pitcher Moore has placed a line design, adding another decorative dimension. The flowers are very well executed, and the leaves rising from the tops of the scrolls add beauty to an already exceptional piece. The pitcher was made for Tiffany and Company and is 9 1/2 inches high and weighs 31 ounces. *Courtesy of* Silver Magazine *(Bill and Connie McNally)*

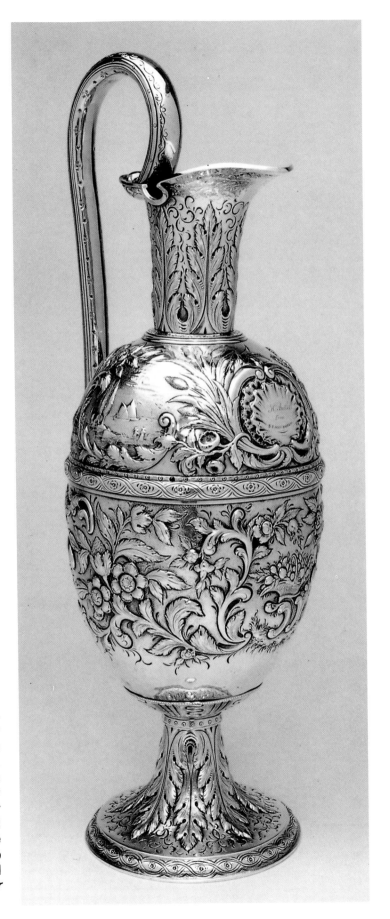

Figure 2.2b
An ewer made of Baltimore-standard silver by Samuel Kirk. The piece is dated 1828, and stands 17 inches high. It rests on a high pedestal base, has an ovoid body with a cane-form handle and a tall collar. The upper body has romantic landscapes, a shell cartouch, scrolling foliage, and flowers. There are similar decorations on the lower body and base, and the neck is decorated with leaf tips. *Courtesy of Butterfield and Butterfield*

Figure 2.2c *(see photo on color page 18)*
A Rococo water set, consisting of a pitcher and two goblets, made by Gale and Willis circa 1857. The body of the pitcher has a pear form with a low dome foot. The body is repousséd and chased with a Rococo floral motif. The cartouche is surrounded with C-scrolls motifs. The applied cast spout and handle mounts are elaborately decorated with foliate and scroll motifs. The pitcher handle is decorated with leaves. The goblets are inverted bell forms on elaborate baluster-shaped stems, above high domed feet. They are chased and repousséd to match the pitcher. The pitcher is 11 3/5 inches high and the goblets are 8 inches high. *Courtesy of Phyllis Tucker Antiques*

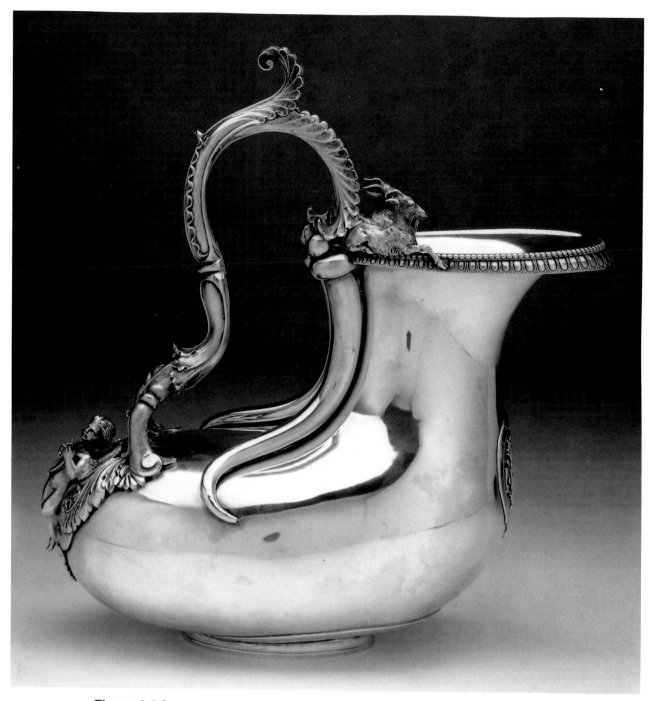

Figure 2.2d
A jug made by Tiffany, with the company's year mark for 1869. This form was inspired by the shape of peasants' wine skins, and is frequently called by the Roman term "Askos jug." Thomas Jefferson, after traveling to France, brought back to America a container in this form, which was used to serve wine. Jefferson then had a similar vessel made in silver, by the important Philadelphia silversmiths Simmons and Alexander. A few items with the same shape were made by Kirk, and appear in museums. *Courtesy of Michael Weller, Argentum Antiques*

Figure 2.3 *(see photo on color page 19)*
A fabulous coin silver beer pitcher, made by Lincoln and Foss in Boston circa 1850. The repoussé work shows hop fruit and leaves with barley heads. The handle is in the form of a hop vine, which is very appropriate for a beer pitcher. The base, with its reeded design, adds strength to the piece. *Courtesy Sherry Langrock, Silver Crest Antiques. Photograph by Debbie Cartwright*

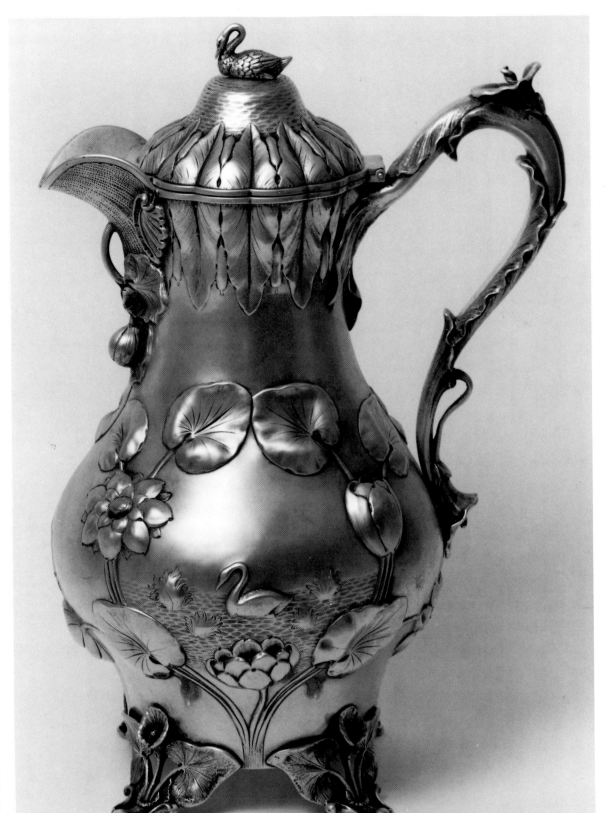

Figure 2.4
A most desirable ewer made by Eoff & Shepherd in New York circa 1851, standing 12 1/2 inches high and weighing 37 ounces. The retailer was Ball, Black and Company. It is easy to see why Ball, Black and Company were such an important firm in the 1850s, with workmanship like this to sell. This ewer features repousséd waterlilies and leaves, topped by a swan finial. The feet are calla lilies and calla lily leaves, and upon the handle rests yet another lily used as a thumb guard. A leaf is placed on the inside of the handle and the stems and veins of the leaf are most apparent. A swan swims serenely in the pond on the side of the vessel. Calla lily leaves begin on the cover and extend onto the body of the pitcher. The lip is covered with fine lines, each adding distinction to the piece. *Courtesy of Constantine Kollitus*

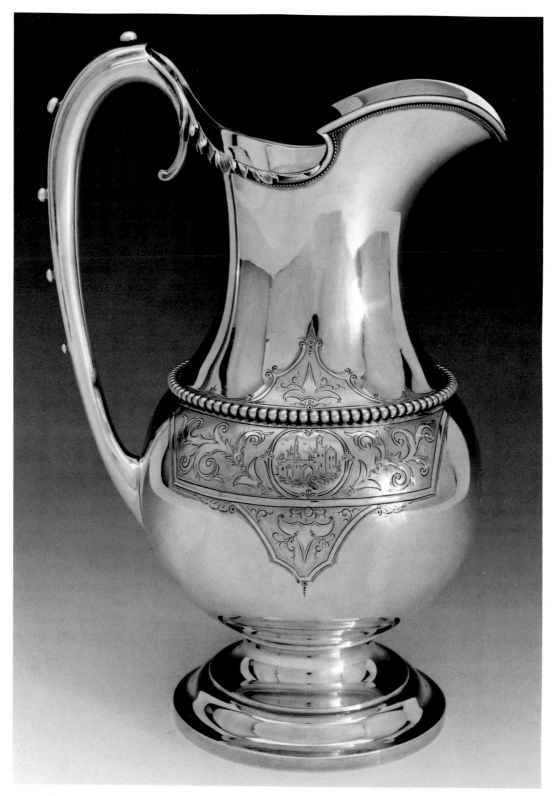

Figure 2.5
A Vanderslice pitcher made between 1865 and 1870. It is very difficult to tell if this is a pitcher actually made by Vanderslice based on a Gorham design, or is an actual Gorham piece just retailed by Vanderslice. In the 1700s and early 1800s, most silver was made by individual jewelers shops, who sold the pieces in their own showrooms. By the late 1870s, however, many of the jewelers turned increasingly to the large silver firms for their wares, thus cutting their own overhead by not needing to maintain a complete manufacturing plant for their wares. *Courtesy of Michael Weller of Argentum Antiques*

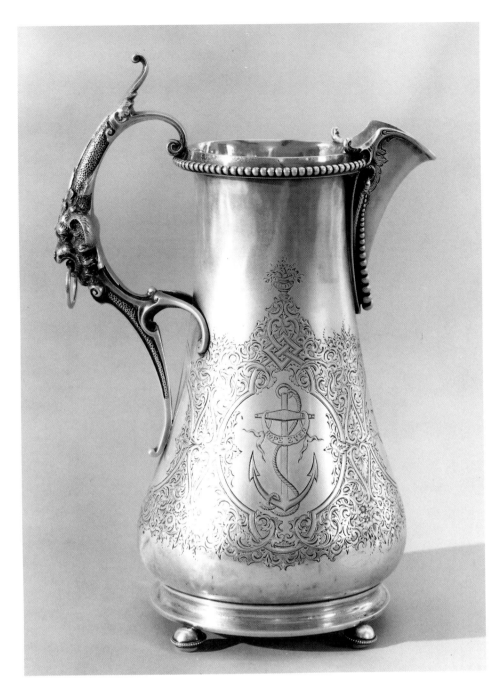

Figure 2.6
A pitcher marked "Vanderslice," but also showing many markings very similar to those on products sold by Gorham around the 1860s. The handle is reminiscent of handles on several Gorham pieces. The silversmith could take design elements from one piece and incorporated these into yet another piece, thus allowing multiple possibilities from one design inspiration. The engraved design is well executed, showing excellent workmanship. *Courtesy of Constantine Kollitus*

Figure 2.7 *(see photo on color page 19)*
A coin silver ewer with undertray, made by Gorham. The handle has a ram's head. Note the acanthus leaf design just above the middle of the pitcher, followed by another band of beading. Under the ram's head, the beading decreases in size until the handle reaches the body of the pitcher, where several leaves appear to reach out for the handle. Beading also appears around the midpoint of the base of the ewer. *Courtesy of Sherry Langrock, Silver Crest Antiques. Photograph by Debbie Cartwright*

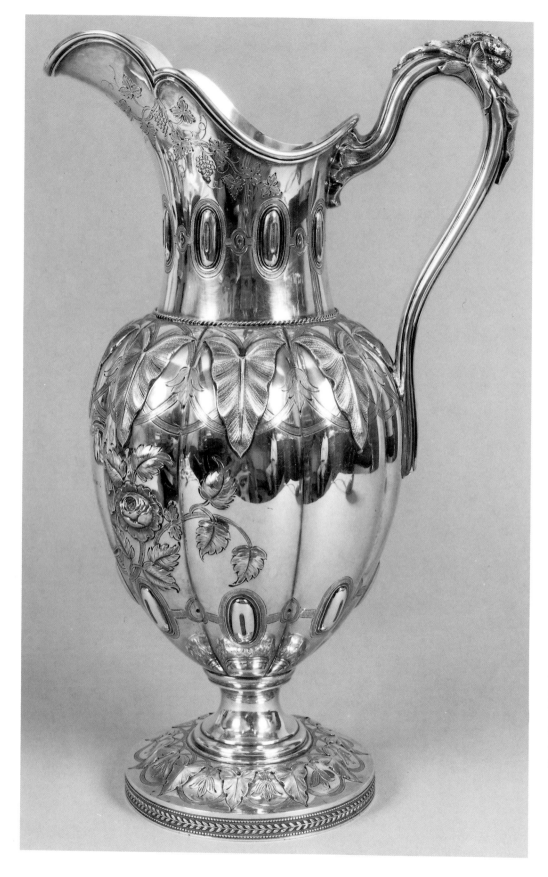

Figure 2.8
A very large ewer bearing the maker's mark "E. G. B." This piece was sold by Ball, Black and Company circa 1855 to 1860. The ewer stands 14 1/2 inches tall and weighs 37 ounces. It is a pleasure to observe workmanship of this quality! Beginning at the base there are two rows of beading, separated by a leaf design. Above this, the leaves alternate with a bell-shaped design. Then there is a narrowing section before the body of the pitcher begins.

There are a number of oval cartouches toward the bottom of the body, above which equally dispersed roses intertwine on the front of the pitcher. The top of this section has calla lily leaves with a flower dropping down between the leaves. A delicate twisted band of silver completes this section.

The neck of the pitcher is relatively plain, except for oval cartouches similar to those on the lower portion of the pitcher (but smaller). Under the front of the lip are delicately engraved grapes and grape leaves. The handle is simple, but elegant. A leaf is positioned where the server would place a thumb when pouring. This protrusion would serve as a guide to steady the ewer, which would be quite heavy when full. *Courtesy of Constantine Kollitus*

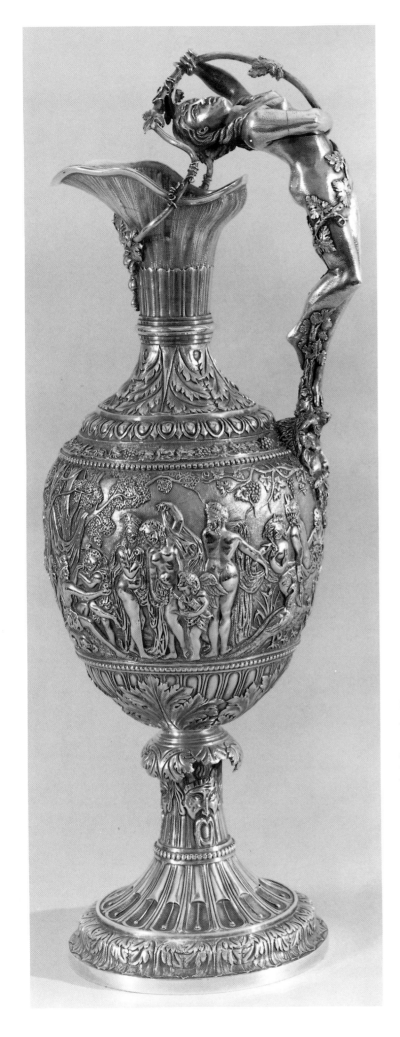

Figure 2.9
A ewer that appears to be a copy of an English piece, made circa 1860 by Francis G. Greshoff in Baltimore. Almost the entire surface of this piece is covered in some design. Note how the handle rises from the middle of the pitcher to form a body, perhaps that of Bacchus, the god of wine. The detailing is very elaborate. The cherubs and the grapes suggest that this ewer was made to serve wine. *Courtesy of Constantine Kollitus*

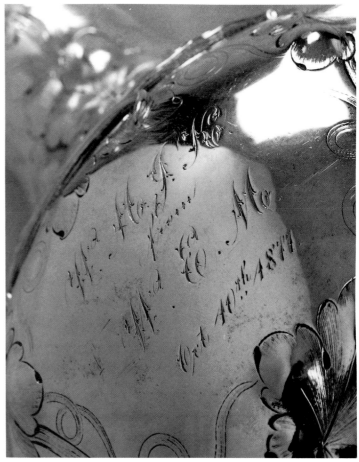

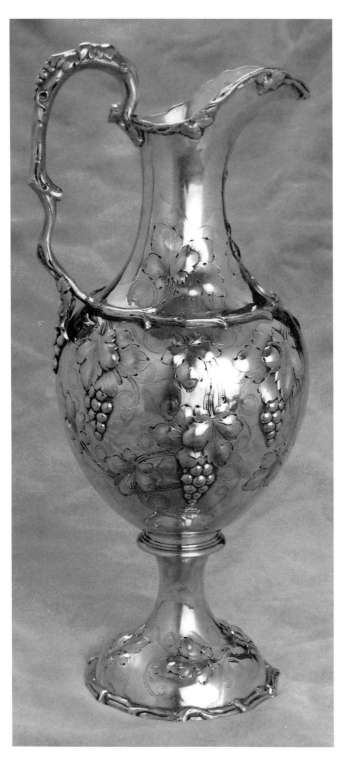

Figures 2.10a and 2.10b *(above and left)*
A silver ewer with an all-over grape design, attributed to John Chandler Moore. It stands 16.5 inches tall, in a form very typical for ewers. The workmanship is truly outstanding. Figure 2.10b shows a close-up of the inscription. The grape leaves surrounding the inscription show the skillful and excellent detailing of the leaves and twigs. The fine twig border on the base and the grape leaves and vines forming the handle are very typical of Moore's workmanship. *Courtesy of Sherry Langrock, Silver Crest Antiques. Photograph by Debbie Cartwright*

Figures 2.11a and 2.11b *(see photo on color page 19)*
A pitcher in a league all by itself. It appears to marry two of the best elements found in antiques—glass and silver. The glass is in fact cranberry glass, and the silver is absolutely magnificent. A letter from Samuel J. Hough provides a report about how this particular pitcher was made. Also included with his report is the original slip (Figures 2.12a and 2.12b) from Gorham for the work and silver that went into it, "pitcher S1618". The pitcher is first marked with the 1893 date mark, but the final cost slip is dated 1895. It may have taken the workers that long to perfect the technique for making this pitcher. *Courtesy of Sherry Langrock, Silver Crest Antiques. Photograph by Debbie Cartwright*

THE OWL AT THE BRIDGE
Samuel J. Hough • 25 Berwick Lane
Cranston, R.I. 02905-3708 • (401) 467-7362

Report on Gorham Pitcher S1618

The costing slip for the S1618 Pitcher (box 8) dates completion of the first one 7 January 1895. Gorham glasswares were assigned codes beginning with the letter "S" followed by numbers, from 1890 until March 1898.

The glass pricing records indicate that the glass for this pitcher was purchased from J. H. & Co., i.e. J. Hoare and Company, at a cost of $7.50.

The silver content is remarkably heavy. They started with 39 troy oz. 10 dwt., reduced in the making by four pennyweight, the silver valued at $31.60.

Preparation of the silver required four hours of spinning (labor cost $1.60), three-quarters of an hour of turning (22 cents), and twelve hours of casting ($6.00). The casting was chased for 52 hours at a cost of $20.80.

The silversmith required 32 hours to fashion the pitcher ($11.20). At this point, there was an hour of piercing (thirty cents) and, astonishingly, another fifty hours of chasing ($20.00). Thus altogether the pitcher embodies 102 hours of chasing as well as 32 hours of silversmithing. It is this enormous expenditure of labor, I believe, which gives the effect of the glass having been blown into the silver.

The one polishing stage was an hour of bobbing (25 cents) followed by finishing, one and a half hours at 45 cents.

Direct silver and labor costs came to $94.42. To this were added $18.48 for overhead, $27.73 profit, and $6.93 administrative costs for a total of $145.56.

This sum was rounded to $140.00; $10.00 was added for the glass and $10.00 for gilding, to make the net factory price $160.00.

Figure 2.12a
A letter from the curator of the Gorham archives.

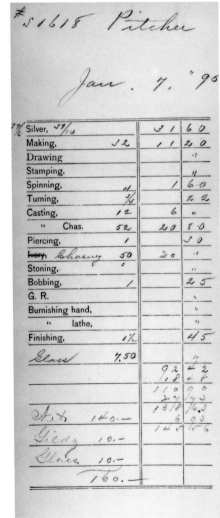

Figure 2.12b *(at right)*
From the Gorham archives, the original records for Gorham Pitcher S1618.

Figure 2.13 *(see photo on color page 20)*
A pitcher dated between 1880 and 1890, according to the Kirk and Son 11 ounces mark. The surface of the pitcher appears to mimic that of the skin of an orange; what a remarkable finish! Under the lip is a face. The handle has a small amount of decoration at each end where it joins onto the bowl of the pitcher. *Courtesy of Sherry Langrock, Silver Crest Antiques. Photography by Debbie Cartwright*

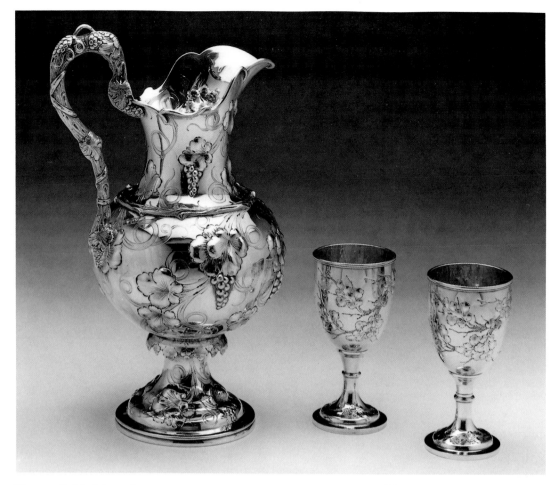

Figure 2.14 *(above)*
A three-piece water set made in Boston circa 1855. The base of the pitcher is unique when compared to other pitchers shown in this book. It forms a pedestal, the top of which is turned back and is decorated with leaves. The rest of the base is worked with leaves and some grapes in a light repoussé style. The body of the pitcher and the neck share the same lightly repousséd grape bunches and somewhat stylized grape leaves. The handle of the pitcher is vinelike and covered with small leaves and grapes. The two goblets emulate the work on the pitcher, differing in the pedestal base. There is very little decoration on the base of the goblets. *Courtesy of Michael Weller, Argentum Antiques*

Figure 2.15 *(opposite page)*
A Gorham water pitcher. This form appears to have developed from Oriental art similar to that which Tiffany's Edward C. Moore collected for inspiration. Moore's work was first displayed at the Paris Expositions of 1867 and 1878. Carpenter states that the pitchers created quite a lasting impression, "being similar and more straightforward in design than the ones being made in Europe at the same time." In fact, this particular style was spun, and the die-rolled border was added to cover the seam where the top and bottom of the bulbous base were connected. In Tiffany pitchers, many variations of this style can be found, and some have additional die-rolled borders. Others have unusual handles, all of which are adaptations or may be considered variations on this design. This is the only Gorham pitcher that the author has seen to date. *Courtesy of Richard White, Vroman's Silver Shop. Photography by John Knapp Studios*

Figure 2.16 *(see photo on color page 20)*
A Kirk *Repoussé* water pitcher, very small compared to most Kirk pitchers—just 8 3/8 inches high. The narrowing of the body and the small neck are deceptive, making it seem that the pitcher is smaller that it really is. The mark is "S. Kirk & Son Co.," used on hollowware from 1903 to 1924. The shell-shaped spout is unusual and lends additional interest, as do the repousséd flowers and foliage. This may be a milk pitcher.

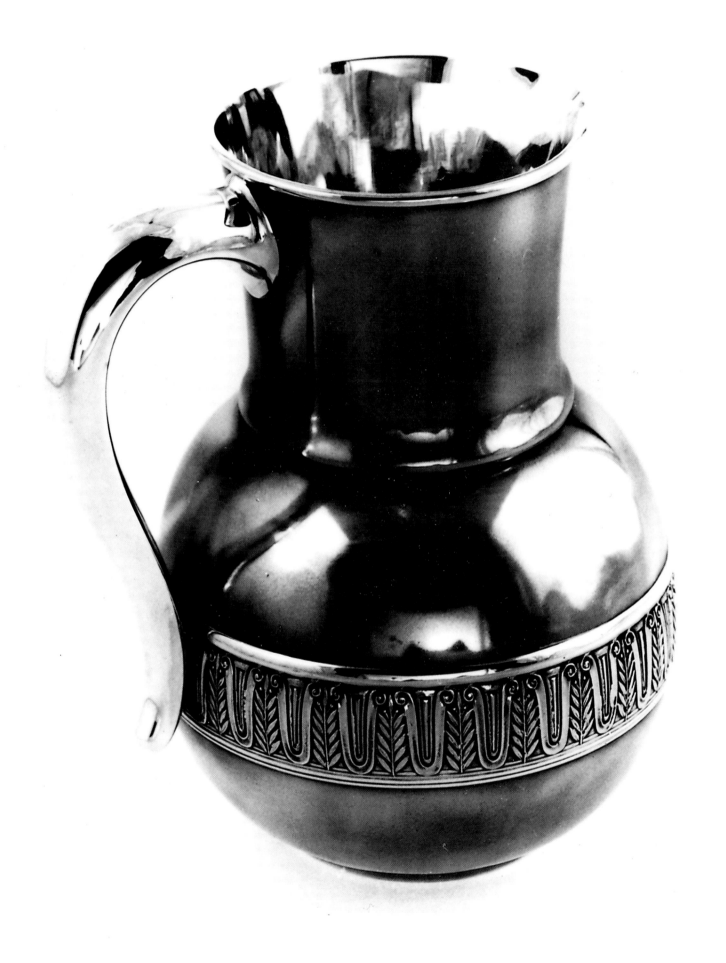

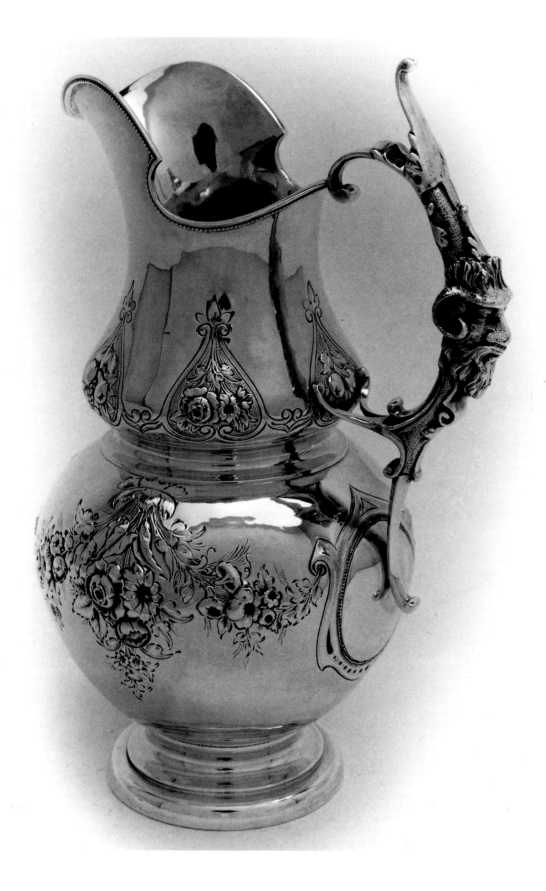

Figure 2.17
An unusually shaped pitcher, with a small bulbous bottom and a long neck. It was made by Frederick Reichel of San Francisco. The massive handle fits the piece and add a note of distinction. The flowers are repousséd on the sides of the pitcher on the lower section. The neck of the pitcher has flowers inserted into inverted heart-shaped spaces that are joined by a series of curves. The spout has an unusual shape which appears to make the lip smaller that is actually is. *Courtesy of Michael Weller, Argentum Antiques*

Figure 2.18a *(See photo on color page 21)*
A *Chantilly* water pitcher bearing the Gorham date mark for 1902. The sides of this vessel show clearly the flowers that adorned the early pieces in this pattern.
Courtesy of Phyllis Tucker Antiques

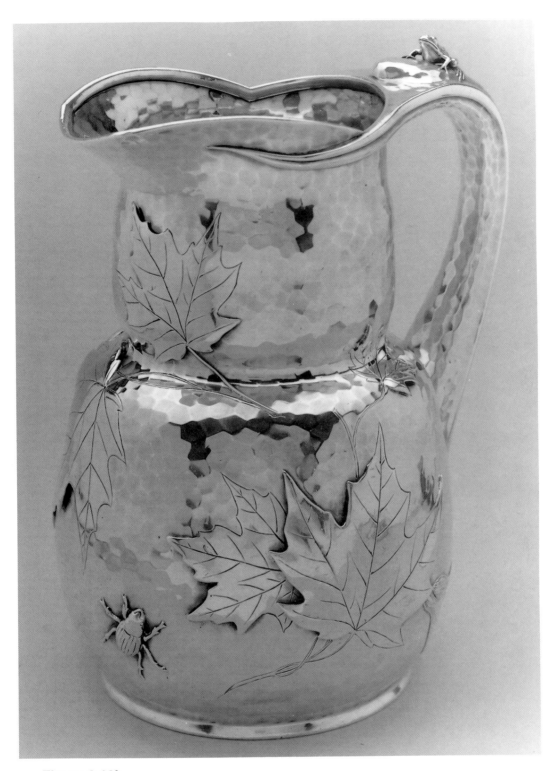

Figure 2.18b
A magnificent pitcher by Tiffany in the Japanese style, with applied maple leaves and a beautiful beetle. Tiffany used copper and gold for the applied items. The surface of this pitcher is chased to resemble hand-hammering, giving the piece a perfect area to display the leaves. The handle rises from the top of the base and appears to become a part of the lip, but instead drops slightly below the edge of the pitcher. The base of the pitcher, less than 1/4 inch thick, is highly polished and gives the impression that this section of the pitcher is important.
Courtesy of Phyllis Tucker Antiques. Photograph by Hal Lott

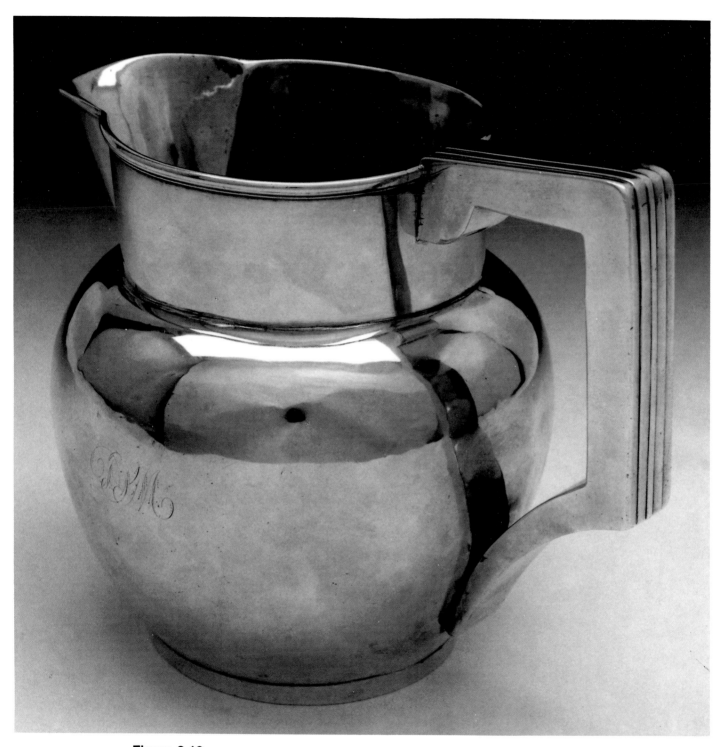

Figure 2.19
A squat pitcher with a massive handle, and little ornamentation except lines or groves on the handle—beautiful in its simplicity. Asa Blanchard of Lexington, Kentucky made this pitcher circa 1815 to 1820. It can be classified as a late Federal-style pitcher. The body of the pitcher is large and the neck is rather squat. The lip is not large, but is formed at the front of the pitcher. There is a slightly rolled edge on the top of this pitcher. The base is approximately the same size as the reeded edge, but is devoid of any decoration. *Courtesy of Michael Weller, Argentum Antiques*

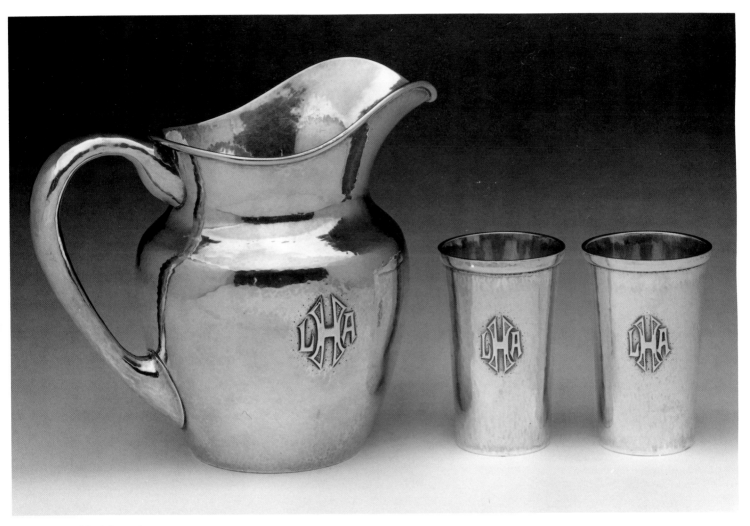

Figure 2.20 *(above)*
A typical Arts and Crafts pitcher made by Clemens Friedell of Pasadena. The design shows faint remnants of Martelé work; still, the rich boldness of the silversmith's own work stands out. Friedell learned his craft in Germany, but adopted Martelé techniques in Providence, Rhode Island, while he worked at the Gorham plant. The pieces convey feelings of strength and of the silversmith's pride in his product. The monogram is unique to Friedell. It appears to be applied, but actually is embossed. *Courtesy of Michael Weller, Argentum Antiques*

Figure 2.21 *(see photo on color page 21)*
A pitcher made and sold just before World War II by International Silver. The delicate design is similar to that of some of Arthur J. Stone's handmade items, but in no way does it have the depth that Stone's work did. The

pattern name for this pitcher is *Sedan,* the piece bears the letter E followed by 14 ("E-14'). It is 8 1/2" from the bottom to the top of the spout and holds 4 1/2 pints. The bottom is plain, but forms an attractive base for this pitcher. The handle begins and ends with a narrow section while the middle is thicker.

Figure 2.22 *(see photo on color page 21)*
A more modern pitcher by Reed and Barton, bearing the date mark for 1955. The pattern is *Hampton Court* and the pitcher stands approximately 9 inches high. The design along the top of the pitcher features scrolls and a stylized shell applied to the border. The four separate feet work well with the overall design of the pitcher. The C-scroll handle is massive, with a thumb rest to give assistance when pouring a full pitcher.

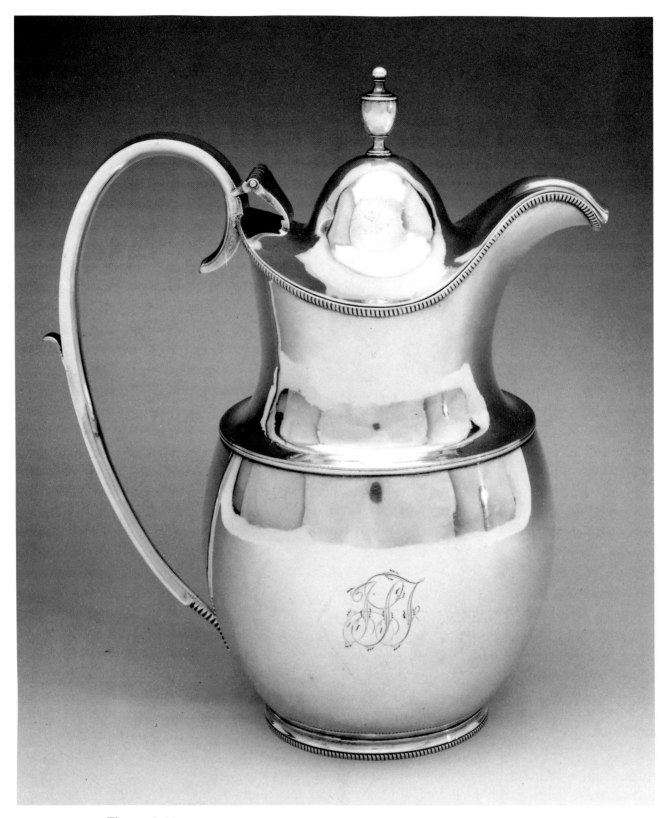

Figure 2.23
A pitcher made to hold cider. It was created by Saunders Pittman in Providence, Rhode Island, circa 1805 to 1808. This pitcher is unique because of the hinged cover. The delicate beading around the base and again at the top of the pitcher lend a distinctive look to the piece. The finial suits the simple, unadorned form of this pitcher. The C-scroll handle has just a small amount of reeding and an area for the thumb at the midpoint of the handle. *Courtesy of Michael Weller, Argentum Antiques*

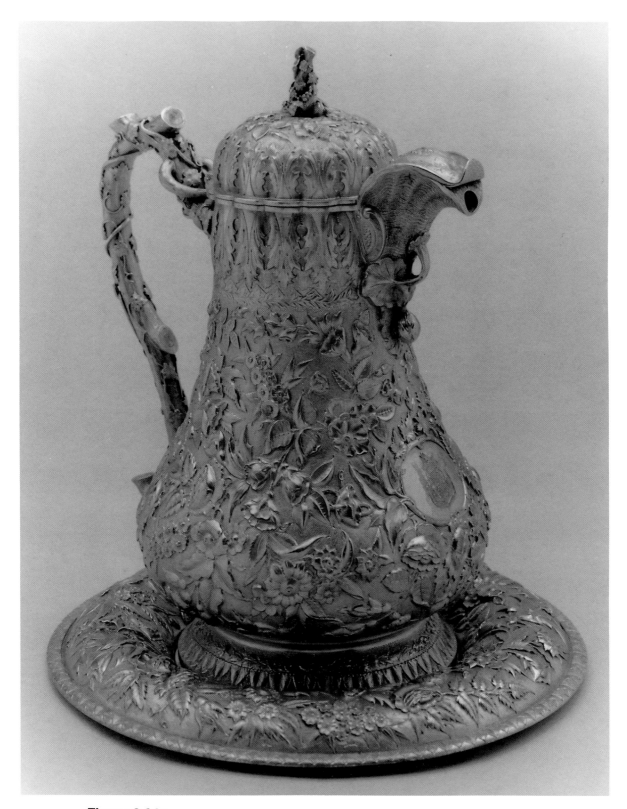

Figure 2.24a
A massive double-walled ice water pitcher in the Baltimore style—that is, repoussé, which is sometimes known as Baltimore silver. Locating an ice-water pitcher along with a matching underplate in this form is rare. The overall design is done in repoussé. On the front of the pitcher is a small cartouche area for a monogram. The hinged lid which covers the lip adds to the beauty of this piece. The handle is designed to look like a grape vine with tendrils still clinging to it. This pitcher is one of very few sterling examples of this type. *Courtesy of Phyllis Tucker Antiques*

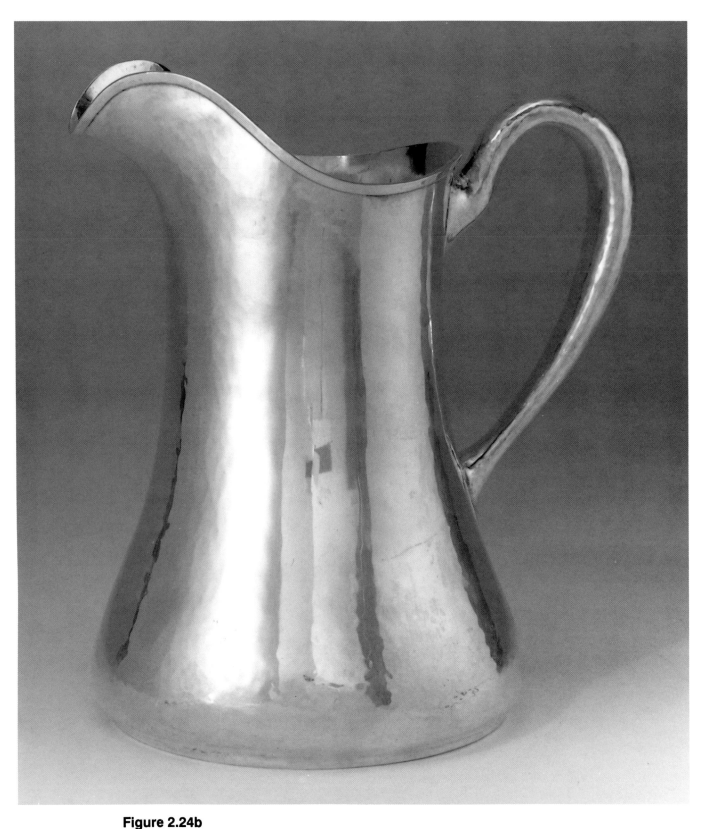

Figure 2.24b
A classical pitcher with simple lines that place it in the Arts and Crafts category. Whiting made this particular piece and the hand-workmanship is superb. Some of the best items made by factories in the Arts and Crafts category are based on an Art Nouveau line, as this particular pitcher shows. *Courtesy of Phyllis Tucker Antiques*

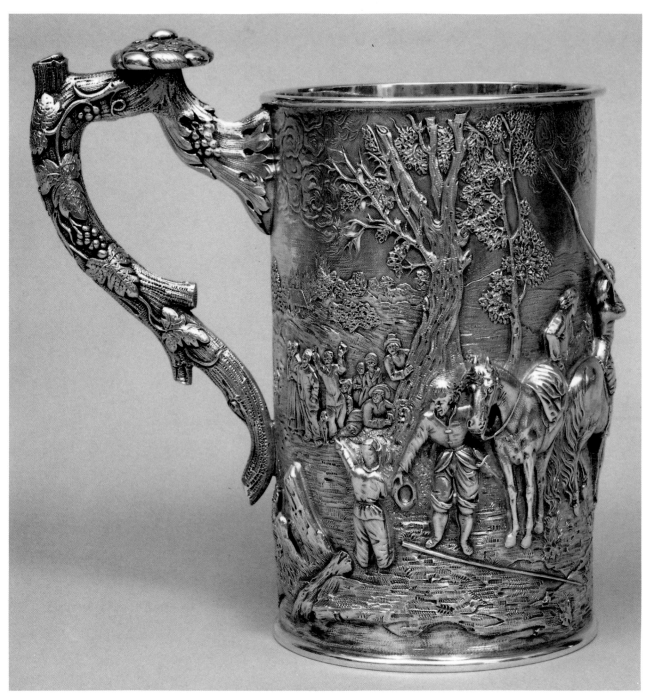

Figure 2.25a *(above)*
A fabulous tankard. The backstamp reads "S. Kirk and Son, 11 oz.," thus dating this item approximately between 1880 and 1890. It is 7 5/8 inches high and weighs 60 ounces. The workmanship and the condition of this piece are outstanding. It is worthy of any museum wishing to display an outstanding example of the silversmith's art. The handle, modeled as a grape vine adorned with grape clusters and grape leaves, adds another dimension to the unusually-shaped tankard. A large button, covered with matching grape designs, is situated to assist the thumb in holding this tankard. *Courtesy Constantine Kollitus*

Figure 2.25b & c *(see photos on color page 22)*
A one-of-a-kind silver and ivory tankard, manufactured by Gorham in 1898. According to Samuel Hough, the factory price in 1898 was $375.00, so the retail was at least $750.00. The design that covers the silver and the ivory show the quality of the workmanship of the time. The classical figures on the ivory portion are incredible. The silver includes fruit, flowers, masks, and more. Gorham did not spare anything in the making of this spectacular tankard! *Courtesy of Constantine Kollitus*

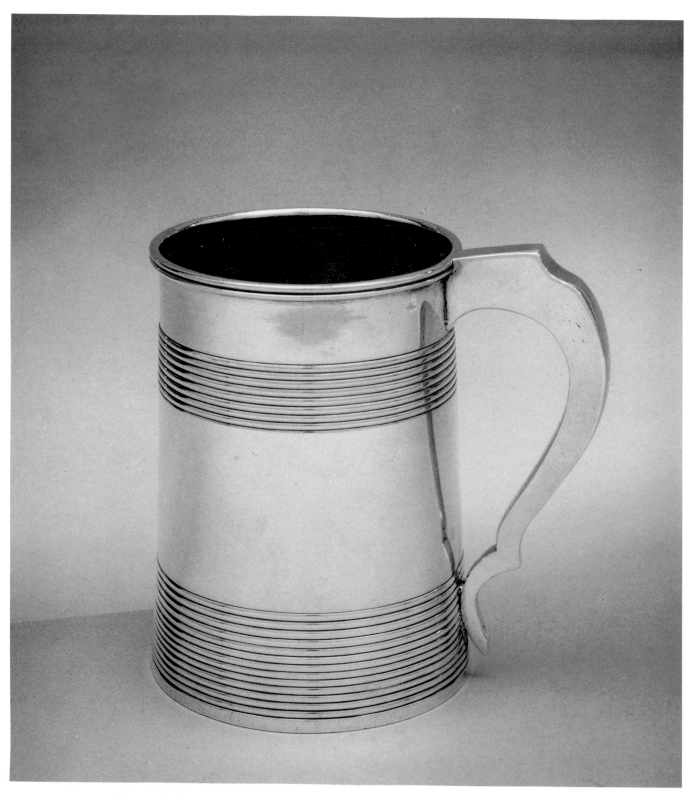

Figure 2.26
An example of an early "hooped" mug, with Federal-style overtones. The maker was Philadelphia's Edward Lownes, who made this piece circa 1800 to 1815. Two sets of parallel lines or hoops ring the mug. The condition of the piece and the care it has received tell how highly it was valued by its owners through the years. The simple handle adds to the overall effect of this mug. *Courtesy of Michael Weller, Argentum Antiques*

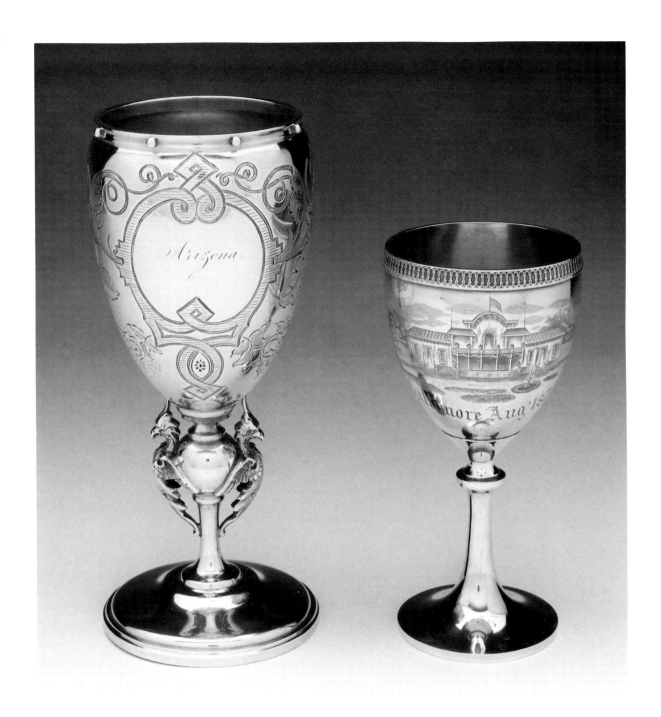

Figure 2.27
Two goblets, one of which boasts an interesting link to American history. The large goblet has three marks: the "Bear" mark of San Francisco's Vanderslice and Company, the retailer's mark of J. W. Tucker, and the engraving: "Sylvester Moury/Arizona." Moury was a colorful character in early Arizona history. He explored for the Pacific Railroad in 1853, serving as a military officer at Benicia and Ft. Yuma. He was elected to Congress from the new territory of Arizona in 1856, but was arrested and tried at Ft. Yuma for disloyalty. He wrote several important books on the geography and resources of Arizona. This goblet is 8 inches high and weighs 13 ounces. The shorter goblet is an early piece by Whiting with an engraving of an elaborate Victorian pavilion in a park-like setting, with the inscription, "Baltimore, Aug 1874". This goblet is 7 1/16 inches high and represents very fine workmanship. *Courtesy of Michael Weller, Argentum Antiques*

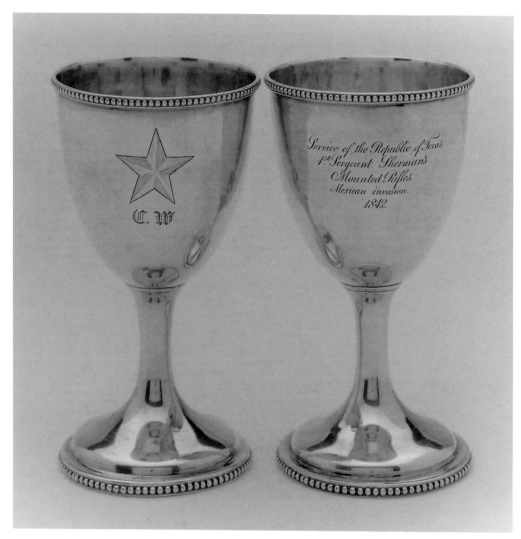

Figure 2.28
Two goblets with significance in the early history of Texas. They were presented for service by the state of Texas in 1842 to "CW," a member of Sherman's Mounted Rifles during the Mexican invasion in 1842. *Courtesy of Phyllis Tucker Antiques*

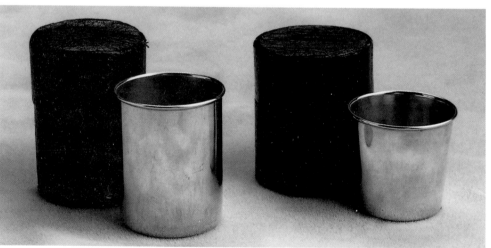

Figure 2.29
Two nineteenth-century cups in their original boxes. One was manufactured by Mauser and Company and the other by Shreve and Company. They were called "nip cups"—small cups that could hold just enough liquor for a short nip to ward off the cold. The rims of both pieces provide wider areas of silver upon which to rest the lips when taking a drink, to prevent spilling the beverage. *Courtesy of Sherry Langrock, Silver Crest Antiques. Photography by Debbie Cartwright*

Figure 2.30.
A goblet, Form 75 in coin silver, made by Gorham circa 1860. It matches the ewer in Figure 2.7. The bases of the two pieces are very similar, but the goblet has a cartouche for a monogram, above which is a finely worked area. The lip of the goblet has a simply beaded edge. *Courtesy of Sherry Langrock, Silver Crest Antiques. Photography by Debbie Cartwright*

Figure 2.31
A octagonal sterling goblet manufactured by Gorham in the 1880s. The form is almost ecclesiastical; this particular goblet could have been part of a set for use in a church. The pedestal base and the bowl of the goblet both carry out the octagonal design. *Courtesy of Sherry Langrock, Silver Crest Antiques. Photography by Debbie Cartwright*

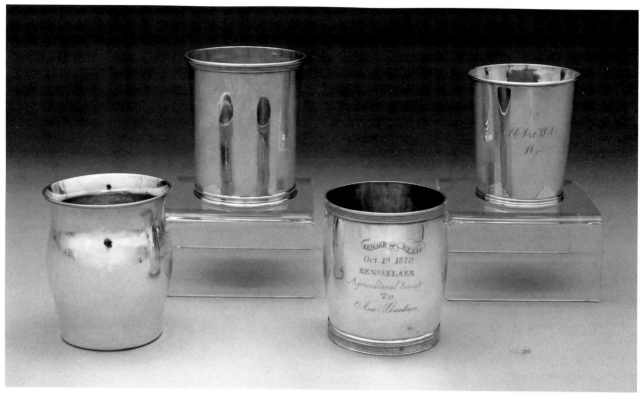

Figure 2.32
Silver beakers, circa 1810, representing a number of makers. Note how each silversmith has added detail with a band, engraving, or extra rims that are soldered or hammered. Frequently beakers were given as prizes in local contests. *Courtesy of Michael Weller, Argentum Antiques*

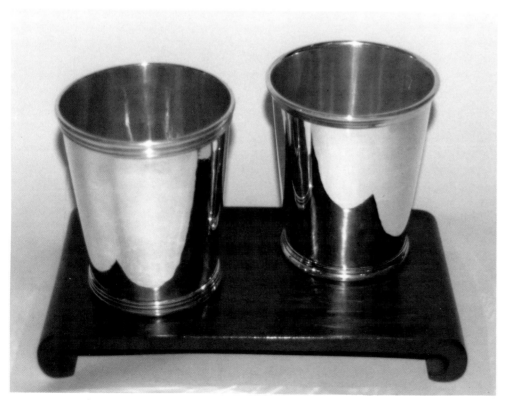

Figure 2.33 *(left)*
A pair of beakers, made by John B. Akin in Danville, Kentucky during the early 1800s. They are in excellent condition. Finding a matching pair by the same maker is not easy. *Courtesy of Maxine Klaput Antiques*

Figure 2.34
(see photo on color page 23)
An after-dinner coffee cup from the fabulous McKay silver service. The set was made by Tiffany's in 1878, and was exhibited at the Paris World Fair that same year. This cup is enameled and heavily gilded. *Courtesy of Michael Weller, Argentum Antiques*

Figure 2.35
A Mt. Vernon Company hot milk pitcher, made circa 1910. It stands 9 1/4 inches from the base to the finial. The handle is insulated and the engraved design is well done. *Courtesy of Michael A Merrill, Inc.*

Chapter 3
Coffee, Tea & Chocolate Pots, Odd Sugars & Creamers, Spooners, & Urns

Coffee was first sold in Italy in the 1600s, and its use spread rapidly throughout Europe. It was sold in coffee houses where people met regularly for serious talk and discussions. Tea arrived with the Dutch in 1610; it arrived in England in 1650. It soon became the national drink in England, and traveled with them to North America immediately. Coffee was probably introduced to the United States sometime after the 1660s. While Americans initially preferred tea, in the nineteenth and early twentieth centuries coffee rapidly overcame its popularity. One wonders if Americans chose coffee because tea had such strong associations with their English rulers. In the early twentieth century, "black coffee sets" were made to serve demitasse cups of strong, black coffee. If large amounts of coffee were to be consumed, then a coffee or tea urn would be used (see Figures 3.27 and 3.28). These urns were larger than the hot water kettles that were used for tea. Each held a heating device to keep the beverage hot.

Silver vessels to hold tea were patterned after those made in porcelain; coffee pots were made in somewhat larger sizes, supposedly to distinguish between the two. The various shapes that the two pots have taken through the years have followed the history of design. Early pots were pear-shaped, then angular, with many changes eventually leading to the most modern of vessels.

Most manufacturers sold a tea pot or a coffee pot separately from the whole set. Pots were expected to make a tremendous statement to guests about the financial assets of the host and hostess, and thus were often expensive. By selling the pots independently of its set, the cost of acquiring an entire service could be spread over a period of time. This explains why the year dates on items in a tea or coffee set can be different.

Many manufacturers mark their wares to indicate the year of production. Gorham had special symbols that reveal the year in which the item was manufactured (see Rainwater's text, *Encyclopedia of American Silver Manufacturers*). Reed and Barton had a similar arrangement. Neither of these companies still mark items with the year date. Some firms use a mark that is good for the decade in which the item was produced. Tiffany's numbering system can be seen in Figures 16.10a and 16.10b. This will show you what to look for on Tiffany pieces. By reviewing the *Tiffany* text by Carpenter, you can approximate the date from the chart he has prepared.

In addition to tea and coffee pots, this section includes examples of sugar bowls or basins and cream pitchers. In general, the size of the sugar and creamer should correspond to the size of the pot (or pots) with which they are to be used. A large pot or tea urn calls for larger sugar bowls and larger creamers. An exception is when a silver sugar and creamer are used with a porcelain pot; since they were not purchased as a set the scale of the items may not correspond fully. Sugars and creamers were not always made to accompany a particular tea or coffee pot, and today are frequently found as a separate pair.

At the end of this chapter is a spooner, a necessity for some tea set owners. This item, shorter than a teaspoon, was used to store the teaspoons in a beautiful display.

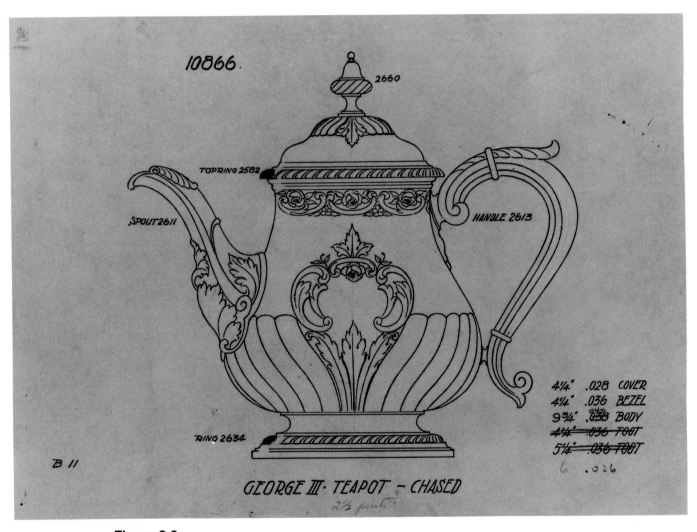

10866.

2660

TOP RING 2582

SPOUT 2611

HANDLE 2613

RING 2634

B 11

GEORGE III · TEAPOT – CHASED

2½ pints

4¼" .028 COVER
4¼" .036 BEZEL
9¾" .038 BODY
4¼" .036 FOOT
5¼" .036 FOOT

6 .036

Figure 3.0
A line drawing from Shreve and Company for their tea pot in the chased *George III* design. You can see the notes written for the silversmith on the drawing pertaining to this particular piece. *Photography by Tom Wachs Photography. Courtesy of Michael Weller, Argentum Antiques*

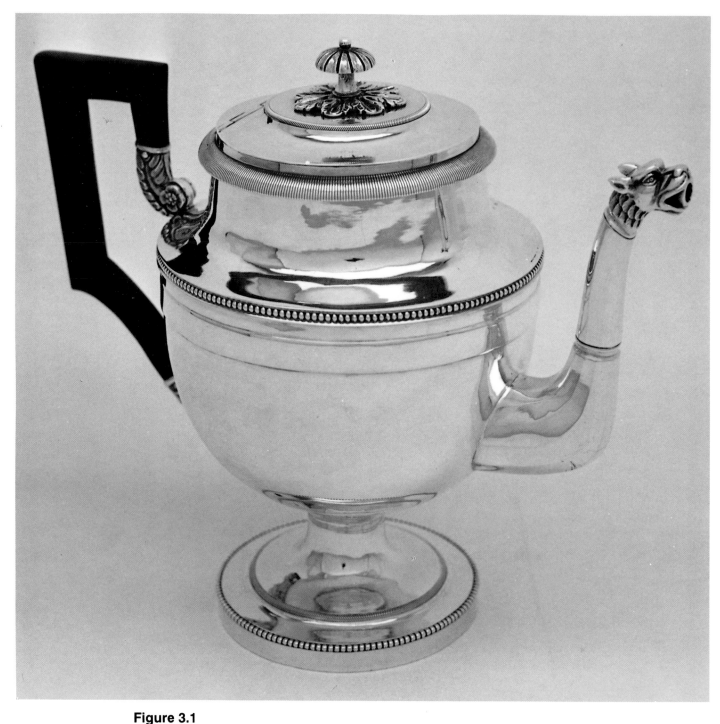

Figure 3.1
An excellent example of early Empire styling. This tea pot was mady by Anthony Rasch in Philadelphia, circa 1815. The ebony handle has classical silver attachments. The spout design is sometimes called a "dog head spout." Other researchers call this a "mammalian animal head" design. The beading around the base and the center of the pot add a touch of elegance. The simple lines radiate out from the pot and under the lid, helping to break up the simplicity of the sides and add detail. *Courtesy of Michael Weller, Argentum Antiques*

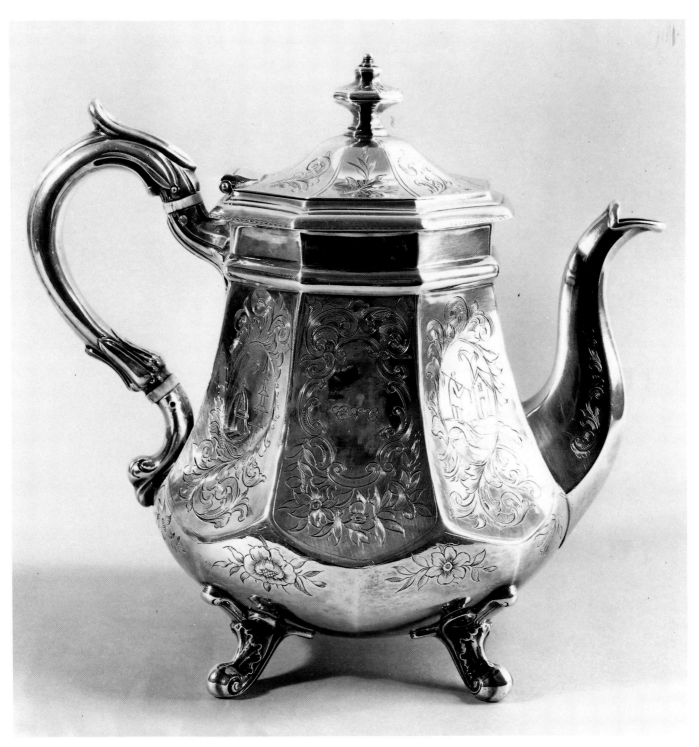

Figure 3.2
A tea pot by Gelston Ladd and Company of New York, circa 1840. The pot is
8 1/2 inches tall and weighs 25 ounces. The engraved design on the pot is
finely executed. On each section of the pot the engraving forms a cartouche
allowing for the usual monogram and also for engraved scenes. The feet are
also interesting; each first appears to be a mundane scroll, but the addition of a
shell gives greater dimension. The pot begins with a footed round shape and
turns into an octagonal shape. The lid matches and carries out the same de-
sign. The finial is simple but engaging. *Courtesy of Constantine Kollitus*

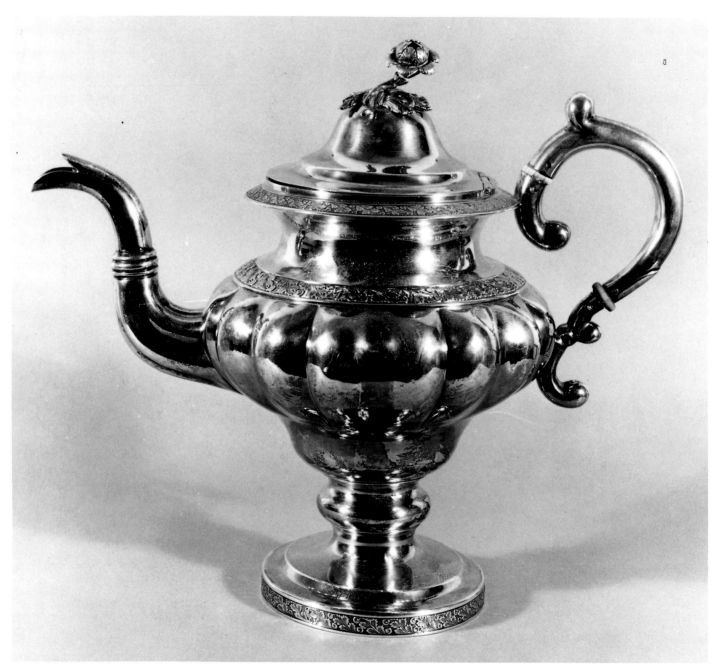

Figure 3.3 *(above)*
An unusual tea pot very typical of Empire styling, marked "J. B. McFadden and Co, Pittsburgh, PA." The banded design on the pedestal base, the midsection of the pot, and the area where the lid is attached to the pot enhance the appearance of this pot. The finial is large and elegant. The C-scroll handle has ivory insulators. Appropriately, the middle of the spout sports three rings of silver, helping to break up the visual line of the pouring spout. *Courtesy of Constantine Kollitus*

Figure 3.4 *(see photo on color page 24)*
An early pot (circa 1830), one of Samuel Kirk's many masterpieces. The spout and the handle are lovely, and the lion atop the finial may be heraldic. This example of Kirk's early work is in a style called "Tuscan." Many of the scenes appear to represent Italian-style villas. *Courtesy of Michael Weller, Argentum Antiques*

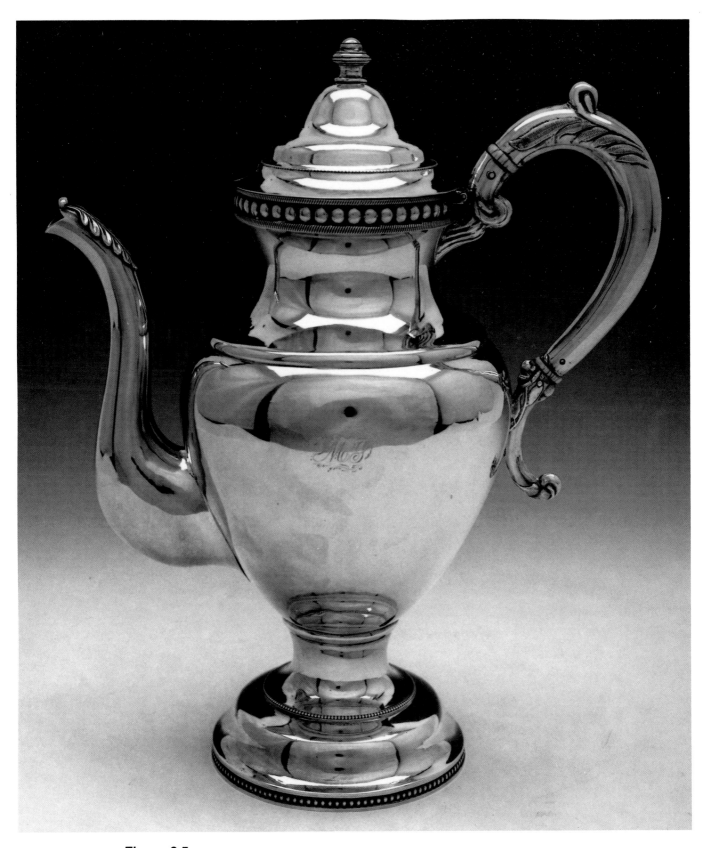

Figure 3.5
A large coin silver coffee pot by Isaac Spear of Chicago, circa 1850. The different bead sizes add to the overall appearance of this pot. The acanthus leaves on spout and on the handle are interestingly done. The leaves on the handle provide a natural fit for the thumb of the person using this pot, and serve as an aid in balancing it when pouring coffee. *Courtesy of Michael Weller, Argentum Antiques*

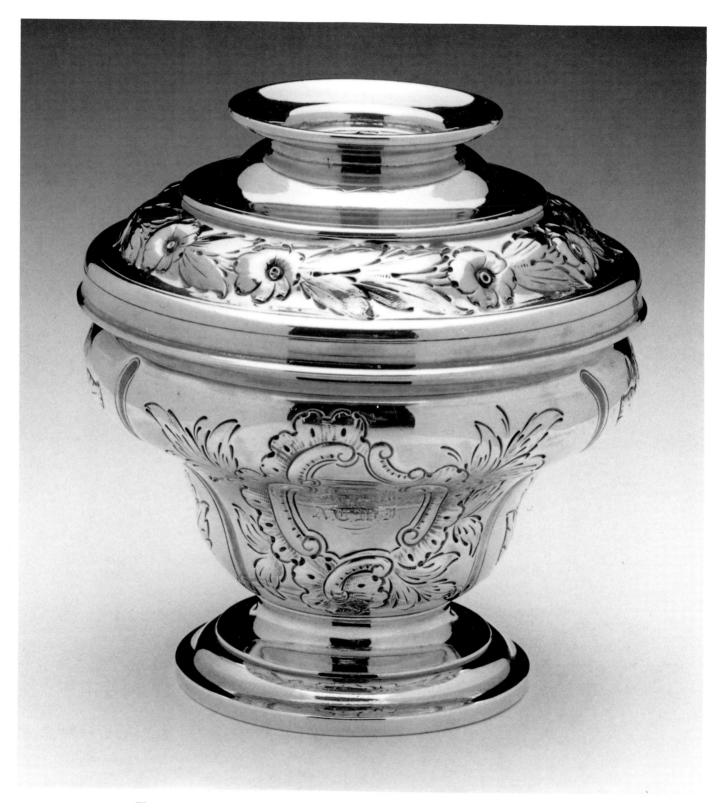

Figure 3.6
A Revival-style sugar bowl, made by George Sharp for Bailey and Company.
The lid could be removed and used as a small compote for lemon slices. This is
most likely a copy of an American or English piece from circa 1760, according
to Venable. George Sharp worked for Bailey and Company in Philadelphia dur-
ing the 1850s and 1860s. *Courtesy of Michael Weller, Artentum Antiques*

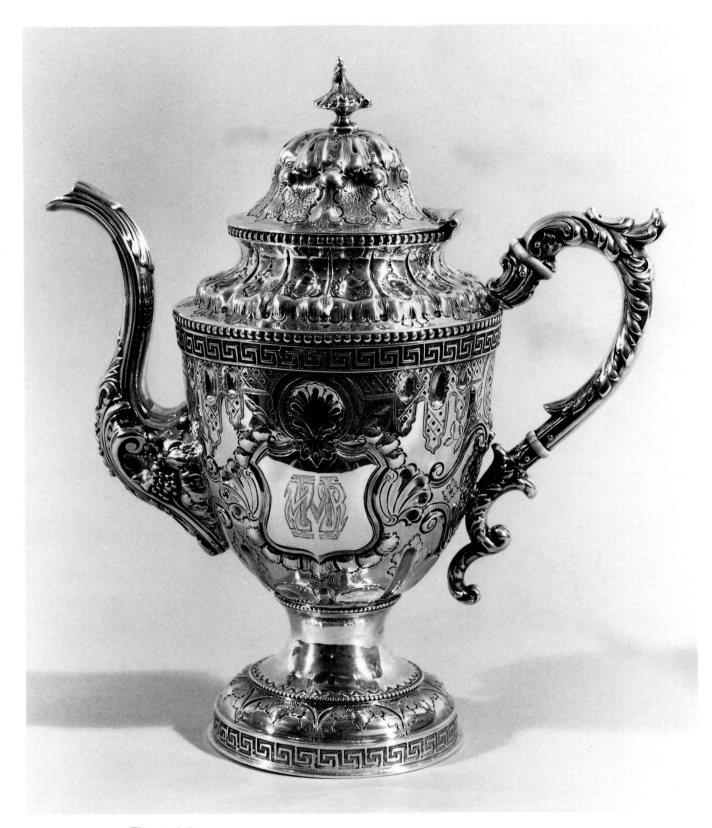

Figure 3.7
A highly decorated coffee pot, perhaps once a part of a complete service, made by William Gale and Sons in New York in 1858. The Grecian key and the overall design identifies this pot as Rococo. The pot has scrolls, beading, Grecian keys, grapes, fruit, acanthus leaves, shells—almost every design motif incorporated into one pot! It is 11 1/2 inches high. The monogram is very distinctive and appears to have been added many years later. *Courtesy Constantine Kollitus*

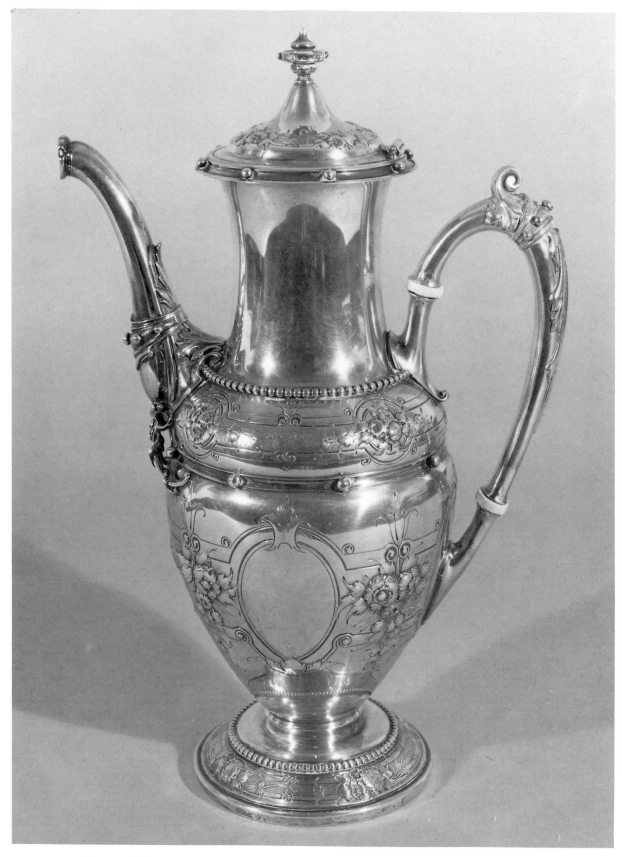

Figure 3.8
A coffee pot made in 1860. Mary Todd Lincoln obtained a complete coffee and tea service in this same pattern—a standard Gorham pattern—during the early 1860s. Because of this, examples that turn up on the market today are usually known as "Mary Todd Lincolns." *Courtesy of Constantine Kollitus*

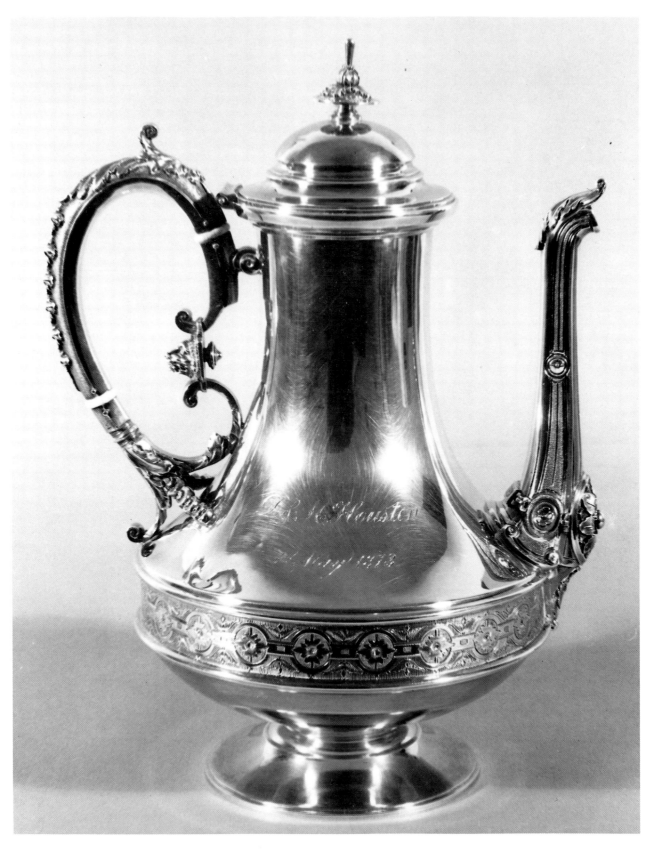

Figure 3.9
A coffee pot made circa 1868-1870 by Albert Coles of New York, part of a five-piece set. The Coles factory, according to Rainwater, sold most of their work to other retailers, who placed their own marks on the goods. Eventually Coles sold out to Morgan Morgans, who sold out in turn to Shiebler. *Courtesy of Constantine Kollitus*

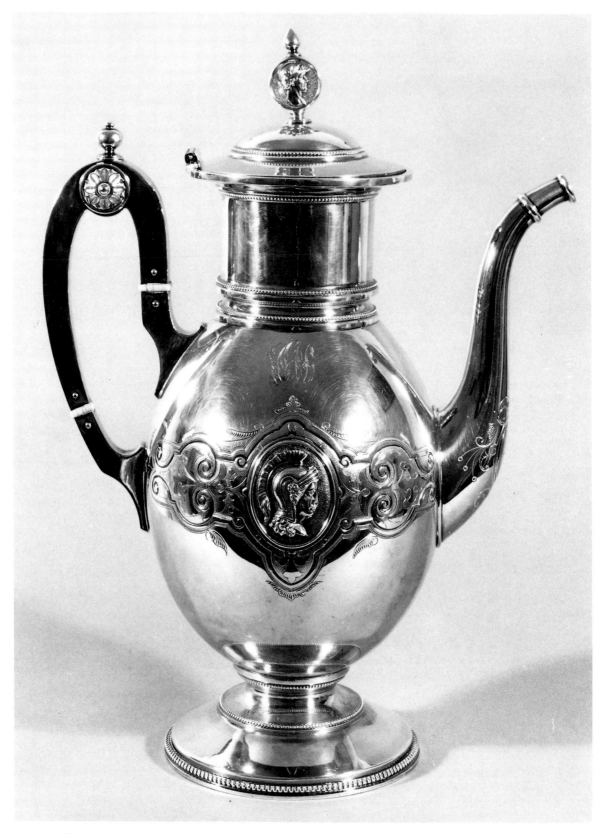

Figure 3.10
A coffee pot from a four-piece set, made in 1862 by William Gale and Son in New York. This particular pot stands 12 inches high. The ebony handle is unique in that it contains insulators. It features a stylized silver ornamentation on the handle, referred to as "paterae design." The finial appears to be a medallion, as is the design on the center of the pot. The use of bead trim truly give distinction to the overall effect of this pot. *Courtesy of Constantine Kollitus*

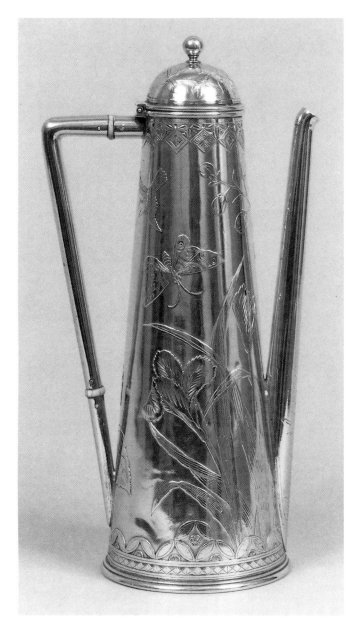

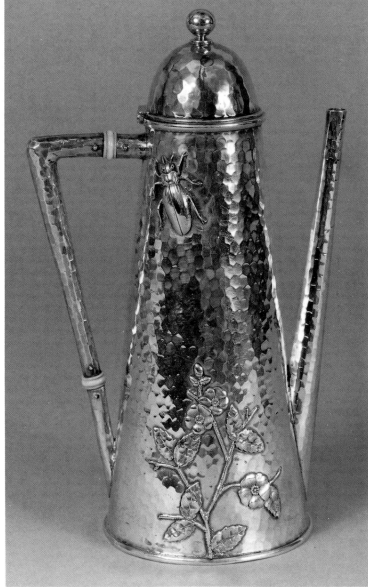

Figure 3.11
A black coffee pot by Whiting with an acid-etched Japanese design, 9 1/4 inches. Made circa 1880 to 1885, it must have provided the original owner a touch of luxury and up-to-date style. The iris, butterflies, and beautiful leaf patterns make this pot very distinctive. *Courtesy of Constantine Kollitus*

Figure 3.12
A second black coffee pot, also in the Japanese style. This piece was made by Bigelow Kennard Company circa 1878 to 1880, and stands 7 1/2 inches tall. While the lines are similar to those of the pot in Figure 3.11, the different design techniques that were used show the endless possibilities each silversmith faced. The flowers and the insect appear to be applied to the hand-hammered surface of the pot. *Courtesy of Constantine Kollitus*

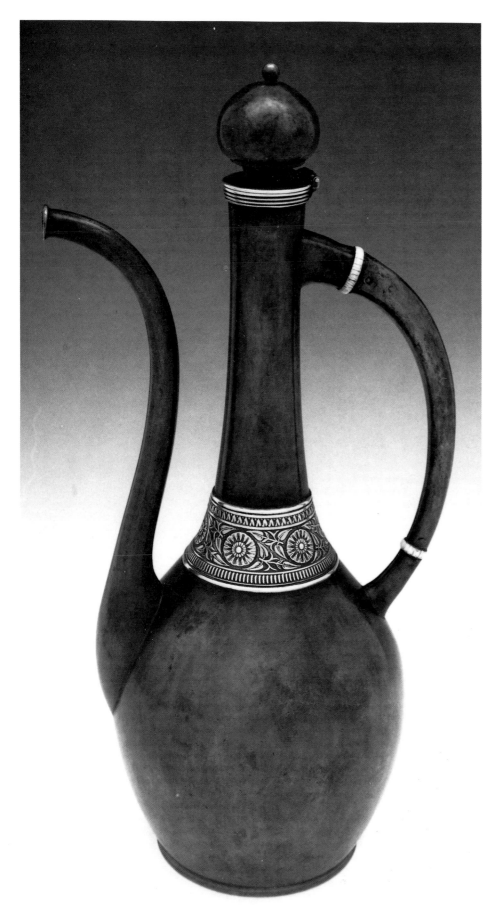

Figure 3.13 *(left)*
A black coffee pot by Gorham, in a Turkish design. With its sterling die-rolled border, this item is very similar to the pot in Figure 3.14a and 3.14b. Gorham made these pots in a great variety. This example is made of copper, but some were even made in all sterling silver. *Courtesy of Michael Weller, Argentum Antiques*

Figures 3.14a and 3.14b
(see photos on color page 25)
The front and back of the same pot, which differs from the example in Figure 3.13 because of the silver and the glaze on the pot itself. These pots were made of beaten copper, and then covered in a glaze that is truly unique to Gorham. In 1982, Carpenter said that the exact formula for the glaze was no longer known. As with many techniques of the past, duplication is difficult. This finish appears baked-on. Even though the silver needs an occasional dab of silver polish to clean it, the copper looks as good today as it did when it left the factory.

Figure 3.15 *(opposite page)*
A chocolate pot from 1880, one example of the truly outstanding silverware produced by Dominick and Haff. The top finial is called a mollinet. The server would grip the finial between the palms and gently roll the hands back and forth, causing the finial to turn. Inside the pot, connected to the finial, is a beater to agitate the chocolate. Since the chocolate that was available at the time was not as finely milled as it is today, it would quickly settle to the bottom of the pot; the mollinet was used to mix the chocolate back into the liquid. *Courtesy of Constantine Kollitus*

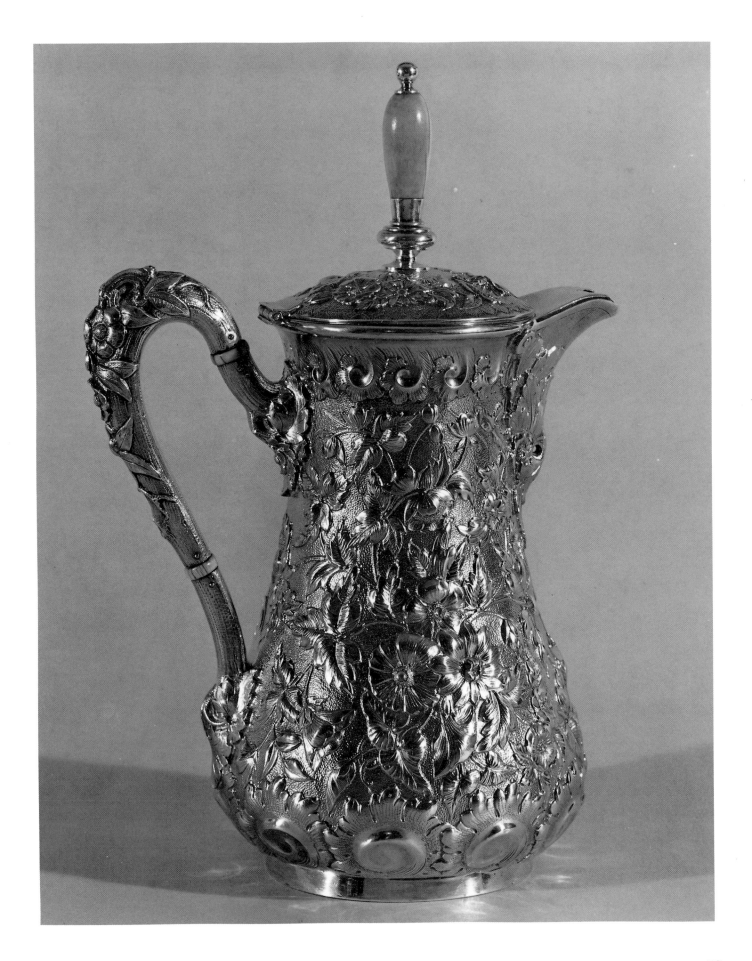

73

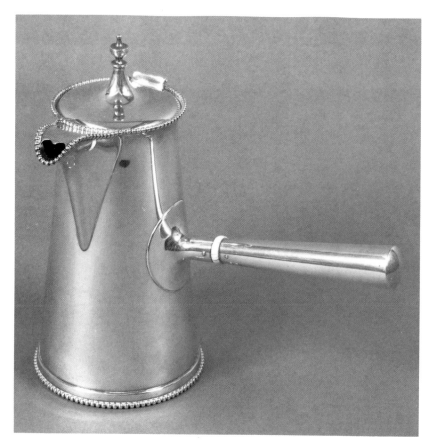

Figure 3.16
A simple pot with a side handle, made in 1900 by the Barber Silver Company. The retail jeweler was Bailey, Banks and Biddle. Most likely this was one of a pair of pots needed for café au lait, and it stands 8 1/4 inches high. The handle is insulated to help contain the heat and to protect the hand when pouring. Most of the pot is perfectly plain, except for the beading around the top and the base. *Courtesy of Constantine Kollitus*

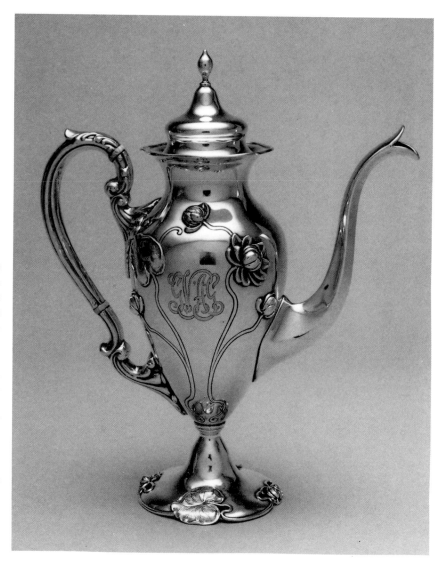

Figure 3.17
An Art Nouveau coffee pot made by Shreve and Company circa 1916, standing 11 1/4 inches high. Other examples with the same overall shape but with different designs were made and sold by Shreve. These were made in their own shop and to their own specificiations. The deYoung Museum in San Francisco has a permanent display of items of the same shape but made in the Iris pattern by Shreve. In this display, museum visitors can see a tea set and a number of other silver hollowware articles all in the same pattern (and even examples of Durgin's *Iris* flatware pattern). *Courtesy of Sherry Langrock, Silver Crest Antiques. Photography by Debbie Cartwright*

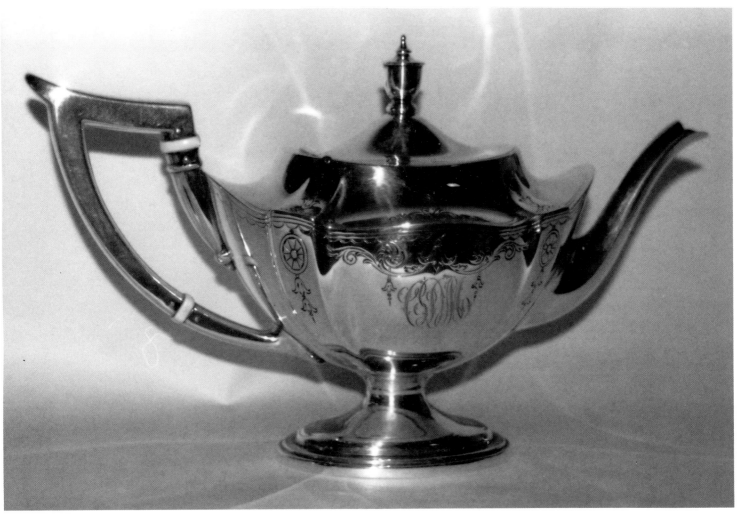

Figure 3.18
A teapot from Gorham's set in the *Plymouth* pattern, bearing the year mark for 1917. The set was retailed by Grogan and Company of Pittsburgh, Pennsylvania. Most *Plymouth* items are plain (see Figures 4.19 and 4.20); this set differs because it is beautifully engraved, with another example of paterae with descending pendant bell flowers. Another difference between this and Figures 4.19 and 4.20 is the handle. This particular handle is all silver, while the others are ebony.

Figure 3.19 *(see photo on color page 26)*
An excellent example of a Gorham black coffee pot, marked with #4166, with no manufacturing date mark. The number 21MJ appears on the inside rim of the foot, on the handle, and on the inside rim of the top of the cover. The decorations incorporate flowers and scrolls.

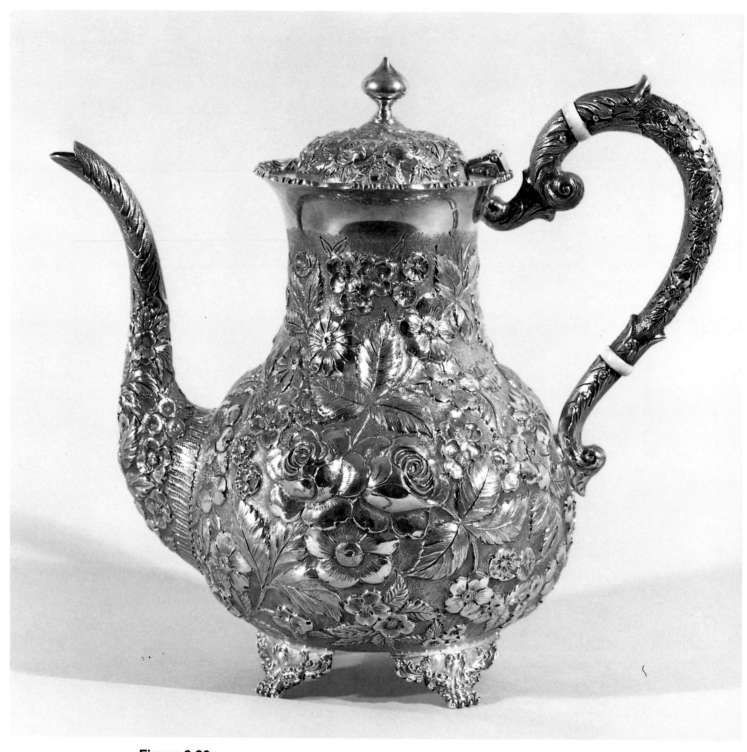

Figure 3.20
A coffee pot from a five-piece tea and coffee service, made circa 1935 by Schofield in their *Baltimore Rose* pattern. This pot stands about 9 3/4 inches high. The details on the flowers is exquisite. The interesting feet and finely crafted handle add to the good looks of this pot. *Courtesy of Constantine Kollitus*

Figure 3.21
A modern coffee pot by Marie Regnier of St. Louis, Missouri, circa 1945 to 1950. It stands an impressive 9 inches tall. The example is thoroughly modern for its time. *Courtesy of Constantine Kollitus*

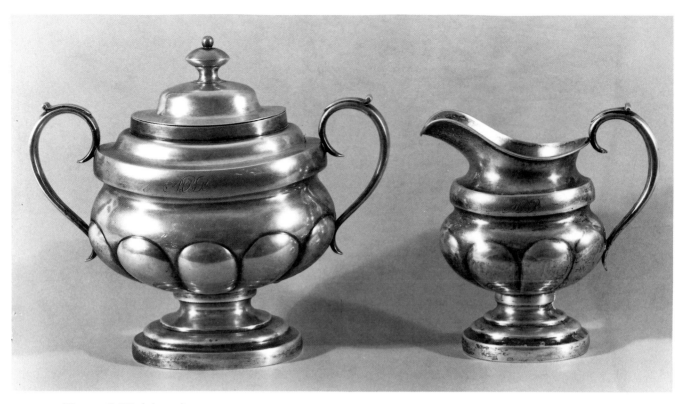

Figure 3.22 *(above)*
A sugar and creamer made by J. B. Jones and Company, circa 1825 to 1830, in Boston. The sugar is 8 1/4 inches high and bears the maker's mark. The creamer, slightly shorter, is unmarked, but appears to have been made at the same time. *Courtesy of Constantine Kollitus*

Figure 3.23 *(below)*
An impressive sugar and creamer set made by Dominick and Haff in New York, circa 1901. The sugar bowl is 7 3/8 inches high and the two pieces together weigh 35 ounces. The beautiful flower design makes these very desirable. The manner in which the designer coordinated different flowers by using similar swirls attests to his ability. The date engraved on each piece—"Dec 25"—suggests that it was a very special Christmas gift for someone around the turn of the century! *Courtesy of Constantine Kollitus*

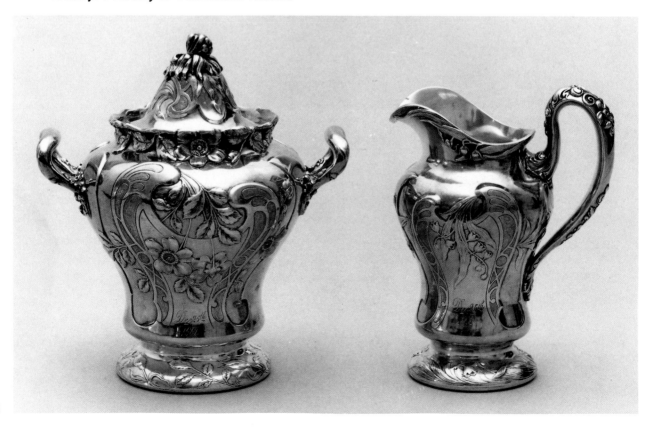

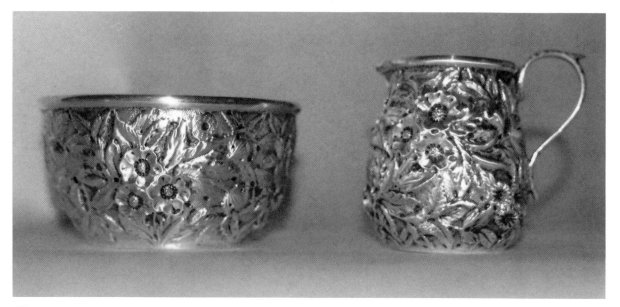

Figure 3.24
A small sugar and creamer pair made by Samuel Kirk and Son. The mark, reading "Samuel Kirk and Son 11 oz.," dates the sugar and creamer to sometime between 1861 and 1868. The creamer weighs 4 ounces and is 2 7/16 inches high. The sugar weighs approximately 5 ounces and is 1 3/4 inches high. Because of its small size, the creamer would be useful for serving hot maple syrup, or for pouring sherry into a thick pea soup. The small size of the sugar would make it useful for serving jelly on a breakfast tray.

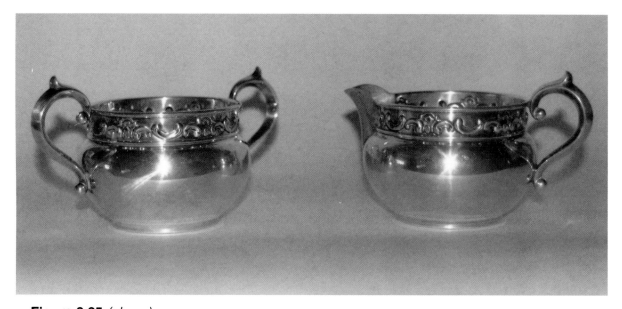

Figure 3.25 *(above)*
A sugar and creamer in Gorham's *Strasbourg*. These items are not old, but they do represent hollowware items in a sterling flatware pattern that has been in production since 1897. During that time a large number of hollowware items have also been produced. These are representative of what is being produced today. Regretably, they do not have the hand-workmanship displayed in so many of the fine antique examples shown throughout this book.

Figure 3.26 *(see photo on color page 26)*
A spooner, as would have been included in any complete tea service. This example by Schultz and Fisher was made circa 1871. It is marked "S.F Cal Coin.," along with the company's trademark. It stands 5 1/4 inches tall, and measures 3 1/2 inches across the top, not including the handles. A classical figure appears atop the handles of the spooner, most likely that of a goddess. The top of the spooner has a delicate band of applied design. *Courtesy of Sherry Langrock, Silver Crest Antiques. Photography by Debbie Cartwright*

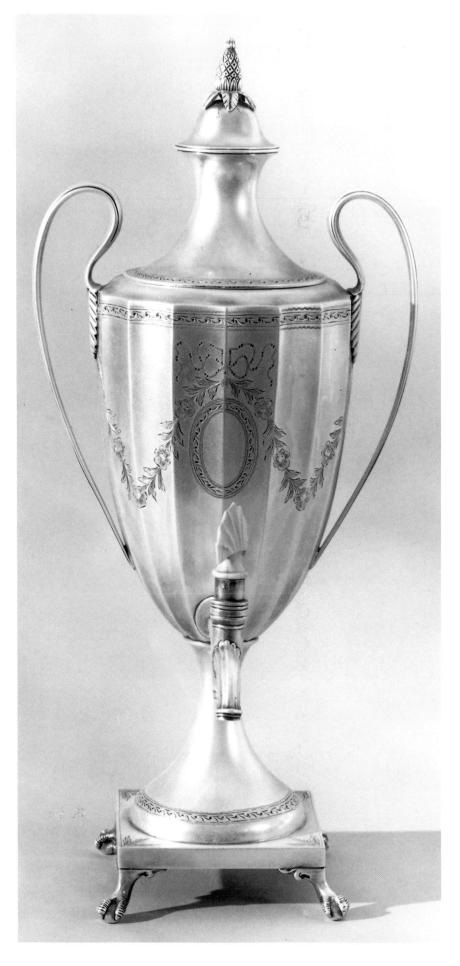

Figure 3.27 *(left)*
A tea urn by Gebelian, made circa 1920 as a copy of a Georgian tea urn. Such an item would be a necessity for hosts serving tea to a large crowd. The very fine engraving and the pineapple finial suggest that this design, Federal in style, would have been very appropriate in the early 1800s. *Courtesy of Constantine Kollitus*

Figure 3.28 *(opposite page)*
A fine example of a tea urn from circa 1810, made by John and Peter Targee of New York City. It embodies early Empire styling with simple lines. *Courtesy of Michael Weller, Argentum Antiques*

Figure 3.29
(see photo on color page 26)
An elaborate tea urn made by Gorham circa 1868 to 1869. It is in the Rennaisance Revival style, but has engraved oriental designs and Chinese figures on the urn. It is most unusual to find oriental designs on silver produced before 1870. *Courtesy of Michael Weller, Argentum Antiques*

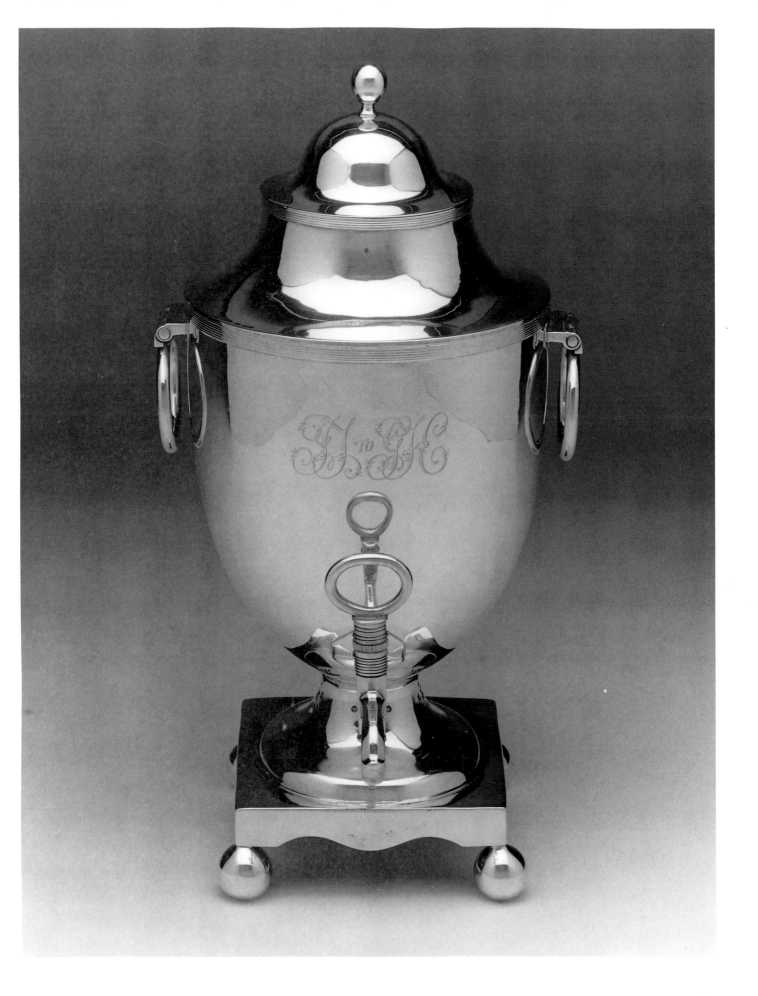

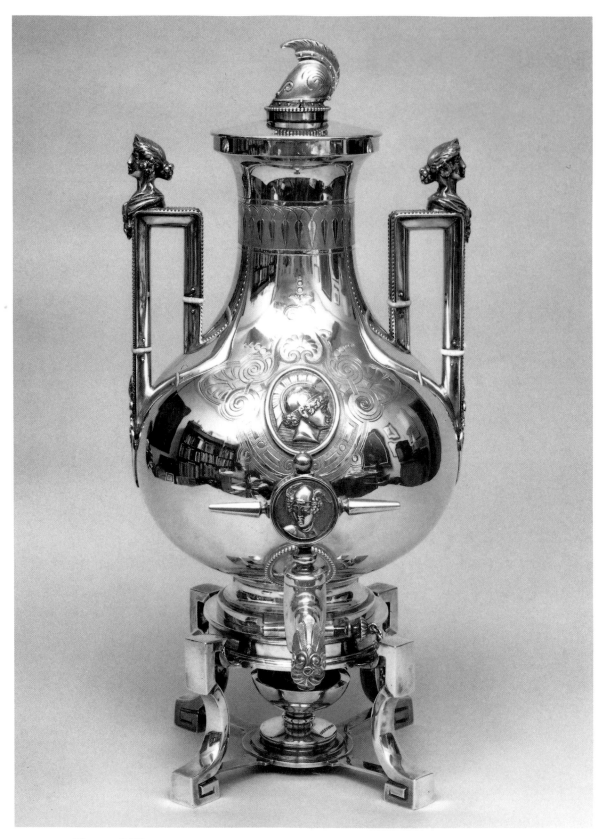

Figure 3.30
An elabrate urn by Wendt, circa 1865. This item, which stands 16 1/2 inches tall, is part of an entire tray set pictured in Figure 4.8. Wendt produced silver mainly for the New York firm of Ball, Black and Company. This particular piece is in the *Medallion* pattern. The fine engraved design attests to Wendt's ability. *Courtesy of Constantine Kollitus*

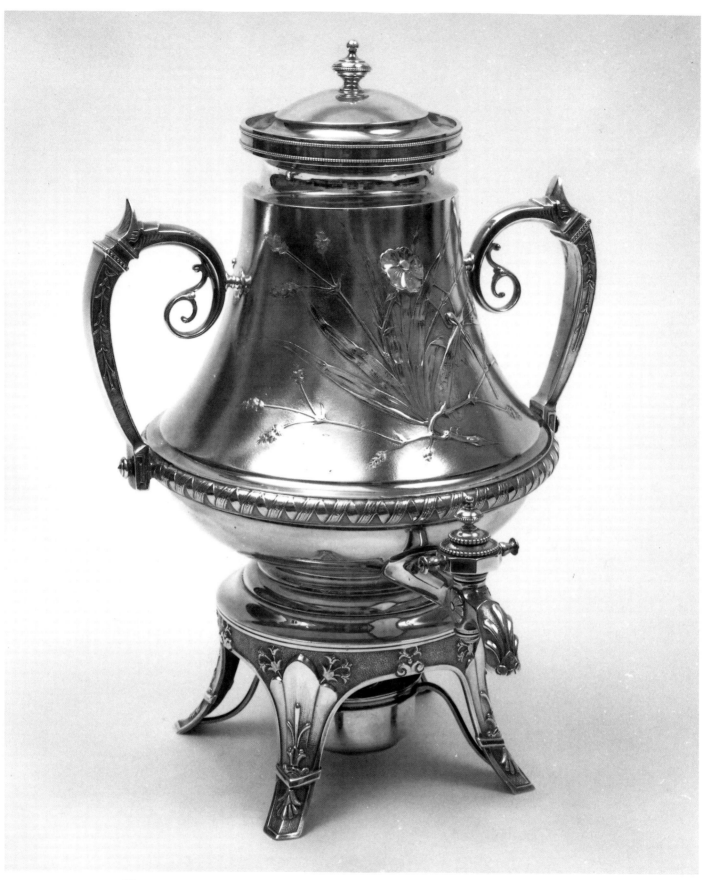

Figure 3.31
An early Japanese-style hot water kettle, made by Gorham in the early 1870s.
It is part of a six-piece tea and coffee service. *Courtesy of Constantine Kollitus*

Chapter 4
Tea & Coffee Sets

A complete tea and coffee set consists of a tea pot, a coffee pot, a creamer and a sugar bowl. Other pieces that were available included a hot water pot, a chocolate pot, a milk jug, a slop bowl, a teakettle, a box for storing tea called a tea caddy (some of which could be locked), and a spooner to hold the spoons. Finding a tray large enough for all these items was impossible—not surprising, since few would have been able to lift it when it was fully loaded! Some sets had small individual trays for resting the coffee and tea pots.

Tea sets came in many sizes and shapes, and the tea and coffee services shown in this chapter represent a wide variety of design styles. Not all of the variations that existed with a design period are shown. Many tea sets were made and if they resulted in strong sales the silver company would most likely add a variety of other hollowware to their offerings.

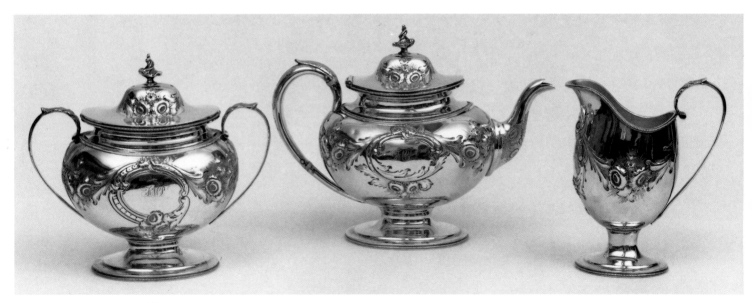

Figure 4.1
A beautiful Rococo tea set made by J. C. Moore for Gelston and Treadwell, New York, circa 1845. Note that the embellishments are not overdone. An area for a monogram is found on each pot. The pot stands 7 3/4 inches high. *Courtesy of Constantine Kollitus*

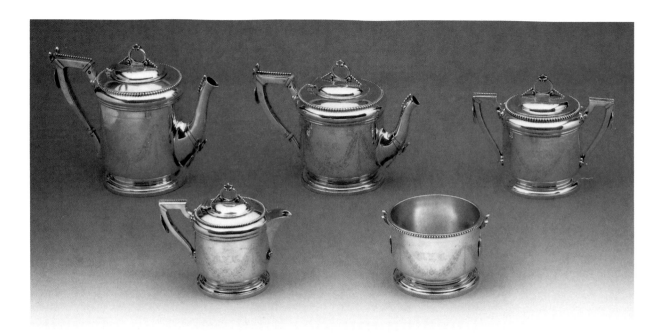

Figure 4.2 *(above)*
A five-piece coffee and tea set in coin silver, made by Wood and Hughes between 1850 and 1860. The heavy beading on the tops of the pieces and across the handles of the pots and the sugar are very unusual. Each finial (on the sugar and the two pots) appears to have a line of beading acting as a brace. Just below the top of the pots' handles there appears to be another embellishment that is round. The covered creamer is most unusual. *Courtesy of Sherry Langrock, Silver Crest Antiques. Photography by Debbie Cartwright*

Figure 4.3 *(below)*
A five-piece tea and coffee set with matching waiter; early nineteenth century Kirk sets like this are very rare. All of the items in this set, except for the waste bowl, have a ram's head terminal on a rectangular handle. *Courtesy of Phyllis Tucker Antiques. Photography by Hal Lott*

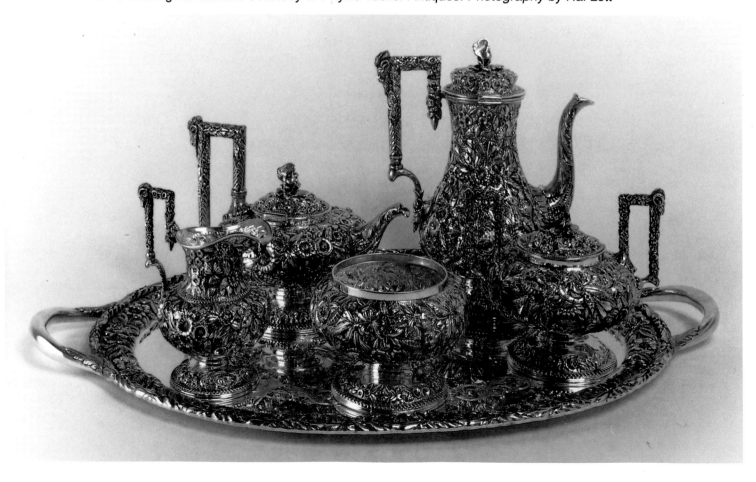

Figure 4.4
A three-piece coffee set made in California circa 1865. The Grecian key design, on the base and slightly above the midpoint of the pieces, is done in two sizes. At the rim of the foot the border was done in a small scale, while the at the top of the body a larger key design is placed to captures the viewer's eye. The pineapple finials on the pot and sugar bowl are well done. The spout on the coffee pot is known as a "dogface spout." *Courtesy of Michael Weller, Argentum Antiques*

Figures 4.5 and 4.6
A medallion set made for Tiffany by Edward C. Moore was made circa 1865. The medallions are very crisp, and are modeled to look like cameos dropping from the beaded border. The handles have ivory insulators. Interestingly, the handles have an area that flares out to make a thumb rest, allowing better leverage when pouring. The helmet finials provide another interesting detail. For a close view of the coffee pot, see Figure 4.6. *Courtesy of Constantine Kollitus*

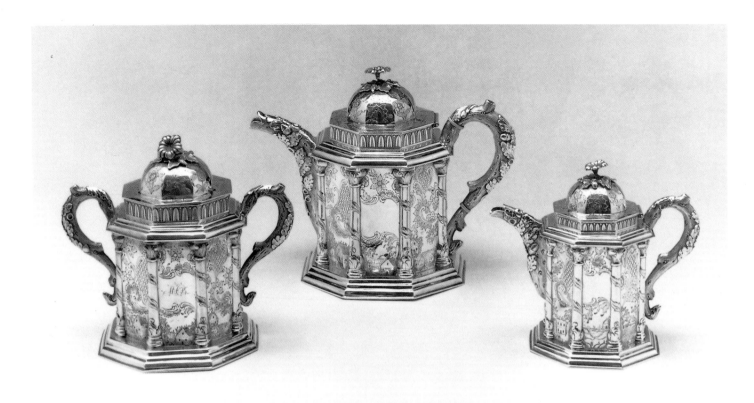

Figure 4.7a *(above)*
A wonderful tea set in the Rococo revival style, extremely rare because few American sets have architectural forms. It was made in 1845 and is marked "Stebbens." Stebbens was the retailer, but the maker is unknown. All the pieces, which are modeled to resemble garden pavillions, have covers. Columns that appear to be iconic rise from the octagonal base. Vines and flowers curl around the columns. The handles and spouts are heavily covered with flowers and leaves. The finial on the top of each high domed piece consists of a finely detailed morning glory and leaves. This set is truly a work of art. *Courtesy of Phyllis Tucker Antiques*

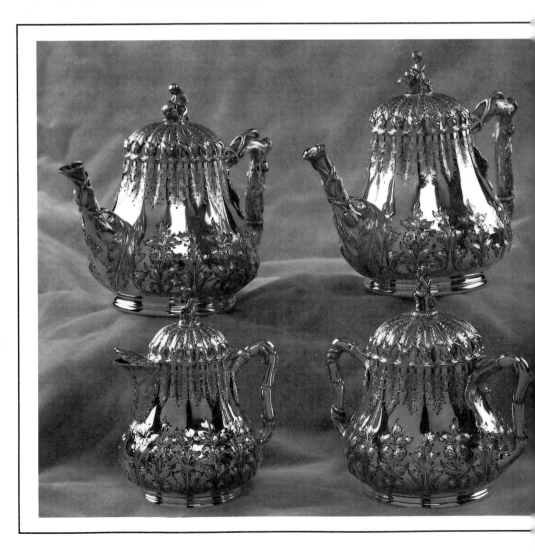

Figures 4.7b and 4.7c *(opposite page bottom and below)*
A coffee and tea service marked with the initials W & G (John H. Woodward and Charles G. Grossjean) and the retailer's mark for Lincoln and Foss. Additional marks are contained inside rectangles with the stamped words "Coin" and "Boston." The makers Woodward and Grossjean began their partnership in Boston in 1848; the last listing for the pair is in 1852. Later that year, the pair began working in New York City, and their mark changed to Grossjean and Woodward. All the silver in this four-piece set is 22-gauge. Each piece has a cover which displays a different wood nymph as the finial. The pieces descend in size: the coffee pot is 8 1/2 inches tall; the tea pot is 8 inches tall; the sugar is 7 1/2 inches tall; and the creamer is 6 3/4 inches tall. *Courtesy of Arthur Hippensteel*

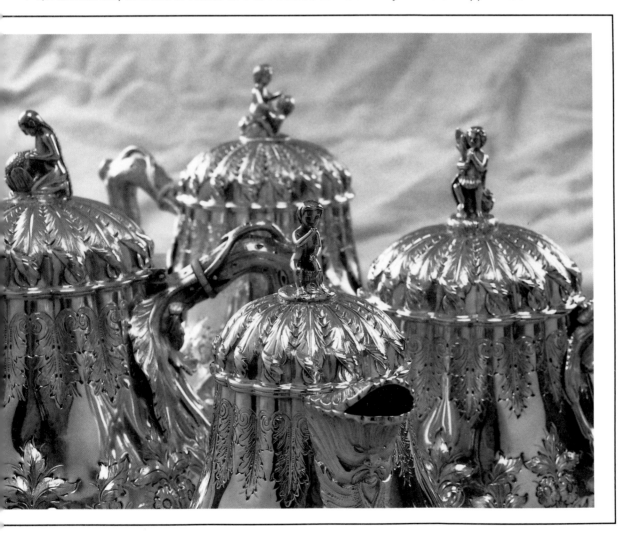

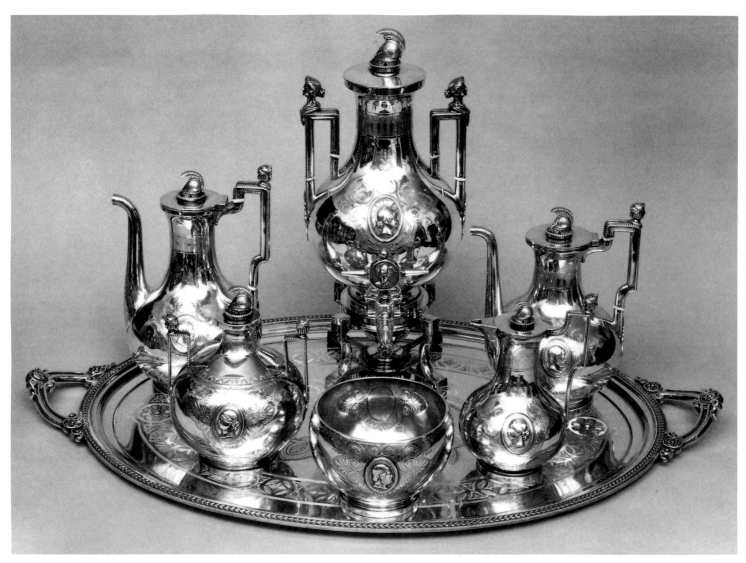

Figure 4.8 *(above)*
John Wendt's *Medallion* tea set, manufactured circa
1865. It is unusual for a six-piece set to remain intact
with a matching tray. The retailer was Ball, Black and
Company. The kettle is 16 1/4 inches high, the tray is
31 inches long, and the entire service weighs 319
ounces. While this set is very much like the one shown
in Figure 4.5, the addition of a woman's head on the
handles and the unique manner in which the handles
are fashioned give this set a graciousness of its own,
another variation within the medallion world. *Courtesy
of Constantine Kollitus*

Figure 4.9 *(opposite page, top)*
A tea set by Kinder and Biddle, circa 1870. This Phila-
delphia company was one of the firms selling select
silver—that is, the owners personally selected merchan-
dise for their store from different silversmiths' work. The
coffee pot is 10 1/4 inches. The influence of the Egyp-
tian Revival style is obvious in this set, particularly in
the handles and orbs. The spouts of the tea and coffee
pots look like bundled papyrus reeds. *Courtesy of
Constantine Kollitus*

Figure 4.10 *(opposite page, bottom)*
A four-piece Tête-à-Tête tea set in the Moorish style,
made by Tiffany and Company circa 1880. The kettle,
teapot, cream pitcher, and sugar bowl have compressed,
spherical, melon-ribbed bodies, each resting on a low
pedestal foot. The low dome lids are finished with low
bud form finials. The square base of the lamp stand
rests on four paw feet with scrolling mounts. The bod-
ies, spouts, handles, and lamp stand are covered with
elaborately chased and repoussé floral and foliate
motifs in an Islamic style. The kettle is 10 inches high to
the top of the handle. The teapot is 4 inches high. The
creamer is 3 3/8 inches high and the sugar bowl is 3 5/
8 inches high. Moore, Tiffany's master silversmith and
designer, was noted for his huge personal collection of
art and artifacts, many of which were Islamic and
Moorish. These items provided Moore with the inspira-
tion for many Tiffany designs during the 1870s and
1880s. Upon his death these became part of the collec-
tion of the Metropolitan Museum of Art. While not dis-
played intact, portions of this gift are still on display. *Cour-
tesy of Phyllis Tucker Antiques. Photography by Hal Lott*

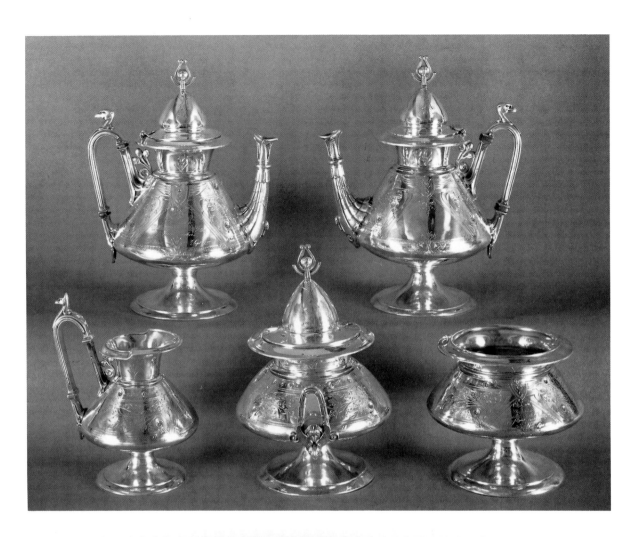

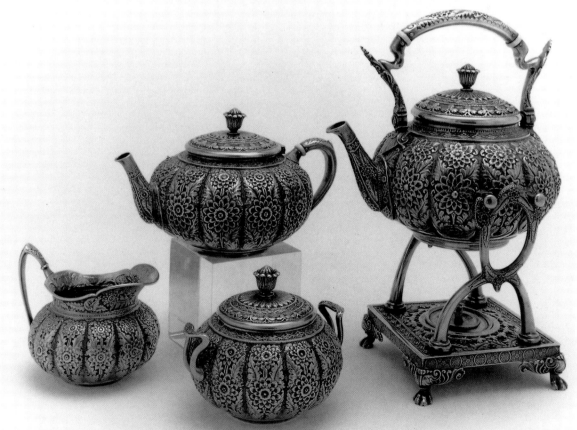

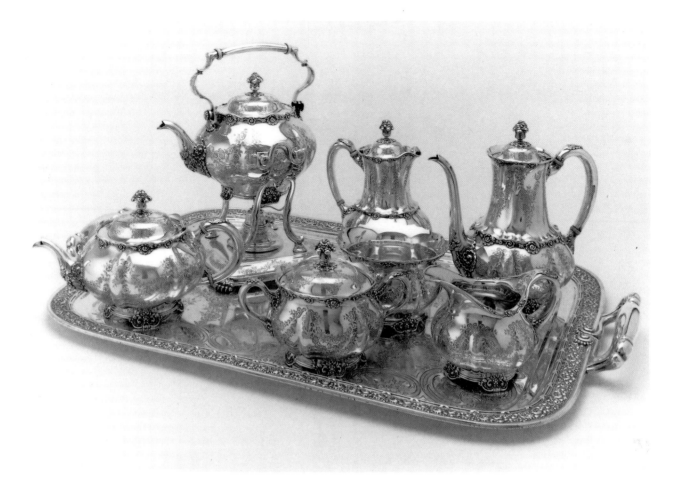

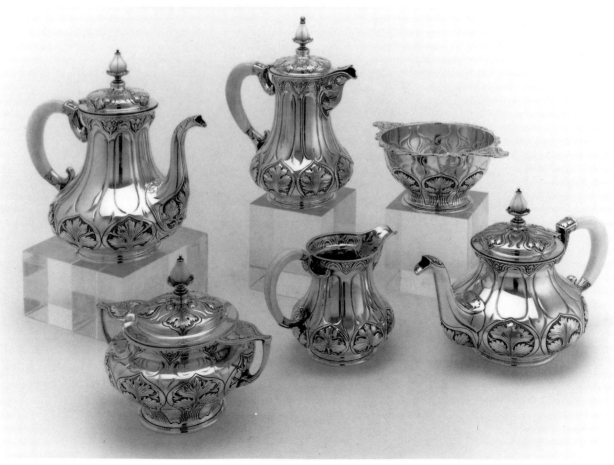

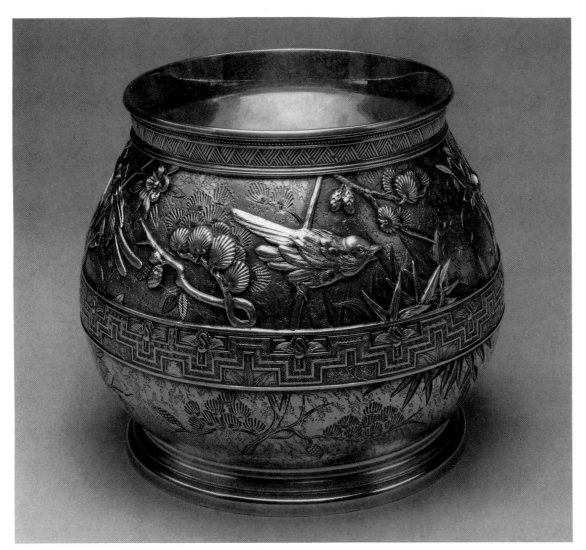

Figure 4.11 *(opposite page, top)*
This six piece set with matching tray was made by Tiffany and Company between 1898 and 1907. It consists of a kettle on a lamp stand with burner, tea pot, coffee pot, hot milk pitcher (rare), cream pitcher, sugar bowl with cover, waste bowl and sterling waiter. Each piece is decorated with hand-engraved floral wreaths and garlands. The tray is also ornately hand-engraved to match the set. The Tiffany date and design marks for 1897-1898 with the pattern number 13313 indicate that all pieces except the tray and teakettle were made at that time. They also have the letter "T" used by Tiffany between 1891 and 1902. The kettle has the letter "C" indicating it was made between 1902 and 1907, and has the design number 13313. The tray is marked with the pattern number 5970, introduced in 1880, and the letter "C." *Courtesy of Phyllis Tucker Antiques. Photography by Hal Lott*

Figure 4.12 *(opposite page, bottom)*
A Gorham six-piece set in the *Athenic* pattern, with ivory handles on the coffee pot, tea pot, hot water kettle, and creamer. The sugar bowl has plain silver handles. The waste bowl also has handles, but not in the same form as the sugar bowl's. The finials on the covered pieces are very interesting, consisting of silver and ivory, topped with a small silver decoration. The design of the leaves on the bottom of the pieces, inserted into ovals, has allowed the silversmith to add depth and detail to the leaves. Over the years, these have oxidized, adding a patina effect to the overall design. The covers of these pieces have a smaller version of the leaf decoration, which (while not mirroring the bottom design) provides a final touch of beauty. The coffee pot is 9 1/2 inches high, and the waste bowl is 3 1/8 inches high. *Courtesy of Phyllis Tucker Antiques. Photography by Hal Lott*

Figure 4.13 *(above)*
A beautiful waste bowl or sugar bowl, inspired by the *Japanese* design, now known as *Audubon*. Since there is no cover, it is impossible to tell whether this was meant to be an uncovered waste bowl, or was a covered sugar bowl that has since lost its lid. It was made by Tiffany circa 1892. It ornamentation includes beautifully executed birds and oriental motifs. The bands around the bottom, middle and top separate two panels of design, provide two distinct areas for decoration. The depth in the illustration of the birds and pine branches show the care taken by the silversmith. *Courtesy of Constantine Kollitus*

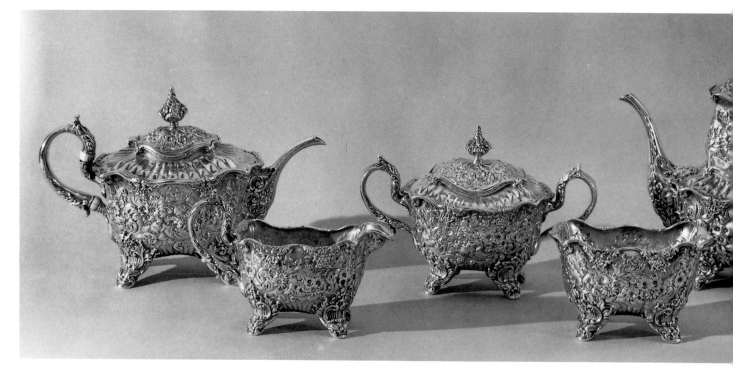

Figure 4.14
A tea set manufactured by Whiting between 1885 and 1890. (The set's hot water kettle is shown in Figure 5.4.) Whiting and Company was noted for their flatware, but the many examples of their hollowware attest to their ability to not only design fabulous hollowware, but to execute the designs with workmanship equal to none. Whiting, located in the Northeast, was truly one of the leaders of its time. Most repousséd work is considered a Southern tradition, yet this example shows that Whiting and Company could supply a unique interpretation of the technique. All the pieces in this set share the same ovoid shape. The hollow handles on the tea and coffee pots are not large, but are in a C-scroll with repoussé on each of the handles.
Courtesy of Constantine Kollitus and Phyllis Tucker Antiques

Figure 4.15
A three-piece group sold by Galt and Brothers in 1888. The pot, the sugar, and the creamer were definitely made by the same company, but the size differences suggest that they were not manufactured as a set. Rather, it looks as if they were grouped together at the time of purchase (or later), at which point they were monogramed. It may have been the style of the day to mismatch the three pieces. The base of each item bears a maker's mark consisting of a shield with a fleur-de-lis in the center. This is the mark, according to Rainwater, for Davis and Galt of Philadelphia.

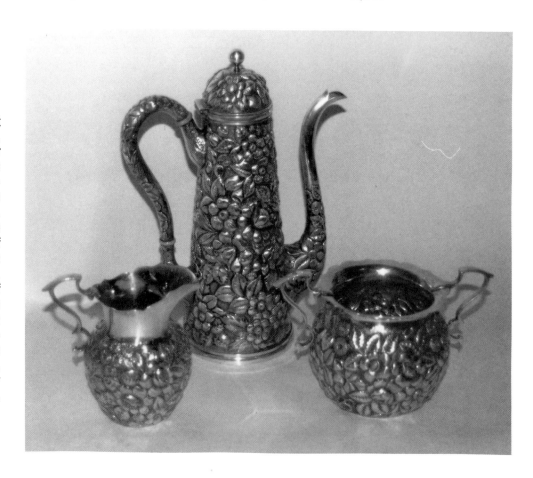

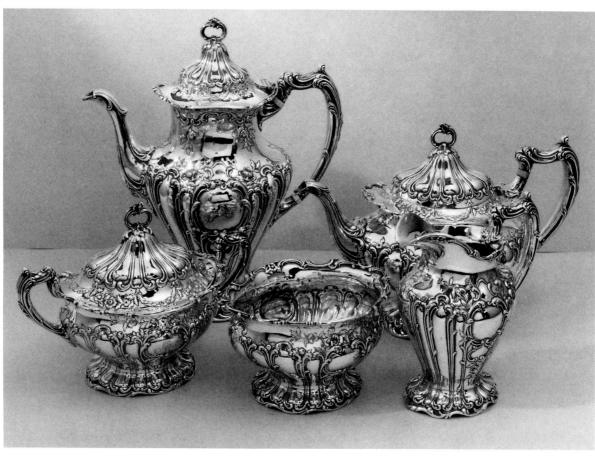

Figure 4.16a *(above)*
A *Chantilly* set marked with Gorham's 1898 symbol (indicating that it was made three years after flatware in the same pattern was produced). *Chantilly* was designed by William C. Codman, and represents the most outstanding design for flatware and hollowware ever conceived, unparalleled by the patterns of any other company. The beautiful scrolls and flowers all contribute to making this interpretation so special. The widely varying swirls make for an elegant handle. *Courtesy of Sherry Langrock, Silver Crest Antiques. Photography by Debbie Cartwright*

Figure 4.16b *(see photo on color page 27)*
A complete six-piece *Chantilly* tea set, consisting of a teakettle, coffee pot, tea pot, sugar bowl, creamer, and waste bowl with a 1899 date mark. The tray has a 1900 date mark. The continuing demand for *Chantilly* can only be attributed to the design's movement and lack of straight lines. The coordinating sterling flatware can be teamed with almost any china or crystal pattern. *Courtesy of Phyllis Tucker Antiques*

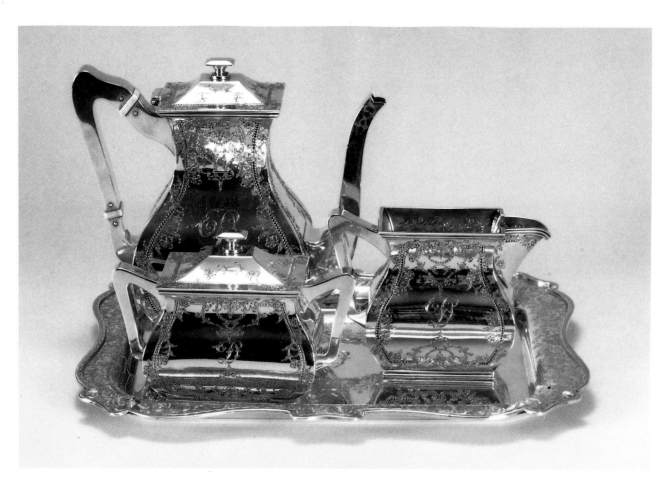

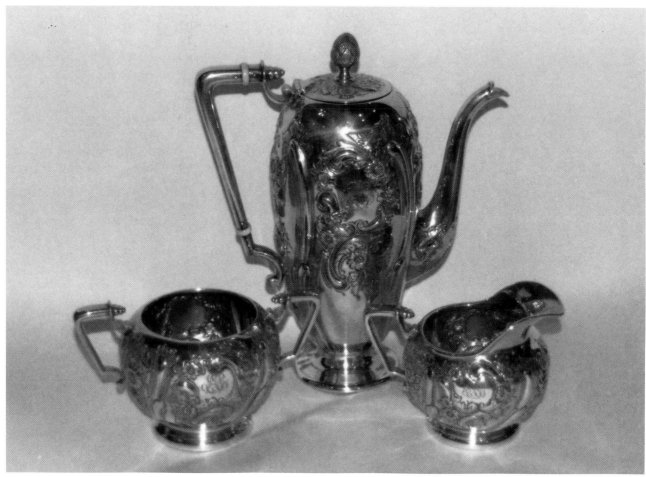

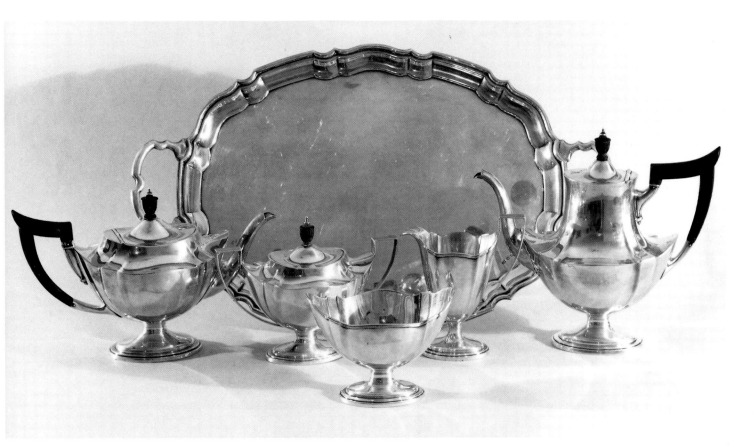

Figure 4.17 *(opposite page, top)*
A three-piece breakfast tea set and tray, hand wrought by Bixby Silver Company between 1896 and 1906. Bixby was located in Providence, Rhode Island, and according to Rainwater they were in business only during the aforementioned decade. The design interpretation is very interesting and the engraving shows excellent workmanship. The pieces are monogrammed with a "D." *Courtesy of Sherry Langrock, Silver Crest Antiques. Photograph by Debbie Cartwright*

Figure 4.18 *(opposite page, bottom)*
A three-piece black coffee set first sold circa 1910 by Black, Star, and Frost, Inc. This was an important New York, which began as Marquad and Company in the early 1800s (Rainwater, page 24). The floral design accomplished with gentle scrolls helps create an inviting silver coffee set. *Courtesy of Maxine Klaput Antiques*

Figure 4.19 *(above)*
A Gorham set in the Colonial Revival pattern *Plymouth*, bearing the mark A 2441-2-3-4-5 and the year mark for 1914. *Plymouth* was introduced as a hollowware pattern before it was made into flatware. Sets like this one were made in a number of variations and sizes. One variation bears the same numbering system without the

letter "A," indicating only a change in the handles. Here they are made of ebony wood; on the other set they were silver (as in the teapot in Figure 3.18). The coffee pot is 9 3/4 inches high and the tray (which is sterling, but not part of the *Plymouth* set) is 22 1/2 inches across. Retailing jewelers could purchase these items from Gorham and then have their own names stamped under the Gorham hallmark (a lion, an anchor, and the letter G). This was appealing to local buyers, and was perhaps a status symbol for the selling jeweler. *Courtesy of Constantine Kollitus*

Figure 4.20 *(see photo on color page 27)*
Another coffee service in Gorham's *Plymouth* design. This group is what is called an "assembled set" — the three pieces all bear different date marks, and thus were manufactured in different years. The black coffee pot was made in 1923 and is 11 1/8 inches high. The sugar was made in 1920 and is 5 1/2 inches high to the top of the handle. The creamer dates to 1919 and is 5 1/2 inches high. These three pieces match the set in Figure 4.17 in that the pots have ebony handles. A tea pot that could be part of this set can be seen in Figure 6.7. Because they are of similar scale, they look appropriate when displayed together.

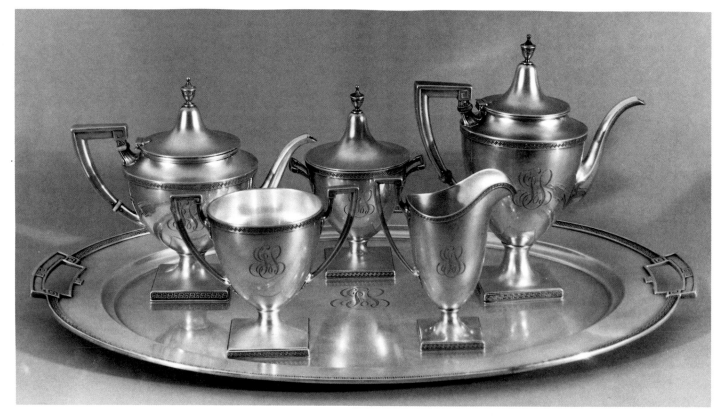

Figure 4.21 *(above)*
A five-piece set and tray in Gorham's *Etruscan* pattern, another example of the Colonial Revival style. This set bears the 1917 Gorham year mark. The Grecian key around the pedestal base and near the top of the pieces is in keeping with the flatware pattern. The finials appear to be exactly like those in Figures 3.18 and 4.20, which also bears the 1917 date mark. *Courtesy of Constantine Kollitus*

Figure 4.22 *(see photo on color page 28)*
A three-piece black coffee service by Gorham, bearing the mark A 1219. The interiors of the sugar and the creamer are gold-washed. The date mark for the pot and the creamer is 1904; the sugar is marked for 1903. The dates are so close that it is doubtful that this set was "assembled" over the years as was the set in Figure 4.20. Perhaps the sugar was made at the end of 1903, and then the other two items were made early in 1904; then the three pieces may well have been purchased together at the same time.

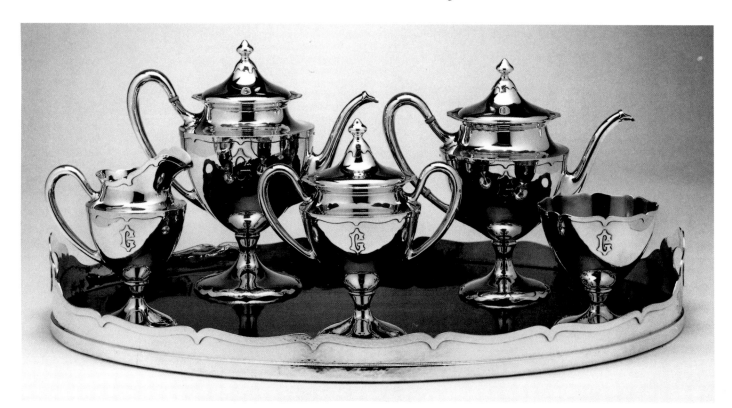

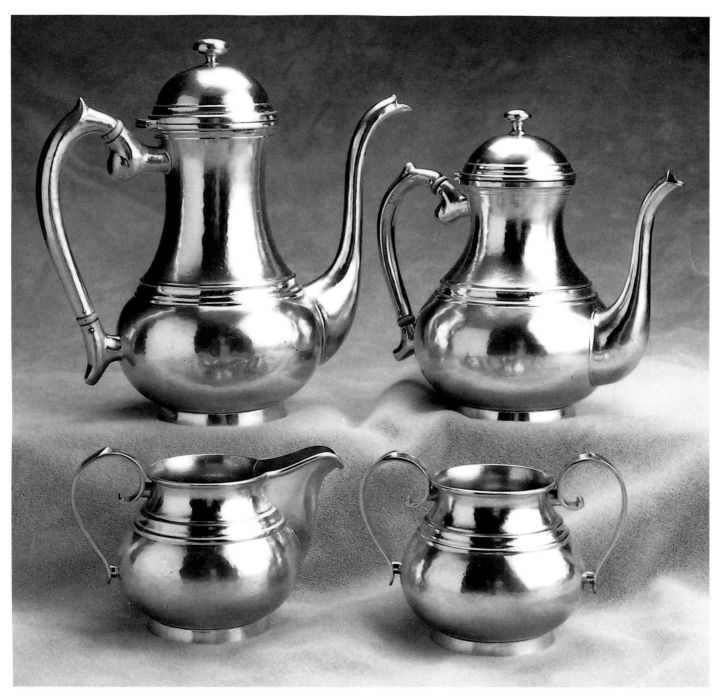

Figure 4.23 *(above)*
A set produced between 1909 and circa 1925 by Falick Novick, a Chicago silversmith who produced typical Arts and Crafts wares in his shop. This set was made in very heavy gauge silver, and its simple lines are elegant. The domed lids of the pots are topped with round finials, and the C-scroll pot are insulated. *Courtesy Sherry Langrock, Silver Crest Antiques. Photograph by Debbie Cartwright*

Figure 4.24 *(opposite page, bottom)*
A five-piece tea set by Shreve and Company, circa 1920, in their *Dolores* pattern. The pieces have the applied monogram that is representative of Shreve's work. The tray is different, with a beautiful mahogany base to which were added a graceful sterling rim with a matching hand-hammered edge. The mahogany tray provides a striking contrast with the silver tea set. *Courtesy of Michael Weller, Argentum Antiques*

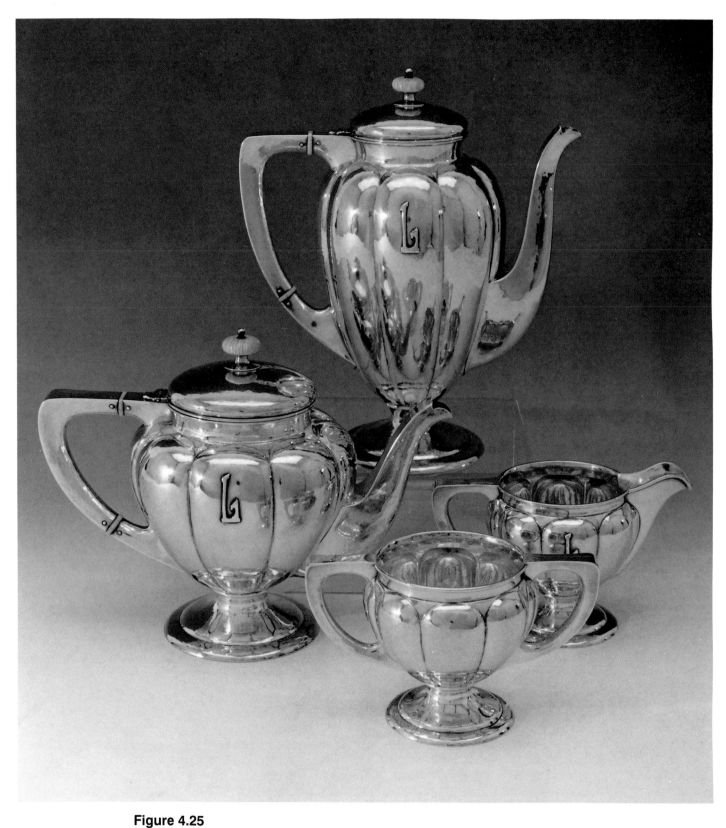

Figure 4.25
An interesting set from the Kalo Shops, typical of many of the company's pieces from the 1920s. The heavily lobed pot with an applied monogram and an ivory knob show this style set to its best advantage. The handles of all four of these pieces are very similar; the only difference is that the tea and coffee handles are insulated. *Courtesy of Michael Weller, Argentum Antiques*

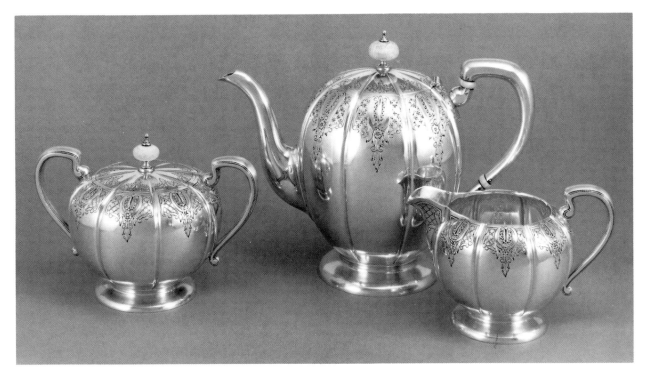

Figure 4.26
A three piece set in the Georgian style. Hollowware from the Tuttle company is certainly not as plentiful as from other manufacturers, but this particular set is a beautiful example of their work. A simple engraved design is imposed on the sectioned, melon-shaped bodies, and the round pedestal bases are appropriate to this design. The ivory handles on the sugar and tea pot lend a air of sophistication to this set. Tuttle named this set "Windsor Castle." *Courtesy of Gebelein Silversmiths*

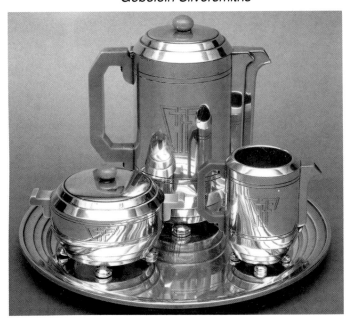

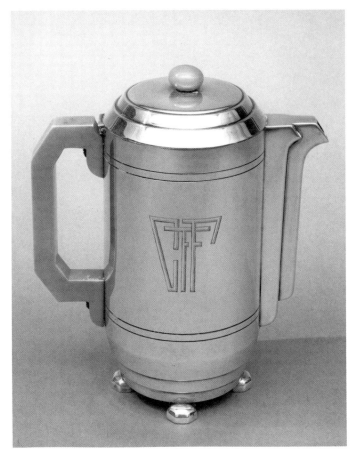

Figure 4.27 and 4.28 *(above and right)*
An Art Deco coffee set and tray, circa 1929, made by Towle Silversmiths. The coffee pot is 8 1/8 inches high and the diameter of the tray is 11 3/4 inches. The total weight of the items is 63 ounces. The handles are Bakelite, a departure from ivory. Note the distinctive monogram, which is typical of the Deco movement. *Courtesy of Constantine Kollitus*

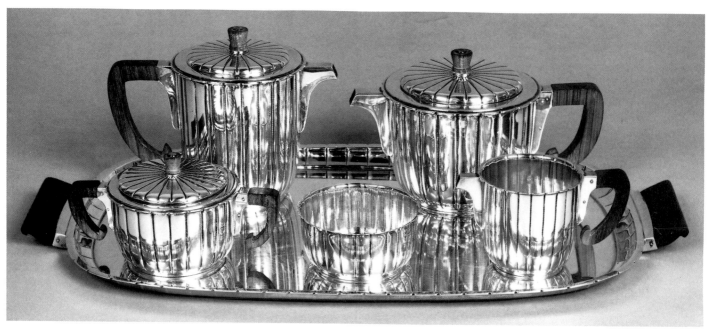

Figure 4.29 *(above)*
A five-piece service by Central Sterling Company of Brooklyn New York. This set is Art Deco, circa 1935, with eye-appealing vertical lines that would fit into almost any decor. The squat shape of the unique spouts add additional interest to this set. *Courtesy of Constantine Kollitus*

Figure 4.30 *(below)*
An International Silver Company set from 1936. The designer has used multiple vertical shafts on an applied silver section to lend distinction. The handles are carved ivory, closely matching the applied silver decoration. The bases of all the items are beaded and add another dimension to the design. The slight spout is typical of Deco pots. *Courtesy of Constantine Kollitus*

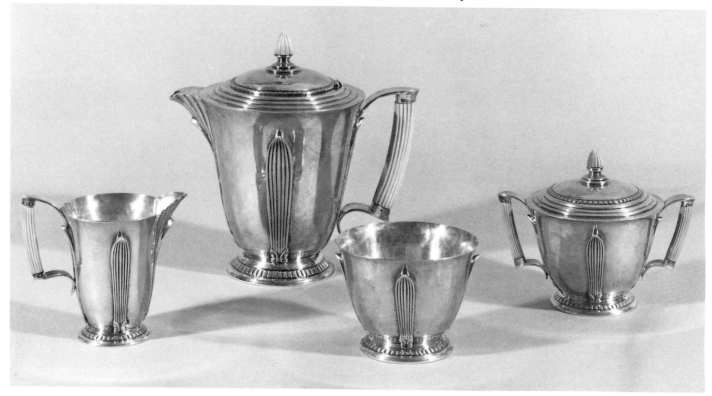

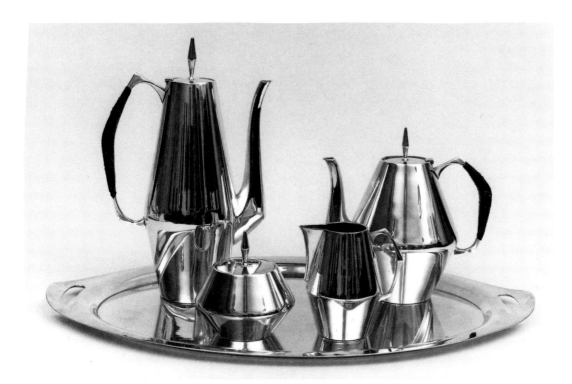

Figure 4.31 *(above)*
A very modern-looking tea and coffee service, made by Reed and Barton in their *Diamond* pattern in 1958. This set, in a Classical Modern style, was designed by John Prip. The pot is 11 3/4 inches high. The handles on the coffee and tea pots are different in that the insulation appears to be wrapped around the silver. The tray does not match, but certainly adds to the set. It was manufactured by the H. Fred Hirsch Co., Jersey City, NJ. *Courtesy of Constantine Kollitus*

Figure 4.32 *(below)*
Another set in Reed and Barton's *Diamond* pattern, including the waste bowl and the matching tray. This design by Prip is Classical Modern and will certainly be an example for silver buffs of the future. The base of this round tray appears to be dark Formica with a sterling rim. *Courtesy of Michael Weller, Argentum Antiques*

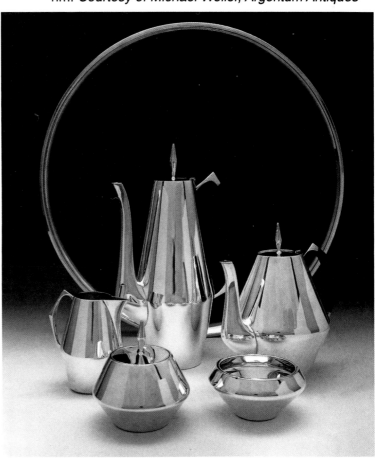

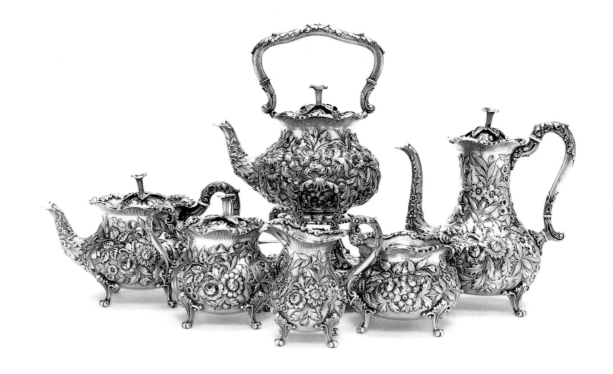

Figure 4.33
A six-piece tea set from circa 1927, made by S. Kirk and Son, Inc., of Baltimore, MD. The set contains a kettle on a lamp stand, coffee pot, tea pot, covered sugar bowl, cream pitcher, and waste bowl. It features floral finials, leaf-capped scrolled handles, and pyriform bodies on scroll supports. *Courtesy of Butterfield and Butterfield*

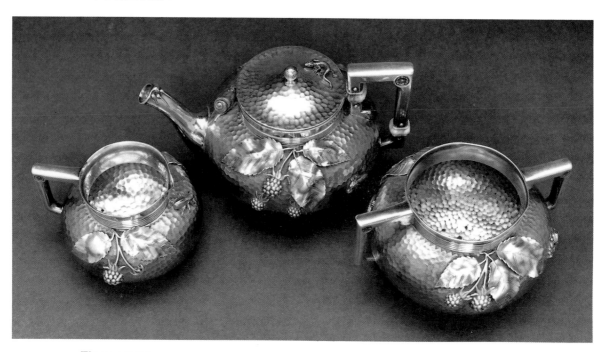

Figure 4.34
A three-piece bachelor's tea set in mixed metal. This Japanese style set is based on the Aesthetic taste, and was manufactured by Gorham in 1880. The height of the teapot is 3 1/2 inches. The set is composed of a teapot, open sugar bowl, and a cream pitcher. The surface is silver with a preened finish, covered with fruits, vines, berries and assorted insects and snails. The snail is visible just above the spout on the teapot. *Courtesy of Butterfield and Butterfield*

... coffee set with matching tray from Gorham, circa 1905. ... displayed against a preened finish. The tray is 16 1/4 ... nded ends that serve as handles. The coffee pot (with a ... sugar bowl, and the cream pitcher are all footed, urn- ... *y of Butterfield and Butterfield*

Figure 4.36
A six-piece tea set by S. Kirk and Son, in hand-chased sterling. The mark indicates that it was produced between 1903 and 1924. The teakettle and lamp stand is 13 1/2 are high. The pieces comprising this set show a range of forms, most with a pedestal base, a round, tall urn-shaped body, a domed lid covered with floral sprays, and an angular hollow handle with a ram's mask. Floral and landscape borders are embossed in the silver. *Courtesy of Butterfield and Butterfield*

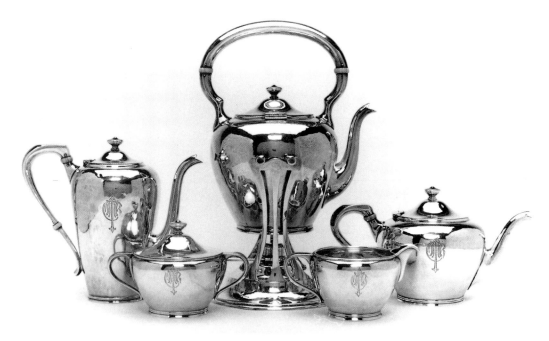

Figure 4.37 *(above)*
An important tea and coffee service, manufactured by Karl F. Leionen of Boston, Massachusetts. Leionen was in charge of the Handicraft Shop of the Boston Society of Arts and Crafts when it first opened in 1901. This set, with a stylized three-letter monogram, consists of a coffee pot, a tea pot, a creamer, a covered sugar bowl, and a kettle on a lamp stand. The pieces have C-scroll handles, knob finials on domed lids, and a canopic shape. *Courtesy of Butterfield and Butterfield*

Figure 4.38 *(below)*
This three-piece coffee set with tray was hand-chased. A special order set made by Gorham, it was retailed by Theodore B. Starr, New York. The coffeepot is 13 1/2 inches tall. All three pieces (coffee pot, creamer and sugar) have pedestal bases and urn forms that are chased with flowers and fruit. The tray is 21 1/2 inches in length. All four pieces weigh slightly over 137 ounces. *Courtesy of Butterfield and Butterfield*

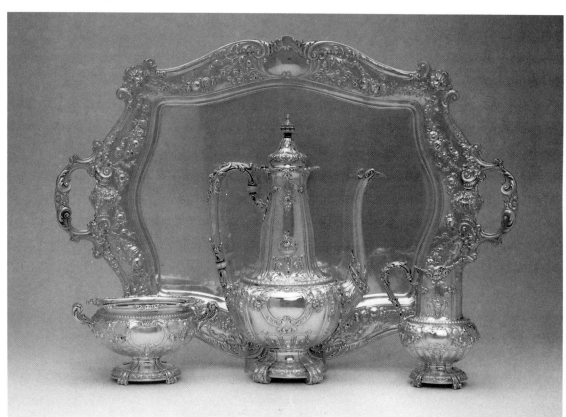

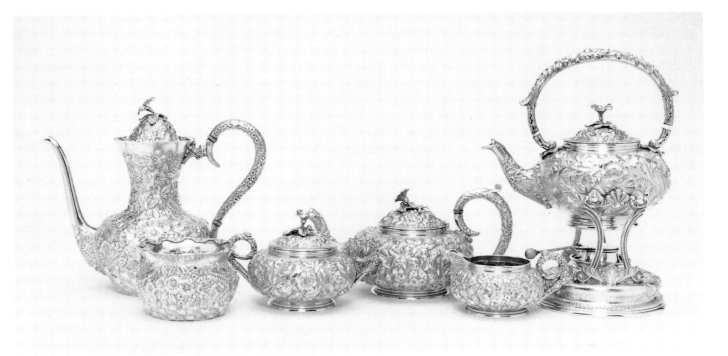

Figure 4.39 *(above)*
A Kirk *Repoussé* service, assembled from pieces made over several decades. The kettle on stand bears the 1903-24 factory stamp. The tea pot, sugar bowl and creamer are circa 1868-1898 and have a three-letter monogram on the base. The coffee pot and the waste bowl have a single monogram, which indicates that these two pieces were added at a later date. All the pieces are urn-shaped, and chased with flowers, leaves and ferns. The entire set weighs over 138 ounces. *Courtesy of Butterfield and Butterfield*

Figure 4.40 *(below)*
A five-piece set made by Clemens Fridell in Pasadena. The pieces are oval canopic form vessels that are ribbed at the corners. The pieces have angular handles and peaked lids with knob finials. The height of the pot is 9 1/2 inches. *Courtesy of Butterfield and Butterfield*

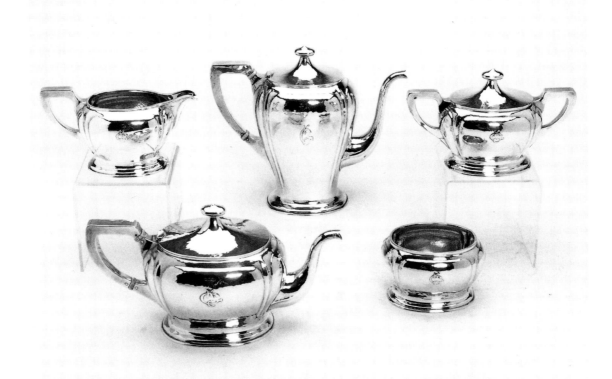

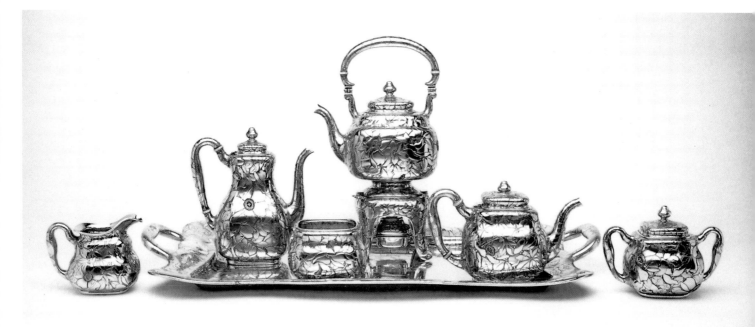

Figure 4.41 *(above)*
A truly one-of-a-kind set, made by Gorham during 1895 and 1896. All of the pieces were hand chased by Nicholas Heinzelman except the tray, which was chased by Christopher W. Clissold after Heinzelman's death. The vessels have a squared pyriform shape on plain collet bases with C-scroll handles. The design is foliate. All the visible surfaces are fully flat chased with a wild rose design in relief. The kettle is 14 1/2 inches high and the tray is approximately 29 inches in length.

In his book *Gorham Silver,* Charles Carpenter goes into some detail about Nicholas Heinzelman. In 1885, this craftsman came to the attention of Mr. Holbrook, the longtime president of Gorham. At that time, Heinzelman's habits were been well established and it was difficult for him to complete tasks for Gorham before "...he would wander off to saturate himself, as it were, with nature." The results of his inclinations are obvious in the details of his work; observers can see that the creator of this fabulous flat chasing had observed plants and foliage in great detail. Every vein and tendril is defined, and the shape of each leaf is clearly established. It is a shame that Heinzelman had not crossed paths with Gorham or some other silver firm at an earlier date. There are relatively few surviving examples of Heinzelman's outstanding work. This complete set is a monument to the man, as well as to Gorham and Holbrook. *Courtesy of Butterfield and Butterfield*

Figure 4.42 *(opposite page, top)*
A rare tea and coffee set, made even more so by the unusual use of three separate trays—one under each pot. The manufacturer was William Gale of New York, and the retailer was Ford and Tupper. The set was made circa 1868. The finely detailed hand engraving is beautifully executed on the surface of each piece. The edges of the trays have a narrow band of rolled decoration. Gale held a patent that involved the use of roller dies. This enabled Gale to manufacture silver flatware rapidly and in turn revolutionized the silver flatware manufacturing industry. Gale's son eventually controlled a firm that became Gale, Dominick and Haff. Later the firm was called Dominick and Haff, and became part of Reed and Barton in 1928. *Courtesy of Phyllis Tucker Antiques and Constantine Kollitus. Photography by Hal Lott*

Figure 4.43 *(opposite page, bottom)*
An early coin silver coffee set, made by Gorham circa 1860. The coffee pot was manufactured first, and bears the name "Adele" and the retailer's name, "J.W.Tucker, San Francisco." The sugar and creamer were added later to complete the coffee set. The three pieces weigh 73 ounces and the teapot is 9 3/4 inches high. *Courtesy of Constantine Kollitus*

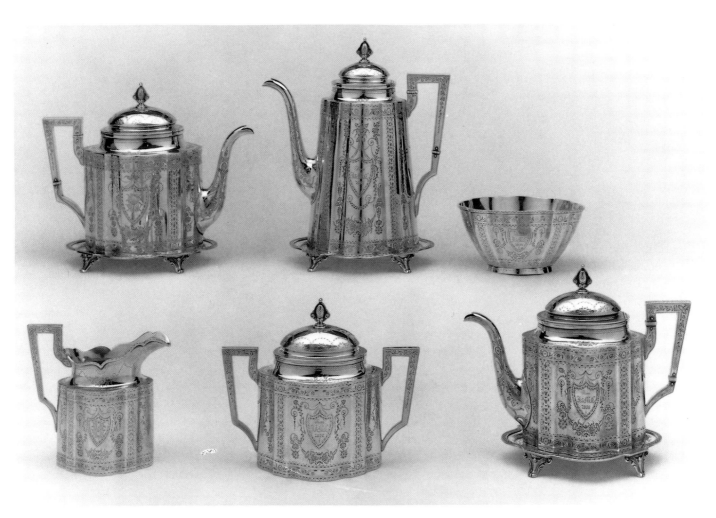

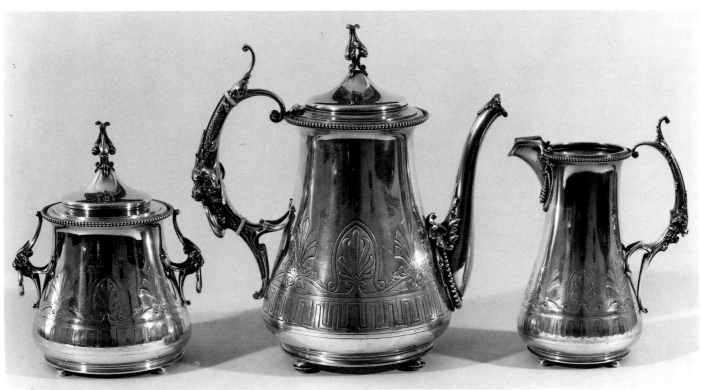

Chapter 5
Tea Items

Examples in this section will show a wide variety of tea-related items. They represent some of the many design motifs used by silver manufacturers over a long period of time.

The teakettle is one of the most impressive parts of a tea/coffee service. Although teakettles were readily available from various manufacturers, not every home had one, partly because they were costly. In addition, using a teakettle's lamp gives off a good amount of heat, most likely limiting the kettle's use to cold weather. Today, teakettles not only add an impressiveness and completeness to a tea/coffee set; they have actually become more necessary than ever, since few people employ hired help. Teakettles offer their owners freedom from returning to the kitchen to refill a teapot and waiting for the water to boil. Another advantage to using a teakettle is that individual guests can make their own selection from a variety of different teas, using additional silver items (such as tea balls, spoons with hinged lids, and tea strainers) to steep a single cup.

When tea was first introduced, it was stored in tea caddies, which were often locked because tea was (and continued for many years to be) so expensive. Most people who owned silver hollowware items also employed servants, whom some home-owners feared would steal the tea; as a result, the mistress of the house kept the key herself, hidden in a safe place. Some of the larger tea caddy containers had dividers, allowing the owner to keep more than one kind of tea separate in the same caddy. The tea caddy also allowed the owner to experiment with customized blends of tea, which they could prepare and store in the tea caddy. Silversmiths made some beautiful examples that can be collected today. This would be very interesting to do, and they are a pleasure to use.

A number of supplementary silver articles have been introduced to assist in the serving of tea—namely, the tea caddy spoon, the tea strainer, the tea ball, and the tea infuser. All of these items have places in the tea ceremony, and are delightful for consummate tea drinkers and silver connoisseurs alike. Examples of these various items will be found at the end of this section.

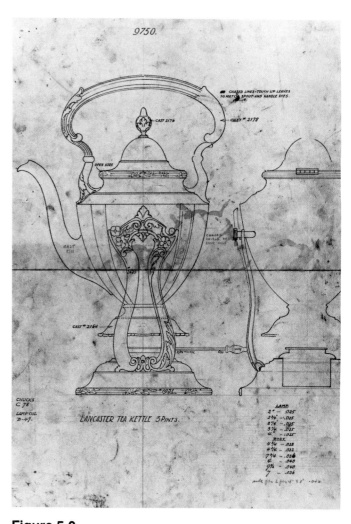

Figure 5.0
A working line drawing from Shreve and Company for their *Lancaster*-pattern tea kettle. The directions for the silversmith are noted with the various cast items on their drawing, number 9750. *Courtesy of Michael Weller, Argentum Antiques. Photograph by Tom Wachs*

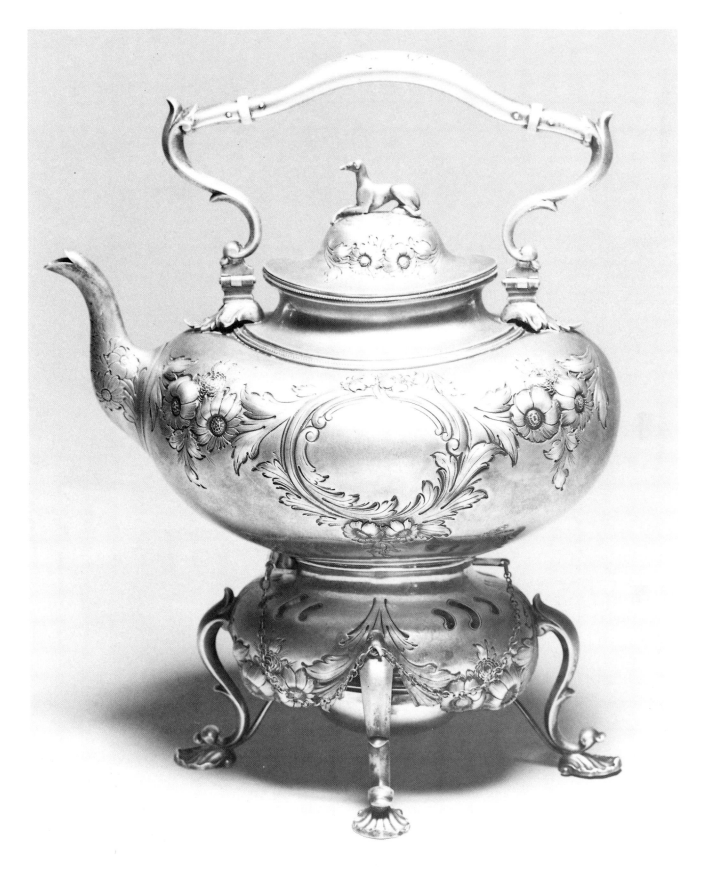

Figure 5.1
A teakettle designed by John Chandler Moore, typical of the Rococo style. Flowers and foliage are well dispersed over the surface of the pot. The finial is a reclining dog. Note the vents just above the heating element, spaced to allow air to enter and heat to escape. *Courtesy of Constantine Kollitus*

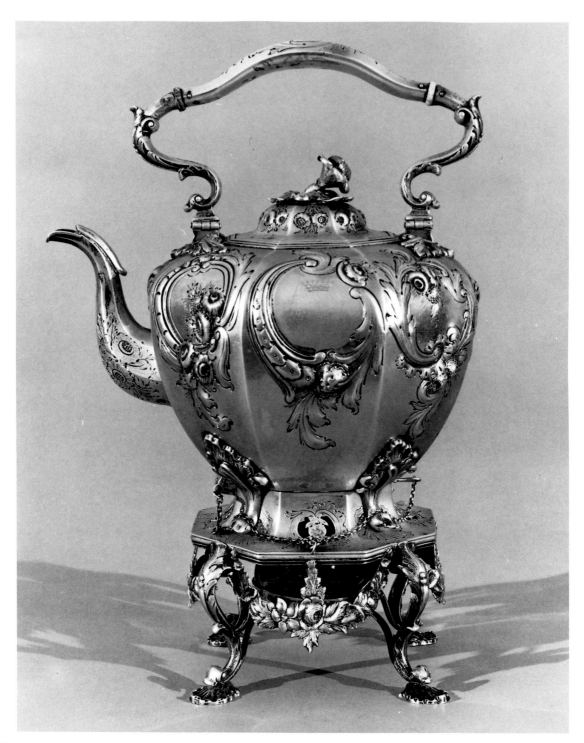

Figure 5.2

Another teakettle by Moore, circa 1841. It has even more flowers (interspersed with scrolls and leaves) than the kettle in Figure 5.1, and the finial is another beautiful flower. Many items made by Moore were sold by the leading jewelry firms of the period until 1851, when he began to supply Tiffany, Young and Ellis alone. According to Carpenter, Moore worked exclusively in hollowware for Tiffany for a short period of time until he retired later that year.

Upon retirement, Moore turned his shop over to his son, Edward C. Moore. Young Moore had apprenticed in his father's shop and knew every aspect of the silver trade. He soon began to develop exciting new designs which were made up to become part of Tiffany's stock. Moore holds the first patent for Tiffany flatware, and designed the flatware pattern *Japanese* (now known as *Audobon*). He was an innovator, responsible for many outstanding hollowware designs. His outstanding work helped make Tiffany the major silver dealer during his lifetime.

Edward C. Moore passed away in 1891. Today, some modern silver dealers feel that Tiffany's leadership in the silver market ended with Moore's death in 1891. Tiffany's never again quite held the status they had enjoyed under Moore. *Courtesy of Constantine Kollitus*

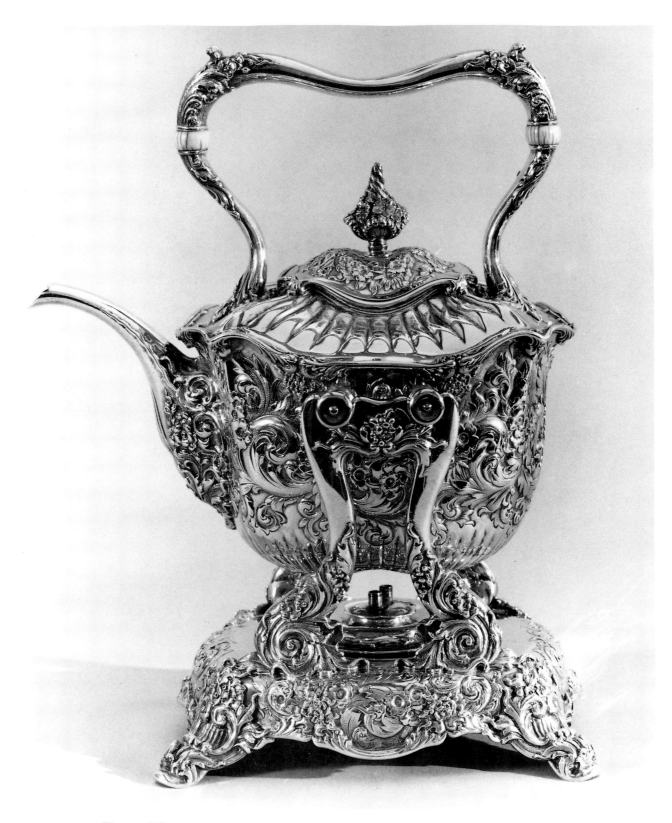

Figure 5.3
A magnificent kettle on a stand, circa 1885-1890. This is a truly fabulous inter-
pretation of repoussé work by Whiting Manufacturing Company. The ornate
repoussé work is enhanced with glimpses of a ribbed silver design (on the base
and on the area between the lid and the top of the pot), adding a refined subtlety.
The spout and handle each boast some repoussé work, but again the look and
feel of their unadorned expanses of silver add to the richness of the design. The
accompanying tea set is shown in Figure 4.14. *Courtesy Constantine Kollitus
and Phyllis Tucker Antiques*

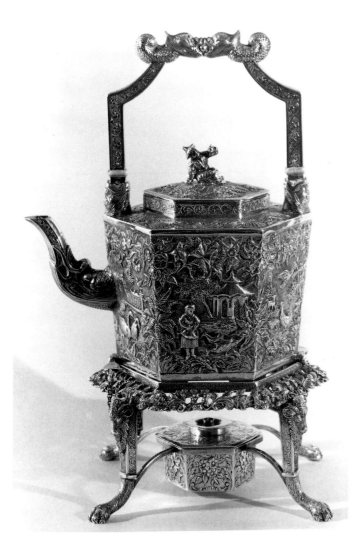

Figure 5.4
Kirk's chinoiserie kettle, circa 1880, a superb interpretation of Oriental design. The intricate work — from the paw feet to the oriental figure serving as a finial — speaks of Kirk's skill as a silversmith. The shape appears to be unique to this aspect of Kirk's work. *Courtesy of Constantine Kollitus*

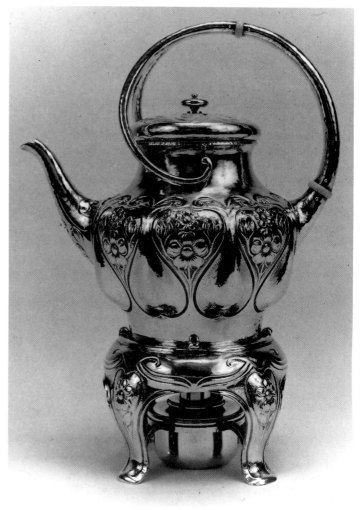

Figure 5.5
The example in Figure 5.5 by Gorham decorated with martelé gives another look at how inventive and creative the silversmith could be. This particular piece is date-marked 1897, except for the burner, which is marked for 1896. It would appear that this teakettle was one of the first examples of Gorham's martelé work. The handle rises from the pot and separates into two sections toward the front of the pot. The placement of the insulators help define the cool area of the unusual handle. Flowers worked within oval medallions help create an elegant example of Gorham's martelé. The designers use of medallions devoid of decorations between the sprays of flowers helps create eye appeal for the viewer. The pot is ten inches high and weighs 28.6 ounces. *Courtesy of Phyllis Tucker Antiques*

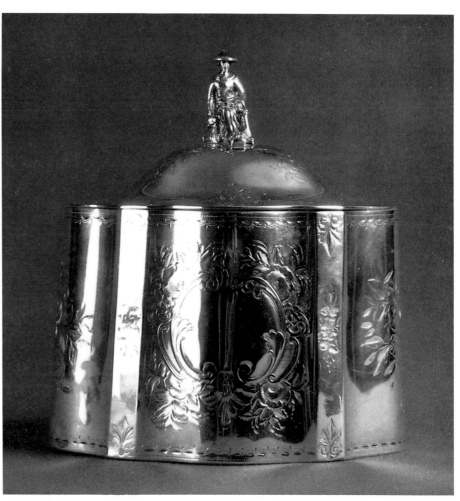

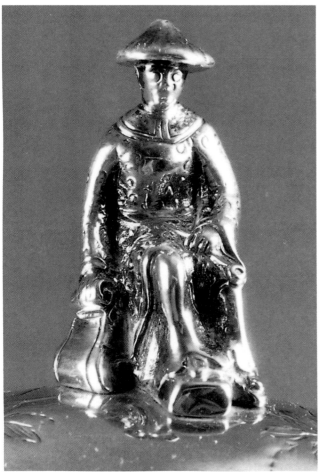

Figures 5.6 and 5.7
A tea caddy sold by Ball, Black, and Company, 950 silver. The undulating sides of the caddy are decorated with delicate engravings of flowers and scrolls. The finial of this excellent example is unique, an oriental figure perhaps intended to evoke tea's Chinese origin. *Courtesy of Sherry Langrock, Silver Crest Antiques. Photography by Debbie Cartwright*

Figure 5.8 *(right)*
A fine example of repoussé, very similar to Kirk's work but marked "Hodgson, Kennard & Co., Boston." No other reference to the name Hodgson has yet been located, but the name Kennard represents a number of firms operating in Boston during the 1870s, finally sold to Gorham in 1880 (Rainwater). The square caddy stands 4 3/8 inches high. *Courtesy of Constantine Kollitus and Phyllis Tucker Antiques*

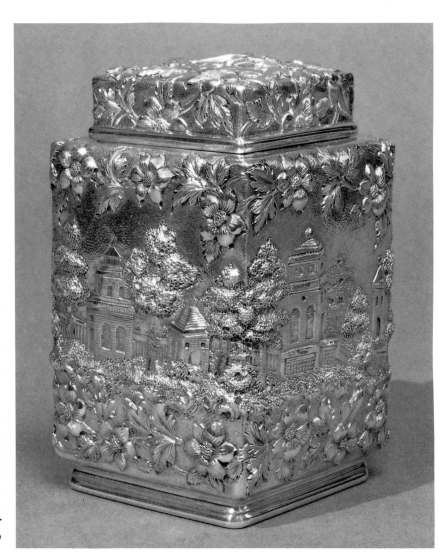

Figure 5.9 *(below)*
A collection of three important tea caddies manufactured between circa 1850 to 1910. The caddy on the left was retailed by Shreve, Crump and Low. It is marked "sterling silver," so it must have been made after 1868. The middle caddy was made by the Alvin Manufacturing Company and was retailed by Theodore Starr of New York. The decorations are not heavy or overdone but suggest a slight Rococo influence. The caddy on the right was made and sold by Howard and Company of New York. This caddy's oval shape and reeded sides suggest a classical affiliation. The finial echoes the design on the caddy's sides. *Courtesy S. Langrock, Silver Crest Antiques. Photography by Debbie Cartwright*

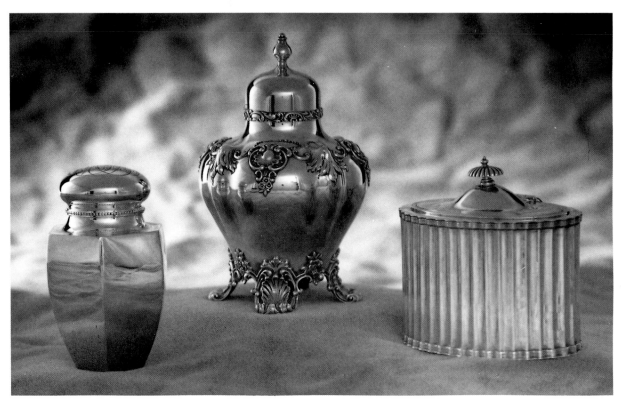

116

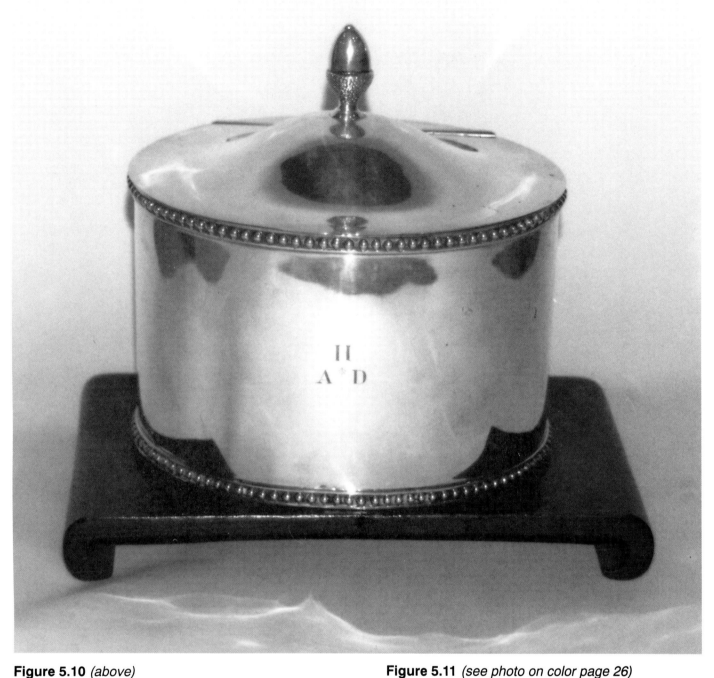

Figure 5.10 *(above)*
A tea caddy manufactured by Jones, Poor and Ball in Boston between 1846 and 1853. The listing of the name in Charles L. Venable's text is "Jones, Ball and Poor." Perhaps the names of the firm's owners were on separate die stamps and the worker responsible for marking this caddy picked them up in the wrong order. Eventually the Jones, Ball and Poor firm became known as Shreve, Crump and Low, which is still in business today. An unusual feature of this particular caddy is a divider which separates the caddy into two even parts. This allows the owner to store two different types of tea. Hypothetically, a tea connoiseur could make a personal blend using tea stored in each side. The beading at the bottom and top of the caddy add detail to the plain surface. The acorn finial and the beading at the top and bottom edges add distinction to the tea caddy. *Courtesy of Maxine Klaput Antiques*

Figure 5.11 *(see photo on color page 26)*
Two tea caddies. On the left, with the lid off and a caddy spoon in the tea, is a caddy made by Tiffany and Company and sold in 1938. This item is 3 13/16 inches high and matches the muffineer in Figure 16.11. On the right is an example of Kirk's *Repoussé,* made between 1907 and 1924. It is 3 19/32 inches tall. The teacup is in the *Morning Glory* pattern by Herend. The teapot is a small example of Gorham's *Plymouth* with an ebony handle and ebony finial. This pot is resting on the *Plymouth* tray from the sauceboat in Figure 15.4. Frequently early tea pots and coffee pots (see Figure 4.42) had separate trays, which served to protect the tabletop.

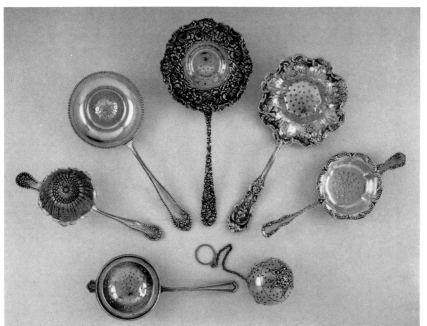

Figure 5.12a
A selection of tea strainers and a single tea ball. The row (in an arc) contains the following tea strainers: two by Gorham in the *Lancaster* pattern, 5 13/16 inches and 6 3/4 inches long; Stieff's *Chrysanthemum,* 7 3/4 inches; Reed and Barton's *Francis I,* 7 1/16 inches; and Whiting's *Louis XV,* 6 inches. On the bottom row is a tea strainer by an unknown manufacturer in an unknown pattern, 5 11/16 inches long, and an unmarked sterling tea ball, approximately 1/3/4 inches in diameter.

Figure 5.12b
Three tea ball spoons, sometimes known as 'infusers'. At the left is Gorham's *Lancaster,* 5 1/2 inches long. Note that this piece appears to be made up, rather than an original Gorham product; a sterling handle has been applied to a tea ball, which appears to be silver-plated. In the center is Tiffany's *Wave Edge* tea ball spoon, 5 15/16 inches long. At the right is a tea ball spoon by Paye and Baker in an unknown pattern, made before 1920, 5 3/8 inches long.

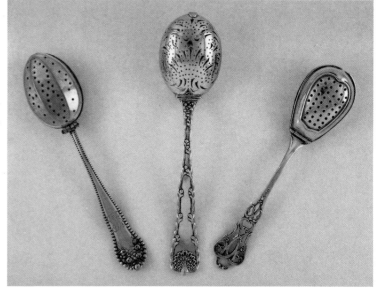

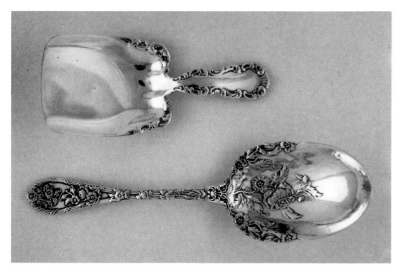

Figure 5.12c
Two tea caddy spoons. The top spoon is Whiting's *Louis XV,* 3 1/4 inches long. The bottom spoon is Durgin's *Dauphin,* 4 15/16 inches long.

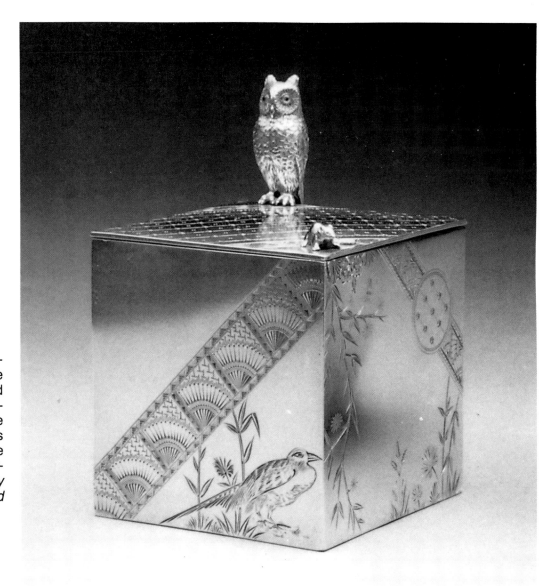

Figure 5.13
A fine tea caddy in the Aesthetic style, made by the Boston company Kennard and Jenks in 1871. The intricate design work on the sides of the square caddy is topped by an owl finial. The top of the box is also covered with designs. *Courtesy of Butterfield and Butterfield*

Figure 5.14 *(see photo on color page 29)*
An unusual tea caddy, circa 1883, completely covered with leaves and insects moving between the leaves. It was modeled and chased by Gorham to imitate a Japanese wine jar wrapped with straw. Notice the small silver dragon trapped in the wrapping and the crab perched on the lid. *Courtesy of Phyllis Tucker Antiques*

Figure 5.15 *(see photo on color page 29)*
An early repoussé tea caddy covered with ferns, foliage, and flowers. This example of Kirk's work dates from 1895. *Courtesy of Phyllis Tucker Antiques*

Figure 5.16 *(see photo on color page 29)*
A tea caddy by Vanderslice and Company, with a unique oriental figure. The engraved design accents the piece. *Courtesy of Michael Weller, Argentum Antiques*

Figure 5.17 *(see photo on color page 30)*
Three tea caddy boxes — but not all are tea caddies! The center item is actually an ink well, made by Tiffany. The caddy on the left is by Gorham and the caddy on the right is by Whiting. Both are in the Japanese style. *Courtesy of Michael Weller, Argentum Antiques*

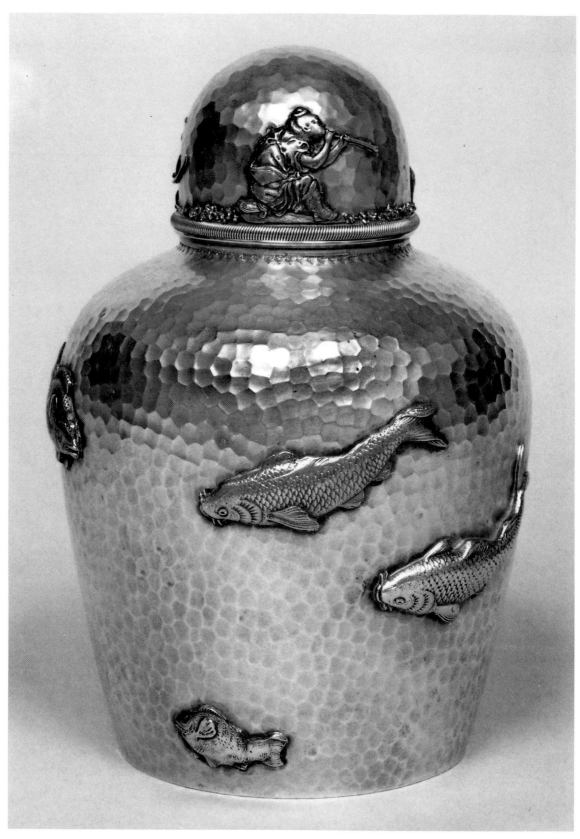

Figures 5.18 and 5.19 *(see color page 30 for 5.19)*
A Gorham tea caddy in mixed metals, made circa 1880. The fine details of the
applied metal fish and of the figures on the lid are excellent examples of the
Aesthetic style. *Courtesy of Constantine Kollitus*

Chapter 6
Centerpieces and Epergnes

Centerpieces come in a variety of sizes and styles, from unassuming to grandiose. Through the years, the attention paid by silversmiths to these forms have granted centerpieces a significance that is unparalleled in the world of hollowware. Most centerpieces are basically decorative, intended as finishing touches to grace the dining experience.

The "epergne" form usually has a large bowl at the top center of a grand frame, and is surrounded by a multitude of smaller containers branching out from the central container. The small containers may be made of silver or crystal.

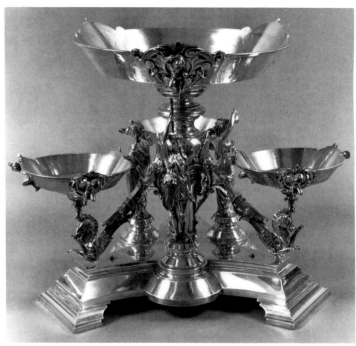

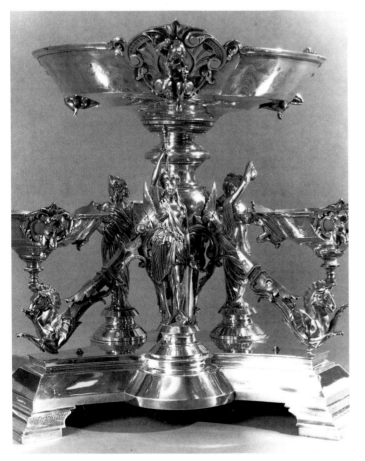

Figure 6.1a and 6.1b
An amazing coin silver epergne, made by William Bogart circa 1865. The beautifully cast classical figures are combined with horses and smaller bowls to create a masterpiece. This piece is 16 1/2 inches high and approximately 19 inches on a triangular dimension. The weight of the piece is an impressive 316 ounces. Bogart was an amazing and important silversmith, and his work requires further study. Pieces made by him would certainly be significant additions to any American coin silver collection. Much of his work was sold to large New York jewelers. *Courtesy of Constantine Kollitus*

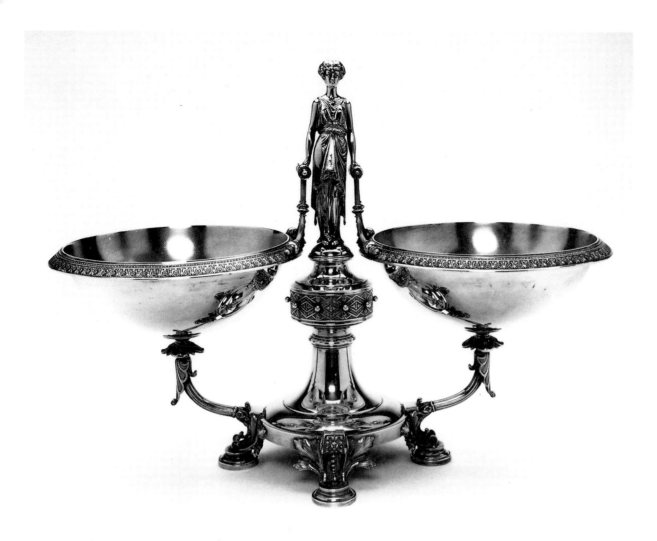

Figure 6.2 *(above)*
An important centerpiece, made circa 1865 to 1870. This item must have been made from silver from the Comstock Lode, judging from the retailer's mark, "M. M. Frederick, Virginia City, Nevada." The classical figure at the center appears to support to two large round bowls, which are edged with a rolled design. Each bowl is supported by a single silver mount that rises from one of the two side legs. The other two legs, at the front and back of the base, provide balance. The centerpiece stands 15 1/2 inches high. *Courtesy of Butterfield and Butterfield*

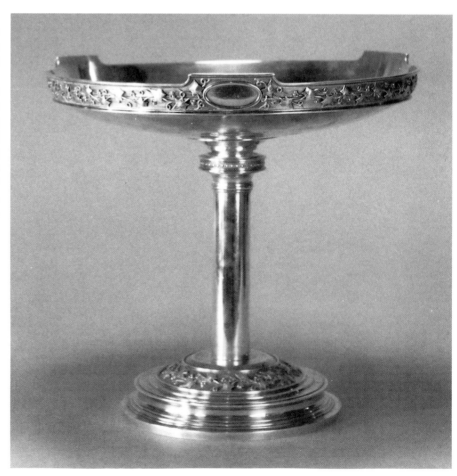

Figure 6.3 *(right)*
A centerpiece made by Gale, Dominick and Haff in New York, circa 1879. It is 11 inches tall and 12 inches wide. The base of the centerpiece has concentric rings and a border of ivy leaves and scrolls. The top has three cartouche areas for inserting monograms. *Courtesy of Michael A. Merrill, Inc., Baltimore, MD*

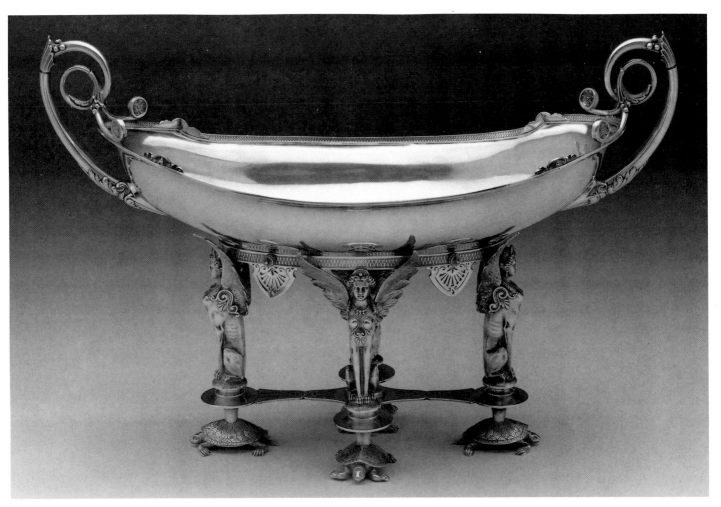

Figure 6.4
A large centerpiece by Gorham, circa 1869, in the Greek Revival style. The turtle feet support winged figures, which rise up to the underside of the oval bowl. The very bottom of the bowl is decorated with an applied edge, along which four classic Greek palmette designs are attached, one between each set of columns. The bowl and the base can be separated, and these same four palmettes form a new base The handles rise from the lower portion of the oval bowl and gently twist to connect at the top of the bowl. Acanthus leaves and berries appear on portions of the handles. The top border of the bowl is edged with a narrow design. *Courtesy of Michael Weller, Argentum Antiques*

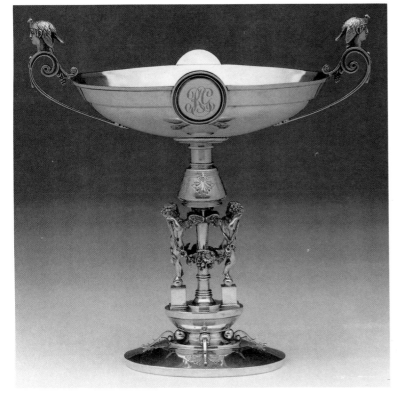

Figure 6.5
A centerpiece retailed by Ball, Black and Company, circa 1860s. The round base has four attached areas that help focus the eye on the thematic central shaft, two cherubic figures holding garlands. The shaft continues upward with an engraved design, and then joins the round central bowl. The bowl itself has a round cartouche for a monogram on opposite sides, which conspire with the handles to divide the bowl into quarters. The handles rise from the bottom of the bowl in gentle curves. Atop each is a classical mask, enriched with engraved designs. *Courtesy of Michael Weller, Argentum Antiques*

123

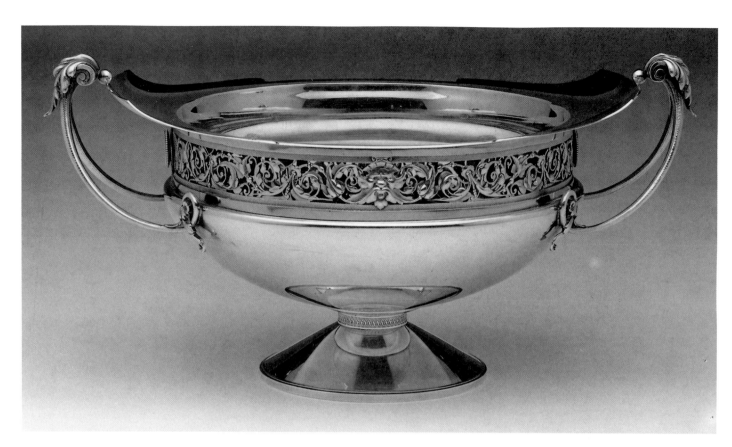

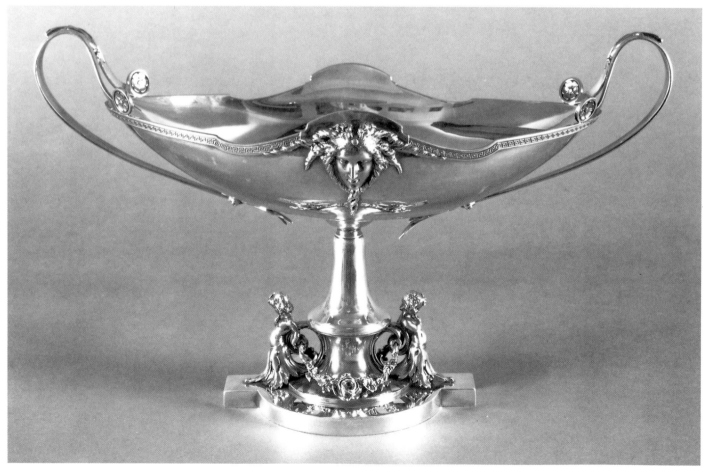

Figure 6.6 *(opposite page, above)*
A unique and very interesting Gorham centerpiece, in the form of a Kylix (a shallow, two-handled bowl often set on a footed stem), circa 1873. The piece is simple yet elegant. The acanthus leaf at the top of the handles contains fine detailing, as does the pierced inserted border. A gentle design separates the top of the base from the bottom of the central bowl. Interestingly, the handles can be removed by turning two set screws that are located in the interior of the bowl. Then the central border can be lifted out for cleaning. *Courtesy of Michael Weller, Argentum Antiques*

Figure 6.7 *(opposite page, below)*
A centerpiece probably made by Gorham, and sold by Shreve, Stanwood and Company of Boston, c. 1865. On page 53 of Carpenter's book *Gorham Silver,* a centerpiece is shown with a very similar central head, though the shape of the bowl and the base are different. What this does seem to show is that silversmiths had the ability to take part of one piece and add it to a different piece. The entire piece was not formed at one time. The overall length of this piece is 16 3/4 inches. The cast figures at the base add interest. There are paternae on this piece as well. The delicate rolled border applied to the top edge of the bowl is a variation from the example in Carpenter's book, which features a Greek Key border. *Courtesy of Constantine Kollitus*

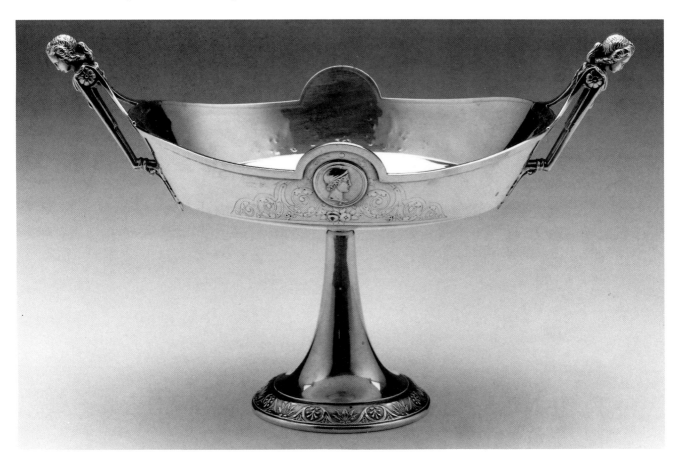

Figure 6.8
A Gorham interpretation of a Medallion Centerpiece, circa 1865 to 1868. The base has a repetitive Grecian design from which the shaft rises to a round bowl. The bowl is sectioned into four equal parts for the handles and medallions, which are on opposite sides. The handles have a cast figure at their apex. The medallion has a Grecian head in its center. *Courtesy of Michael Weller, Argentum Antiques*

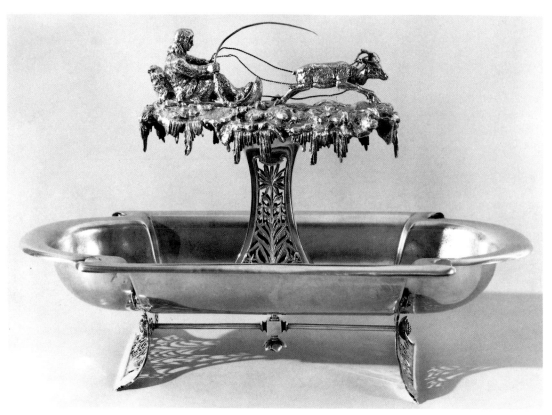

Figure 6.9
A large Gorham center-piece made circa 1867, 16 1/2 inches long and 11 inches high, from the Sam Wagstaff collection. Close examination shows that the piece easily comes apart for cleaning. The silver screws on the bottom of the center allow the figural part to be removed. The end supports, or base sections, are beautifully pierced to match the central support. This piece is truly magnificent and would make a tremendous statement on any Victorian table large enough to display it properly. This piece of silver is representative of many items made by some dealers to commemorate the purchase of Alaska, as part of the "Alaska Movement." This particular piece could serve as a large ice bowl. *Courtesy Constantine Kollitus*

Figure 6.10
An Egyptian Revival style centerpiece made in sterling silver and crystal by Gale, Dominick and Haff, circa 1872 to 1876. The sterling base features pawed feet underneath the cast female heads, with engraved papyrus on the side of the base as well as on the side of the crystal insert. There appear to be six figures on the sterling silver bottom. Five winged sterling figures in the center provide support for the magnificent crystal vase. *Courtesy Constantine Kollitus*

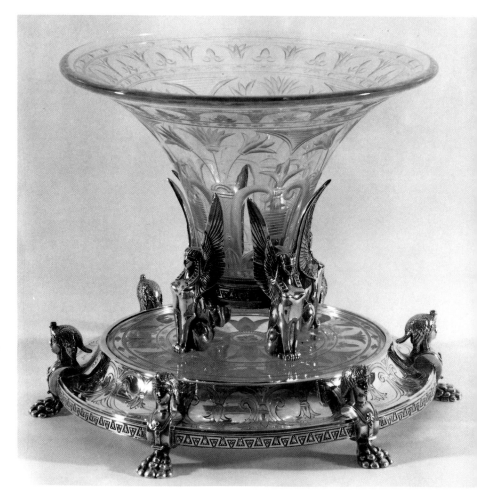

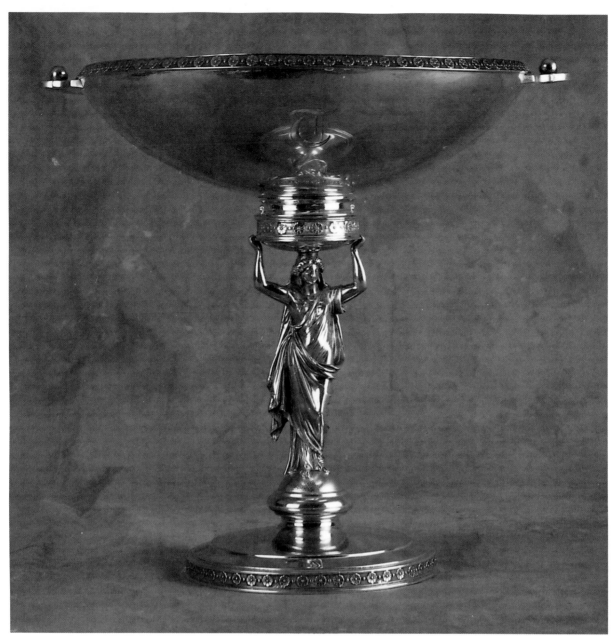

Figure 6.11 *(above)*
A silver centerpiece retailed by Ball, Black and Company which appears to be circa 1860. The design around the base lends weight to the form, and the cast figure is very well done. The height of this piece is 11 1/4 inches, and the bowl measures 10 1/8 inches across. The marks are attributed to Wendt, and read "English Sterling." Wendt was one of the companies that was supplying large retailers like Tiffany's, though he was not exclusive to them. Some American customers wanted to purchase only silver that was of sterling grade, and preferred the reputation of English-made wares. American jewelers and silversmiths got wise, and began to mark their pieces "English Sterling" to signify that they maintained the .925 English standard. In 1868 the mark became just "Sterling." *Courtesy of Sherry Langrock, Silver Crest Antiques. Photography by Debbie Cartwright*

Figure 6.12 *(see photo on color page 31)*
A Gorham centerpiece from the 1860s, very typical for the period. The base gives stability to the central figure, which in turn supports the large central bowl. The handles in the form of birds are unusual. The width of the base and the top rim of the bowl have a band of design. *Courtesy of Silver Magazine, Connie and Bill McNalley*

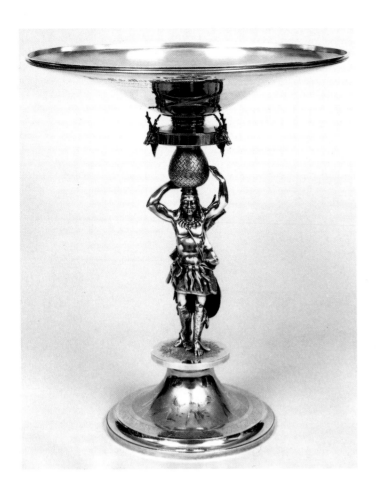

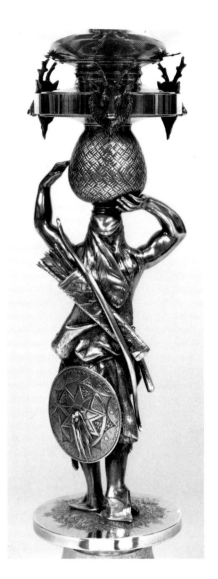

Figures 6.13a, b, c

A Gorham centerpiece or fruit stand made circa 1868 in sterling silver. The use of an Indian motif in sterling is not usually seen during this time period. The Indian balances a woven basket on his head. The fine details seen in the figures show the patience and time Gorham silversmiths spent in creating this masterpiece. On the upper surface is the following inscription: "John B. and Mary E. Gough, Worchester, Nov. 24, 1868, From Their Neighbors and Friends." Mr. Gough was active in the Temperance Movement. This centerpiece is 19 inches high, and the diameter of the top is 16 inches. The entire piece weighs 109 ounces. *Courtesy of Constantine Kollitus*

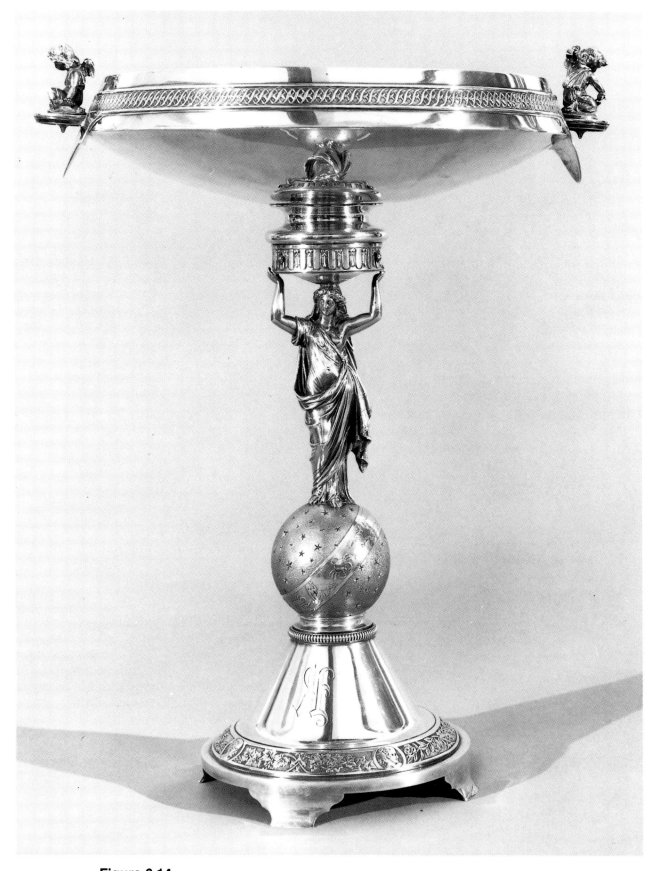

Figure 6.14
A fruit stand or centerpiece made by Gorham, circa 1880. The base design
incorporates ivy leaves and cameos. This may have been made to accompany
Gorham's *Ivy* pattern flatware. *Courtesy of Constantine Kollitus and Phyllis
Tucker Antiques*

Chapter 7
Tazzas, Compotes, & Cake Baskets

Three significant types of dessert servers are tazzas, compotes, and cake baskets, all of which could be used after dinner or at a tea table. A tazza is a flat tray or shallow dish on a stand. Aside from its usefulness as a dessert server, the tazza is perfect for displaying an arrangement of flowers or a plant in a container. The compote is deeper — usually characterized as a bowl on a pedestal — and can hold a larger variety of items, including fruit displays. Decorations may be applied or engraved on these items, and some are even heavily pierced. Cake baskets, as the name implies, were produced to serve cake. A basket can be round, oval, or square with rounded corners, and can be pierced or unpierced. It almost always has a handle. It may have a pedestal-shaped foot, or four small feet at the corners of the piece. They can easily be used as centerpieces for holding flowers, provided the basket is not pierced. Victorian brides viewed the cake basket much as today's bride looks at yet another toaster or blender. The wide variety shown here illustrates how the designs for cake baskets have changed over the past one hundred and fifty years.

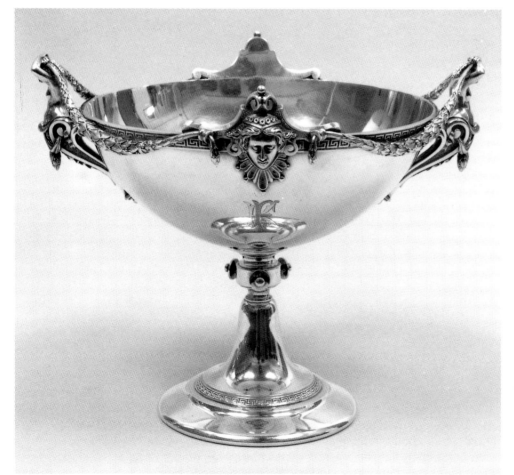

Figure 7.1
A Bogart compote produced for Tiffany, dating from circa 1866. It is 9 1/2 inches high and weighs 40 ounces. The center of the round base has a Greek key design, from which a shaft slowly rises to attach to the round center bowl. The handles not seem as functional as those in other examples. There is a face attached on opposite sides of the bowl. Beginning at the handles and extending almost to the face area are gracefully flowing garlands of small leaves, a very classical touch. A monogram is located below one of the faces. This attests to the quality of Bogart's work for Tiffany. *Courtesy of Constantine Kollitus*

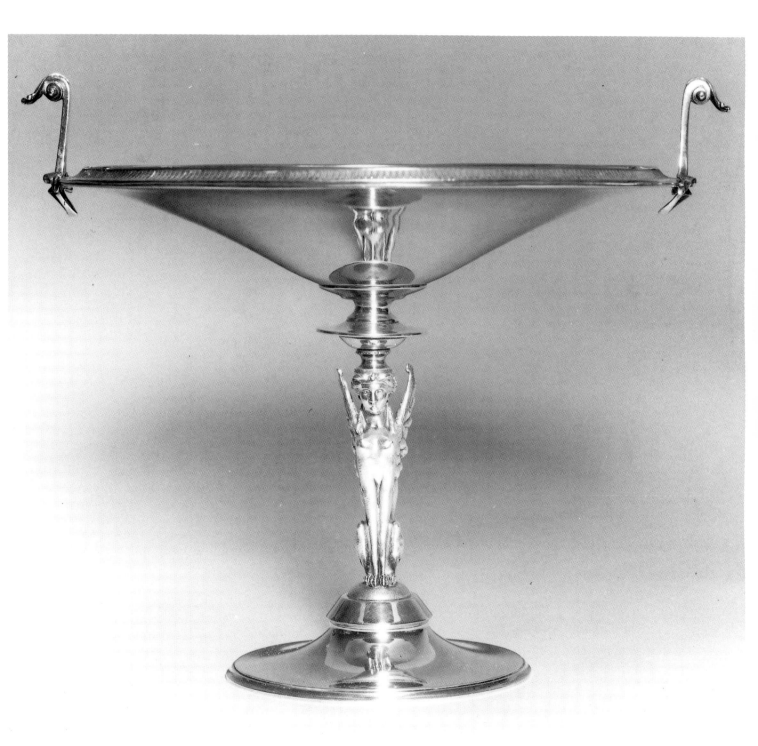

Figure 7.2
A Gorham compote, circa 1860s, exemplifying the Egyptian Revival style. The base is round and supports a single Ionian sphinx figure. The compote has a rim with decoration and small handles. *Courtesy of Constantine Kollitus*

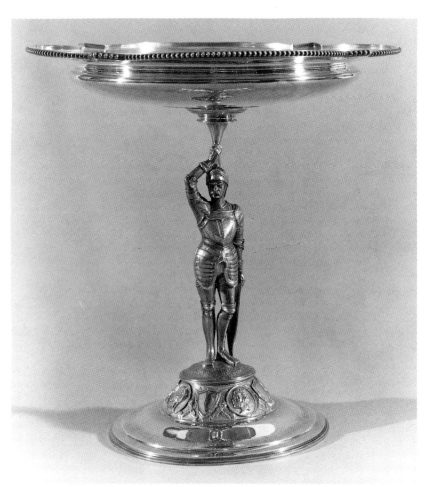

Figures 7.3 & 7.4
Two tazzas by Whiting, manufactured circa 1870. The figures — one a knight, the other a young man — support shallow bowls, which have strong beaded edges. The crisp detail in each of the figures shows tremendous workmanship. Each shallow circular base has a frieze of profiles and trophies. These tazzas stand 12 inches tall. *Courtesy of Constantine Kollitus*

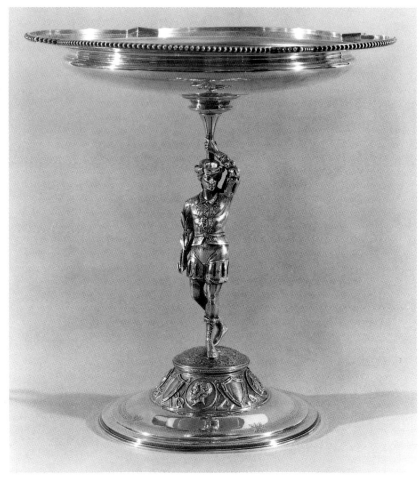

Figure 7.5 *(right)*
A hand-hammered Shreve compote. The round bowl is 5 inches in diameter, with handles measuring 7 5/8 inches across. The piece stands 6 3/8 inches high with a base of 3 3/4 inches, and weighs 13.22 ounces. *Courtesy of Sherry Langrock, Silver Crest Antiques. Photography by Debbie Cartwright*

Figure 7.6 *(below)*
A pair of compotes sold by Cartier, and made by the Lebkuecher & Company of Newark, New Jersey. According to Rainwater, this firm was in operation from 1896 to 1909. The design is surprisingly plain, considering that Art Nouveau and Colonial Revival styles that were beginning to sweep the country at the time; these compotes are classics in their interpretation. The gauge of the silver used to make these compotes was very heavy. *Courtesy of Maxine Klaput Antiques*

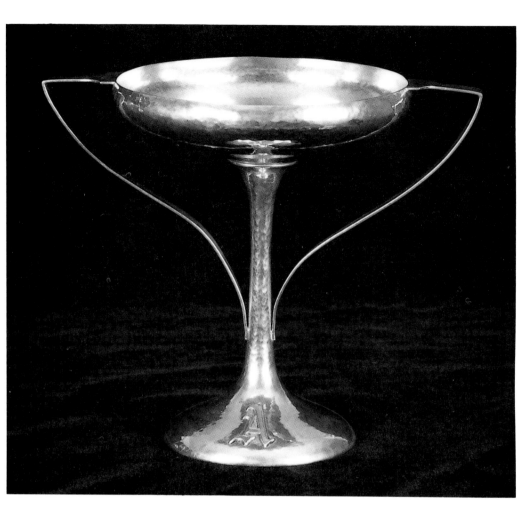

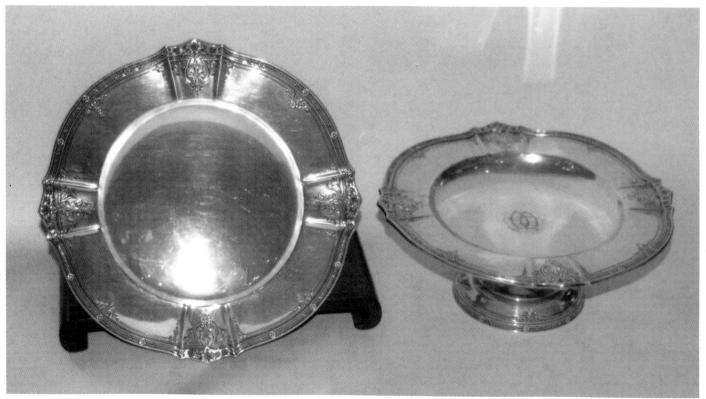

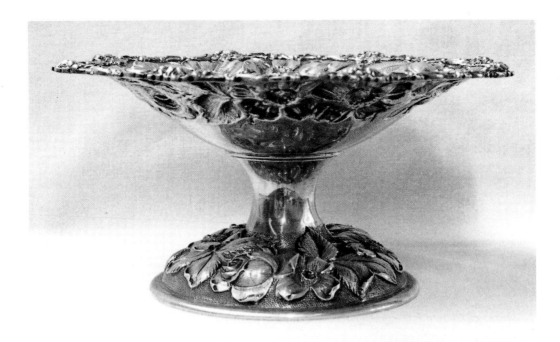

Figures 7.7 & 7.8
An exquisitely detailed compote by Stieff, showing that company's craftsmanship at its very best. Each flower reveals the craftman's attention to detail. Notice how the two roses and the large daisy chrysanthemum that appear on the top rim are incorporated into the design. Small flowers dispersed with delicate scrolls appear on portions of the rim to make for an interesting pattern. The pedestal base is equally well-done. *Courtesy of Silver Magazine, Connie and Bill McNalley*

Figure 7.9
A square compote with a diapered center, by Jacoby and Jenkins of Baltimore, Maryland. It was made in the period between 1894 and 1908. The rounded corners feature delicate ferns; a group of buttercup-type flowers is centered between the ferns on the border. The buttercup flowers have been formed to show each petal, the centers, and the radiating lines with great detail. The smaller flowers, daisy-shaped or stylized forget-me-nots, are shown with a wide variety fo leaves over the remainder of the border. The square base, which is very unusual, is formed from four overlapping leaves.

Figure 7.10 (above)
A pair of compotes in the *Leamington* pattern by Gorham, made in 1933. They are very substantial in weight, and the ribbed design is flawlessly executed. At one time Gorham produced a number of sterling items in this pattern. *Courtesy of Maxine Klaput Antiques*

Figure 7.11 (below)
A new *Repoussé* compote by Kirk. It is sterling with a filled base, so an exact silver weight cannot be obtained. The piece is, of course, machine-made and stamped. It is 7 3/8 inches in diameter and bears the number 103 on its base. This piece doesn't compare to the handwork in other Kirk or Jacobi pieces, but the cost of hand labor today is prohibitively high, assuming one could find a craftsman with the skill to do the work.

Figure 7.12
(see photo on color page 32)
A square Gorham compote with the 1880 date mark on it. It measures 7 11/16 inches square and 4 7/8 inches high. This piece is very different from the many other Gorham pieces of the time period shown in this book; the piece was made for those customers not interested in purchasing the most popular designs. The scrolled border is very elegant, and quite unusual. Since Gorham was so much into the Japanese movement when this particular piece was made, it shows that they were trying to have a line of products for every desire.

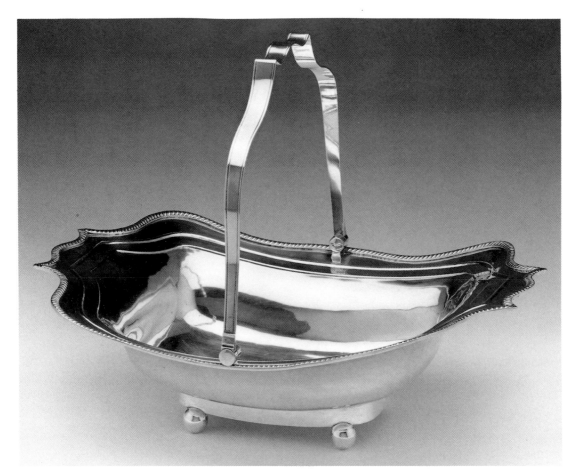

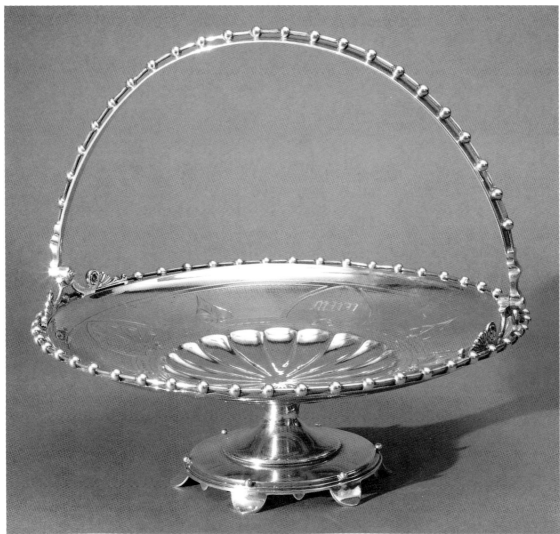

136

Figure 7.13 *(opposite page, top)*
A Federal style cake basket producd by Liberty Brown and William Seal of Philadelphia in 1810. The basket is approximately 12 inches by 9 inches. It rests on ball feet, and has a swinging handle with a pleasing bent area that would assist in passing the basket. There is a delicate gadroon border on the rim of the basket. On the two narrow sides of the basket, the rim is extended to form side handles. *Courtesy of Michael Weller, Argentum Antiques*

Figure 7.14 *(opposite page, bottom)*
A coin silver cake basket by Gorham, circa 1860, approximately 10 inches in diameter and 9 inches high. The movable handle features an unusual pattern of large, equidistant beads. These beads, in addition to some engraving, also decorate the round edge of the basket itself. The base is a pedestal with six tab feet, and the center of the basket is fluted. *Courtesy of Constantine Kollitus*

Figure 7.15 *(below)*
A repousséd cake basket by Kirk, typical of their style. This item appears in the company's 1914 catalog reproduction from Michael Merrill. The center of this basket is plain, as is the round shaft where the base joins the top. The the rest is filled flowers and foliage typical in repousséd hollowware. Similar items were sold by Stieff as flower and fruit baskets in their 1920 catalog. *Courtesy of Constantine Kollitus*

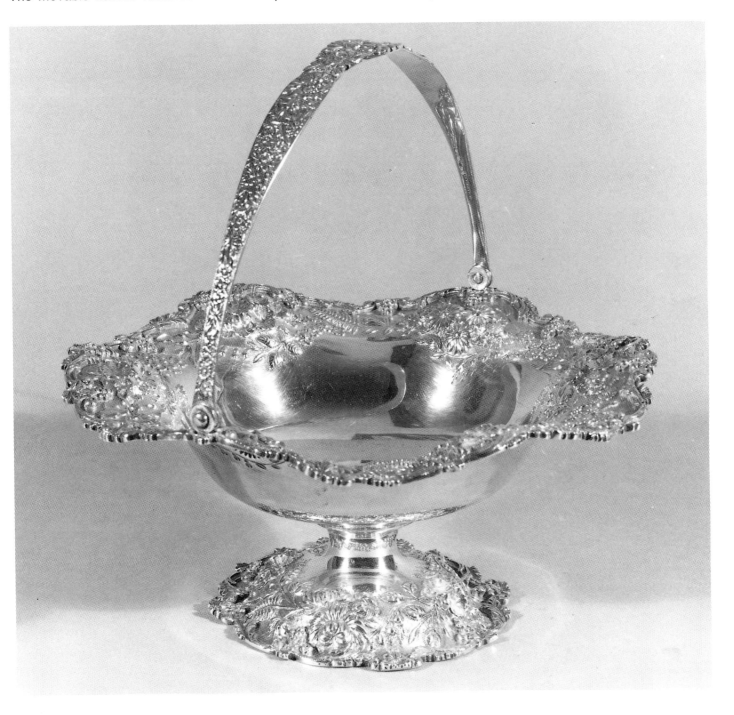

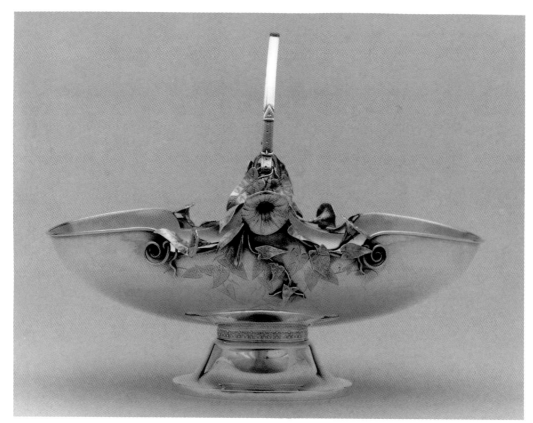

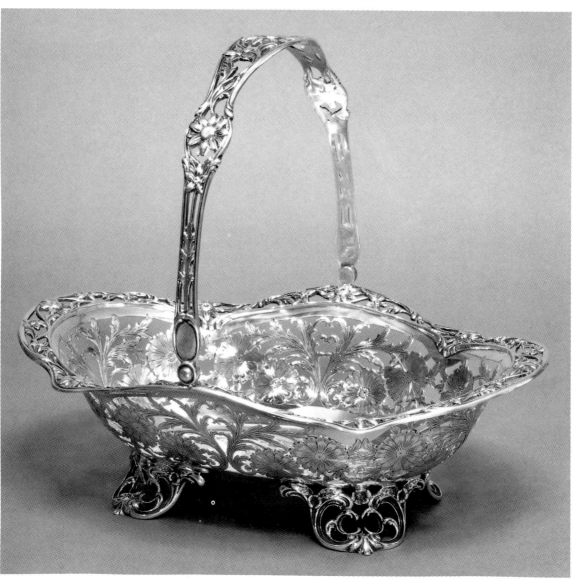

138

Figure 7.16 *(opposite page, top)*
A fabulous Gorham cake basket, made in 1872. The basket and base are both oval, with a fixed bale handle. The rim is trimmed with an applied wire, and a fully modeled morning glory is placed where the handle joins the basket. Applied morning glory leaves and tendrils surround the flower and engraved leaves fill parts of the basket's sides. The handle is formed as a strap with buckles and is looped through the detached tendrils. The top of the foot has a narrow die-rolled band. The interior of the basket is matte and gilded. The length of this cake basket is 11 1/2 inches. *Courtesy of Phyllis Tucker Antiques*

Figure 7.17 *(opposite page, bottom)*
A cake basket made by the Roger Williams Silver Company of Providence Rhode Island, circa 1901. It measures 14 inches long and weighs 41 ounces. The very elaborate, all-over piercing attests to the ability of the workers. The flowers and engraving add depth and dimension, while the very interesting pierced edge continues the floral tradition. Even the feet have flowers and tendrils. The pleasing handle is highly pierced with occasional flowers and leaves along its width. *Courtesy of Constantine Kollitus*

Figures 7.18a, b *(below; see detail on page 32)*
A cake basket attributed to Wendt, and sold by Ball, Black and Co., circa 1860s. This cake basket is marked "English Sterling" and features a pedestal base and a movable handle. It is 13 1/2 inches across from medallion to medallion, 4 inches from the base to the surface of the plate and 9 3/4 inches from the base to the top with the handle extended. The very fine work of the silversmith is evident in the detail of the handle medallion. *Courtesy of Sherry Langrock, Silver Crest Antiques. Photography by Debbie Cartwright*

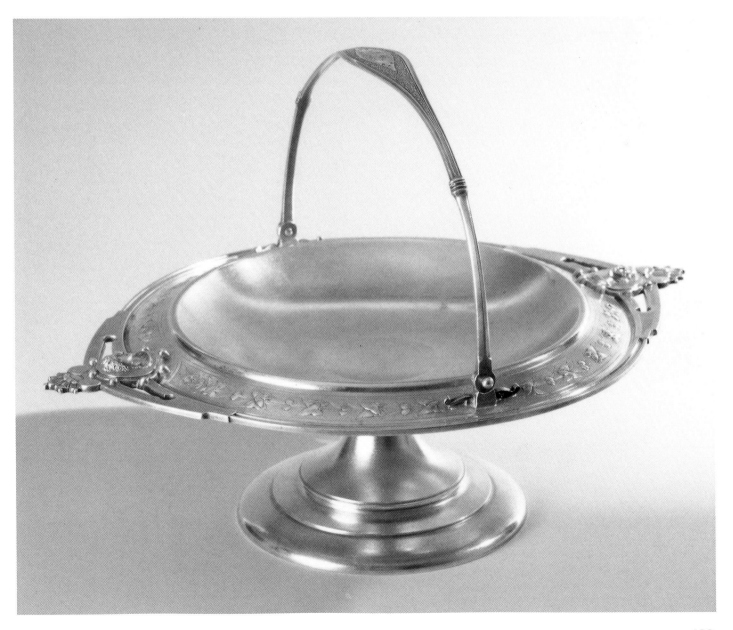

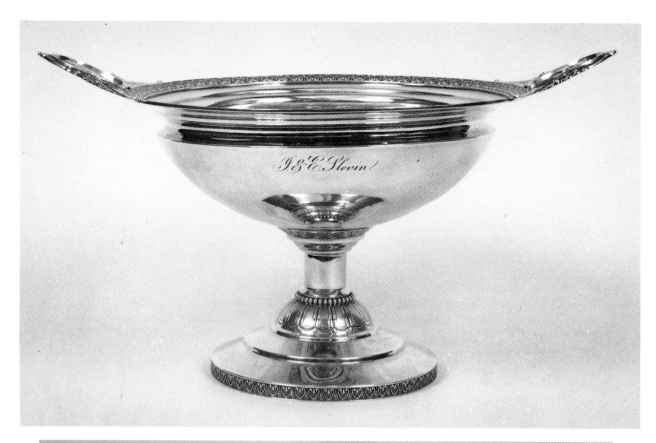

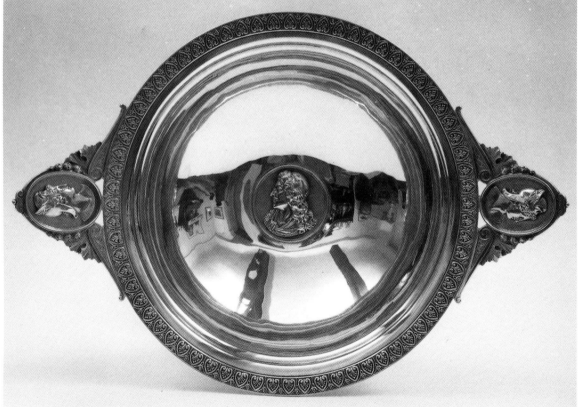

Figures 7.19a, b
A compote made by Wood and Hughes, circa 1865. Wood and Hughes used a border typical of the time, incorporating a palmette design. Notice the oval medallions that serve as handles, and the large round medallion that decorates the center of the bowl. The piece is 14 1/4 inches in length, and weighs 31 ounces. *Courtesy of Constantine Kollitis*

Chapter 8
Sterling & Crystal

For as long as sterling goods have been manu-factured, designers have thought to pair it with crys-tal. In many cases, the results have been tremen-dous, and could easily be expanded into a whole book of their own. This very short section shows only a small number of examples, a selection of those that were available to me. Four of the figures are from Martha Louise Swan's book *American Cut & Engraved Glass*, reprinted in 1994 by Wallace-Homestead, a division of Chilton Books.

See also Figure 12.27 for an intaglio punch bowl made of glass and rimmed with sterling.

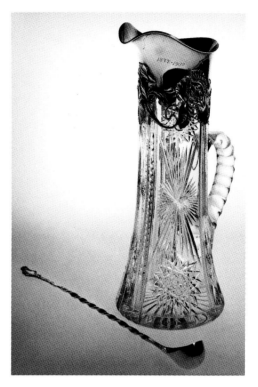

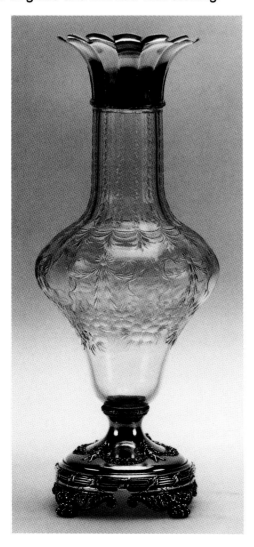

Figure 8.1 *(left)*
A silver base and collar combined with crystal, making this 20-inch vase most impressive. The silver was pro-duced by the William B. Durgin Company of Concord, New Hampshire, and the glass is attributed to Hawkes. The glass is engraved and polished in the rock crystal fashion. The sterling collar blends very well with the base and the glass. Note the very Victorian cherubs on the silver base. *Courtesy of Martha Louise Swan*

Figure 8.2 *(above)*
A tall martini pitcher with a Shreve and Company ster-ling collar. This pitcher commemorates a 25th anniver-sary, 1877 to 1902. The date and the name "Ross" ap-pear on the collar. The Iris border is a Shreve design. Iris flowers lent themselves to Art Nouveau design styles. Durgin made an flatware pattern called *Iris*, which ws introduced in 1900, just two years before this piece was presented. The claret ladle in this figure is in Durgin's *Watteau*, which was introduced in 1891. *Courtesy of Martha Louise Swan*

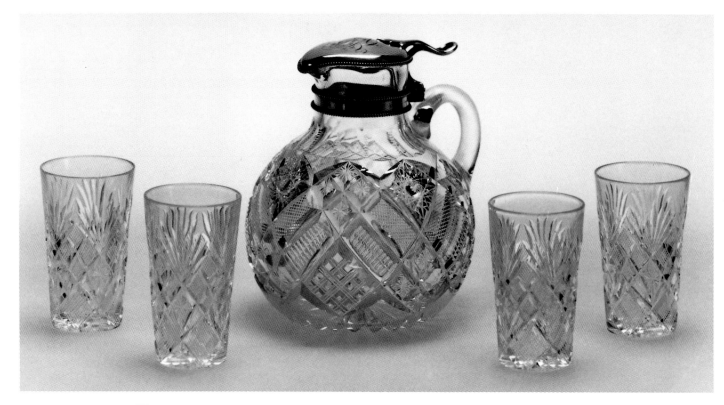

Figure 8.3
A small sterling covered jug with an elaborately engraved monogram at the top of the sterling lid, and four glasses. The bead-edged lid has an attachment for the thumb to press. When the fingers of the hand are wrapped around the handle, the thumb is free to hold back the silver lid by means of this attachment, allowing the liquid to flow unhindered from the jug. *Courtesy of Martha Louise Swan*

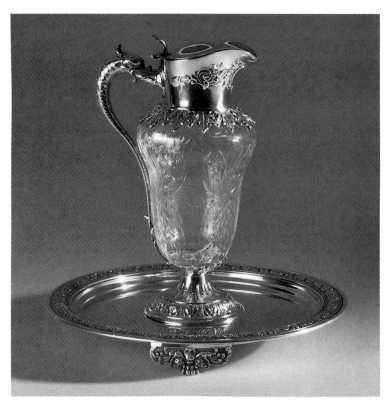

Figure 8.4 *(opposite page)*
A cigar humidor, 8 inches high, with a sterling top and magnificent cut glass base. The lid is in a repoussé style and is marked "Wilcox Sterling." Rainwater does not list a company by this name, but does list Wilcox and Evertson, which became part of the conglomerate later known as the International Silver Company. *Courtesy of Martha Louise Swan*

Figure 8.5 *(left)*
A most unusual claret jug made of Durgin sterling and Hawkes crystal, resting on a Durgin undertray. Only the body of the claret jug is crystal, with a sterling neck and collar that form an interesting handle, connecting to the sterling base. The very fine crystal work is typical of Hawkes. *Courtesy of S. Langrock, Silver Crest Antiques. Photography by Debbie Cartwright.*

143

Chapter 9
Candlesticks

Figure 9.1
A massive candelabra made by Gorham in 1905, 18 inches high, guaranteed to make a lasting impression. With the current trend of placing covered round tables throughout the house, single candelabra like this one are becoming more highly desirable for a use other than as the dining table's centerpiece. This particular piece contains some beautiful design elements. The base has a small leaf pattern surrounding it. The top of the base has a cartouche for a monogram, which is surrounded by leaves. The shaft of the candelabra rises from a series of leaves, and at the top of the shaft are more leaves. While this five-light candelabra is massive, if placed correctly it could complete a setting in elegant fashion. *Courtesy of Phyllis Tucker Antiques*

Of all the items found in a formal table setting, none adds a touch of elegance and romance like a lighted candle in a polished silver candlestick; it sets the entire mood.

Manufacturers have gone to great lengths to make this accessory useful in many ways. In their simplest form, candlesticks can be used singly, in pairs, or in complementary groups, and come in varying heights. The lowest single candlestick can stand as low as two or three inches, while the largest can be monumental, like the 18-inch high example is shown in Figure 9.1. The candle taper would then be chosen to keep the silver candlestick in proportion with the table and the room. This allows a great deal of flexibility in decorating with even the most basic silver candlesticks.

But here the real differences begin! Some candlesticks can be taken apart to make a lower candlestick; others can even be made into a low branched candelabra. Some manufacturers have accessorized a three-branched candelabra with a glass item that served as a vase; it could be fit into the center of the branches, allowing the host or hostess to place a small flower arrangement in the candelabra's center. This makes it possible to use a single silver item as both the centerpiece and the candlesticks simultaneously. Some candelabra can be separated into a number of pieces: one section would be the branched portion, and a second section would be the tall candlestick itself. Sometimes the central segment (or shaft) of the tall candlestick can be removed; then the cup for the candle can be reattached to the base to form a very short candlestick. By allowing such a variety of forms to be created from one item, the silversmith has ensured that the silver owner has a wide number of options for using the candlestick.

Figure 9.2
A set of four candlesticks by Kirk in the *Repoussé* pattern, gorgeous when they are placed two on each side of a magnificent floral centerpiece. Kirk made these candlesticks in three different heights ranging from 6 1/4 inches to 10 1/4 inches, circa 1910. The finely detailed joinings and well detailed repoussé make these exceptionally fine examples. The joinings of the foot and socket to the stem — the most common design weak points for candlesticks — are very successfully accomplished in this set. *Courtesy of Phyllis Tucker Antiques*

Figure 9.3
Shreve and Company candlesticks, 10 1/2 inches high, with an applied beaten design. These would be great to use with the matching Shreve flatware or hollowware. The name *14th century* or *Crusader* was used at different times by the manufacturer to for this particular design. It was later called *Dolores. Courtesy of Phyllis Tucker Antiques*

Figure 9.4
A pair of Shreve and Company candlesticks from San Francisco, with cast bases that are delicately pierced and highly ornate. The simple shaft rises 15 inches to the cup and the bobéche on the top. The shaft is delicately engraved with a classical design containing scrolls and bell flowers. *Courtesy of Phyllis Tucker Antiques*

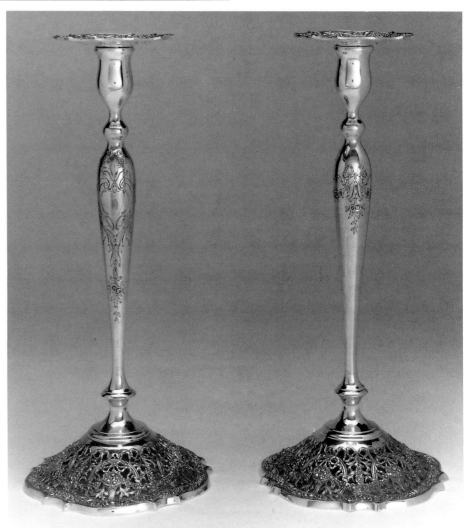

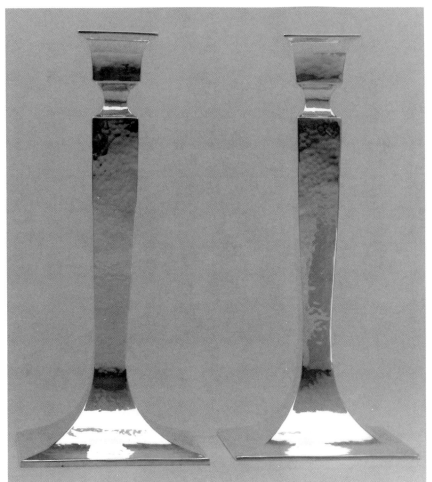

Figure 9.5
Square hand-hammered candlesticks that are well executed in the Arts and Crafts style by the Mulholland Brothers. The cup for the candle is deep enough for a standard taper, and the hand-hammered surface radiates reflected light. These would have been very difficult to make. The four sides are individually cut from sheets of silver, and soldered together. This technique is extremely demanding because of the need for an invisibly soldered line the length of the taper. These candlesticks are not only artistic but a tour de force. *Courtesy of Phyllis Tucker Antiques. Photography by Hal Lott*

Figure 9.6
Martelé candlesticks by Gorham, beautiful examples of this style. Four flattened, integral feet support each domed base, which is circular, but slightly squared. The feet are in the form of elongated leaves trailing from corners of the base. Four cartouches appear on the sides of the each base — three plain, and one bearing script monogram "ALM." A leaf decoration surrounds each cartouche and proceeds onto the knob at the bottom of the stick above the base. Tendrils support simple three-petaled flowers on the shaft. Between each decoration is a plain surface covered with a subtle hammered finish, typical of Martelé. The bobéche at the top of the candlestick has a floral decoration similar to that found on the shaft. These candlesticks were made by Gorham in 1905 and sold in England in 1908. They bear English import marks consisting of "925," the maker's mark for Gorham, the date mark for 1908, and an assay mark for Birmingham. *Courtesy of Phyllis Tucker Antiques*

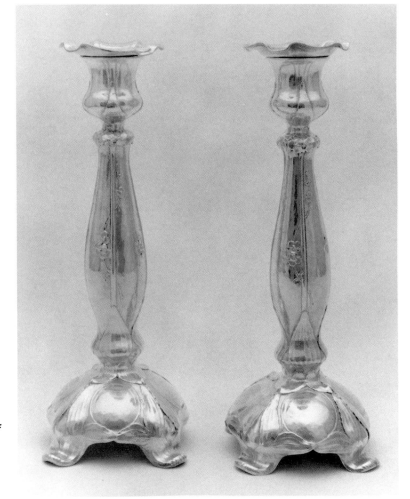

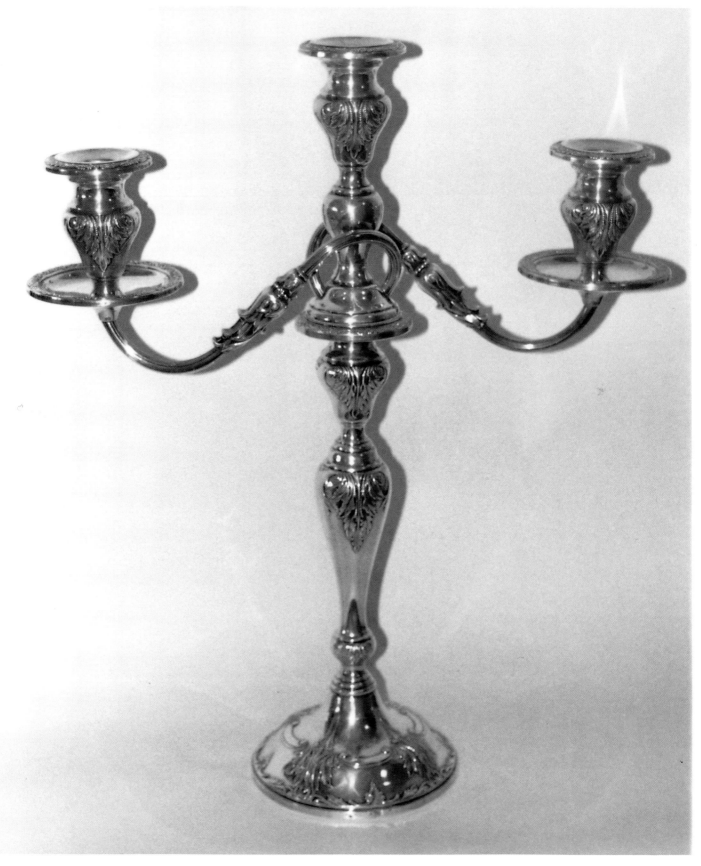

Figure 9.7
A candelabra made by Frank Whiting in the 1920s. The top comes off, leaving a single candlestick. The entire piece is 17 inches high and has a 15 inches spread. The leaves that are interspersed in various spots on these tapers add to the beauty of the candelabra.

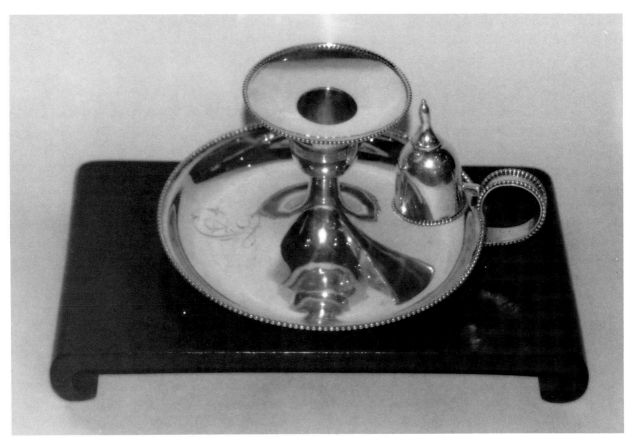

Figure 9.8
A delightful chamber stick with an attached snuffer, made by Whiting Company, circa 1880. The chamber stick measures 2 7/8 inches high. The edge of the dish portion, the handle, and the top of the piece are beaded, giving stability to the design of this item. *Courtesy of Maxine Klaput Antiques*

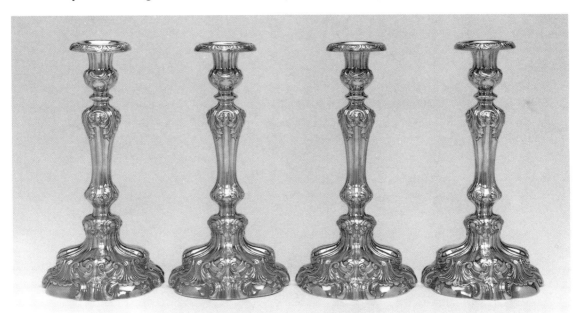

Figure 9.9 *(above)*
A set of four candlesticks made by Gorham in 1913, bear their number A5200. They stand 11 1/2 inches tall and have a baluster form with nozzles, and quadripartite panel decoration with foliage, scrolls, and shells. *Courtesy of Butterfield and Butterfield*

Figure 9.10 *(see photo on color page 177)*
A set of four candlesticks made by Tiffany in the Colonial Revival style, circa 1910. Each candlestick is 10 1/2 inches high. As a group they make a strong statement about the Colonial Revival movement. *Courtesy of Phyllis Tucker Antiques*

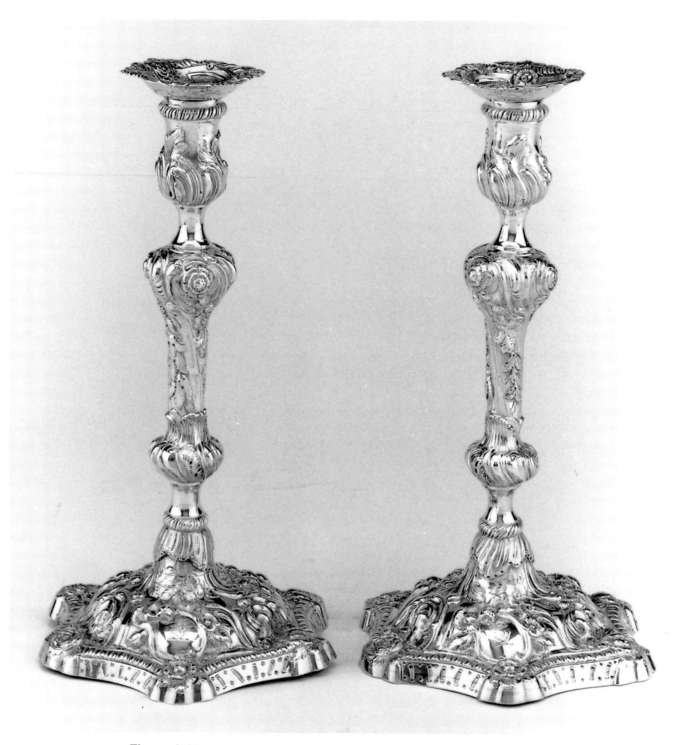

Figure 9.11
An early set of Kirk candlesticks, circa 1830 to 1835, of superb quality. The candlesticks are 11 3/4 inches high and stand on cast hexagonal bases cased in repoussé with scrolls and flowers. The candlesticks have a baluster-shaped nozzle with a cylindrical neck. At the top of the candlesticks are bobéches that have applied leaves and flowers on a gadrooned border with strippled ground.
Courtesy of Butterfield and Butterfield

Chapter 10
Tureens

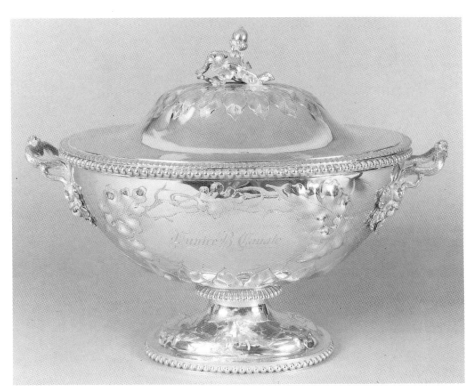

Figure 10.1
An outstanding example of Rococo Revival, retailed by Jones, Ball and Company of Boston circa 1853. The length over the handles is 14 1/2 inches, and the weight is 95 ounces. A beautiful design of leaves and acorns covers much of the tureen's surface. The cover uses these same elements to form the finial, maintaining the theme. The edge of the pedestal base and the edge of the lid are fluted. *Courtesy Constantine Kollitus*

Tureens, made to serve soup, have been made in many styles and represent some of the most magnificent examples of the silversmith's art. Usually a notch for the soup ladle's handle is cut into the lid. With this notch, the ladle can remain in the bowl while the lid is shut tight, preserving the warmth of the soup. Tureens either have a pedestal base or applied feet. A few even have a matching tray. Most have handles to assist in carrying the tureen. In addition to soup tureens, many manufacturers made and sold small tureens for sauces or gravies.

The size of the container chosen depends not only on the number of people to be served, but also on the type of soup. Thick soups and stews, intended as the main course of a meal, were served from large tureens into large individual bowls. When cream soups are part of the meal, however, they are not often served in such quantity. They are eaten from small, two-handled bowls, and a medium (or possibly large) tureen suffices. Bouillon, a thin, light soup, is served in two-handled bowls that only the size of a cup; a small tureen is generally large enough to serve everyone the proper portion. It is interesting to note that the variety of soup spoons and ladles in silver flatware also reflect these size differences.

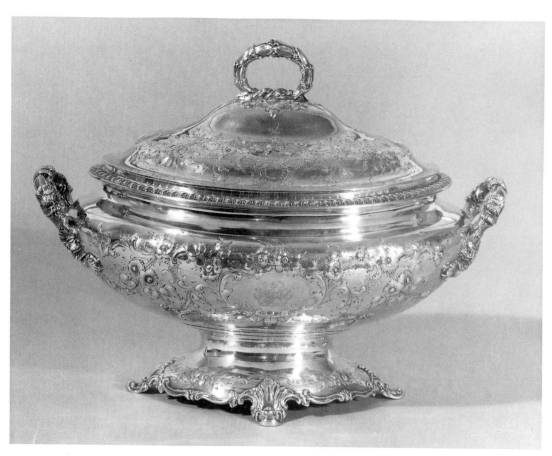

Figure 10.2
A tureen in the Rococo style, manufactured by William Gale and Son in 1853. This particular tureen has flowers chased on the base and lid, accompanied by a series of intertwined scrolls. The finial consists of overlapping leaves and berries. The handles are flowers and leaves worked together in a distinctive way. The base's strong scrolls and flowers work well with the rest of the design material. *Courtesy of Constantine Kollitus*

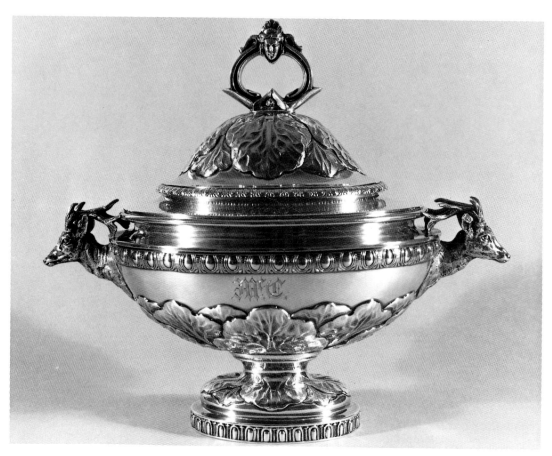

Figure 10.3
A sauce tureen made by Edward C. Moore and sold by Tiffany. The side handles are animal heads, while the handle on the cover is interestingly designed to incorporate a number of design motifs. Leaves cover the top portion of the domed lid. The decoration at the base and just below the top of the base is a variation on classical design. *Courtesy of Constantine Kollitus*

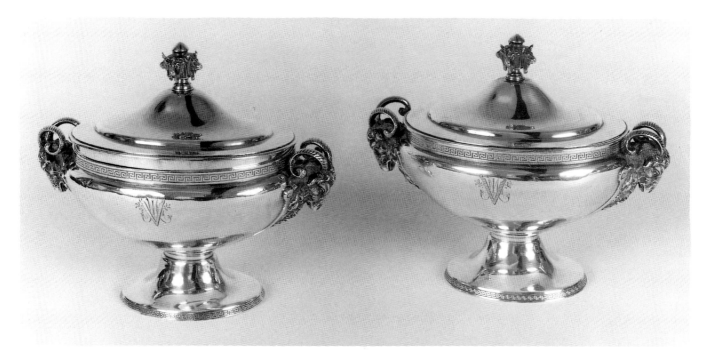

Figure 10.4 *(above)*
Gorham sauce tureens dating from 1865. They have
what appear to be goat head handles and stylized fini-
als atop dome-shaped lids. A Greek key design (at the
base and at the top of the bowl) lends an interesting
look to these pieces. The horns of the animals provide
additional spaces to hold the sauce tureen. *Courtesy of
Constantine Kollitus*

Figure 10.5 *(below)*
A very unusual Tiffany tureen using the heads of beef
cattle for handles on the base. A simple Grecian key
border on the base and a larger key design at the top of
the bottom of the tureen combine with a generous and
unusually-shaped handle for lifting the domed top. This
typifies good design, and was probably executed by
Moore. There is a definite grace about this large tureen.
Courtesy of Constantine Kollitus

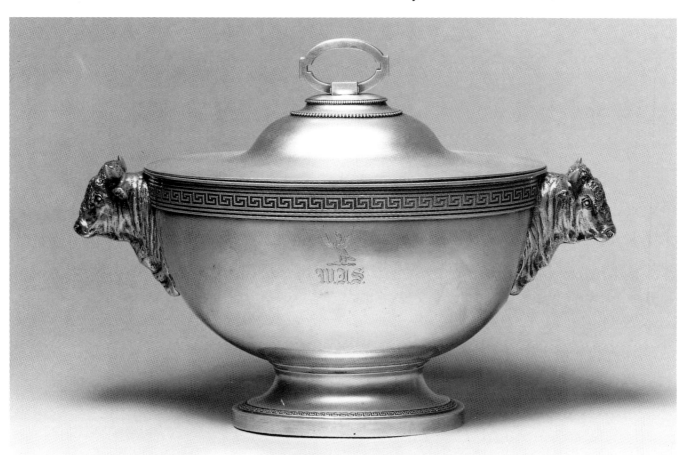

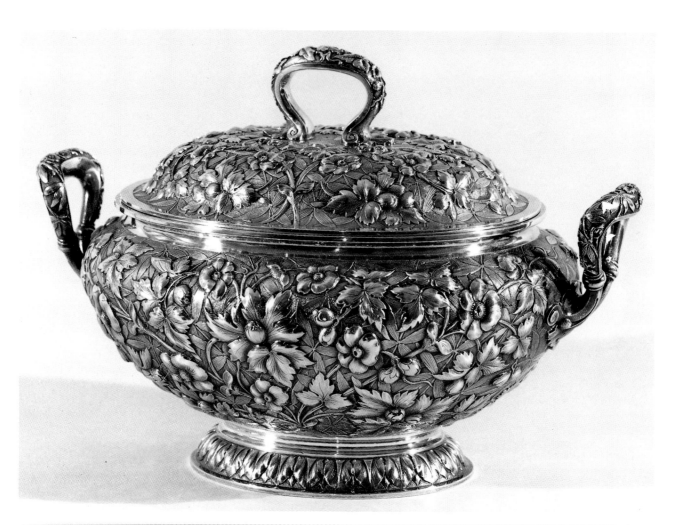

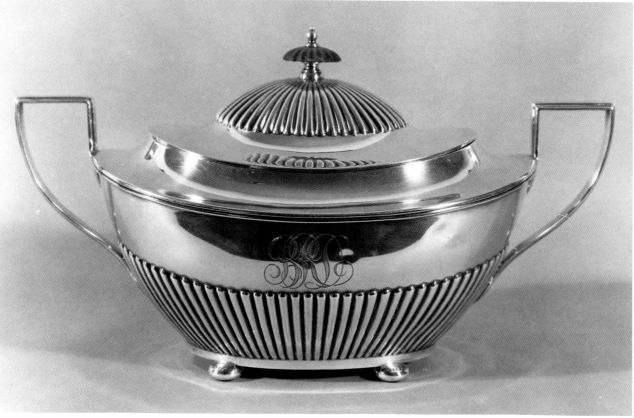

154

Figure 10.6 *(opposite page, top)*
A repousséd soup tureen by Dominick and Haff, circa 1880. This is another example of the fine repoussé work that was done by American silversmiths. The handles on the side and the lid maintain a consistent theme. The base uses an overlapping leaf design to set off the flowers covering the remainder of the tureen. *Courtesy of Constantine Kollitus*

Figure 10.7 *(opposite page, bottom)*
A truly elegant Colonial Revival tureen with bun feet and large handles, topped with an ebony-trimmed finial. The tureen is 8 inches high, the length over the handles is 14 3/4 inches, and the piece weighs 36 ounces. The script engraving on the plain band above the ribbed base design adds detail to this piece. The domed lid has a ribbed design. *Courtesy Constantine Kollitus*

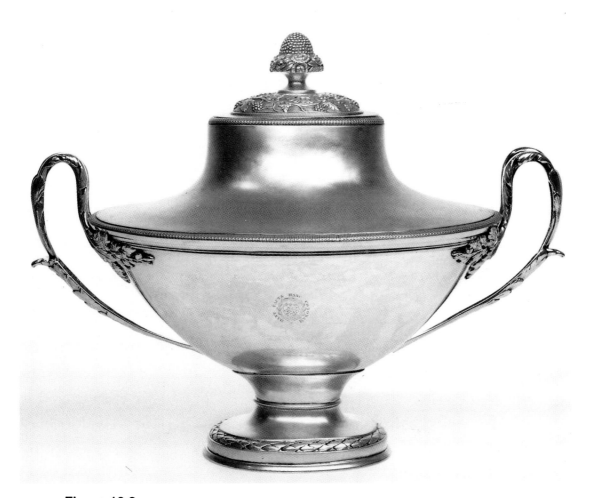

Figure 10.8
A tureen in the Neoclassical style, exemplifying graceful elegance. Hugh Wishart was an American silversmith working in New York when he manufactured this tureen, circa 1795. The finial is quite interesting; together with the areas where the handles join the body and the rim of the pedestal base, it is the only decoration. The areas where the handles join the body of the tureen appear to be an interpretation of the classical acanthus leaf. *Courtesy of Campbell Museum, Camden, New Jersey*

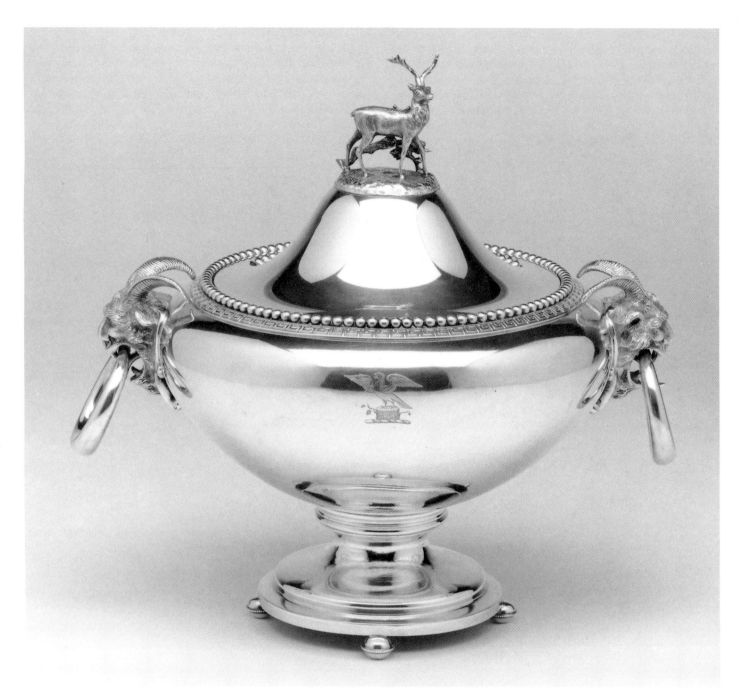

Figure 10.9 *(above)*
A round soup tureen sold by Vanderslice and Company of San Francisco in the 1860s. It is very similar to Gorham's tureens, and most likely was made by Gorham for Vanderslice. The French would have served a stew in a round tureen like this, which they called a *pot-aoilles*; tureens were oval-shaped and reserved for soup. We in United States use the term tureen to mean any vessel of any shape used to serve any type of soup (including stews). *Courtesy of Michael Weller, Argentum Antiques*

Figures 10.10a, b *(opposite page, top, bottom)*
A soup tureen made by Gorham in coin silver. The engraved inscription gives the date as 1858. Figure 10.10b shows the close attention that was given to every detail in this piece. The striking design on the leaves and flowers attest to the care taken in making this tureen, and the piece's condition suggests how well it has been cared for ever since. The tureen stands 12 inches high, is 16 inches in length, and weighs 88 ounces. *Courtesy of Constantine Kollitus*

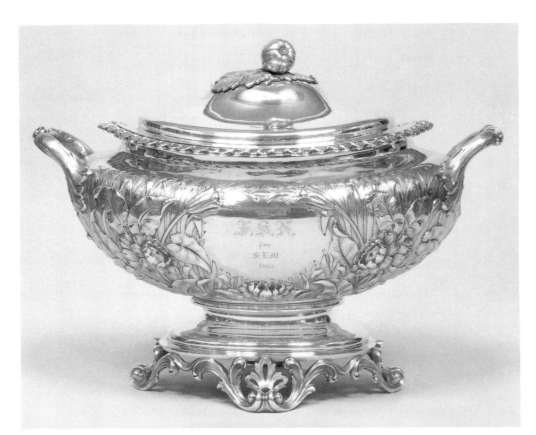

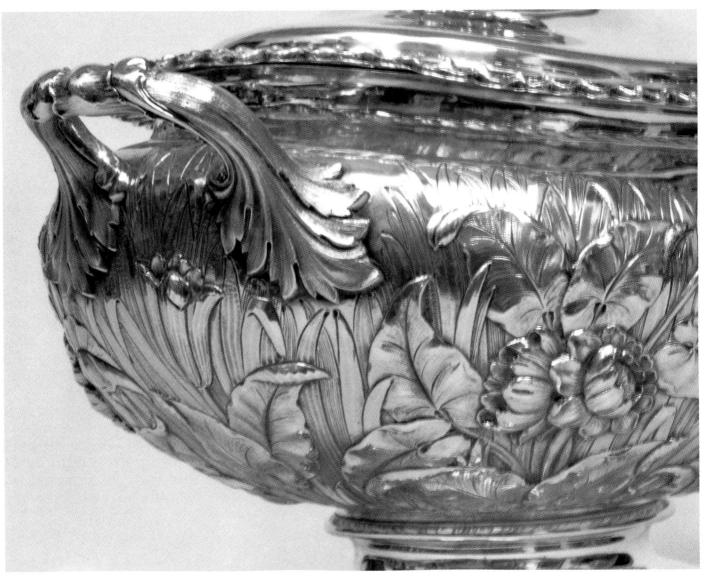

Chapter 11
Covered Entree or Vegetable Dishes, Chafing Dishes, & Egg Coddlers

Figure 11.1
A particularly remarkable covered entree dish, carrying the names of three great silver manufacturers. The bottom of this entree dish was made by Gale. Later Wood and Hughes made the top to match the bottom. Still later, during the short period that Tiffany produced silverplated ware, they made a liner for the bottom of this piece. Three great names in silver represented by a single serving piece! The dish is 12 inches long and weighs 65 ounces. *Courtesy of Constantine Kollitus*

Entree and vegetable dishes are truly elegant serving items for the table. Many have top handles that can be removed, so the lid can be turned upside down and used as a serving bowl in its own right. Most entree and vegetable dishes are approximately ten to twelve inches in length. The outside decoration can vary from repoussé work to engraving or chasing. The interiors of these pieces are plain, which allows for easier cleaning.

Entree dishes are intended to serve the meal's main dish, presumably a casserole of some type. Vegetable dishes serve, as expected, vegetables—steamed, creamed, roasted, or prepared in any other manner.

Chafing dishes are another type of serving ware. They usually have heating devices to help keep foods warm.

Silver serving pieces were made for every meal, and breakfast was no exception. One of the most interesting items to be manufactured for use at the breakfast table wa the egg coddler. Finding an example in silverplate is unusual, but examples in silver itself are even more rare. One rare example is presented in this chapter.

Figure 11.2 *(above)*
A covered vegetable server from a set of four made by Taylor and Lawrie of Philadelphia, circa 1850. The cover of each of these dishes has a removable handle; when it is removed, the cover can be inverted and used as a second serving bowl. There is a beaded border on the top edge of the bottom section, and also on the top of the lid — to protect the top surface when the lid was turned over and used as a serving bowl itself. *Courtesy of Constantine Kollitus*

Figure 11.3 *(below)*
A covered vegetable dish by Gorham, circa 1860. The top finial is removable and thus allows the owner to use this as two serving pieces. The delicate designed edge gives a leafy appearance to this section and seems to tie in with the deer finial. *Courtesy of Constantine Kollitus*

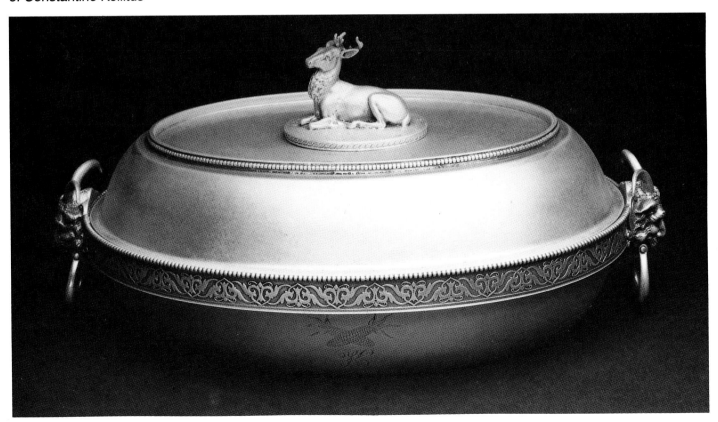

159

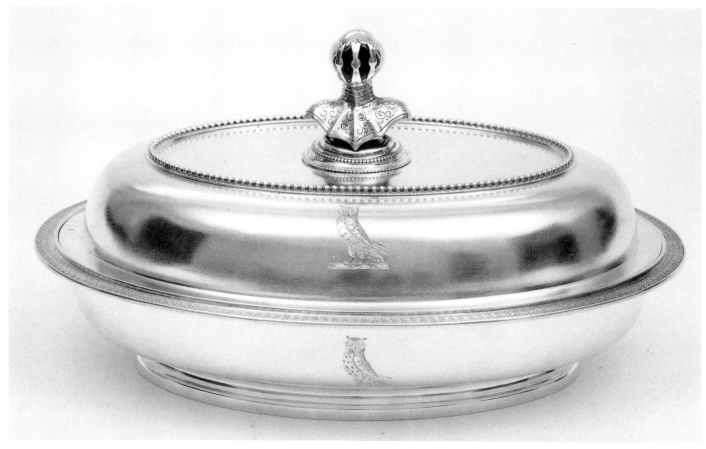

Figure 11.4
A sterling covered vegetable dish, 11 inches long and 43 ounces, bearing the Tiffany & Co. Union Square mark. This dish was manufactured circa 1870 and bears an "M" for Moore. The finial can be removed to form two separate vegetable dishes. The row of beading on the top is not just decorative; it also prevents scratching when the dish is inverted. This entire piece has a very substantial feel, which is probably due to the design. The Gothic handle is beautiful and the engraving on the finial is interesting.
Courtesy of Constantine Kollitus

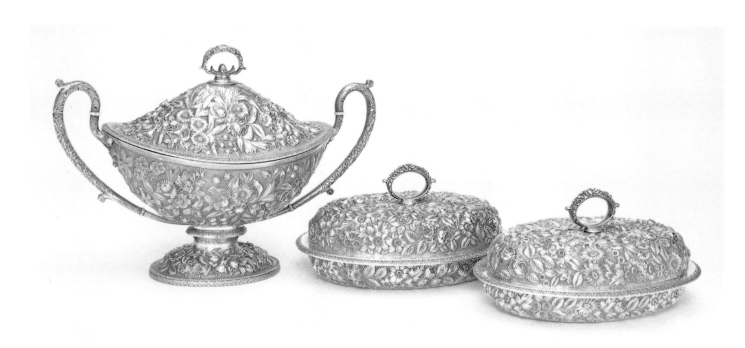

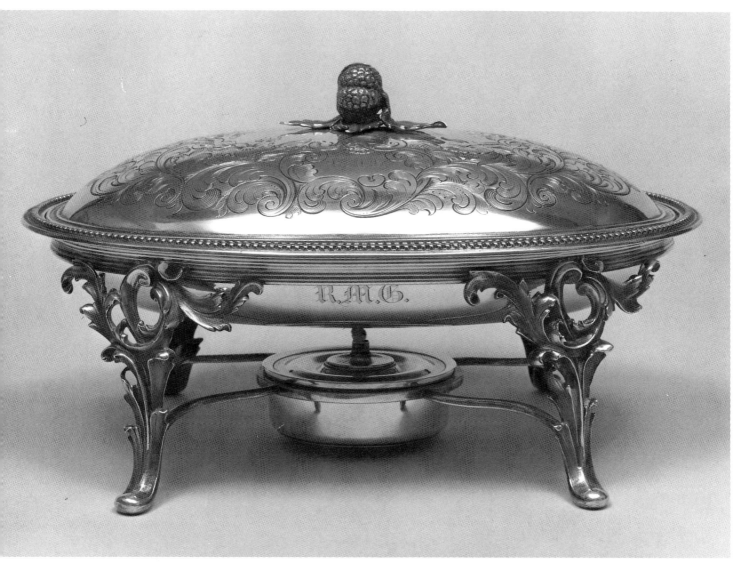

Figure 11.5 *(opposite page, bottom)*
A pair of oval covered vegetable dishes from Jacobi
and Jenkins circa 1894. They measuring approximately
11 3/8 inches long, and together weigh over 75 ounces.
They are covered with an embossed foliate decoration
upon a matte ground and have a foliate ring finial. Shown
along with them is a soup tureen also made by Jacobi
and Jenkins. *Courtesy of Butterfield and Butterfield*

Figure 11.6 *(above)*
A chafing dish sold by Tiffany, Young and Ellis circa 1850.
It was made by John Chandler Moore and is about 12
1/2 inches long. The cover is engraved with a fine de-
sign of scrolls and leaves, and the entire edge of the lid
has a beaded border. The finial appears to be fruit with
leaves covering part of the top section. The legs were
created from a scroll design and are joined by a sepa-
rate rod, which converges to form a container for the
heating element. Sterling dishes of this magnitude are
not easily found and are quire rare. *Courtesy of
Constantine Kollitus*

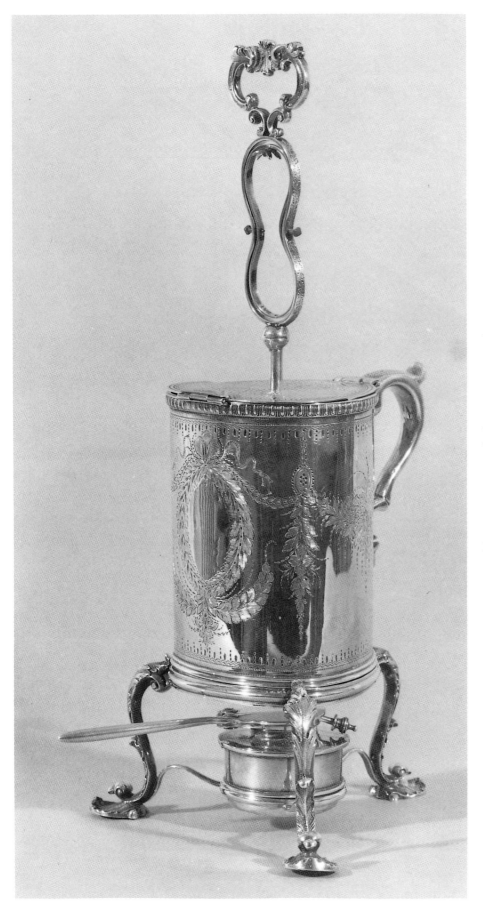

Figure 11.7 *(left)*
This very rare example of an egg coddler in Figure 11.7 was made by William Gale c1856. The height of the coddler is 13 3/4 inches and the weight is 29oz. Few of these coddlers are found, and they are rare in sterling. The beautiful engraving on the sides of the container are excellent examples of classical work. *Courtesy of Constantine Kollitus*

Figure 11.8
(see photo on color page 177)
A fine example of an early covered vegetable dish by Kirk, in their *Tuscan* pattern. Villas and scenes can be seen between the floral repoussé work. Kirk often used scenes in their eraly work. *Courtesy of Michael Weller, Argentum Antiques*

Chapter 12
Bowls

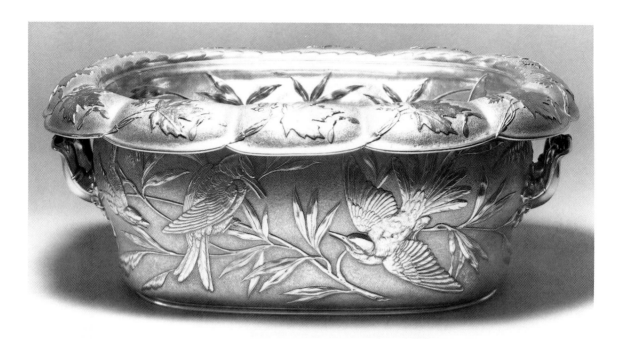

Figure 12.1
A bowl-shaped piece that appears to be a wine cistern. The silver department at Tiffany's under Edwin C. Moore became one of the top silver manufacturing companies after the Civil War. The reasons for this are obvious if you study a piece like this one in the pattern *Audobon* (also known as *Japanese*). It measures 22 inches long by 16 1/2 inches inches wide, and stands 8 1/2 inches tall. The highly detailed work makes the birds and foliage seem almost alive; the birds look ready to fly from the sides of the bowl! *Courtesy of Constantine Kollitus*

Silver bowls come in almost every size possible, from tiny bon bon dishes to huge punch bowls. They are extremely durable, and since the metal can withstand extremes in temperature they can be used with a variety of foods. The bowl itself can be almost any shape and design, only limited by the inventiveness of the silversmith creating it.

Bowls can be footed or not, or can have pedestal bases. They can be highly decorated from the inside, perhaps with repoussé work in which the design is pushed out, or they can be engraved or chased on the outside. The exteriors can also be smooth, hand-hammered, or even pierced. The lip of a bowl can be decorated with applied decorations like a gadrooned edge, and some bowls feature gold-washed interiors. The bowl can have applied decorations, which are often fruit, flowers, or bows. Some applied decorations are made of silver or other metals, like the Japanese-style pieces often associated with Whiting, Gorham, or Tiffany.

Monograms can make a tremendous statement on a significant piece of silver. When placed correctly and incorporated into the design, they personalize the bowl for the owner, and express something about the individual choosing the monogram. Occasionally, when there is no room or the design fills the entire surface (as in repoussé work), monograms have been placed on the undersides of items.

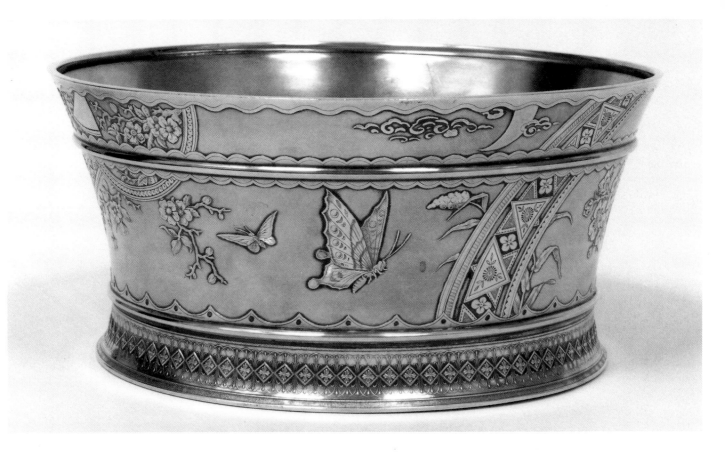

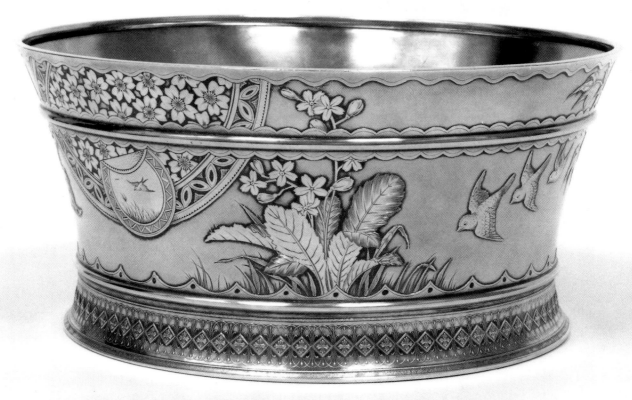

Figures 12.2 and 12.3
An example of Japanese-style silver, made by Whiting (shown front and back). The oriental blossoms, insects, and birds combine with the sweep of the design to add dimension to this bowl. It measures 9 inches in diameter, stands 4 1/2 inches high, and weighs 29 ounces. This piece was probably made circa 1875. It would be an asset to any sterling collection. *Courtesy of Constantine Kollitus*

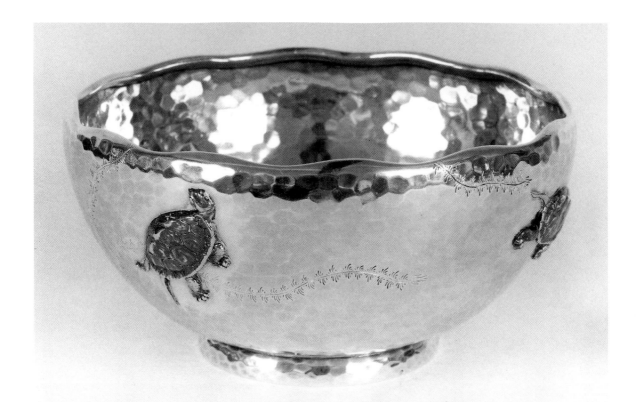

Figure 12.4 *(above)*
A Tiffany bowl made of sterling and other metals, approximately 8 inches in diameter. The copper turtles are applied to the sterling bowl. The delicate engraved design gives the illusion that the turtles have moved across the charming hand-hammered surface of the bowl. *Courtesy of Constantine Kollitus*

Figure 12.5 *(below)*
A bowl with an oriental scene on the base and oriental banding at the top. Gorham's entry into the Japanese design market produced a number of wonderful pieces, including this one. The monogram on the side of the bowl also has an oriental feel. *Courtesy of Constantine Kollitus*

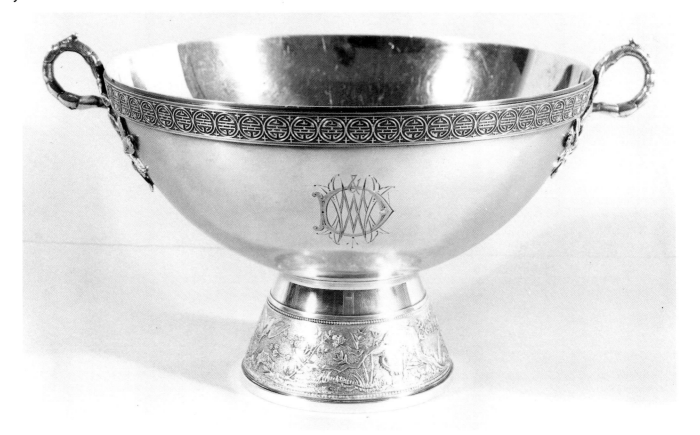

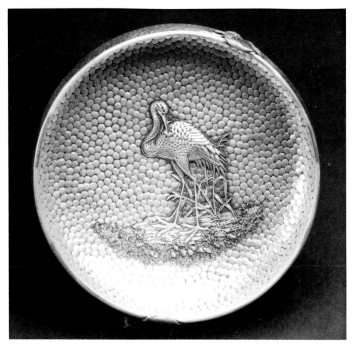

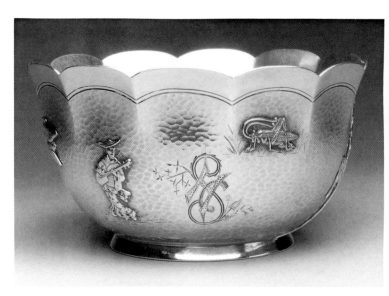

Figure 12.6
A small bowl by Gorham, circa 1880. Only 4 3/4 inches across and weighing 6 ounces, this bowl has a metal bird applied inside the bottom of the bowl. It is so well done it appears that at any moment it might stop preening and take flight! The sharpness of the applied details make this a highly desirable piece of silver. The beaten surface makes the perfect contrast for the applied bird. *Courtesy of Constantine Kollitus*

Figure 12.7
A hand-hammered bowl made by Kennard and Jenks in a Japanese style. This bowl is entirely made of silver, including the applied decorations. The scalloped rim is a band of plain silver, with an additional narrow border underneath it. The bowl features oriental figures and a stylized monogram. There appears to be a narrow rimmed base. Kennard and Jenks operated in Boston from 1875 until 1880, when they were purchased by Gorham and were moved to the Providence, Rhode Island plant. *Courtesy of Constantine Kollitus*

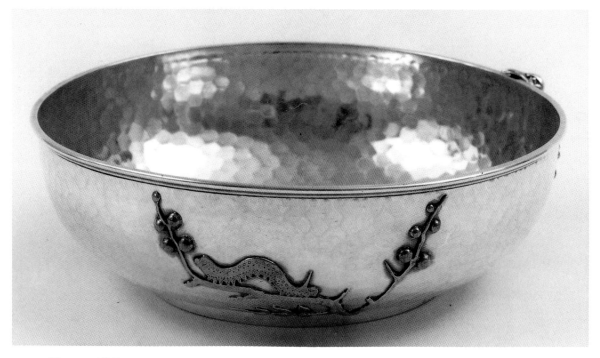

Figure 12.8
Another example in mixed metals work from the Whiting Manufacturing Company. This bowl, 8 inches in diameter, features a caterpillar moving along a floral branch applied to the side of the bowl. The hammered surface is not heavily done and adds a muted background for the applied items. *Courtesy of Constantine Kollitus*

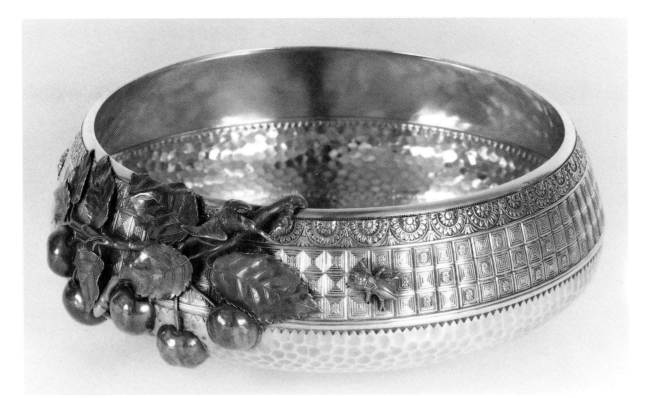

Figure 12.9a *(above)*
A sterling bowl by Gorham, with a very intricate design on the exterior. An applied insect appears to be moving toward the applied copper cherries and leaves. These cherries (similar to those on the Turkish black coffee pot in Figures 3.13, 3.14a, and 3.14b) appear to have a coating that does not tarnish, yet allows the unusually rich copper color to show through, creating a great deal of contrast. The top half of this bowl has two bands of oriental design and is separated from the bottom portion by beading over the hand-hammered lower surface. *Courtesy of Constantine Kollitus*

Figure 12.9b, c *(see photos on color page 178)*
Two excellent examples of mixed metal work. The example on the left was made and sold by Schultz and Fisher in San Francisco. It has a gilded interior, a pedestal base, and applied copper fruit. The item on the right has applied leaves and insects and was made by Gorham. *Courtesy of Michael Weller, Argentum Antiques*

Figure 12.10 *(below)*
A sterling bowl with a pedestal base and sterling attachments on the sides. One of the attachments is a crayfish, while on the opposite side a cupid is riding a dolphin. The bowl is 8 1/4 inches in diameter, 4 1/4 inches high, and weighs 25 ounces. It bears the retailer's mark for Duhme and Company of Cincinnati, Ohio. The style dates the piece the early 1880s. It was most likely manufactured by Duhme and Company in their own factory. *Courtesy of Constantine Kollitus*

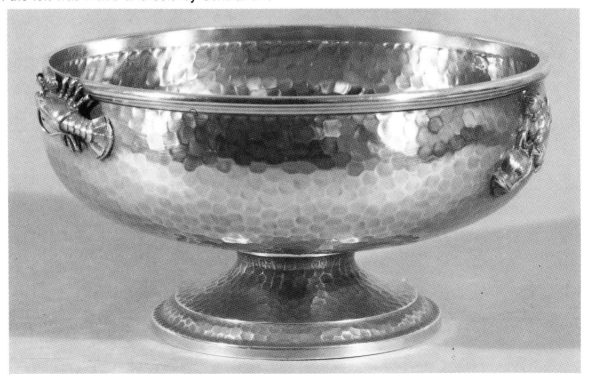

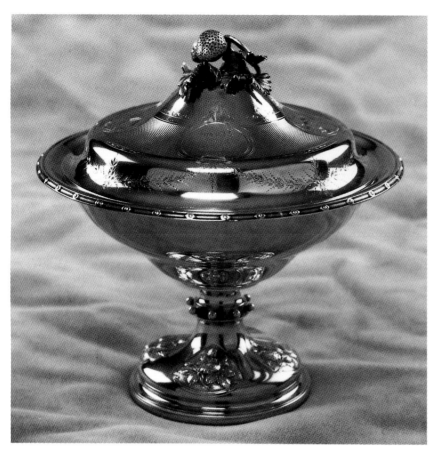

Figure 12.11a
A coin silver strawberry bowl on a stand, bearing the Gorham mark with the lion facing left. The entire piece is 10 inches high and 9 3/4 inches wide. Lemon gilt covers the interior of the bowl and the underside of the lid. A very realistic strawberry, with stem and leaves, forms the finial. The lid is divided into three separate cartouches. Scenes are engraved in two sections, and the third has the monogram "FLC" and the inscription "Florence Riford, Senior Club." One of the two engraved scenes consists of an engraving of buildings with a man walking uphill to a house, and the second has a steamboat and a sailboat on the water, with a man on the shore. *Courtesy of Sherry Langrock, Silver Crest Antiques. Photography by Debbie Cartwright.*

Figure 12.11b
A bowl made by Gorham in 1905, almost square with its dimensions of 13 inches by 16 1/2 inches. The style is Art Nouveau, not Martelé. There is a charming balance in the swirls and flowers of this piece, especially with the oval heart-shaped section at the center of each side. The monogram in the center of the bowl carries the swirls into the center of the bowl. *Courtesy of Constantine Kollitus*

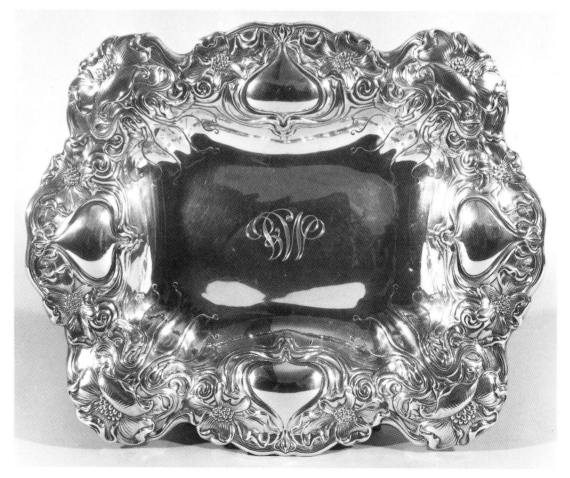

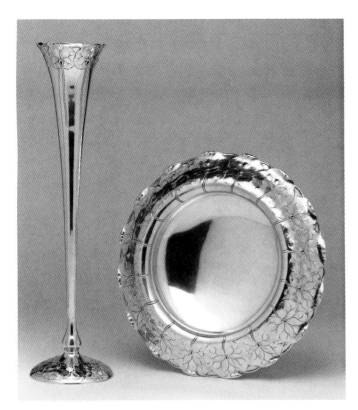

Figure 12.12
A low bowl and matching vase made by Shreve and Company. The chasing on these two pieces resembles the work done by Nicholas Hinzelman, a Gorham worker, as shown in Figure 4.46. Hinzelman's work is chased in such low relief that it is best called "flat chasing." *Courtesy of Michael Weller, Argentum Antiques*

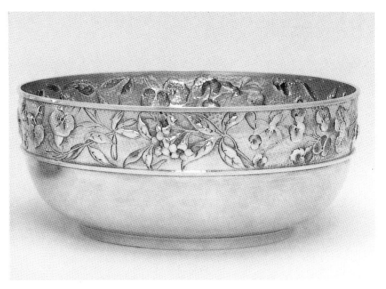

Figure 12.13
A sterling bowl with a chased border in the Japanese taste, circa 1880, created by Dominick and Haff of New York. It is 8 1/4 inches in diameter and stands 3 1/4 inches tall. Insects can be found within the chased border design. This bowl weighs 19 ounces and 14 pennyweights. *Courtesy of Butterfield and Butterfield*

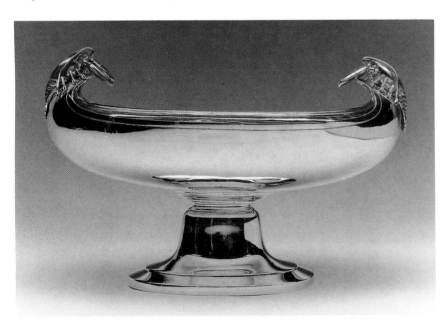

Figure 12.14a, b *(above and right)*
A most unusual 12-inch bowl and accompanying servers, which must have been special order items. The applied lobsters with fine detailing appear ready to cast themselves into the bowl. The 12-inch spoon and fork have applied lobsters at the end of their handles. The only mark on these pieces is "English Sterling." They may have been made by J. Wendt, circa 1860s. *Courtesy of Phyllis Tucker Antiques*

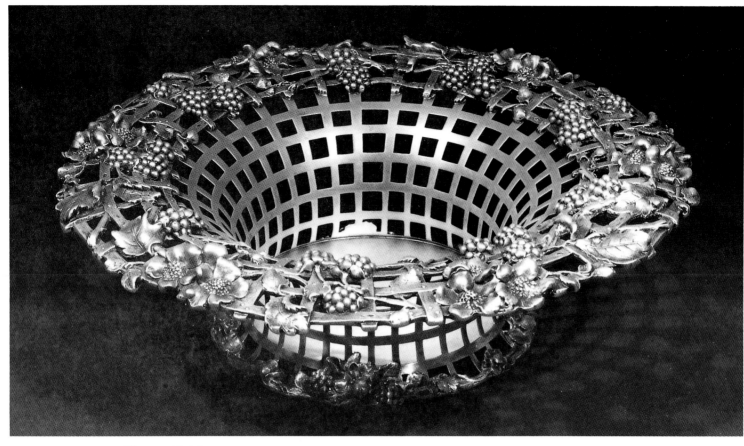

Figure 12.14c
A Dominick and Haff pierced fruit bowl, a testament to what silversmiths can do with metal. Clusters of berries, leaves, and flowers are applied to the top edge of the bowl and on the bottom of the bowl. The windowpane design in the bowl is precisely symmetrical, and each pane is perfectly spaced. The flowers and the berries show great detail. *Courtesy of Constantine Kollitus and Phyllis Tucker Antiques*

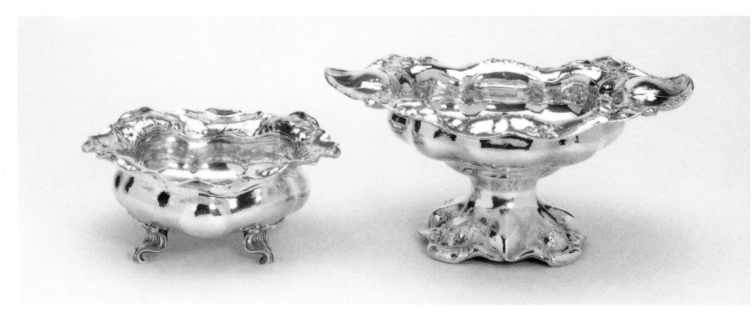

Figure 12.15a
Two samples of Gorham's Martelé. The lobate bowl on the left has four cast scroll support legs and is 4 inches high and 10 inches in diameter. The pedestal bowl on the right is 14 inches wide and 6 1/2 inches high. Both bowls are marked "950 Martelé." *Courtesy of Butterfield and Butterfield*

Figure 12.15b *(right)*
An exceptionally enormous Tiffany bowl, hand-chased with repoussé work. Measuring 19 1/2 inches in diameter, it is a most impressive piece of Rococo silver. *Courtesy of Michael A. Merrill, Inc., Baltimore, Maryland*

Figure 12.16 *(below)*
Three bowls, each with a special quality. The fluted dish on the left, with the twig-form handle, is by Wood and Hughes of New York, circa 1880. The gilt sides are engraved to simulate a fringe and the center engraved with silver and gilt flowers. It is 5 1/2 inches in diameter. The center bowl is by Gorham, marked with the date code for 1873, and is an example of their Classic Revival style. The outside is alternately matte and polished silver, and the inside is gilt. The bowl is 9 inches in diameter including the handles. The tray on the right was made by Wood and Hughes in the Japanese style, circa 1880. The center motif of lilies-of-the-valley is applied. The sides are chased to simulate basketwork. The tray measures 8 inches over the handles. *Courtesy of Michael Weller, Argentum Antiques*

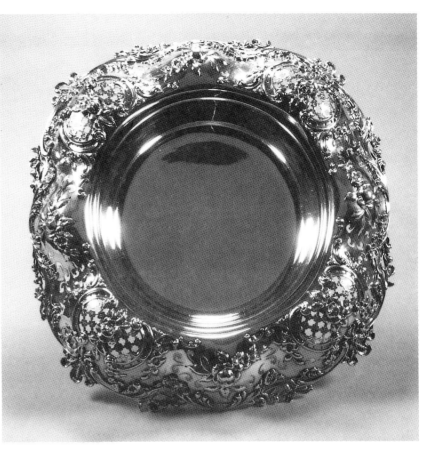

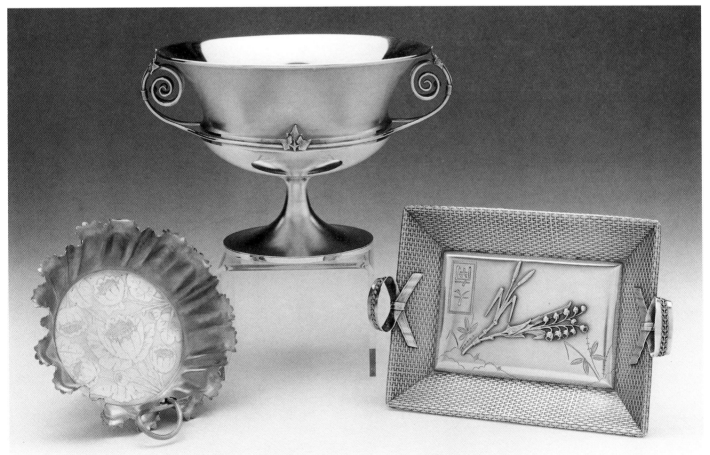

Figures 12.17a, b *(see photos on color page 179)*
An early example of Whiting's *Louis XV,* at first glance unrelated to the flatware pattern of the same name. This fruit basket's delicate piercing and heavily worked floral and swag design cover the piece so thoroughly that one almost overlooks the edge — which is exactly like that on the nut spoon from the *Louis XV* flatware line. The shaft of the pedestal base has a matching border at the bottom.

Figure 12.18 *(see photo on color page 179)*
A Dominick and Haff bowl. This item is representative of a type of work in which the silversmith takes machine-stamped flowers, adds depth and dimension to the individual flowers and leaves by chasing and/or engraving, and then reapplies them to the edge of the bowl. This technique makes the flowers really stand out from the surface of the bowl. The background of the bowl is also highly pierced, adding another dimension. *Courtesy of Phyllis Tucker Antiques*

Figure 12.19 *(see photo on color page 180)*
A large bowl by Frank W. Smith Silver Co. Inc., which speaks highly of this factory's work. The applied edge mirrors the fluted sides of the bowl. The delicate engraving, incorporating flowers into the scrolls, is a work of art in itself. This piece, 16 inches in diameter, was probably made during the 1920s.

Figure 12.20a *(see photo on color page 180)*
An early fruit bowl with repoussé work and scenes, most unusual. It dates from the mid 1840s and is representative of Rococo silver of the period from the South. The beautiful pedestal adds to the charm of this footed bowl. *Courtesy of Phyllis Tucker Antiques*

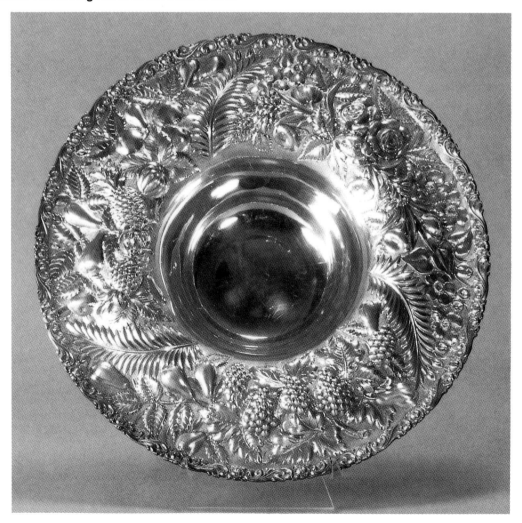

Figure 12.20b
A centerpiece bowl by Jacobi and Jacobs, circa 1895. The workmanship is very similar to that of the compote in Figure 7.21, by the same firm. The two pieces are very similar, but this bowl has grapes worked into the design. The edges of the two pieces differ as well. *Courtesy of Michael A. Merrill, Baltimore, MD*

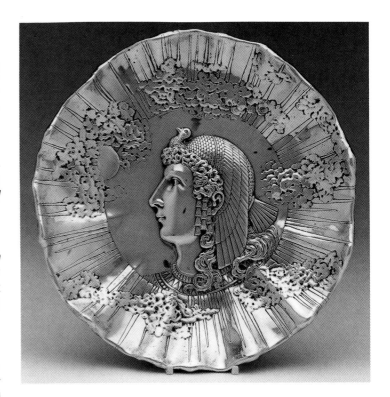

Figure 12.21a *(right)*
A magnificent bowl by Gorham in an Egyptian motif, manufactured in 1884. Gorham called this a "sideboard piece," meaning that it was intended for display purposes, to be kept on a sideboard for guests to admire. *Courtesy of Michael Weller, Argentum Antiques*

Figure 12.21b *(see photo on color page 181)*
A coin silver bowl manufactured by Shreve in the *Medallion* pattern, circa 1890s. The coins add a special nuance to the simplicity of the bowl. *Courtesy of Michael Weller, Argentum Antiques*

Figure 12.21c *(see photo on color page 181)*
A coin silver bowl made by Gorham in the *Medallion* pattern. The backwards curve of the handles is extremely graceful. This low piece would make an excellent fruit bowl for the center of a table. *Courtesy of Michael Weller, Argentum Antiques*

Figure 12.21d *(see photo on color page 181)*
A jam set consisting of a gilded bowl and a gilded spoon. The bowl and the bowl of the spoon are both leaf-shaped. The handle of the bowl is formed by the stem of the leaf. On the spoon, the handle shaft is entwined by the stems; a few grapes and a leaf are at the end of the piece. *Courtesy of Michael Weller, Argentum Antiques*

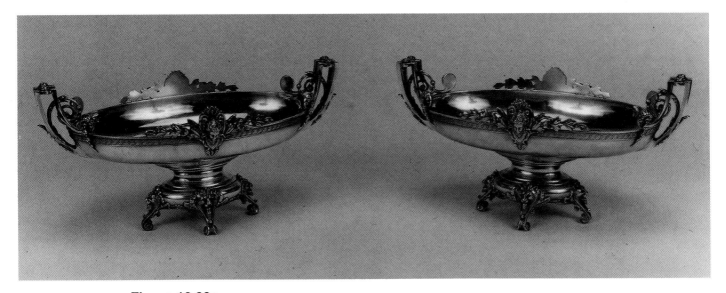

Figure 12.22a
A pair of American footed bowls made by Tiffany, circa 1870. Each bowl is of oval form on a low, stepped, domed foot, with a die-rolled band at the rim. Four high, scrolling feet, decorated with large lions masks amid foliage, support the piece. The double handles have scrolling foliate mounts. The surface of each bowl has a satin finish. Elaborately cast mounts in the form of female masks are flanked by foliage, and are applied to the bowls' upper bodies. These two pieces are representative of the Renaissance Revival style, and are 6 3/4 inches high by 7 inches wide. *Courtesy of Phyllis Tucker Antiques. Photography by Hal Lott*

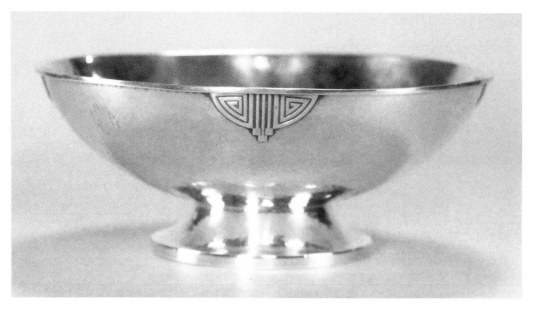

Figure 12.22b *(above)*
A hand-hammered pedestal bowl. This Art Deco piece by Wallace is simply elegant. The bowl is 9 inches in diameter. The design on the side of the bowl is hand-applied. *Courtesy of Michael A. Merrill, Inc., Baltimore, MD*

Figure 12.23 *(below)*
A small punch bowl by Kirk. While this company made a number of punch bowls, this particular example is unusual because of the way corn worked into the repoussé design. This can be seen on the left of the photograph. The edge is typical of monteith bowls, but they are usually oval in shape. The design on the rim of the bowl is unlike rims of other Kirk examples seen to date. *Courtesy of Constantine Kollitus*

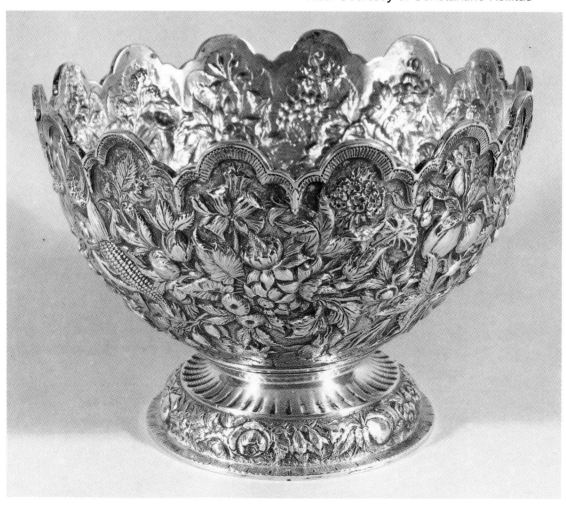

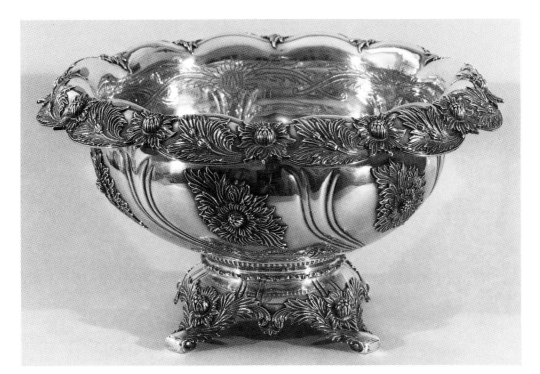

Figure 12.24 *(above)*
A huge punch bowl in one of the most beautiful floral patterns, Tiffany's *Chrysanthemum.* According to Carpenter, this pattern was first introduced in 1880 as *Indian Chrysanthemum,* but Tiffany soon changed the name. This bowl measures 17 inches in diameter, holds 18 pints, and weighs a tremendous 113 ounces. Chrysanthemum flowers, buds, and leaves are boldly worked around the rim and on portions of the bowl's sides. The feet use flowers, buds, and leaves to form a pedestal base for the bowl. *Courtesy of Constantine Kollitus*

Figure 12.25 *(below)*
A large punch bowl decorated with grapes, grape leaves, tendrils, and branches surrounding the top portion of the bowl. The heavily patterned feet carry out the theme. The plainness of the rest of the bowl make the decorations stand out even more boldly. Whiting manufactured this punch bowl circa 1900, when grape designs were reaching peak popularity, and companies incorporated the motif into their hollowware or flatware lines. Whiting was an all-around company, noted for both its hollowware and its flatware. *Courtesy of Constantine Kollitus*

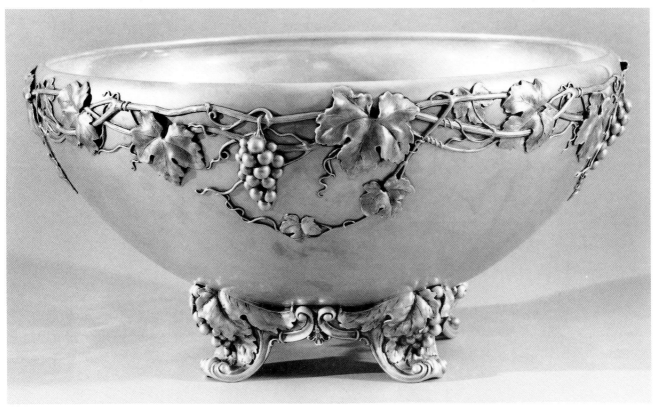

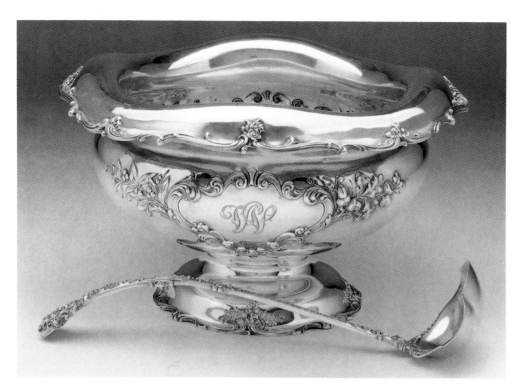

Figure 12.26 *(above)*
A large Gorham punch bowl, bearing the date mark for 1899. The design on both pieces match, but the very large ladle, with the design appearing on a smaller area, is fantastic — a work of art. The bowl has a turned lip, and uses scrolls along with acorns and oak leaves for the carefully worked design. The front portion of the bowl has an area for a monogram that is set off by a beautiful series of connected scrolls. *Courtesy of Michael Weller, Argentum Antiques*

Figure 12.27 *(below)*
Spectacular! This might be the most magnificent cut glass intaglio punch bowl to be displayed for some time. The crystal was done by T. J. Hawkes and Company of Corning, New York. The silver rim was made by Gorham of Providence, Rhode Island. Majestically flowing iris flowers and leaves cover the bowl in an Art Nouveau style. The silver rim undulates around the top of the bowl and protects the glass from being damaged by the punch ladle. The rim itself has an applied cluster of foliage. This outstanding piece is 10 1/2 inches high and a massive 21 inches in diameter. *Courtesy of Butterfield and Butterfield*

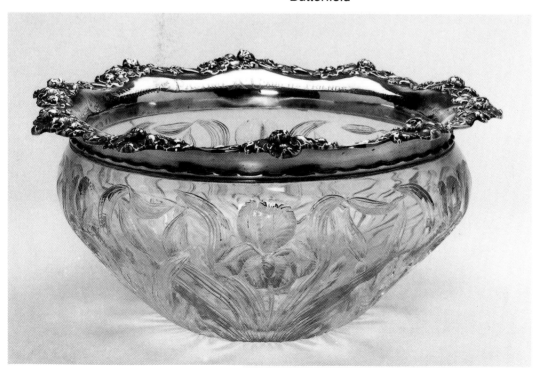

9.10

11.8

12.9b

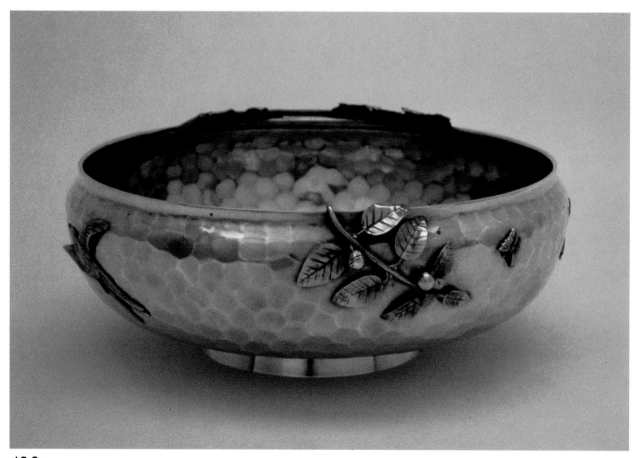

12.9c

178

12.17a

12.17b

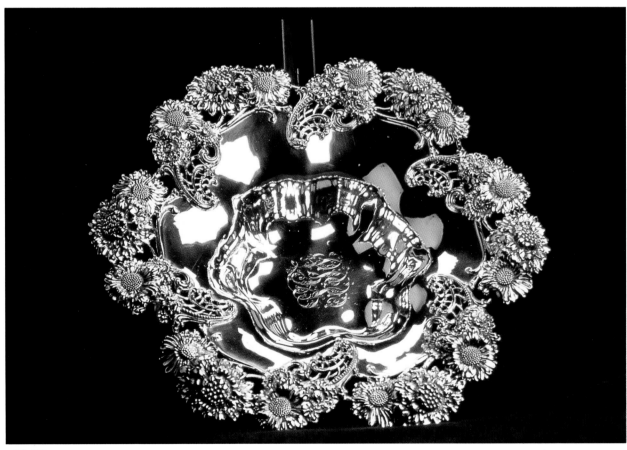

12.18

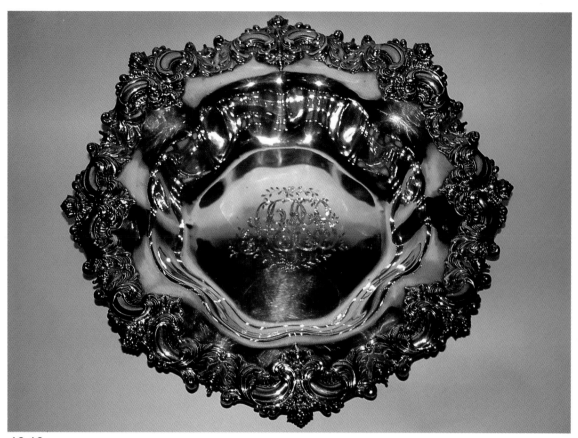

12.19

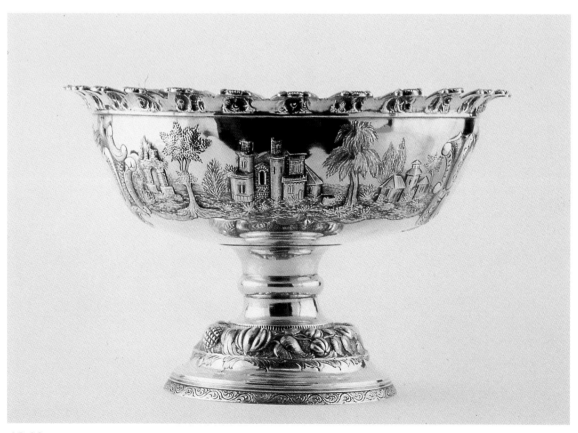

12.20a

180

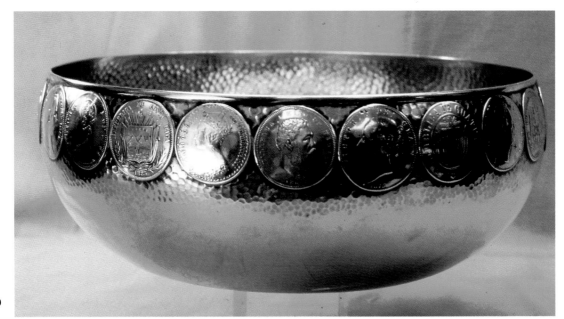

12.21b

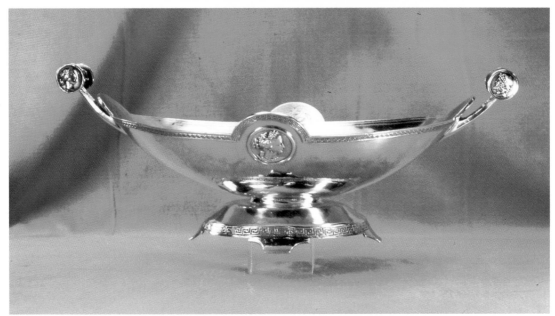

12.21c

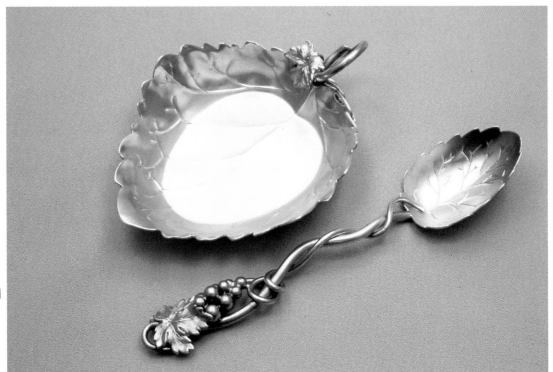

12.21d

181

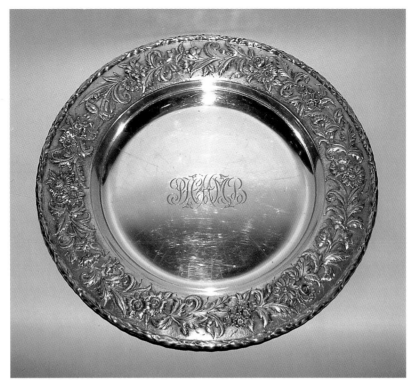

13.13

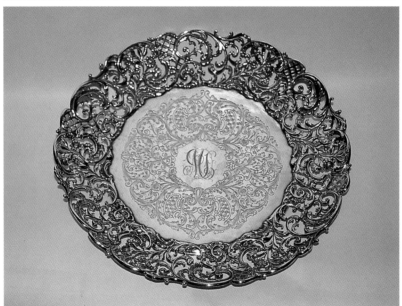

13.14

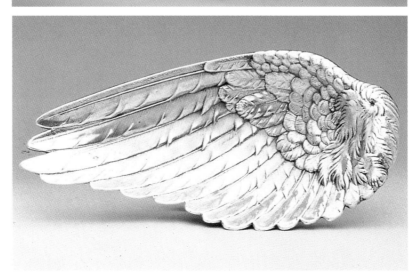

13.18a

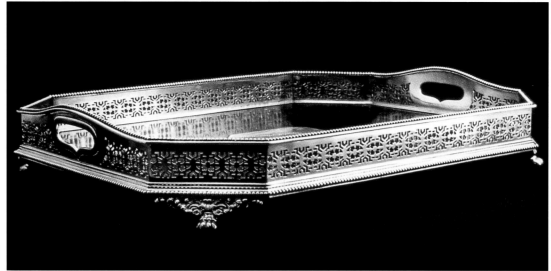

13.22

13.23

14.3b

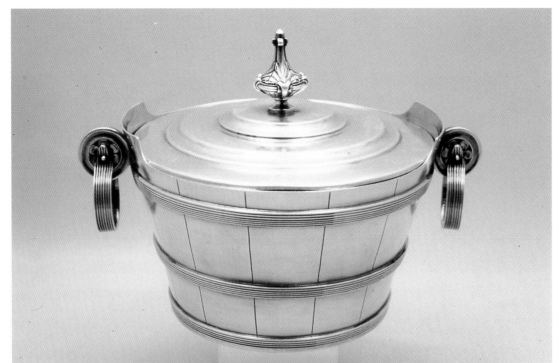

14.7

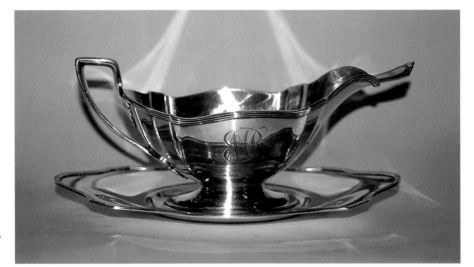

15.5a

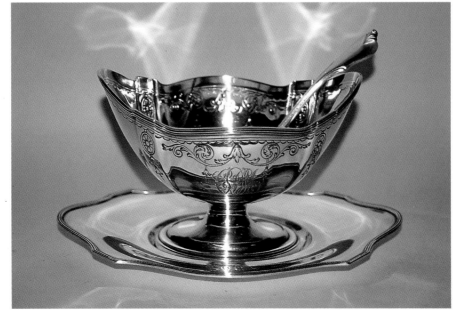

15.5b

184

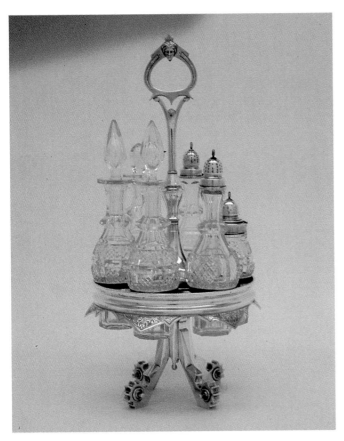

16.2b

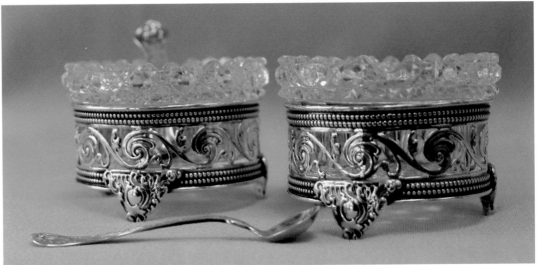

16.7

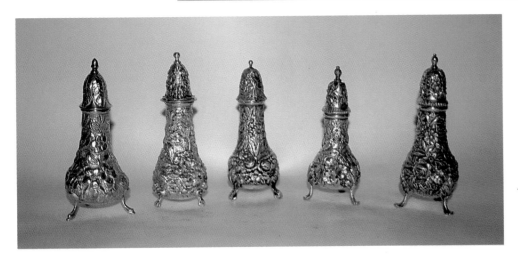

16.13

185

16.18

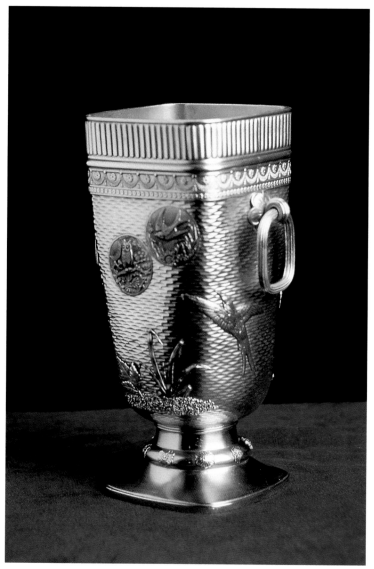

17.1

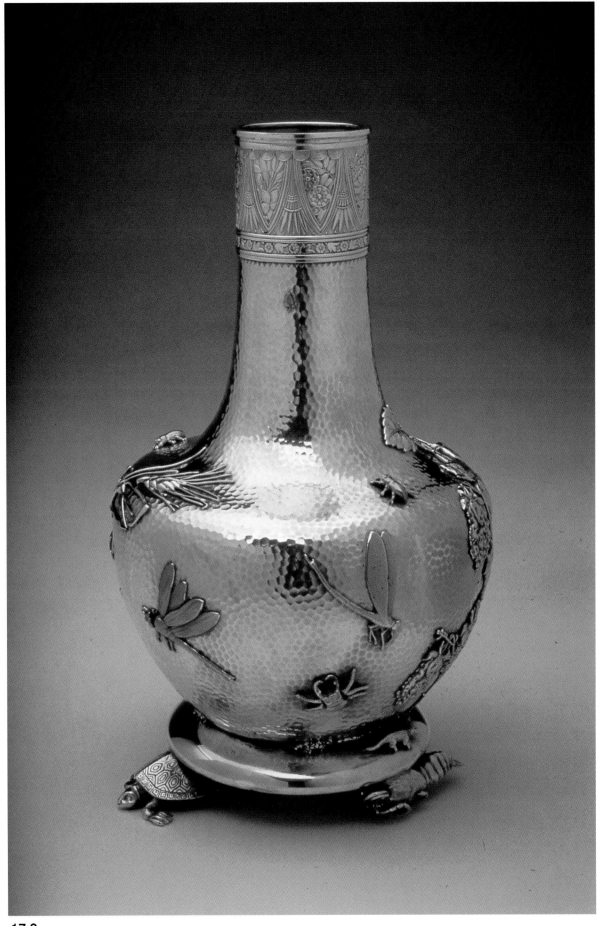

17.2

17.3

17.4

18.5

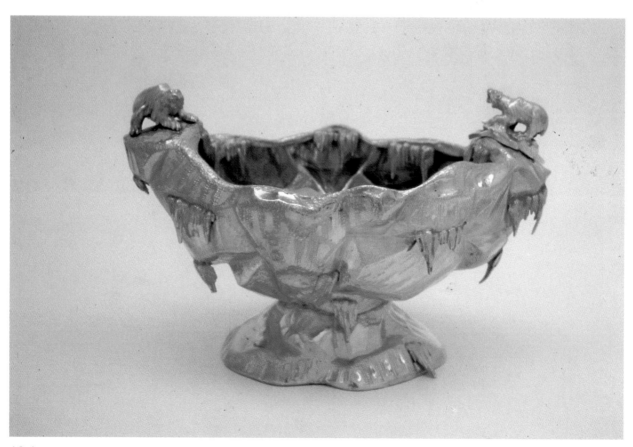

19.1

190

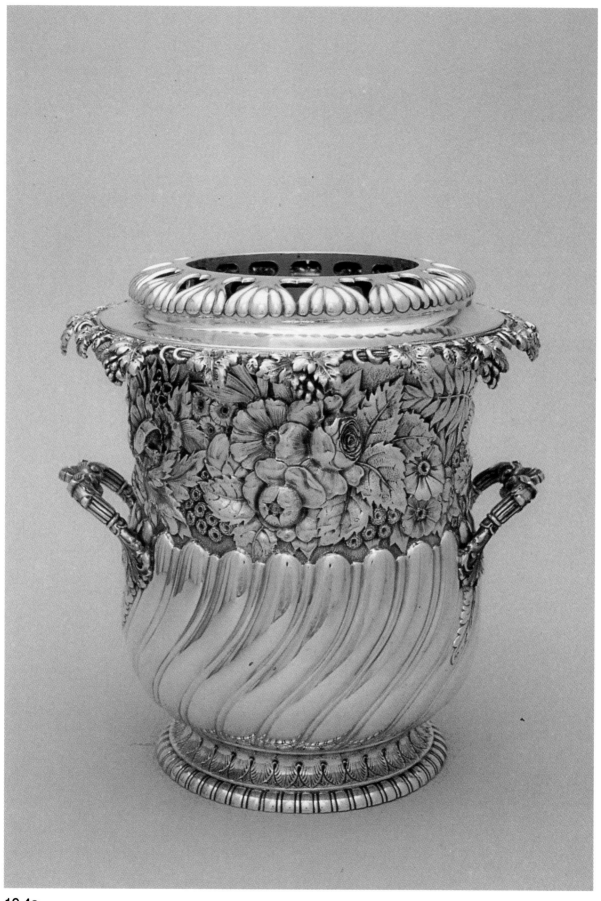

19.4a

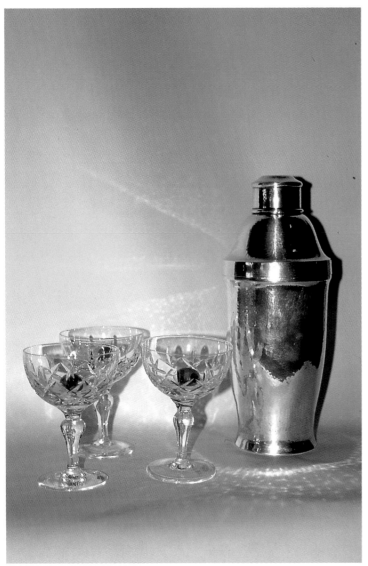

19.6

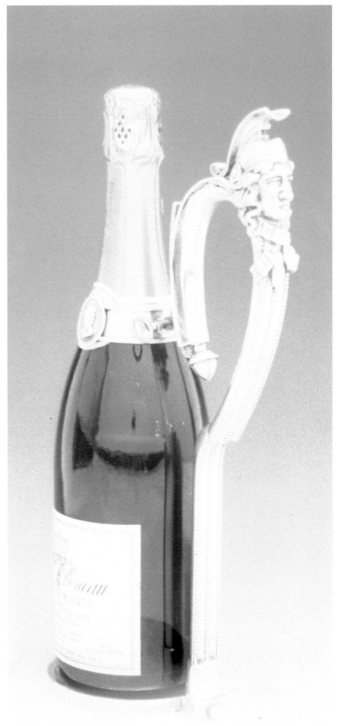

19.7

Chapter 13
Trays and Platters

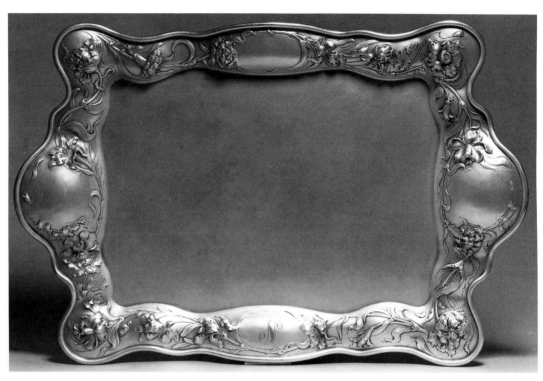

Figure 13.1
A very large tray from circa 1900, made by the firm of Dominick and Haff. The form of this piece is somewhat in Gorham's Martelé style. The flowers, swirls, and leaves combine to form a most beautiful. The present owners of this tray have had a wooden stand made so that the tray forms the top of a table. It can be removed for serving or for cleaning. *Courtesy of Constantine Kollitus and Phyllis Tucker Antiques*

Most trays are associated with the serving of coffee and tea, or with the serving of specific foods. Often they have a design on them, engraved or (more usually) chased. This provides protection against the marks and scratches that can easily be inflicted upon a tray while in use. Still, some owners cover the surface of the tray with small doilies, or place one under the foot or base of each item on the tray. Trays can be rectangular, square, or round, with or without handles. Sometimes handle grips are cut into the wide lip of the tray, or they are made separately and then attached to the lip.

Many manufacturers made their trays to coordinate with a particular flatware pattern; in other cases, the hollowware brought about the design of a flatware pattern. Each hollowware and flatware pattern has not enjoyed equal success. Gorham's *Plymouth* holloware has been produced for almost a century, but the corresponding flatware pattern has long been inactive. Gorham's *Chantilly* pattern, on the other hand, has been unparalleled in both its flatware and hollowware incarnations.

Platters are slightly different. They were first used to serve roasts or to bring a turkey into the dining room to be carved for the guests. As such, they came in a wide range of sizes. Kirk made oval platters in 15-, 17-, 18-, and 20-inch sizes, according to their 1938 catalog. Stieff made their platters in 14-, 16-, 18-, 20-, and 22-inch sizes, as shown in their 1920 catalog. Other types of platters made by Kirk were round, known as "entree platters." Well and tree platters have a design which allows the meat juices to drain from the joint of meat and to collect in a "well" at one end of the tray.

Since carving meat on a silver tray will result in knife scratches, some hosts and hostesses prefer to carve the meat in the kitchen and place the meat on the tray, especially helpful at a buffet table. At times, manufacturers made wooden inserts that could be placed into the well of the platter, avoiding the damage caused by a knife blade on a silver surface. Some of the protective wooden inserts had a plain surface on one side, and a well and tree on the other.

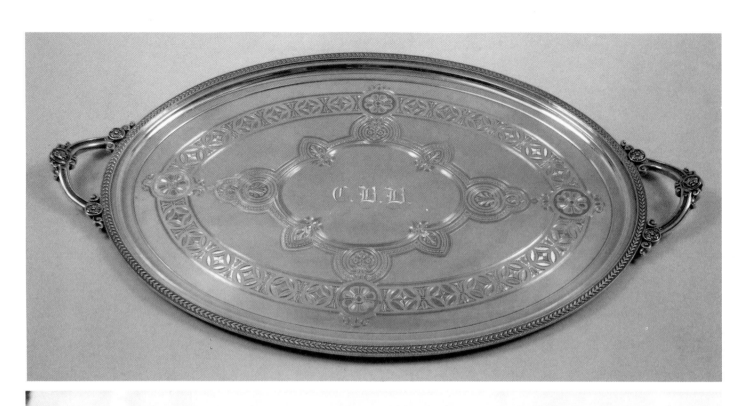

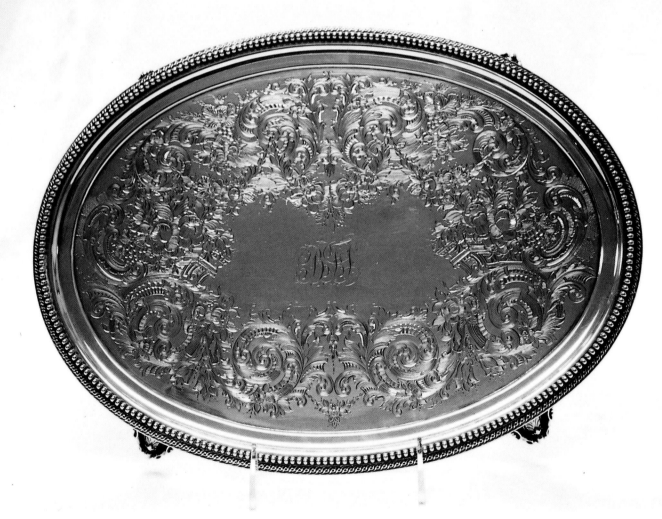

194

Figure 13.2 *(opposite page, top)*
A tray made by Wendt and retailed by Ball, Black and Company, circa 1865. It measures 31 inches over the handles and weighs in at 140 ounces. The tray's surface is chased, with a monogram in the center of the tray. The chased design and the handles are decidedly of Victorian origin. *Courtesy of Constantine Kollitus*

Figure 13.3 *(opposite page, bottom)*
A footed tray by Vanderslice, in coin silver. The strong beaded edge is followed by an unadorned section of silver, which helps to make the engraved central portion really stand out. The very center of the design leaves room for a beautiful script monogram. *Courtesy of Sherry Langrock, Silver Crest Antiques. Photography by Debbie Cartwright*

Figure 13.4 *(below)*
A tray made by Peter Krider circa 1865 in Philadelphia. The beautiful handles are in a palmette design, and make a strong statement. The central portion, engraved in typical Victorian design, provides a great platform to display a tea set.. The double row of design on the edge of the tray gives a masculine feel to this section of the tray. Again, a narrow band of plain silver adds depth to the chased center portion. At the very center of this tray, in a large oval mirroring the shape of the tray, the name "Margaret" has been engraved. *Courtesy of Michael Weller, Argentum Antiques*

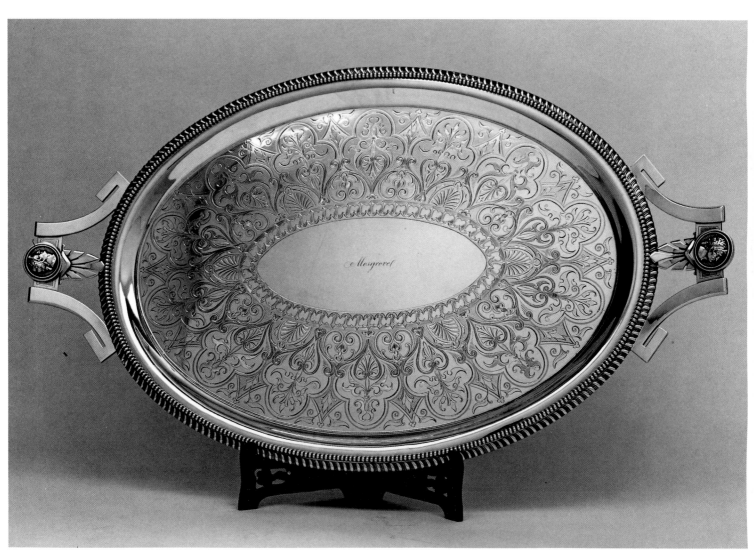

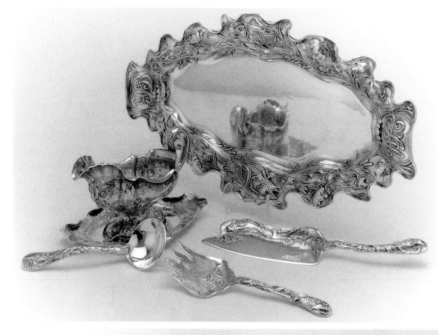

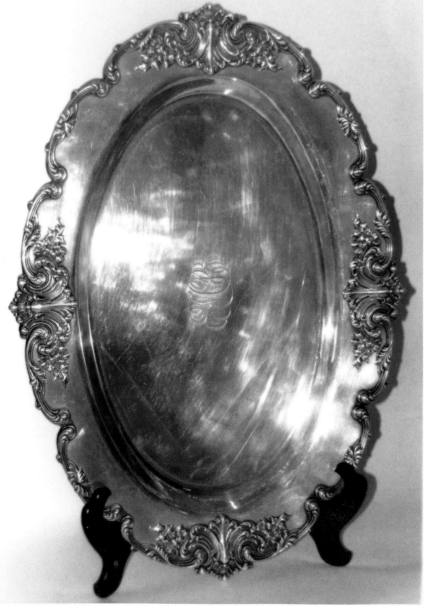

Figure 13.5 *(left)*
A fabulous Gorham Martelé fish set, complete with a fish platter, a sauce boat and stand, a sauce or gravy ladle, a fish serving fork, and a fish serving knife. Seldom does one find such a complete set of this quality; the workmanship on these pieces is superb. The lip of the sauceboat has a face that resembles a fish. The silversmith has used an occasional scroll as if a seashell were present. Other elements of the design appear to be seaweed. The date mark of 1903 is chased into the right end of the tray. Other pieces indicate that the original owner purchased the items at approximately one year intervals. Note the unusual placement of the monogram on the right side of the tray. In addition to these pieces, the set includes a dozen all-silver fish forks and all-silver fish knives. *Courtesy of Phyllis Tucker Antiques. Photography by Hal Lott*

Figure 13.6 *(below left)*
A large meat tray that was retailed by Galt and Brothers in the 1890s. It is 21 inches long and 15 inches wide. A turkey served on this platter would long be remembered by the family and invited guests. For its age, this piece has very few knife marks to mar its surface; clearly it has had excellent care.

Figure 13.7 *(opposite page, top)*
Three examples, all made by Whiting. Since so many items were made in this design, the pattern must have had a specific name at one time, but it has long been forgotten by the family that owns these items. The main platter is 16 inches by 11 1/2 inches long and is identified by the number 2616. It has a monogram in the center of the dish. The vegetable dish is small, 9 1/2 inches by 6 3/4 inches, and bears the number 4029. Note the placement of the monogram on the rim of the vegetable dish. A 6-inch bread-and-butter plate is shown here, since it does match the other pieces. It has the Whiting mark and the number 2620.

Figure 13.8 *(opposite page, bottom)*
A Kirk meat platter in the *Mayflower* pattern, 18 inches long. It bears the number 4118AM on the reverse. The beautifully engraved design on the rim of the platter adds a distinctive elegance. This piece would be an excellent candidate for a wood insert, to protect the highly polished center.

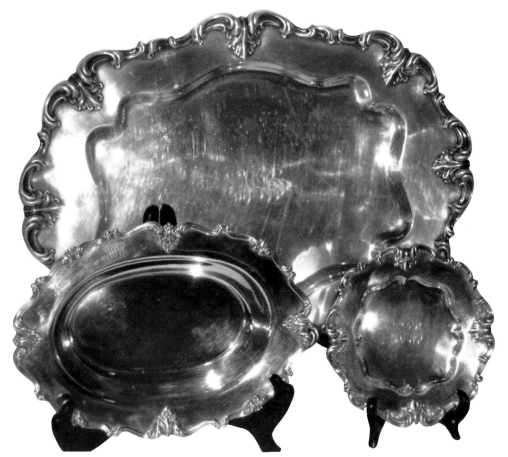

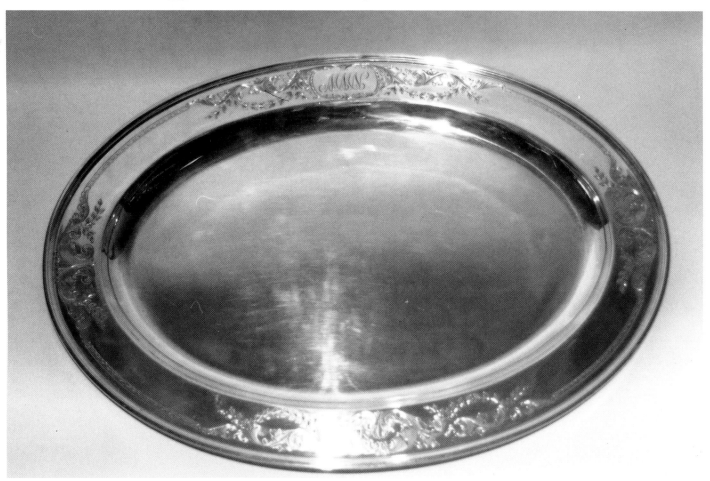

197

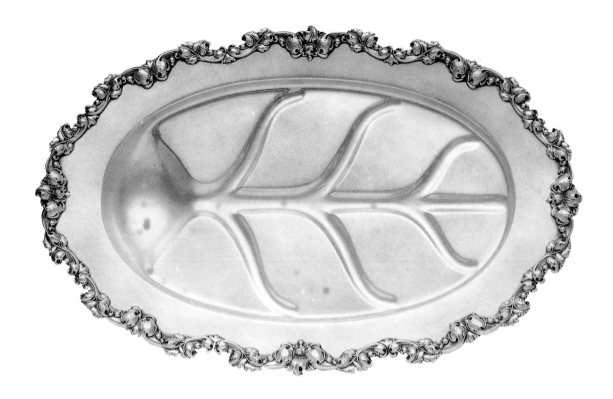

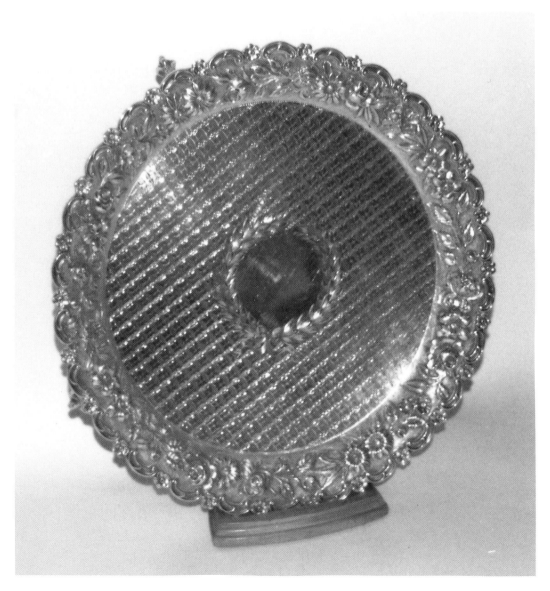

Figure 13.9 *(opposite page, top)*
A meat platter by Frank Smith, typical of the well and tree design. The edge has a beautifully applied border design. The deep well would serve to collect meat juices. *Courtesy of Silver Magazine, Connie and Bill McNalley*

Figure 13.10 *(opposite page, bottom)*
A round, footed tray by A. G. Schultz and Company of Baltimore, Maryland, with a delightful diapered design. A similar design can be seen in Figure 13.15 and Figure 7.21, all made by different silversmiths from the South. This tray is 10 inches in diameter with a floral border in repoussé. The center area is devoid of a monogram. *Courtesy of Maxine Klaput Antiques*

Figure 13.11 *(below)*
A round Kirk tray bearing the number 1927 on the reverse side. The border has castles and scenes in delicate repoussé work. This picturesque work is representative of Kirk's *Tuscan* design. The center of the tray is engraved. This tray weighs approximately 16 ounces and is 12 inches in diameter. *Courtesy Maxine Klaput Antiques*

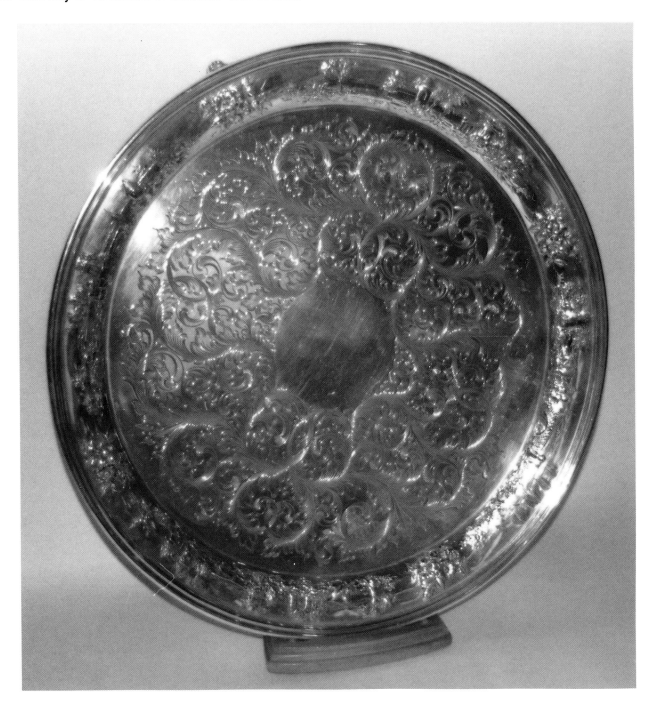

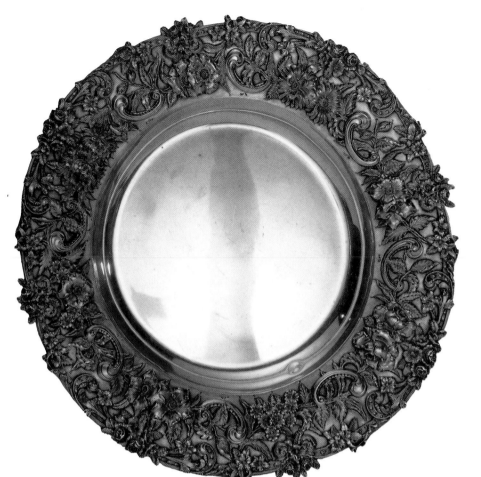

Figure 13.12a
A large round charger, circa 1903 to 1924. This piece exemplifies the fantastic repoussé work done by the silversmiths at the Kirk factory. The detail on each of the flowers makes this extremely fine and rare in American sterling work. The charger has a round body with an unornamented well and a high-relief border of repoussé work, and hand-chasing on a matte background. The decoration consists of many different floral examples interspersed with foliage and C-scrolls. The charger is 15 3/4 inches wide and weighs 52 ounces. *Courtesy of Phyllis Tucker Antiques. Photography by Hal Lott*

Figure 13.12b
A piece of "sideboard silver" from Tiffany. This 9 7/8-inch tray was a display piece, and Tiffany records show that it was made to order in 1883 at an exceptionally high cost for that time. The expense was largely due to the fine acid-etched design. The piece must commemorate a northern expedition or be related to the Alaskan pieces discussed in Chapter 20. *Courtesy of Phyllis Tucker Antiques.*

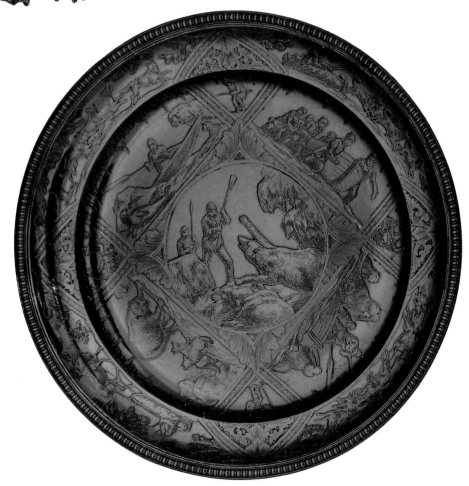

Figure 13.13 *(see photo on page 182)* A round entree dish by Kirk in the *Repoussé* pattern, 13 inches in diameter. The piece is marked with "#2503" on the reverse; also appearing are the words "Hand Decorated," indicating that instead of being machine stamped, the design was entirely worked by hand. Comparing hand-decorated and machine-stamped work makes this distinction obvious.

Figure 13.14 *(see photo on page 182)* A round tray by Black, Star, and Frost, 11 3/8 inches in diameter, bearing the number 7238. The delicate engraved center is in marked contrast to the pierced floral border. Close examination of this tray from all side and angles is the only way too truly appreciate the craftsmanship that existed when it was made. All areas were carefully done and every possible detail to clarify a flower petal, leaf, or scroll has been added. According to Rainwater, the mark "Black, Star and Frost" indicates manufacture between 1876 and 1929, after which the name was changed to "Black, Star and Frost Inc."

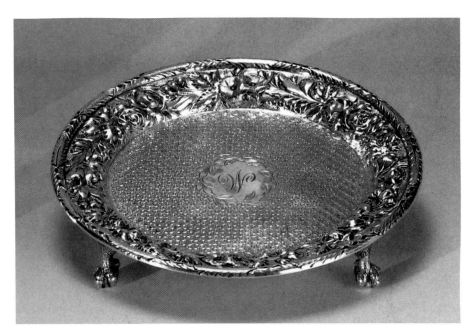

Figure 13.15
This small footed salver by Andrew Ellicott Warner, Jr.in Figure 13.15 is 6 inches in diameter, weighs 11 ounces and was made about 1875. The Warner firm also made silver with the Repoussé style and between this firm and Kirk much early silver in this style was made. This tray could be used to collect calling cards, important in Victorian etiquette, or be used under a pitcher to collect water condensation. The center around the monogram area is called a diapered design, and is engraved. *Courtesy of Sherry Langrock, Silver Crest Antiques. Photography by Debbie Cartwright*

Figure 13.16
A 6 inches-square tray sold by Galt and Bros. in the 1890s. The heavily designed border incorporates scrolls, flowers and leaves. The large monogram is most impressive. It is attributed to Justin Morrill, a Vermont senator for almost fifty years. He is known for the federal Land Grant College Act of 1861, which started agricultural colleges in every state. Morrill realized that new methods of farming were necessary for the westward expansion, since methods used on small, hilly New England farms did not work for the wide open spaces of the West. *Courtesy of Maxine Klaput Antiques*

Figure 13.17 *(above)*
A Reed and Barton bread tray in the *Silver Wheat* pattern. It was manufactured in 1954, as noted by the date marks on the reverse side of the silver. It is 11 inches long and 5 7/8 inches wide. On the reverse the number x271W appears.

Figure 13.18a *(see photo on color page 182)*
An unusual winged tray, made circa 1870 by Whiting. The tray measures 12 inches long. The fine detail makes each feather stand out. *Courtesy of Phyllis Tucker Antiques*

Figure 13.18b *(right)*
A 9-inch triangular tray with engraved decorations, in perfect condition. It may have been a card receiving tray, and was made by Whiting. The design is very typical of the Japanese movement of the 1880s. *Courtesy of Phyllis Tucker Antiques and Constantine Kollitus. Photography by Hal Lott*

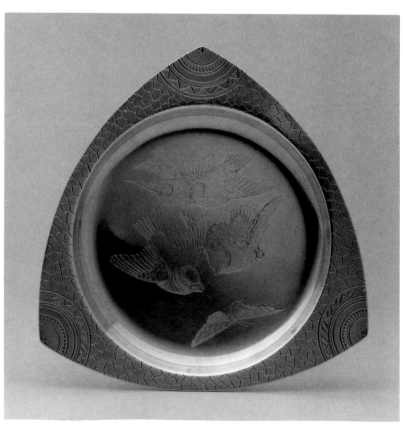

Figure 13.19 *(above)*
A bread dish with grapes, 11 1/4 inches by 7 inches, made by Mauser Manufacturing Company. According to Rainwater, this company began business in Attleboro, Massachusetts in 1887 and moved to New York in 1890. In 1903 they merged with a number of firms, which were purchased by Gorham in 1913 and moved to Providence, Rhode Island. The grape design would date this piece close to 1900.

Figure 13.20 *(below)*
A Gorham bread tray measuring 13 3/4 inches by 6 1/2 inches. The beautiful edge suits the design well. A monogram in the center is very typically placed. The tray weighs 11 ounces. *Courtesy of Maxine Klaput Antiques*

Figure 13.21 *(above)*
A hand-wrought sterling pentafoil tray, made by the Kalo shops. It measures 12 3/8 inches in circumference. The base is flat, but the sides have a slight curve. The tray weighs slightly over 23 ounces. *Courtesy of Butterfield and Butterfield*

Figure 13.22 *(see photo on color page 183)*
A magnificent Tiffany footed gallery tray from the 1890s, with a pierced border. The 28-inch tray has a mahogany bottom with a large silver plaque in the center. The plaque is engraved with a romantic inscription from a lady to a gentleman. *Courtesy of Phyllis Tucker Antiques*

Figure 13.23 *(see photo on color page 183)*
A two-part cheese tray and cheese serving knife, in Gorham's *Chantilly* pattern. The cheese tray is the exact same size as the individual bread dishes, differing only in the added silver mounts for the cheese knife. These two items were made sometime after World War II.

Figure 13.24 *(opposite page, top)*
A cheese dish made by Gorham in 1871. A small mouse peers over the edge of the bowl at the top of the shell. The added scrolls helps form a handle. This piece is 6 3/4 inches in diameter. Compare this dish with the cheese tray in Figure 13.23, made by the same company almost a hundred years later. *Courtesy of Phyllis Tucker Antiques*

Figure 13.25 *(opposite page, bottom)*
Beautiful bread trays made by Kirk circa 1900, marked "925 sterling." They are excellent examples of the work that was done by the silversmiths at Kirk's The repousséd flowers and beautiful rim scroll design are unusual. *Courtesy of Michael A. Merrill, Inc., Baltimore, MD*

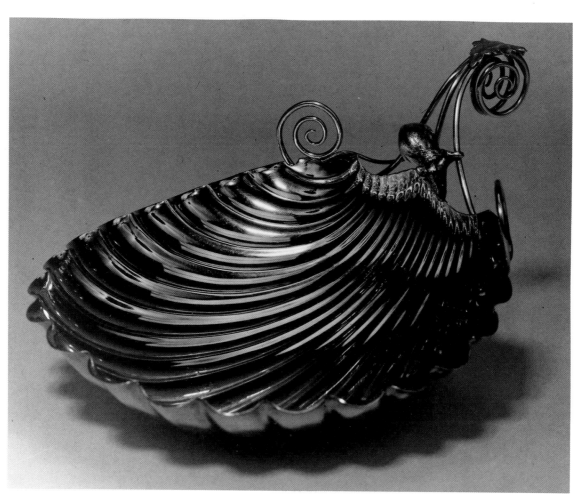

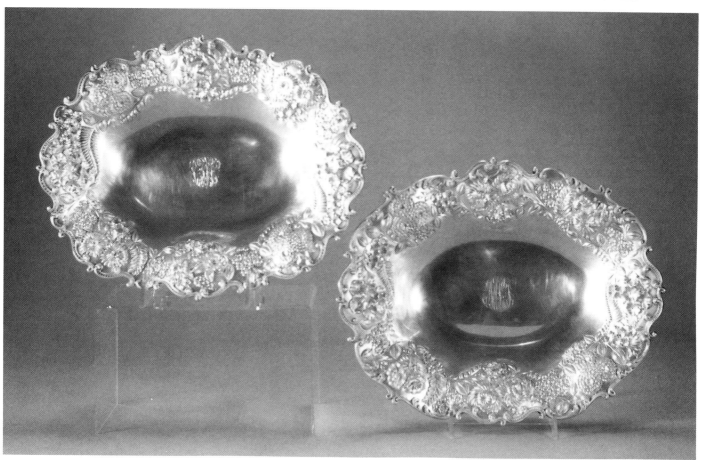

Chapter 14
Butter Dishes

American cooking in the past called for tremendous amounts of butter. Though margarine made its appearance during World War II, there was no substitute for butter when most of the silver shown in this book was produced.

In order to use butter in the large one-pound blocks in which it was generally sold, a dish was invented that not only helped with the presentation at the table, but was a necessity. Most old butter dishes consist of three silver parts: the lid, the pierced liner, and the base. Butter was placed on the liner, allowing excess water from the butter to drain through the piercing; if the weather was warm, ice was added with the butter on top, and the melting ice could drain through the piercing.

For fancy dinners, the hostess may have had one of the servants make fancy molded pieces of butter called "butter pats" or butter balls, which were served on crushed ice in the butter dish to be picked up with a butter pick. These required yet another butter serving piece, itself known as a "butter pat." Butter pats were tiny plates placed at each individual setting, to be used for a single piece of butter. They range in diameter from approximately 2 5/8 inches to about 3 1/4 inches, and were made in sterling as well as in porcelain. Many sterling silver companies produced butter pats to match their sterling flatware patterns.

As butter began to be commercially produced for distribution in individually wrapped quarter pound cubes, the large pound form became obsolete. Thus the butter dish began a new form. This new dish usually had a crystal liner, to protect the silver from the salt used in making the butter. Most of the new butter dish forms are 8 to 9 inches long.

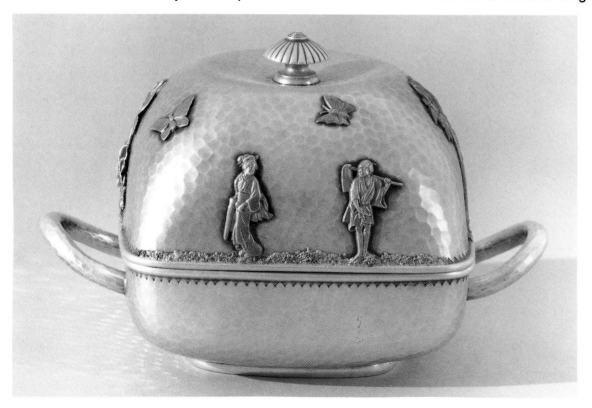

Figure 14.1
A simple, elegant butter dish, capturing the essence of the Japanese style. The dish is 6 3/4 inches long and 4 1/14 inches high. The copper figures are applied to hand-hammered sterling silver. The butterflies and the finial contribute to the overall design. *Courtesy of Constantine Kollitus*

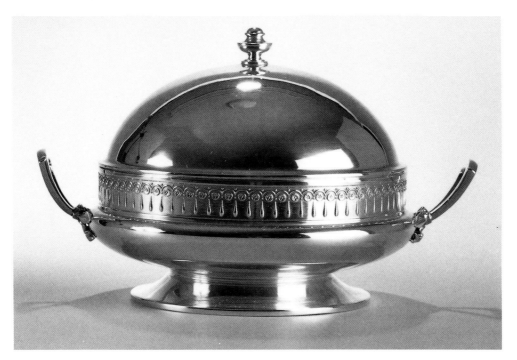

Figure 14.2 *(above)*
A three-piece butter dish from Gorham, with a separate liner. The Gorham year mark for this item is 1872. The very simple lines of the butter dish, the upturned handles, and simple finial make this piece very refined, while the delicate banding on the bottom imparts an air of elegance. *Courtesy of Sherry Langrock, Silver Crest Antiques. Photography by Debbie Cartwright*

Figure 14.3a *(below)*
A covered butter dish and tray by S. Kirk and Son, bearing the 11 ounce mark, placing its date of production between 1846 and 1861. The flower finial appears to rise from the heavily repousséd cover, which has delicately reeded. A row of small beading at the bottom of the communicates that the tray is separate from the butter dish. *Courtesy of Sherry Langrock, Silver Crest Antiques. Photography by Debbie Cartwright*

Figure 14.3b *(see photo on color page 183)*
A *Repoussé* butter pat, shown with a Wedgwood plate in the *Bianca* pattern. The sterling butter spreader is by Gorham in the *King Edward* pattern. An elegant monogrammed linen napkin awaits use.

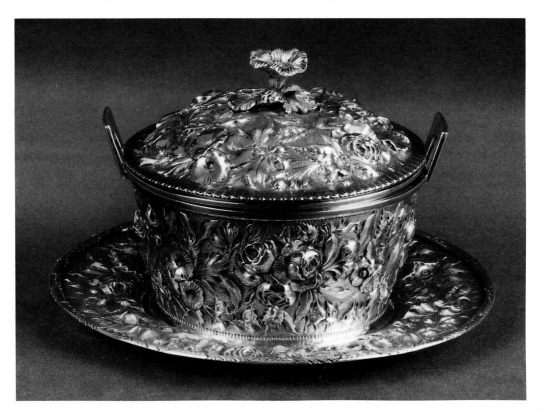

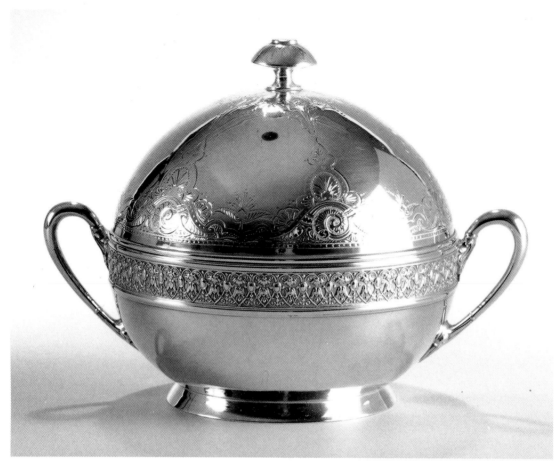

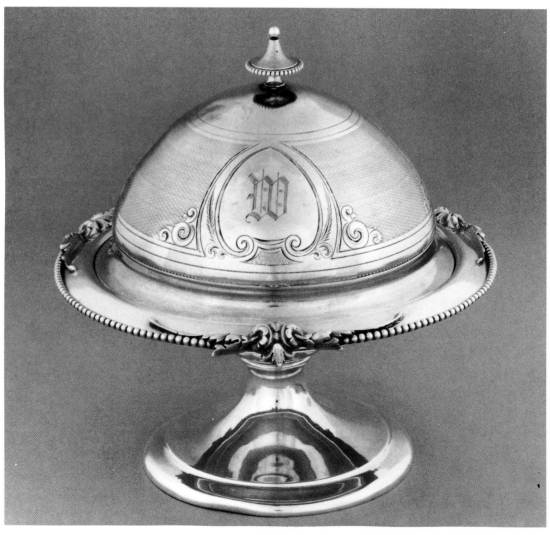

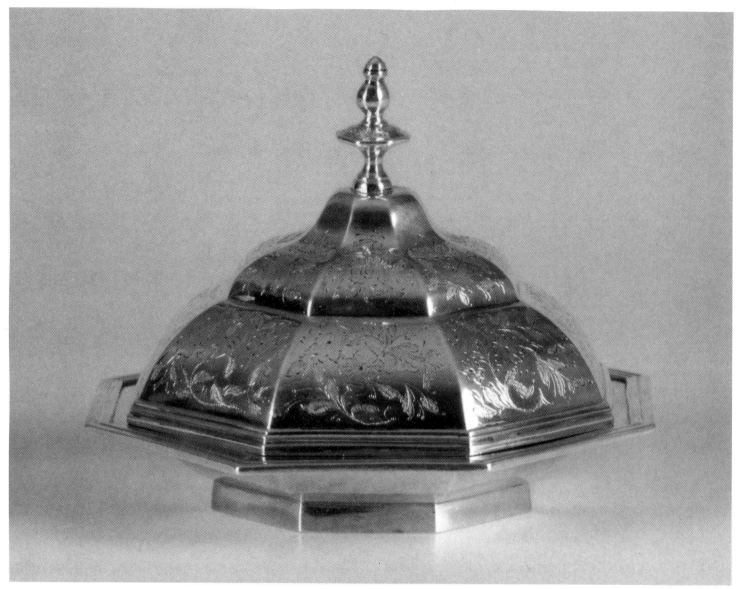

Figure 14.4 *(opposite page, top)*
A covered butter dish by Wendt, circa 1865. It is round, with handles that are similar to those found on cups. The petals on the finial are slightly flaring, making it easy for the user to hold securely. The design on this dish is on both the top and the bottom of the dish. The small die-rolled design on the bottom matches the larger engraved design on the lid. *Courtesy of Sherry Langrock, Silver Crest Antiques. Photogaphy by Debbie Cartwright*

Figure 14.5 *(opposite page, bottom)*
An unusual coin silver butter dish on a stand, made by Gorham between 1856 and 1859. The mark — featuring a lion that is facing left — is an early mark of the company. The lid contains a monogram. There is beading on the finial and around the edge of the base. The beaded design is broken up three scrolled ornaments, which divide the edge into three parts. *Courtesy of Sherry Langrock, Silver Crest Antiques. Photography by Debbie Cartwright*

Figure 14.6 *(above)*
A covered butter dish with an unusual shape, and a liner bearing the marks of Low, Ball and Company, circa 1840. The company is known today as Shreve, Crump and Low, Incorporated. This piece weighs 22 ounces and contains the inscription "Whitney" on the reverse lip. The octagonal shape of the dish and the beautiful engraving add to the overall look it presents. The finial is large enough to assure that the user will get a good grip on the lid. *Courtesy of Sherry Langrock, Silver Crest Antiques. Photography by Debbie Cartwright*

Figure 14.7 *(see photo on color page 184)*
A round butter dish, without a liner, known as an "English butter tub." The heavy finial provides easy access to the butter. The side rings help in lifting the entire dish. *Courtesy of Michael Weller, Argentum Antiques*

Chapter 15
Gravy & Sauce Boats

During the elaborate Victorian dinner, many courses called for gravy or sauce. The silversmith made a variety of shapes and forms designed to serve all types of gravies and sauces. The typical gravy boat can be described as an elongate pitcher with a handle. Most gravy boats have a separate tray, but many are simply one-piece, a tray and pitcher either molded or soldered together. Each style has its advantage. Sauce boats are smaller than gravy boats.

Most boats have a matching gravy or sauce ladle, depending upon the vessel and the contents that it is to serve. Some boats have feet in the form of shells or scrolls, while other stand on simple applied feet or a pedestal base.

Figure 15.1 *(opposite page)*
A pair of Gorham sauce boats, circa 1872. The flat pedestal base is unusual, as is the placement of the round handles and the design at the back of the boats. The delicate edge at the top and bottom of these pieces is important to the overall design, and is referred to as "vermiculure." *Courtesy of Michael Weller, Argentum Antiques*

Figure 15.2 *(below)*
A gravy boat by William Forbes of New York City, a magnificent example of the silversmith's art. The pattern of the C-scroll handle with its decorative edge is continued onto the body of the piece. The base, in the form of a pedestal, has decorations on the top and bottom adding to the overall beauty of this gravy boat. *Courtesy of Michael Weller, Argentum Antiques*

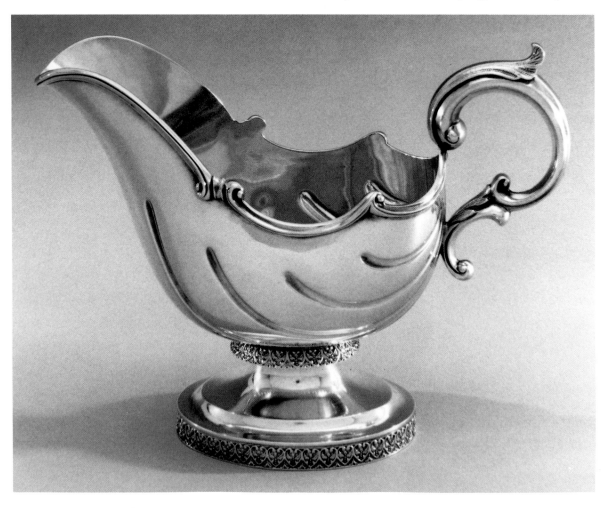

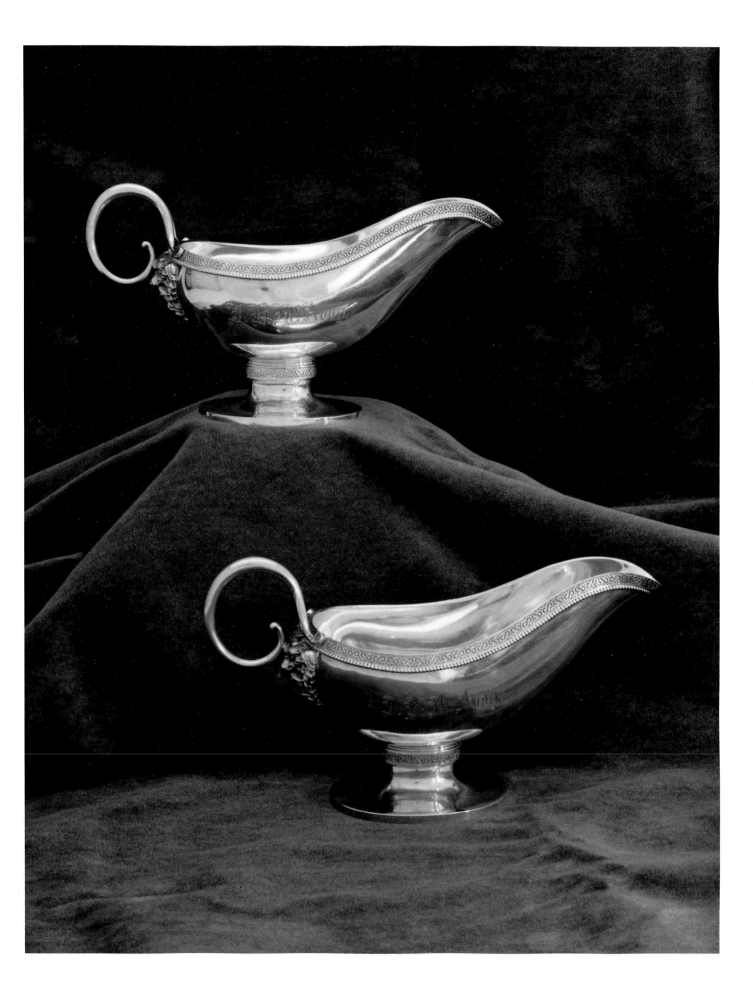

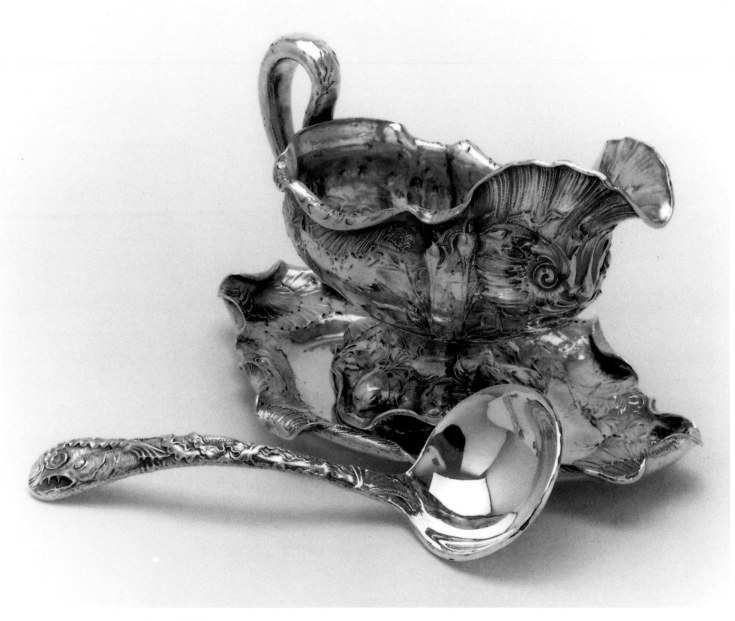

Figure 15.3
A gravy boat, stand, and gravy ladle by Gorham in their Martelé line. The delicate lines embellish all that is representative of Martelé. This particular boat is part of a fish set seen in its entirety in Figure 13.5. The fish face on the front of the boat is very unusual. The undulating rim of the boat and stand recall the waves of the ocean. *Courtesy of Phyllis Tucker Antiques. Photography by Hal Lott*

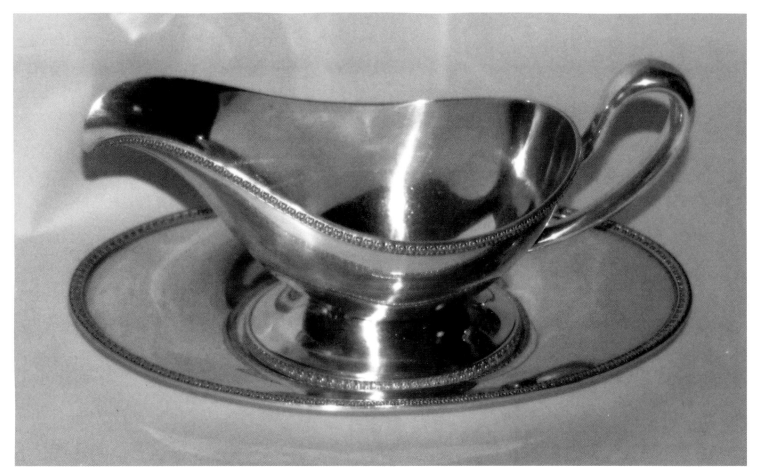

Figure 15.4
A gravy boat and loose stand in two separate pieces. They were made by International Silver Company and sold in 1938. The stand is 8 9/16 inches by 4 15/16 inches and weighs about 8 ounces. It is marked "G 54-3." The boat is 8 1/16 inches from the tip of the boat to the end of the handle. It weighs about 11 ounces and has the mark "G 4-3."

Figure 15.5a *(see photo on color page 184)*
A sauce boat and unattached tray in Gorham's *Plymouth* pattern, bearing the date mark for 1915. The boat is 3 5/8 inches high and the stand is 8 5/8 inches by 5 3/8 inches. These two items are in the Colonial Revival style and represent only a small portion of the available Gorham *Plymouth* line. The tray is very utilitarian. It is used in Figure 6.7 as a tray under the teapot. It also be combined with the waste bowl of the tea and coffee set to improvise another gravy boat, as seen in Figure 15.5b.

Figure 15.5b *(see photo on color page 184)*
The tray from the sauce boat in Figure 15.5a, here used to form a gravy boat with the waste bowl from the five-piece tea and coffee set in the same pattern (Gorham's *Plymouth*). The gravy ladle is Wallace's *Grand Colonial*. The waste bowl in most tea sets is limited in its usage, but in this pattern it is not.

Chapter 16
Condiment Containers

For centuries, condiments were necessary because of the lack of refrigeration. Even when used expediently, meat sometimes had begun to spoil by the time it reached the dinner table; spices, vinegars and oils were used to hide the pungency of the spoiling meat. In addition, salt and pepper on food were an absolute necessity at the Victorian table. This section includes an array of items made for servng these condiments, ranging from fabulous sterling cruet sets to various salt and pepper receptacles.

The basic condiment set began with salt and pepper servers; next a mustard jar would be added. Other containers, called cruets, were then added, in various sizes. These were generally used for a variety of vinegars and oils. Another serving piece was the muffineer, a caster that held sugar or any other condiment meant to be sprinkled onto foods.

Salt was usually served in open containers, sometimes referred to as a salt cellar or salt stand. Some salt containers had glass liners to help prevent the corrosion that begins when silver and salt come in contact with each other. A number of open salts are shown here, none of which with a liner.

Pepper has been a very important spice from before the Middle Ages up to the present time. During the Middle Ages it was prized above all other spices, according to Eileen Tighe, the editor of the *Woman's Day Encyclopedia of Cookery.* In Victorian days pepper was usually served from a pierced container referred to as a pepper cruet.

Mustard was an important condiment, warranting its own server. At the time that mustard pots were in favor (probably from the 1840s on), dry mustard powder was mixed with water to make a mustard paste, as prepared mustard in its modern glass or plastic jar was not yet available until the early 1900s. Mustard is extremely corrosive to sterling, causing a chemical reaction which results in heavy discoloration of the silver. Many mustard pots have glass liners to prevent this. Gold can also be used to provide a barrier; many old mustard ladles were gold-washed on the lower portion, where the silver would have touched the mustard.

The decoration of some condiment servers can be a clue as to the use of the item. For example, a server meant for chili pepper might sport a small chili applied in another metal to the side of the container. A honey pot (see Figure 16.9) might be in the shape of a beehive, with small applied bees incorporated into the design.

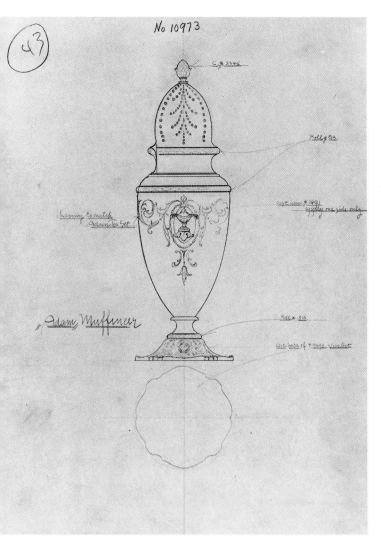

Figure 16.0
Shreve and Company's line drawing No. 10973 for a muffineer in the *Adam* pattern. The notes to the engraver are to match the *Adam* tea set. Casting parts are carefully noted, as well as what roll to use for the design. The line drawing at the bottom is the tracing for the base of their # 9493 sherbet dish. *Photography by Tom Wachs. Courtesy of Michael Weller, Argentum Antiques, San Francisco*

Figure 16.1
An attractive cruet set in Figure 16.1 consisting of glass containers in a coin silver stand, was manufactured by Gorham in 1868. The glass containers are all original to this stand, which is rare. So many times one or more of the bottles is broken, chipped or has a missing stopper or silver lid. This stand is 14 inches high and approximately 9 1/2 inches wide. The silver stand has an area for a monogram plus several figures and head that appear in regular fashion on the stand. The handle appears to have an Egyptian motif. *Courtesy of Constantine Kollitus*

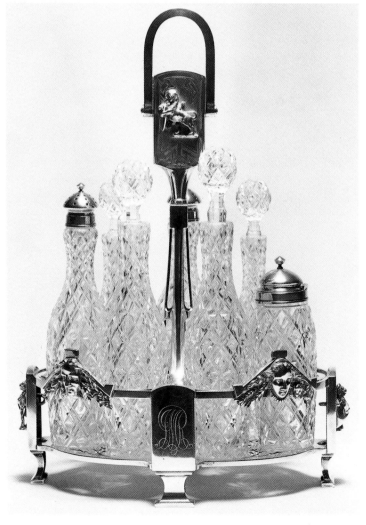

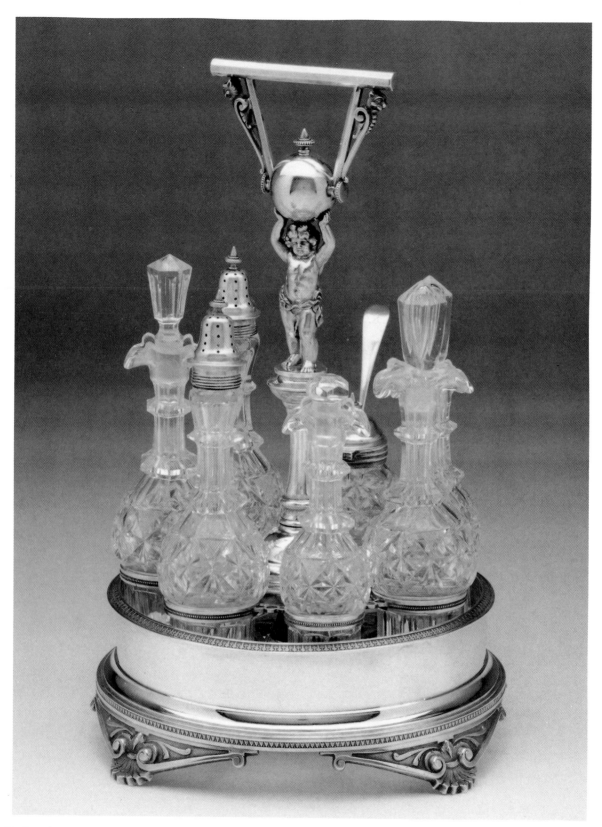

Figure 16.2a *(above)*
A fine cruet set made by the New York firm Wood and Hughes, circa 1865. The seven bottles in this set are all original. Those for vinegar and oil have pouring lips, while the mustard pot and two bottles have silver tops. The central support features an angel holding an orb above her head. The handle rises out of the orb. The feet and the width of the base provide a substantial look

to this outstanding cruet set. *Courtesy of Michael Weller, Argentum Antiques*

Figure 16.2b *(see photo on color page 185)*
A cruet set with feet that appear to be gears, made in the 1870s by Vanderslice and Company. The design style of the feet is referred to as "mechanistic." *Courtesy of Michael Weller, Argentum Antiques*

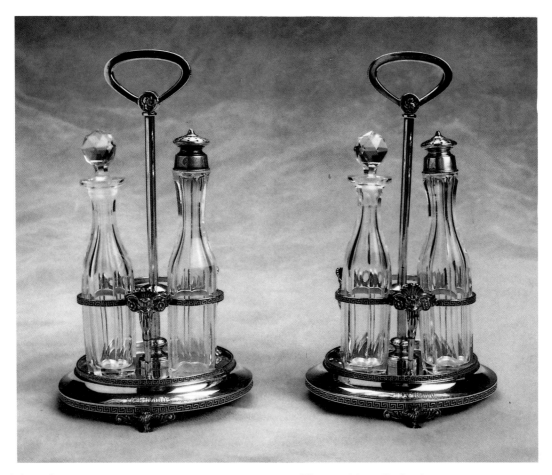

Figure 16.3 *(above)*
A pair of cruet sets sold by Tiffany and Company, each with three condiment bottles. The silver is of sterling grade and there are medallions applied to the stand. The base of the footed stand has a Grecian key design the width of the silver base. The bottles are very plain, but elegant. *Courtesy of Sherry Langrock, Silver Crest Antiques. Photography by Debbie Cartwright*

Figure 16.4 *(below)*
A pair of early salt dishes by Kirk, in their *Repoussé* pattern. The workmanship and the "11 ounces" mark dates them between 1846 and 1861. This particular pair of salts has a very unusual rim edge, in a design variation of the gadroon border. *Courtesy of Sherry Langrock, Silver Crest Antiques. Photography by Debbie Cartwright*

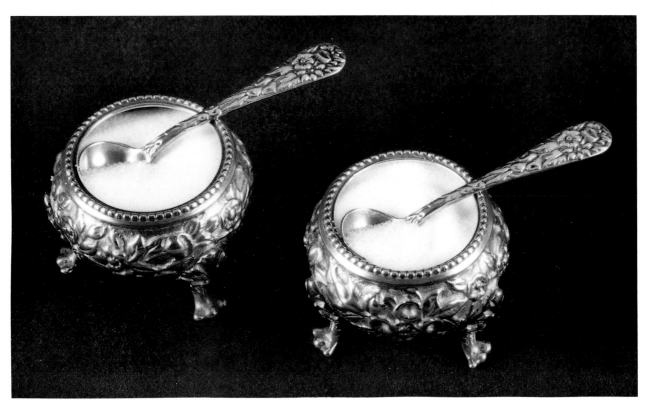

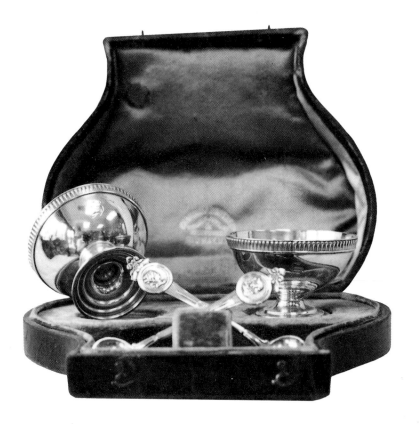

Figure 16.5 *(left)*
Rare Gorham master salts and *Medallion* spoons, resting in an original box. The box and the superb condition of these silver pieces suggest that the owner did not use this set very often. While it is unfortunate that some owners think their silver is "too good" to use often, the nearly new condition of their pieces makes them especially valuable for collectors later. *Courtesy of Sherry Langrock, Silver Crest Antiques. Photography by Debbie Cartwright*

Figure 16.6 *(below)*
A pair of coin silver master salts on single pedestal bases, with beaded base and body rims, made by George Sharp. They were retailed by Bailey and Company between 1850 and 1855, and weigh 3.7 ounces. *Courtesy of Sherry Langrock, Silver Crest Antiques. Photography by Debbie Cartwright*

Figure 16.7 *(see photo on color page 185)*
A pair of salt dishes with sterling frames by Gorham and Company. The glass liner prevented a chemical reaction between the silver and the salt. Salt spoons were also included in sets similar to this. *Courtesy of Sherry Langrock, Silver Crest Antiques. Photography by Debbie Cartwright*

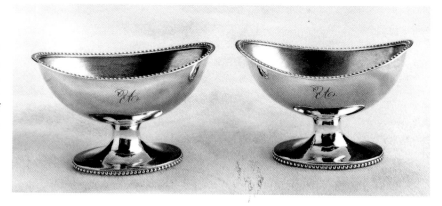

Figure 16.8
A set of mustard pots, each with a glass liner. The mustard pot on the left (with Whiting's *Lily* master salt spoon serving as a mustard spoon) is 2 1/4 inches high and has a clear liner. It is marked only as sterling. The mustard pot at center, 2 7/8 inches high with a cobalt liner, is also marked as sterling. The mustard pot on the right has a cranberry liner, is heavily pierced, and contains a mustard spoon marked as sterling. The pot bears the Wallace Sterling trademark, and is 3 inches high.

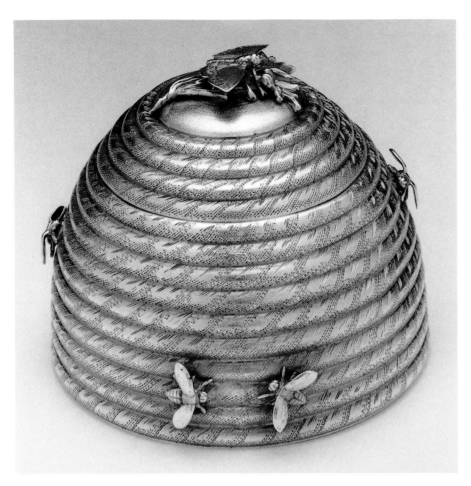

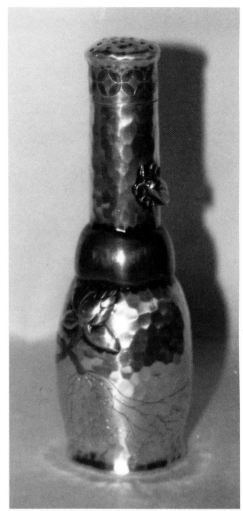

Figure 16.9 *(above)*
A honey pot made by Gorham in 1870 and retailed by Starr and Marcus. Each of the applied bees has exacting detail. They seem to be almost ready to fly off the hive. A great deal of care was taken in making the hive realistic as well, as it resembles a European straw skep. The fine rows have intricate detail, showing the effort that was put into making this outstanding honey pot.
Courtesy of Michael Weller, Argentum Antiques

Figures 16.10a, b *(above right and right)*
A condiment shaker, with a detail of its underside. This Tiffany piece is of mixed metal and dates to circa 1879. The pond lily appears to be gold, and the insect appears to be copper. The top of the narrow neck is encircled by a four-part copper design. The accuracy with which the copper was placed demonstrates the skill of Edwin C. Moore at Tiffany's. The highly detailed surface has copper worked into the stems of the leaves as well. The bottom of the container, seen in Figure 16.10b, shows the pains Tiffany took to have design appear on every surface of their wares.

Figure 16.11
A muffineer from Tiffany, made circa 1938, when it was first received as a wedding gift. The piece, 13/16 inches high, matches the Tiffany tea caddy in Figure 6.7 exactly, except for the pierced top on this piece. Using this for parmesan cheese would certainly add elegance to a simple spaghetti meal. Filled with powdered sugar, it can be used at a dessert table.

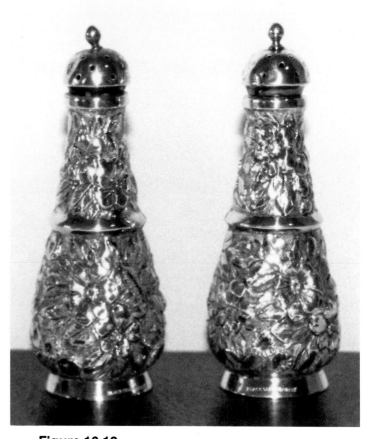

Figure 16.12
A pair of salt and peppers sold by Black, Star and Frost (the name used from 1876 to 1929, after which "Incorporated" was added). They are 3 3/4 inches tall. The repoussé work is interesting because of the plain rims and tops. Each shaft is also broken by a small rim of plain silver. The elegant design of this beautiful sterling silver pair speaks well of the work of the silversmith who made them.

Figure 16.13 *(see photo on color page 185)*
A collection of pepper cruets, showing how a number of companies interpreted the Repoussé design technique. From left to right, the first pepper cruet in sterling is by J. S. McDonald and stands 4 3/16 inches high. The second cruet is by Stieff, in their pattern *Stieff Rose*, and stands 4 9/32 inches high. The third cruet is by Kirk, 3 15/16 inches high, and was made in the period between 1907 and 1924. The fourth cruet, made by Baltimore Silver Smiths (Stieff's predecessor), stands 3 13.16 inches high and was made between 1892 to 1904 period. The last cruet, again by Kirk, is 4 3/8 inches tall and was made between 1925 and 1932. *First cruet courtesy of Maxine Klaput Antiques*

Figure 16.14 *(left)*
A salt stand and pepper cruet, each bearing the number 58, made by Kirk between 1924 and 1932. The salt is 2 5/8 inches wide and 1 1/2 inches high. The pepper cruet is 4 3/8 inches tall. Both were made in the *Repoussé* floral pattern. *Courtesy of Maxine Klaput Antiques*

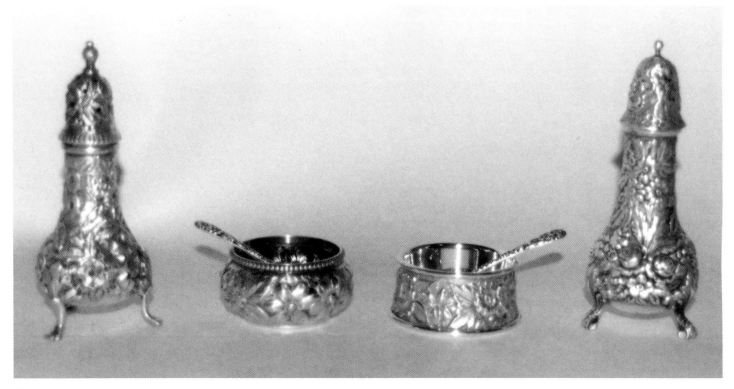

Figure 16.15
A collection of salt stands and pepper cruets, illustrating how easily a wide variety of work in the repoussé design can be mixed together. The pepper cruet on the left is by the Baltimore Sterling Silver Company and is 3 15/16 inches tall. The next item, a gold-washed salt stand by Gorham, has a beaded top rim. The Gorham piece is 1 7/8 inches in diameter and 7/8 inches high. The next salt is by Kirk, and bears number 59. It is 1 5/16 inches in diameter. The last pepper cruet is Kirks's number 58, which is 4 3/8 inches tall. The Kirk items are not a pair; if they were, they would most likely bear the same imprinted identification number.

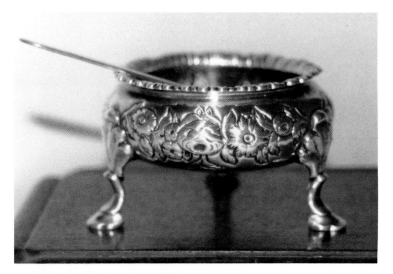

Figures 16.16 and 16.17
A salt stand by the famous New York silversmith Meyer Meyers. The piece features fabulous workmanship in the repoussé style. Note the very delicate top edge; it is among the most interesting rims on any piece in this book. To think that it is over two hundred years old makes it even more special. The base of the salt stand shows the Myers mark. Abram Kanof, in his book *Jewish Ceremonial Art and Religious Observance*, states that "Meyers was one of the most successful craftsman of his day." These particular items were purchased during the 1790s by the great-great- great-grandparents of the present owners. The form could date them a few years earlier, perhaps in the 1770s to 1780s.

Myers mark

221

Figure 16.18 *(see photo on color page 186)*
A pepper grinder unlike any present-day model. The grinder must first be inverted; then the knobs (which serve as the stand) are turned, to make the pepper fall from the narrow neck of the grinder. The silver part of this piece was made by Vanderslice and the grinding part by Will & Finck, early San Francisco cutlers. *Courtesy of Michael Weller, Argentum Antiques*

Figure 16.19 *(below)*
A Tiffany sugar shaker dated 1877, 4 1/2 inches high. The shape of the bowl and the neck make it appear to be a smaller version of the pitcher in Figure 2.15. The design and form of this pitcher helped make a special name for Tiffany and Company. *Courtesy of Michael A. Merrill, Inc.*

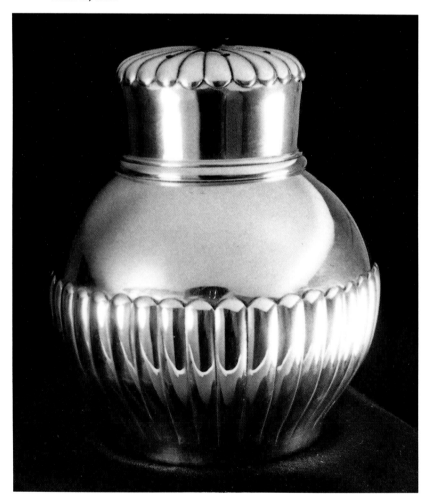

Chapter 17
Vases

Vases were made in all styles and with almost limitless design potential. In ancient times, vases were called urns, and they were used for a variety of domestic and ceremonial purposes. Today, vases are ornamental or decorative vessels that usually hold flowers. Vases have many shapes and in themselves can be quite beautiful. They are well worth appreciating for their workmanship and design. Shapes are limitless and include spheres, pear or egg shapes, and cylinders.

Silver vases have been produced for holding celery as well as the more typical flowers. A flat shallow bowl called a "fernery" was also produced.

Figure 17.1 *(see photo on color page 186)*
A Japanese-style vase by Gorham, measuring 8 7/8 inches high. It is dated 1879 and is one of only four that Gorham made like it. The mixed metals are copper and brass. *Courtesy of Phyllis Tucker Antiques*

Figure 17.2 *(see photo on color page 187)*
A Gorham mixed-metals vase, with both Japanese and Grecian influences. The narrow banding of Grecian design on the top of the neck of this vase is unique. The turtle forming one of the feet is also a mark of Grecian design. The remainer of the ornaments, including insects, are of Japanese influence. This vase is truly unique. *Courtesy of Michael Weller, Argentum Antiques*

Figure 17.3 *(see photo on color page 188)*
A pair of vases very well-done in the Japanese style, with small bowls and long necks. The hand-beaten gilt surface is covered with engraving and applied insects. *Courtesy of Michael Weller, Argentum Antiques*

Figure 17.4 *(see photo on color page 189)*
Gorham's "elephant foot" vases, featuring applied silver insects and birds on unusual bases. They are largely decorated in patinated iron. This particular form is extremely rare. *Courtesy of Michael Weller, Argentum Antiques*

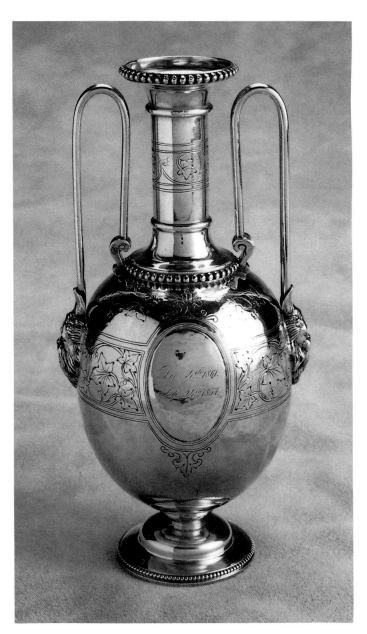

Figure 17.5
An amphora vase retailed by Ball, Black and Co. in 1861. It bears the maker's mark of "S" and a .950 mark. Engraving on the vase explains that it was presented for ten years of service. *Courtesy of Sherry Langrock, Silver Crest Antiques. Photography by Debbie Cartwright*

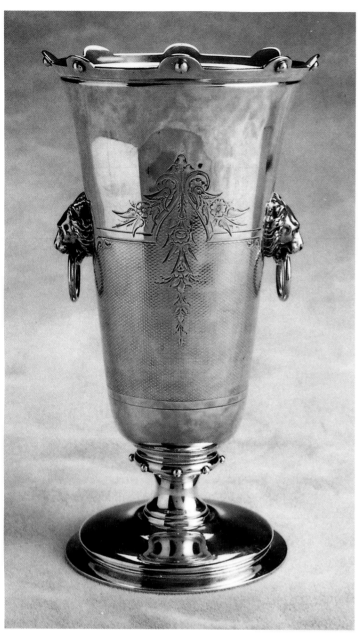

Figure 17.6
A coin silver footed vase with lions' heads for handles, retailed by Anderson and Gaines in 1852. It has been identified as a celery vase, but it could easily double for flowers. *Courtesy of Sherry Langrock, Silver Crest Antiques. Photography by Debbie Cartwright*

Figure 17.7 *(right)*
A sterling Tiffany vase with a very unusual finish; this piece could easily be mistaken for favraile glass. The entire piece is gilded, and was made circa 1885. The oriental design and the detailed dragonfly make this a most unusual piece of silver. *Courtesy of Constantine Kollitus*

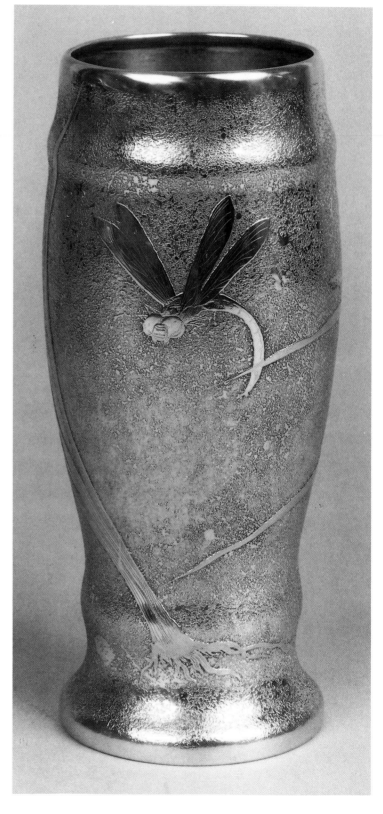

Figure 17.8
An Art Deco fluted rosebud vase made by Tiffany in the 1920s. Along the length of the rising stem is a ribbing of narrow lines. A horizontal line a third of the way up separates this decoration from the beginning of the fluting, which expands into a wide mouth for flowers. *Courtesy of Sherry Langrock, Silver Crest Antiques. Photography by Debbie Cartwright*

Figure 17.9 *(opposite page)*
An Art Nouveau basket manufactured by Dominick and Haff around the turn of the century. The cutwork of the flared basket contains irises and scrolls that have been engraved. There is a reeded edge, a pedestal foot, and a swing bail handle. The basket stands 14 inches high. *Courtesy of Sherry Langrock, Silver Crest Antiques. Photography by Debbie Cartwright*

Figure 17.10 *(below)*
A shallow bowl known as a "fernery," used to display a fern. It has textured side walls, three identical floral sprays, and tripod supports. This silver piece is 10 inches in diameter, and was made by Whiting circa 1880. *Courtesy of Butterfield and Butterfield*

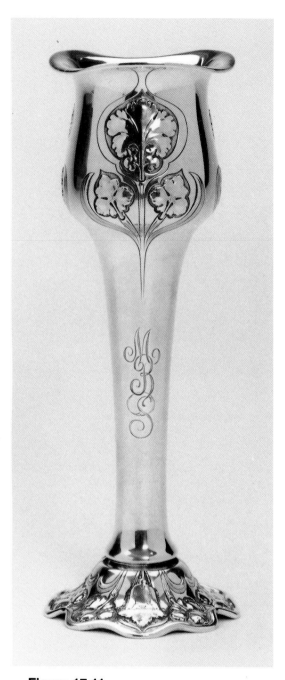

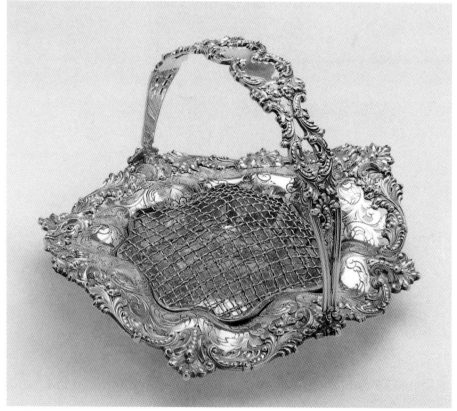

Figure 17.11
A silver vase with a skirt base and a tulip shape. Made by Gorham, this vase also features a wave-edge finished with a moulded rim, chased and applied foliage decoration, and a plain stem. It stands 11 7/8 inches tall and weighs over 15 ounces. *Courtesy of Butterfield and Butterfield*

Figure 17.12
A Shreve and Company floral arranger with a plated liner and wire frog fittings. The oval-shaped shallow bowl has wide borders that have been engraved and pierced with hollow molded scrollwork decoration. The arranger is 10 inches high, 15 3/4 inches long, and 13 1/2 inches wide. It would allow for a spectacular floral display. *Courtesy of Butterfield and Butterfield*

Chapter 18
Plates

Most companies manufactured service plates and individual butter plates. A service plate has an edge that extends at least an inch wider than the dinner plate all around. The extra area allows the design of the service plate to show beyond the dinner plate. Service plates remains at the table through the soup course, or at the most through two courses. They were usually coordinated with a flatware pattern; however, there were exceptions. The service plate was very popular around the turn of the century, and many china manufacturers offer them currently.

Butter plates are smaller versions of the service plate and generally match. Butter plates were made by many companies. Some of the larger firms made butter plates to compliment their flatware patterns.

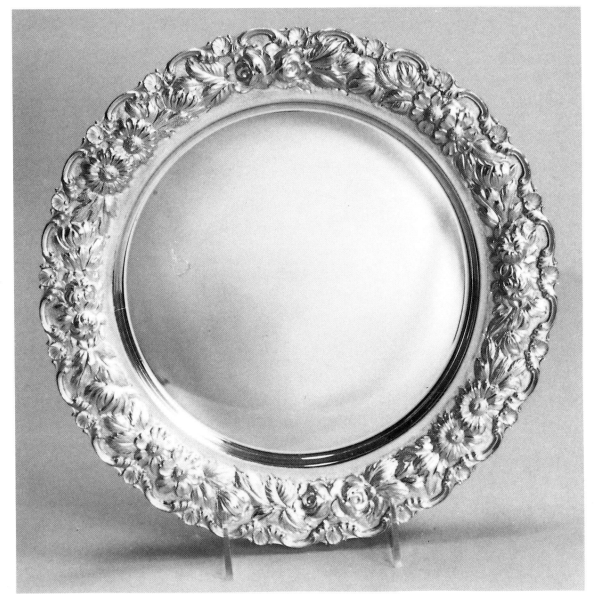

Figure 18.1
A plate from the Stieff Company, with the number 225 on the reverse side. This plate is 11 inches in diameter. The 1920 Stieff catalog described this piece thus: "Number 225—Round Tray, made in all sizes, for all uses, from 6 to 16 inches in diameter." The flower border is encircled with a scroll and shell rim design. *Courtesy of Michael A. Merrill, Inc., Baltimore, MD*

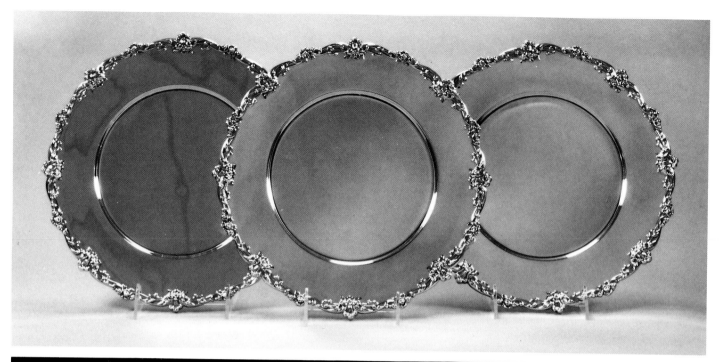

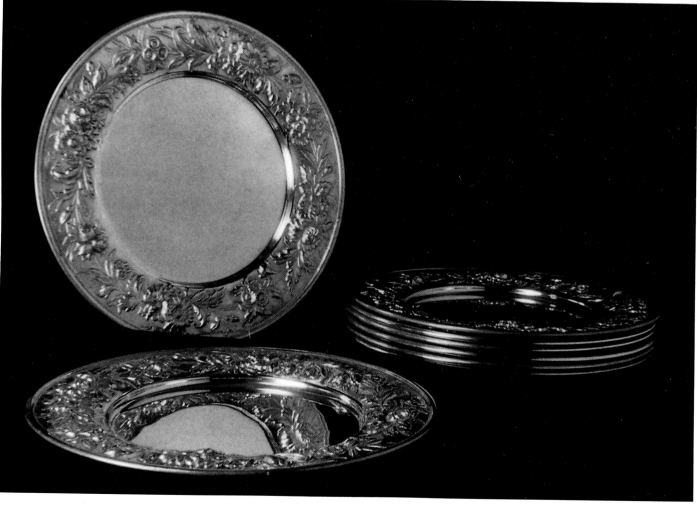

230

Figure 18.2 *(opposite page, top)*
Service plates bearing the Gorham date mark for 1913. They are 11 inches in diameter. The delicate applied border is in stark contrast to the plainness of the plates' bodies. *Courtesy of Michael A. Merrill, Inc., Baltimore, MD*

Figure 18.3 *(opposite page, bottom)*
Bread and butter plates by Kirk in their *Repoussé* pattern, 6 1/4 inches in diameter. The 1914 Kirk catalog reproduction published by Michael A. Merrill shows similar plates as having the number 28 on the back side and being 6 inches in diameter. Kirk's 1938 catalog, also published by Michael A. Merrill, lists a plate numbered 128F as being 6 1/4 inches in diameter. These must have been made sometime near the date of this catalog. Kirk made bread and butter plates to match a number of their sterling flatware patterns. *Courtesy of Michael A. Merrill, Inc., Baltimore, MD*

Figure 18.4 *(below)*
Two different sets of service plates. Both sets were made by the now-defunct Norbert Manufacturing Company of New York City, which Rainwater lists as going into business in 1950. The plates on the left are of circular form with beaded borders. The plates on the right are octagonal in shape, with an embossed bamboo edge. Plates in both designs measure 12 1/4 inches in diameter. *Courtesy of Butterfield and Butterfield*

Figure 18.5 *(see photo on color page 190)*
Three terrapin dishes from Shreve and Company, circa 1903, shown with Wedgwood dishes in the *Bianca* pattern. These particular terrapin dishes were wedding presents to the grandparents of one of the contributors, at which time they were also available with a small turtle applied on the short handle. Three different terrapin forks are presented in this picture: Gorham's *Strasbourg*, 5 1/32 inches long; Durgin's *Dauphin*, 5 1/2 inches long; and *Louis XV*, 5 3/8 inches long. The handle of the *Louis XV* fork was made by Whiting, but the bowl and tines were made by Shreve and Company. These *Louis XV* forks, too, were wedding presents to the contributor's grandparents.

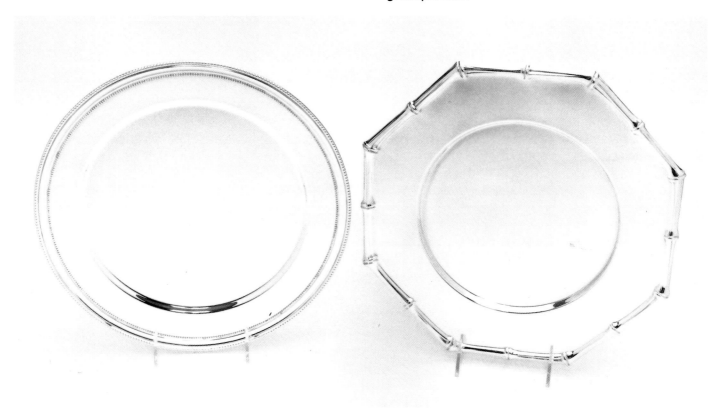

Chapter 19
Wine and Cocktail Items

This section contains a number of items that were used to serve wine, cocktails, and ice over a period of years. The first items shown are ice containers, followed by coctail shakers, and finally a spectacular wine bottle holder in the *Medallion* pattern.

Ice Containers

The ice business started in 1799 when a shipload was sent from New York down to South Carolina. A Boston firm later sent a shipment to England. In 1844 an English inventor, Thomas Masters, noted that man could now duplicate one of nature's most wonderful phenomoma, ice, once the product solely of nature's own laboratory. By 1870 there were four commercial ice-making plants in the United States. The pressing need for ice created an expanding new industry. By the end of the nineteenth century every Southern plantation had its own icehouse, and all industrial centers added ice storage houses. By 1944 there were almost seven thousand plants, producing almost fifty million tons of ice annually.

Ice containers intended as wine coolers were probably filled with bits of ice, and then the wine bottle could be placed in the cooler. Most likely they would have been placed on a tray to catch the condensation, and then put on the sideboard.Ice containers could also come with an ice spoon, which allowed one to take a portion of ice, which presumably was then put into a glass.

Though ice containers were made by several companies, they are scarce and hard to find. Not many were ever made, since ice itself was a rare commodity in bygone days; it some areas it had to be saved from the frozen streams and stored in sawdust for the heat of summer. Today this is almost incomprehensible, as automatic ice machines in our home refrigerators and in public places have made ice available everywhere.

Cocktail Shakers

The sterling cocktail shaker belongs to the recent past, coming into its own during the 1920s through the 1940s. Usually shakers are made in three sections—a bottom part for mixing and storing the liquor; a removable mid-section which contains the narrow, round pouring portion; and the cap or cover, which must be securely in place before the drinks are mixed. These items were made by many manufacturers over the years. Though they are most often associated with such drinks as the martini or the Manhattan, they could easily serve even instant iced tea and instant lemonade.

Figure 19.1 (See photo on color page 190) Gorham's classic ice bowl, in a style dubbed by collectors and museum directors as "the Alaska Movement." Items in this style were made shortly after Seward's 1867 purchase of Alaska, which many Americans thought of at the time as "America's Ice Box." This magnificent bowl is not large—not surprising, since ice at this time was expensive, and smaller pieces would have been chipped from a large block of ice with an ice pick while still in the kitchen, before being brought into the dining room for use. The ice spoon designed by Gorham to accompany the bowl has an elongated, pleated, pierced bowl, and a two-piece handle. A bear is attached to the base of the handle to match those on the bowl. The two parts of the handle appear to be whaling harpoons, minus the barbs. A twisted silver wire holds all of this together. *Courtesy of Michael Weller, Argentum Antiques*

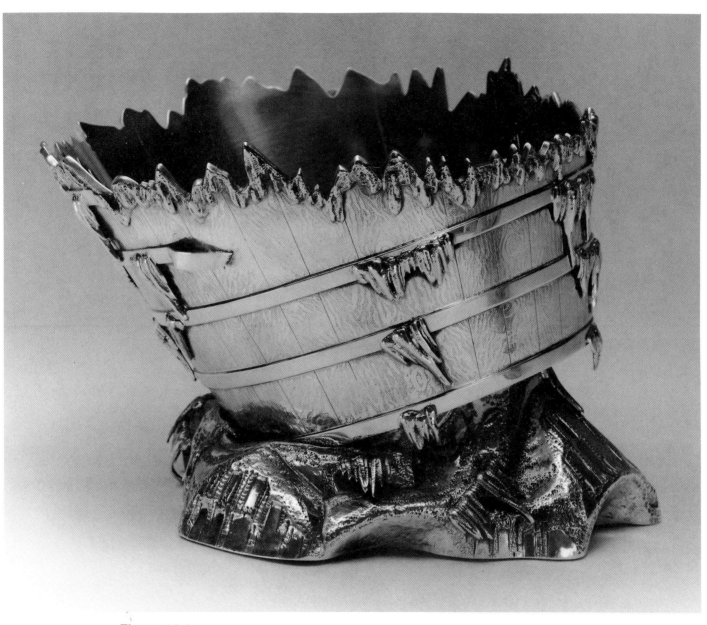

Figure 19.2
Another form within Gorham's ice bucket line. It is dated 1871, and very few of these were made. The similarity to the ice bucket shown in Figure 20.1 is easy to observe. *Courtesy of Phyllis Tucker Antiques*

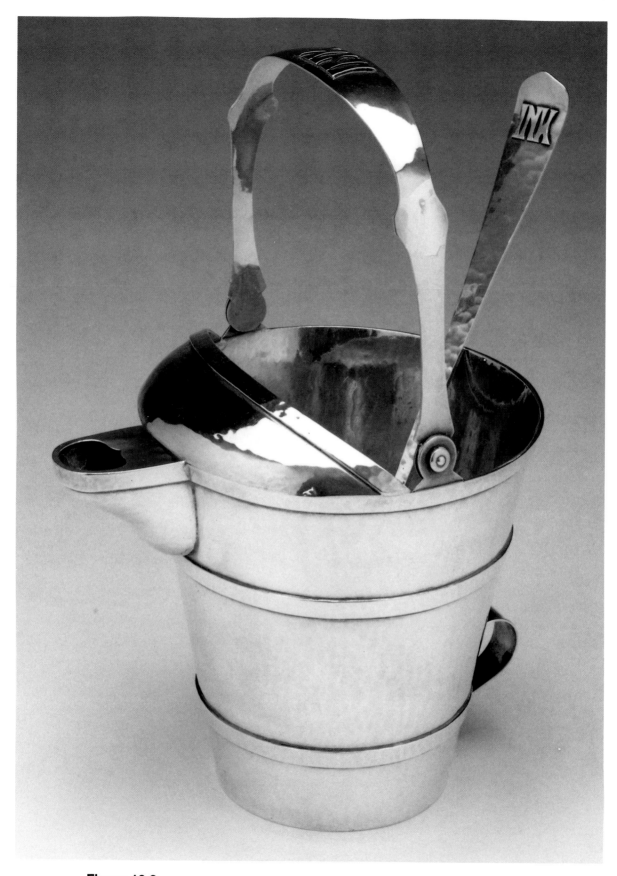

Figure 19.3
An ice container with a lip, a top handle, and even a back handle. This item was probably made by Falick Novick in Chicago, circa 1920. Also shown is an ice spoon with applied letters forming a distinctive monogram. *Courtesy of Michael Weller, Argentum Antiques*

Figure 19.4a *(see photo on color page 191)*
A Tiffany wine cooler made circa 1885. Additional parts of this cooler are the removable sleeve and collar, which are necessary elements for a complete wine cooler. American wine coolers from this era are seldom found, perhaps due to the strong temperance movement afoot during the late nineteenth century. *Courtesy of Phyllis Tucker Antiques*

Figure 19.4b *(below)*
An Art Deco cocktail shaker by Gorham, made circa 1929. A bowl accompanied this item when it was first made. *Courtesy of Constantine Kollitus*

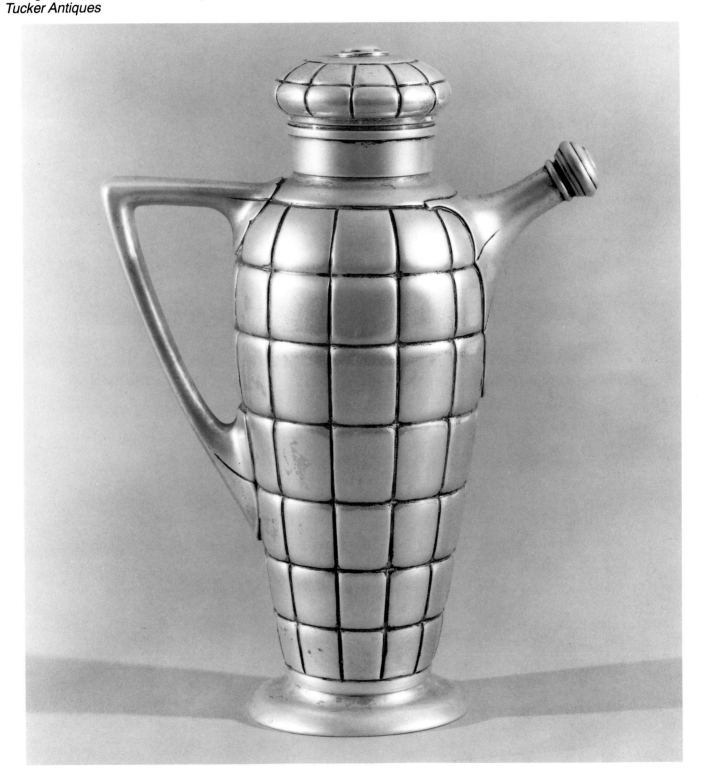

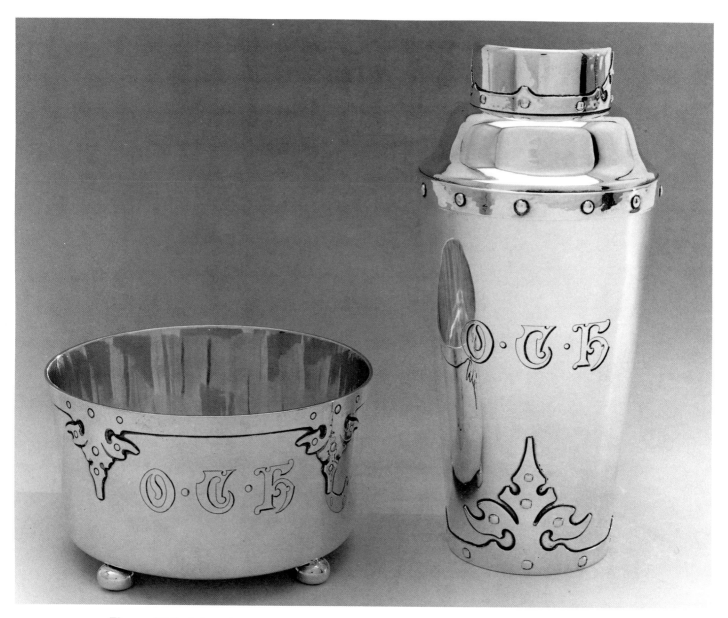

Figure 19.5 *(above)*
Two monogrammed pieces made by Shreve and Company, in their *14th Century* or *Strap* pattern. The Gothic script of the mongrams coordinates with the overall medieval style of the two sterling pieces. *Courtesy of Michael Weller, Argentum Antiques*

Figure 19.6 *(see photo on color page 192)*
A Towle cocktail shaker made in 1937. This piece has three parts: a base, a strainer, and a top cap. The surface is lightly hand-hammered. Three martini glasses in the *Regent* pattern by Stuart are ready — with olives! — for pouring.

Figure 19.7 *(see photo on color page 192)*
A very rare champagne bottle holder in the *Medallion* pattern by Wood and Hughes. The sturdy handle features a classical head, and there is a cameo on the silver band circling the neck of the wine bottle. All of these elements conspire to make this a "one-of-a-kind" item. *Courtesy of Michael Weller, Argentum Antiques*

Glossary

The terms included in this glossary are commonly used by serious silver collectors and dealers. While the list does not include every silver-related word, all the words defined here do appear in the text of this book.

A bobéche.

bobéche A piece of glass or metal with a hole in the center, to be placed on a candlestick to catch melting wax. On some candlesticks the bobéche is permanently attached; on others it is loose.

borders Decorations that are applied to the edges of wares. There are three types used commonly on silver hollowware:

applied border A decorative edge soldered onto the item. The edge is cased to produce a framed effect.

An applied border.

A stamped border.

stamped border an edge that is part of the original hollowware form, shaped when the piece is manufactured.

gadroon border An edge resembling braided rope. Many variations exist, some incorporating shells, flowers, and bows.

buffing polishing sterling items on a rotating wheel, using a compound like jewelers' rouge.

casting reproducing a model by pouring molten metal into a mold, generally used for solid pieces like feet that are applied to stamped items. The end product is called a "casting."

chasing ornamentation of metal using small tools and punches. The silversmith gently taps the silver with these tools. There are two types of chasing, 'flat chasing' and 'repoussé'. Flat chasing occurs when flowers, scrolls, or other designs are impressed into the surface. Repoussé occurs when the chasing brings the ornamentation into high relief by pushing the metal out from the inside. See **repoussé** for more information and an example.

A gadroon border.

compote a serving dish that is usually footed and occasionally covered, used for serving nuts, jelly, candy, etcetera.

Flat chasing.

238

diapered an overall surface pattern that is engraved onto the silver. This served to hide small surface scratches.

embossing A raised design molded onto a silver surface by rolling the flat silver between a roller and an embossing plate. No metal is lost in this process, unlike engraving.

engraving a design added to a silver surface by cutting lines into the piece, thereby removing some of the metal.

A diapered surface.

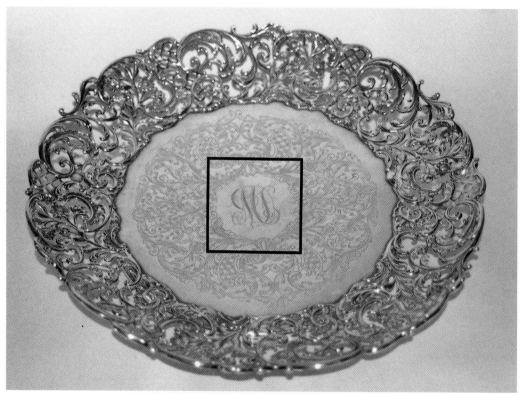

Engraving.

epergne a decorative centerpiece of silver that may have two or more arms emerging from the center. It is used to hold flowers, fruit, and candy.

etching a method of changing the surface texture of sterling, usually by applying acid to part of the object. Depending on how the acid is applied, the silver surface can become bright or dull, or assume the texture of an orange.

gilding using a gld wash over part or all of a silver item to prevent tarnishing.

hammered silver using repeated blows of a silversmith's hammer on the surface of a piece to add texture to the silver.

hollowware any silver wares that have depth; as opposed to flatware.

insulators small pieces of ivory, usually placed on two parts of the handle of a vessel designed to hold hot foods or liquids. The ivory keeps the handle from getting too hot for the user to hold.

martelé a technique of hand-wrought .950 pure **insulators** small pieces of ivory, usually placed on two parts of the handle of a vessel designed to hold hot foods or liquids. The ivory keeps the handle from getting to hot for the user to hold.

martelé a technique of hand-wrought .950 pure silver developed by Gorham circa 1895-1896 and used until circa 1920. Because it is hand-wrought, a piece in this technique would have small hammer marks all over the surface.

mixed metal a combination of silver with copper, gold, and/or iron. This decorative technique was used primarily during the height of the Japanese style. A mixed metal piece will have applied decorations of metals that contrast with the metal used for the vessel's surface.

piercing A technique in which metal is removed from a silver item, leaving 'holes' in an ornamental pattern.

repoussé a technique in which a raised design has been hammered from the inside of a silver vessel, creating a bumpy surface of various heights on the silver. Engraving can then be used to add extra detail to the relief pattern.

A mixed metal piece with insulator rings on the handle.

A repoussé design.

240

Bibliography

Books & Magazines

Berman, Anne E., "Antiques: Japanese Silver." *Architectural Digest,* August 1995, 94-99, 143.

Carpenter, Charles H. Jr., *Gorham Silver 1831–1981.* New York: Dodd, Mead & Company, 1982.

Carpenter, Charles H. Jr. with Mary Grace Carpenter, *Tiffany Silver.* New York: Dodd, Mead & Company, 1982.

Courtney, Nicholas, *A Little History of Antiques.* London: Penguin Group, 1994.

Cox, Helen, *Silver Flatware.* New Orleans: As You Like It Silver Shop, 1994.

Goldsborough, Jennifer Faulds, *Silver in Maryland.* Baltimore: Museum and Library of Maryland History, 1984.

Grant, Eileen ed. *Woman's Day Encyclopedia of Cookery.* New York: Fawcett Publications, Inc., 1966.

Kanof, Abram, *Jewish Ceremonial Art and Religious Observance.* New York: Harry N. Abrams, Inc.

Morse, Edgar W. ed., *Silver in the Golden State.* Oakland: History Department of he Oakland Museum, 1986.

Osterberg, Richard F. and Betty Smith, *Silver Flatware Dictionary.* San Diego: A. S. Barnes and Company, 1994.

Osterberg, Richard F., *Sterling Silver Flatware for Dining Elegance.* Atglen, PA: Schiffer Publishing Ltd., 1994.

Rainwater, Dorothy J., *Encyclopedia of American Silver Manufacturers.* Atglen, PA: Schiffer Publishing, Ltd., 1986.

Roberts, Patricia Easterbrook, *Table Settings, Entertaining and Etiquette.* New York: Bonanza Books.

Soeffing, D. Albert, *Silver Medallion Flatware.* New York: New Books, Inc., 1988.

Swan, Martha Louise, *American Cut and Engraved Glass.* Radnor, PA: Wallace-Homestead Book Company, 1994.

Tunis, Edwin, *Colonial Craftsman.* Cleveland: The World Publishing Company, 1965.

Venable, Charles L., *Silver in America, 1840-1940, A Century of Splendor.* New York: Harry N. Abrams Inc., 1995.

Williams, Henry Lionel and Ottalie K. Williams, *Great Houses of America.* New York: G.P. Putnam and Sons, 1969.

Catalogs

Samuel Kirk & Son Co., 1914 Catalog Reproduction. Baltimore: Michael A. Merrill, Inc., 1994.

Sterling Silver by Kirk, 1938 Catalog Reprint. Baltimore: Michael A. Merrill, Inc., 1993.

Stieff Handwrought Repoussé Sterling Silver, 1920 Catalog Reproduction. Baltimore: Michael A. Merrill, Inc., 1991.

Value Guide

There are many factors that affect the price of silver items like those shown in this book. Among the factors are the following:

- diminishing supply of spectacular items
- demand for a particular pattern
- geographic location
- condition of the item (including, but not limited to, monogram or monogram removal)
- place of purchase (auction, estate, dealer, etc.)
- just how much the purchaser wants the particular item.

For many of the items illustrated in this book, I have provided a price range that takes into account the variations explained above. Some of the items that are shown here are now in museums and most likely will not be available for purchase. Therefore, a category of *museum quality* is used to indicate their high value. *Auction* means that the item was sold at auction.

The reader should remember that this guide is only that—a guide. Similar items may be found at prices above or below these estimates. Neither the author nor the publisher assume any responsibility for losses that a collector may incur using this guide.

Figure Number	Value ($U.S.)	Figure Number	Value ($U.S.)
CHAPTER 1		Figure 2.2b	auction
Figure 1.0	not available	Figure 2.2c	not available
Figure 1.1	$1500-3500	Figure 2.2d	museum quality
Figure 1.2	$2750	Figure 2.3	$3000-4000
Figure 1.3	$750-950	Figure 2.4	$3500-4500
Figure 1.4	$5000-6000	Figure 2.5	$4000-6500
Figure 1.5	auction	Figure 2.6	$2500-3000
Figure 1.6	not available	Figure 2.7	
Figure 1.7	$1200-1500	(includes Figure 2.30)	$7000-7900
Figure 1.8	$1200-2000	Figure 2.8	$4000-5000
Figure 1.9	$2000-2500	Figure 2.9	$6000-7000
		Figure 2.10a, b	$4000-5000
CHAPTER 2		Figure 2.11a	not available
Figure 2.1a	$3000-4000	Figure 2.11b	not available
Figure 2.1b	$1500-2000	Figure 2.13	$2000-3000
Figure 2.2a	$6500	Figure 2.14	$3500

Figure 2.15	$1000-1500	Figure 3.20	$2500-3000
Figure 2.16	museum quality	Figure 3.21	$4000-5000
Figure 2.17	$4000-6500	Figure 3.22	$800-1000
Figure 2.18a	$2000-3000	Figure 3.23	$1200-1500
Figure 2.18b	museum quality	Figure 3.24	not available
Figure 2.19	museum quality	Figure 3.25	$175-275
Figure 2.20	$2000-3500	Figure 3.26	$900-1200
Figure 2.21	$700-800	Figure 3.27	$2500
Figure 2.22	$750-900	Figure 3.28	$6000-9000
Figure 2.23	museum quality	Figure 3.29	museum quality
Figure 2.24a	$6000-8000	Figure 3.30	$6000-7000
Figure 2.24b	not available	Figure 3.31	not available
Figure 2.25a	$9000-10,000		
Figure 2.25b	$35,000-40,000	**CHAPTER 4**	
Figure 2.25c	$35,000-40,000	Figure 4.1	not available
Figure 2.26	$2000-3000	Figure 4.2	$8000-9000
Figure 2.27	$4000-9000	Figure 4.3	$20,000-25,000
Figure 2.28	museum quality	Figure 4.4	$2500-3500
Figure 2.29	$60-80 each	Figure 4.5	$9000-12,000
Figure 2.30	see Figure 2.7	Figure 4.6	see above
Figure 2.31	$500-700	Figure 4.7a	museum quality
Figure 2.32	$250-850 each	Figure 4.7b	not available
Figure 2.33	$1250/pair	Figure 4.7c	not available
Figure 2.34	museum quality	Figure 4.8	not available
Figure 2.35	$450-600	Figure 4.9	$5000-6000
		Figure 4.10	museum quality
CHAPTER 3		Figure 4.11	$20,000-25,000
Figure 3.0	not available	Figure 4.12	$10,000-15,000
Figure 3.1	$2500-4500	Figure 4.13	$1500-2000
Figure 3.2	$1200	Figure 4.14	$12,000-15,000
Figure 3.3	$1500-2000	Figure 4.15	$1500
Figure 3.4	$3000-4000	Figure 4.16a	$7500-8500
Figure 3.5	$1500-2500	Figure 4.16b	$20,000
Figure 3.6	$650-1000	Figure 4.17	$2750-3250
Figure 3.7	$2000-2500	Figure 4.18	$950
Figure 3.8	$1500-200	Figure 4.19	$3500+
Figure 3.9	$2500-3000	Figure 4.20	$1200-1500
Figure 3.10	$3500	Figure 4.21	$10,000-12,000
Figure 3.11	$2500		with sterling tray
Figure 3.12	$2200	Figure 4.22	$1800-2200
Figure 3.13	$2000-4500	Figure 4.23	not available
Figure 3.14a	$2000-4500	Figure 4.24	$5000-6500
Figure 3.14b	$2000-4500	Figure 4.25	$6000-8000
Figure 3.15	$5000-6000	Figure 4.26	$2500
Figure 3.16	$600-1000	Figure 4.27	not available
Figure 3.17	$1500-1700	Figure 4.28	not available
Figure 3.18	not available	Figure 4.29	not available
Figure 3.19	$1500-1850	Figure 4.30	$3000-4000

Figure 4.31	$2500-3000
Figure 4.32	$3000-3500
Figure 4.33	auction
Figure 4.34	auction
Figure 4.35	auction
Figure 4.36	auction
Figure 4.37	auction
Figure 4.38	auction
Figure 4.39	auction
Figure 4.40	auction
Figure 4.41	auction
Figure 4.42	museum quality
Figure 4.43	$3500-4500

CHAPTER 5

Figure 5.0	not available
Figure 5.1	museum quality
Figure 5.2	$10,000
Figure 5.3	part of set, see Figure 4.14
Figure 5.4	$5000-6000
Figure 5.5	museum quality
Figure 5.6 and 5.7	$2250-2750
Figure 5.8	not available
Figure 5.9	left: $300-500 middle: $900-1250 right: $700-800
Figure 5.10	$1950
Figure 5.11	not available
Figure 5.12a	not available
Figure 5.12b	not available
Figure 5.12c	not available
Figure 5.13	auction
Figure 5.14	$5000-7000
Figure 5.15	$1500-2000
Figure 5.16	$6000-8000
Figure 5.17	$600-2500
Figure 5.18 and 5.19	$8000-9000

CHAPTER 6

Figure 6.1a, b	museum quality
Figure 6.2	$14,000
Figure 6.3	not available
Figure 6.4	museum quality
Figure 6.5	$2000-3500
Figure 6.6	$1500-2500
Figure 6.7	$3000-3500
Figure 6.8	$1200-2000

Figure 6.9	museum quality
Figure 6.10	museum quality
Figure 6.11	$2000-2750
Figure 6.12	$3000-3500
Figure 6.13a, b, c	museum quality
Figure 6.14	museum quality

CHAPTER 7

Figure 7.1	$5000-6000
Figure 7.2	$1200-1700
Figure 7.3	$2000-2500 each
Figure 7.4	$2000-2500 each
Figure 7.5	$900-1200
Figure 7.6	$750/pair
Figure 7.7	not available
Figure 7.8	not available
Figure 7.9	$1200-1800
Figure 7.10	$450/pair
Figure 7.11	$350-550
Figure 7.12	$450-600
Figure 7.13	$3000-4000
Figure 7.14	$1500-2000
Figure 7.15	$3500-4000
Figure 7.16	$3500-4000
Figure 7.17	not available
Figure 7.18a, b	$2250-2850
Figure 7.19a, b	$2000-2500

CHAPTER 8

Figure 8.1	$2500-3000
Figure 8.2	$1400-1650
Figure 8.3	not available
Figure 8.4	$900-1000
Figure 8.5	not available

CHAPTER 9

Figure 9.1	$15,000-18,000/pair
Figure 9.2	$8000-10,000
Figure 9.3	not available
Figure 9.4	not available
Figure 9.5	$6000-8000
Figure 9.6	museum quality
Figure 9.7	$1800-2200
Figure 9.8	$450
Figure 9.9	auction, $4025
Figure 9.10	$5000-6000
Figure 9.11	auction

CHAPTER 10

Figure 10.1	not available
Figure 10.2	museum quality
Figure 10.3	$4000-5000
Figure 10.4	$5000-6000
Figure 10.5	$14,000-16,000
Figure 10.6	$6000-7000
Figure 10.7	not available
Figure 10.8	museum quality
Figure 10.9	$6000-10,000
Figure 10.10	not available

CHAPTER 11

Figure 11.1	not available
Figure 11.2	$20,000-25,000 (very rare set)
Figure 11.3	$6000-7000
Figure 11.4	$4000-5000
Figure 11.5	auction, $2587.50
Figure 11.6	$8000-10,000
Figure 11.7	$4000-5000

CHAPTER 12

Figure 12.1	museum quality
Figure 12.2a, b	$5000-6000
Figure 12.4	$9000-10,000
Figure 12.5	not available
Figure 12.6	$1500-2000
Figure 12.7	$5000-6000
Figure 12.8	$5000-6000
Figure 12.9a	$5000-6000
Figure 12.9b	$5000-6000
Figure 12.9c	$3000-4000
Figure 12.10	$3000-4000
Figure 12.11a	$4900-5900
Figure 12.11b	not available
Figure 12.12	$1500 each
Figure 12.13	auction
Figure 12.14a	not available
Figure 12.14b	not available
Figure 12.14c	$8000-9000
Figure 12.15a	auction
Figure 12.15b	not available
Figure 12.16	left: $900 middle: $1500 right: $1600
Figure 12.17a, b	$2500-3250

Figure 12.18	not available
Figure 12.19	$1450-1850
Figure 12.20a, b	not available
Figure 12.21a	$3500-4500
Figure 12.21b	$2500
Figure 12.21c	$3500-4500
Figure 12.21d	$1200
Figure 12.22a	$8000-10,000
Figure 12.22b	not available
Figure 12.23	$6000-7000
Figure 12.24	$15,000-20,000
Figure 12.25	$8000-10,000
Figure 12.26	$12,000-14,000
Figure 12.27	auction

CHAPTER 13

Figure 13.1	$1800-2200
Figure 13.2	not available
Figure 13.3	$2750-3750
Figure 13.4	$4000-6000
Figure 13.5	museum quality
Figure 13.6	$1500-2000
Figure 13.7	platter: $1450-1750 vegetable dish: $350-500 butter dishes: $100-125 ea.
Figure 13.8	$2200-2500
Figure 13.9	$1850-2200
Figure 13.10	$1275
Figure 13.11	$850
Figure 13.12a	$3500-4500
Figure 13.12b	$6000-7000
Figure 13.13	$1250-1500
Figure 13.14	not available
Figure 13.15	$700-850
Figure 13.16	$250
Figure 13.17	$250-350
Figure 13.18a	$1200-1800
Figure 13.18b	$1200-1500
Figure 13.19	$350-500
Figure 13.20	$250
Figure 13.21	auction
Figure 13.22	not available
Figure 13.23	$250-300 (including cheese serving knife)
Figure 13.24	$1500-2000
Figure 13.25	not available

CHAPTER 14

Figure 14.1	$8000-9000
Figure 14.2	$1200-1500
Figure 14.3a	$1200-1500
Figure 14.3b	butter pat: $75-95
Figure 14.4	$1200-1400
Figure 14.5	$2000-2500
Figure 14.6	$1500-1750
Figure 14.7	$1500-2000

CHAPTER 15

Figure 15.1	$4000-6000
Figure 15.2	$6000-9000
Figure 15.3	not available
Figure 15.4	$650-850
Figure 15.5a	$350-595
Figure 15.5b	not available

CHAPTER 16

Figure 16.0	not available
Figure 16.1	$8000-10,000
Figure 16.2a	$4000-5000
Figure 16.2b	$5000-7000
Figure 16.3	not available
Figure 16.4	$400-500
Figure 16.5	$800-950
Figure 16.6	$600-675
Figure 16.7	$600-750
Figure 16.8	not available
Figure 16.9	$2000-3000
Figure 16.10a	$3500-4000
Figure 16.11	$800-1000
Figure 16.12	$200-350
Figure 16.13	first cruet: $175; remainder not available
Figure 16.14	pepper cruet: $100-150

	salt stand: $85-125
Figure 16.15	not available
Figure 16.16 and 16.17	museum quality
Figure 16.18	$3500-4500
Figure 16.19	not available

CHAPTER 17

Figure 17.1	not available
Figure 17.2	museum quality
Figure 17.3	$3500-5000
Figure 17.4	$4000-6000
Figure 17.5	$1600-1700
Figure 17.6	$1000-1300
Figure 17.7	$8000-10,000
Figure 17.8	$750-850
Figure 17.9	$2200-2700
Figure 17.10	auction
Figure 17.11	auction
Figure 17.12	auction

CHAPTER 18

Figure 18.1	$800-1200 each
Figure 18.2	$700-800 each
Figure 18.3	$100-150 each
Figure 18.4	auction
Figure 18.5	not available

CHAPTER 19

Figure 19.1	$15,000-25,000
Figure 19.2	not available
Figure 19.3	$2000-3000
Figure 19.4a	$10,000-15,000
Figure 19.4b	$1000-1500
Figure 19.5	$800-1500 each
Figure 19.6	cocktail shaker: $800-1000
Figure 19.7	$2000-3500

Index